S0-AIM-396

WORLD AT WAR
1945 TO THE PRESENT DAY

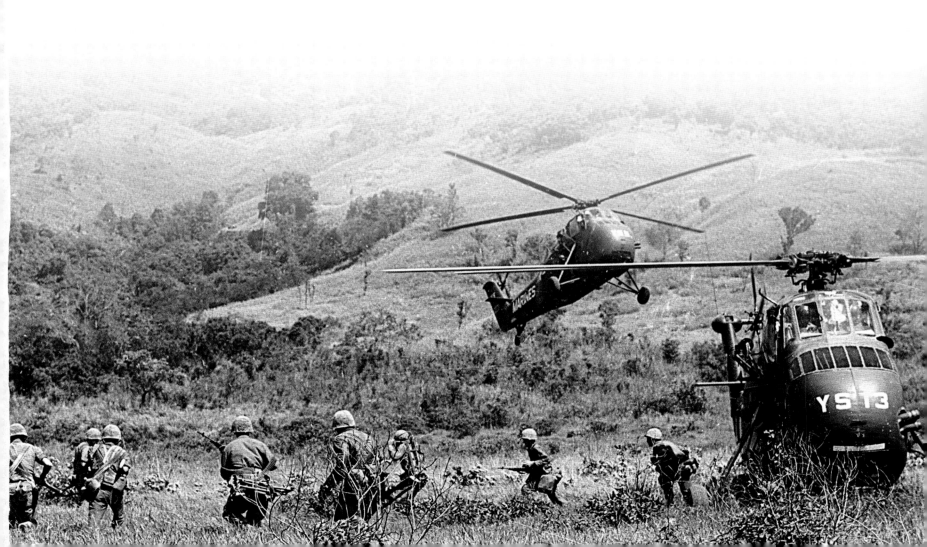

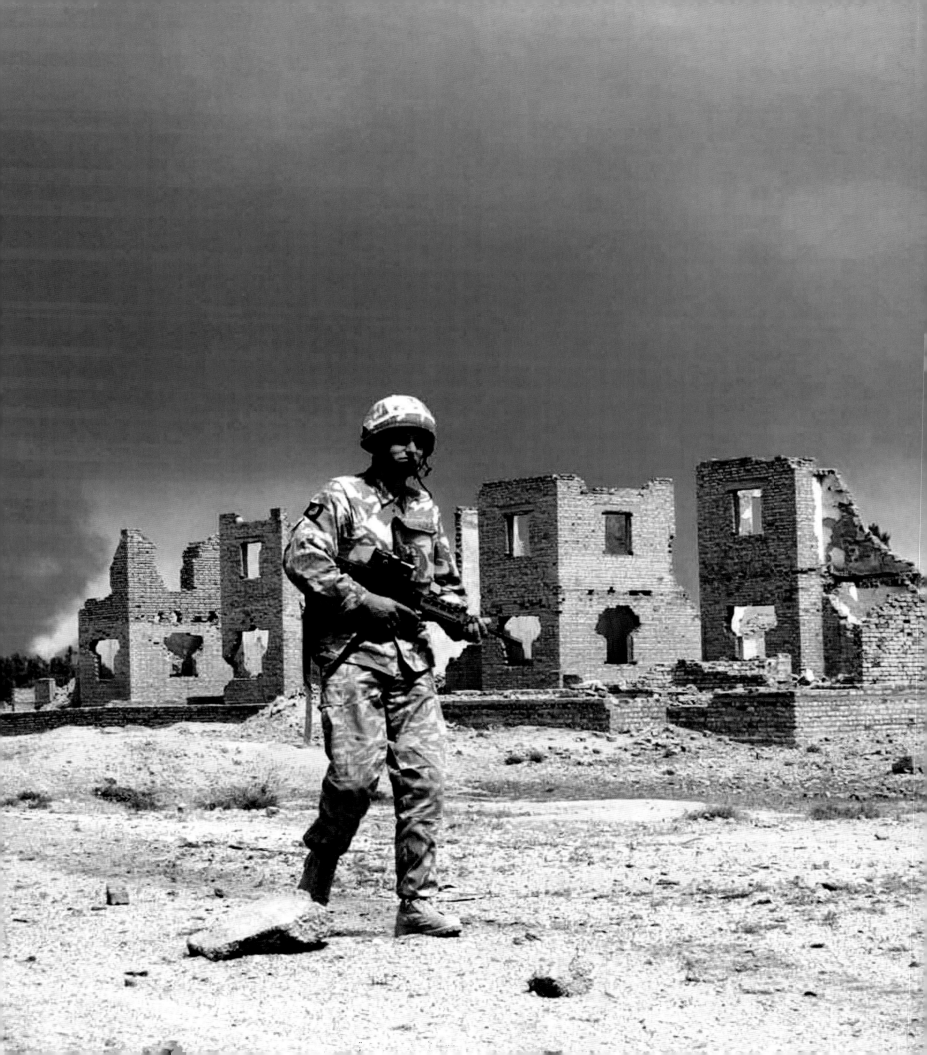

WORLD AT WAR
1945 TO THE PRESENT DAY

DUNCAN HILL

PHOTOGRAPHS BY
Daily Mail

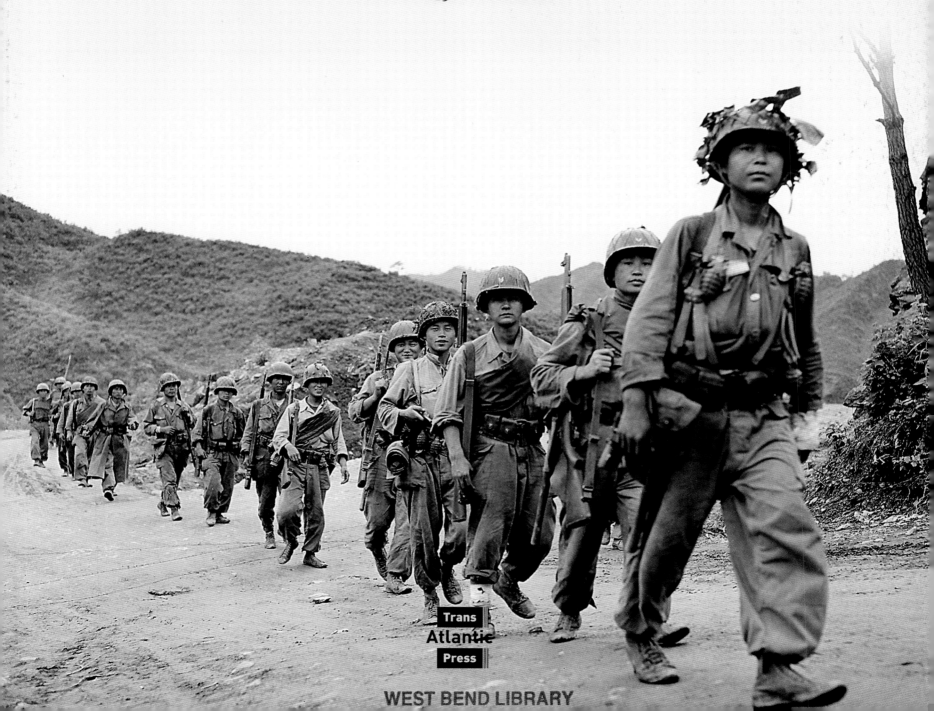

Trans
Atlantic
Press

WEST BEND LIBRARY

Contents

Introduction

355.009
H551

The United Nations sat for the first time in 1946, its charter expressing lofty aims regarding worldwide peace and security. That same year saw Winston Churchill warn of the threat posed by the proliferation of communist ideology, a threat crystallised in the Iron Curtain that had descended across Europe. Victory for Mao Zedong's communists in China in 1949 left the West facing a Bamboo Curtain too. Russia caught up with America in the nuclear arms race and a delicate balance based on mutually assured destruction was reached.

Save for the 1962 Cuban Missile Crisis, when the superpowers pulled back from the brink of direct conflict, they engaged in a string of proxy encounters during the 40-year-long Cold War. Korea laid down the template for such clashes, limited in both scale and the weaponry deployed. America's ill-fated foray into Vietnam sprang from the belief that other Southeast Asian states would fall domino-like under the Soviet sphere of influence.

The disintegration of the Eastern bloc in the 1990s led to many bloody conflicts, involving Russia itself and, in particular, ethnically diverse Yugoslavia. Eastern Europe was waking up to the idea of self-determination, which had swept across the colonies of Europe's old imperial powers in the postwar years. Independence was sometimes hard won. Algeria fought a long battle with France to gain its freedom, as did Angola from Portugal. Britain faced a Mau Mau revolt in Kenya before independence was delivered in 1963.

Withdrawal itself often led to instability and civil strife, as Congo found when Belgium left its former colony to its devices in 1960. Britain's departure from India in 1947 left the newly partitioned country in turmoil, with Muslim-dominated Pakistan and Hindu India immediately at armed loggerheads. And just 24 hours after the state of Israel was founded in May 1948, its Arab neighbours fired the opening shots in another seemingly intractable dispute.

Saddam Hussein spent most of the 1980s fighting neighbouring Iran, and brought a US-led coalition force to Iraq's door after invading Kuwait in 1990. A decade later, Saddam was toppled as part of the 'war on terror', and Taliban-led Afghanistan was also targeted as a haven for the Islamic extremist al-Qaeda network that carried out the 9/11 attack.

The lessons of the past 60 years show that while a third global conflagration may have been averted, and the use of nuclear weapons confined to testing, war remains an ever present evil; as much part of the human condition today as it was 4500 years ago when the first documented battles took place.

Chronicle of War: 1945 to the Present Day examines the conflicts of the nuclear age. Contemporaneous reports and photographs from the Daily Mail archives, including many eyewitness accounts, show how the conflicts developed, describing the key battles, tactical decisions and turning points that settled the outcome.

Chinese Civil War 1945-1949

Unifying China

There was near anarchy in China in the early years of the twentieth century. The establishment and the imperial court were widely believed to be corrupt and had lost of control of large parts of the country. A republican revolution, which overthrew the Manchu emperor in 1911, did not solve the country's problems. China fragmented into fiefdoms as local warlords took power and opposed efforts to reunify the country. In 1931, the Japanese seized Manchuria in northeastern China, further complicating the situation.

The leader of the republican movement, Sun Yat-sen, formed several governments in an attempt to unite China. To that end he also established a political party named the Kuomintang (KMT). Sun encouraged links with the emerging Communist Party of China (CPC) as they shared the nationalist goal of the KMT. He died in 1925 and was succeeded by Chiang Kai-shek, a military man who had been appointed head of the Whampoa Military Academy by Sun. In 1925 he became commander-in-chief of the National Revolutionary Army.

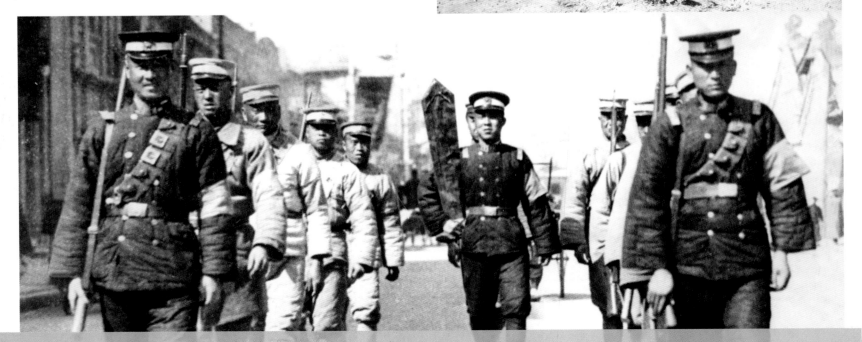

The Shanghai massacre

In April 1927, Chiang Kai-shek, who was on the political right of the KMT, broke with the Communist Party and massacred its members in Shanghai. Fighting broke out in several places, and there was an unsuccessful CPC uprising in Hunan, which was led by a young revolutionary named Mao Zedong. By late 1927, the split between the KMT and the CPC caused China to have three capitals: Beijing, which was internationally recognized; Nanking, the KMT base; and Wuhan, the Communist capital. However, by June 1928, the KMT had driven the Communists out of Wuhan and captured Beijing. Most of eastern China was now under their control, and Chiang had largely destroyed the CPC in the cities.

The Long March

It took Chiang time to control his rivals in the KMT before he could return his attention to the Communists, and during this period they became armed and better organised. The KMT launched five campaigns to encircle the Communists in their strongholds in the rural areas of Jiangxi, finally overwhelming them in late 1934. From then until 1936, the Communists began a series of retreats, undertaking lengthy journeys northwards through the mountainous territory of western China. The most famous of these was the Long March involving the First Front Army, led by Mao Zedong. The casualty rate was high on all the marches and many people also dropped out en route; it's been estimated that 300,000 set out but only 30,000 made it to their target, the area around the city of Yan-an in Shaanxi. There were only about 8,000 survivors of the Long March itself. Mao was now the almost undisputed leader of the Communists, but internal divisions were present: the Fourth Army, which was led by one of Mao's rivals, was barred from Yan-an and diverted towards remote Gaotai, where they were later largely destroyed by KMT forces.

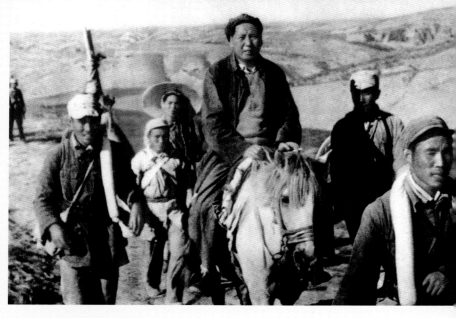

War with Japan

The Second Sino-Japanese War now flared up, and the Communists began fighting the Japanese invaders; the CPC was becoming effective politically, and Communist armies were developing into an increasingly efficient force. The Communists stressed nationalism, the desire to rid China of foreign influence, which further increased their popularity. Chiang, meanwhile, was still trying to suppress his domestic rivals and refused to make peace with the Communists despite the threat from Japan. In December 1936 two of his generals mutinied to draw his attention to the greater threat from Japan and to force him into a United Front with the Communists. This, known as the Xi'an Incident, was the first example of cooperation between a part of the KMT and the CPC since the death of Sun Yat-sen. The war against the Japanese proved to be an excellent training ground for the Communists, as well as helping them with recruitment. Their invaluable military experience against the Japanese gave them the upper hand when fighting between them and the KMT began again after the Japanese surrendered to the Allies at the end of the Second World War.

OPPOSITE ABOVE: **Mao Zedong proclaims the establishment of the People's Republic of China, October 1, 1949.**

OPPOSITE BELOW: **Chiang Kai-Shek's men round up Communists for execution during the Shanghai massacre in 1927.**

OPPOSITE RIGHT: **Nationalist troops pass the bodies of dead Japanese soldiers as they move in to reoccupy the country.**

RIGHT: **Soldiers defend foreign interests in Shanghai during the KMT purge in April 1927.**

ABOVE: **Mao on horseback near Yan-an in 1947.**

BELOW: **Aided by Soviet volunteers, Chinese Communists capture the headquarters of an anti-Communist warlord.**

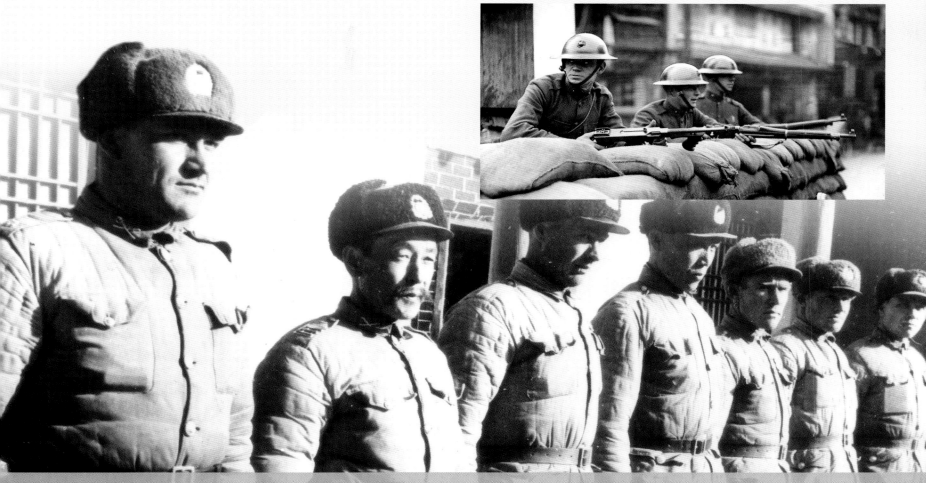

Japanese surrender

The atomic bombs dropped on Hiroshima and Nagasaki in August 1945, meant that the Japanese surrender came much sooner than either the Communists or Nationalists had expected. A temporary truce was put in operation with the encouragement of the United States, who wished to avoid instability in post-war Asia. However, it quickly fell apart, as the two sides raced against one another to capture territory from the retreating Japanese. The trigger was to be the province of Manchuria, in northeastern China, which had been seized by Japan in 1931. It was a formidable prize because it had undergone significant development during fourteen years of Japanese rule.

The battle for Manchuria

It was to be the Soviet Union who had first pick at this prize. Under the terms of the Yalta Agreement in February, 1945, the Soviets agreed to declare war on Japan, and moved into Manchuria just days before the Japanese surrender. Officially, the Soviets remained neutral, but they allowed the Communists to seize much of the arms and ammunition confiscated from the Japanese. Japanese troops usually tried to surrender to the KMT – and indeed were supposed to do so under the terms of the surrender agreement. However, this was not always possible because the Communists usually reached the occupied areas first.

The Soviet Union withdrew from Manchuria in April 1946 and the United States airlifted KMT troops in to fill the power vacuum and prevent the Communists from taking over the region. However, the Communists were now stronger militarily and had greater support among the public. Mao pushed moderate policies, which contrasted favourably with Chiang Kai-shek, whose regime appeared corrupt, too much linked to the pre-war warlord past and to massive inflation. As a result, the KMT experienced an enormous loss of popular support and the CPC were eventually victorious in Manchuria.

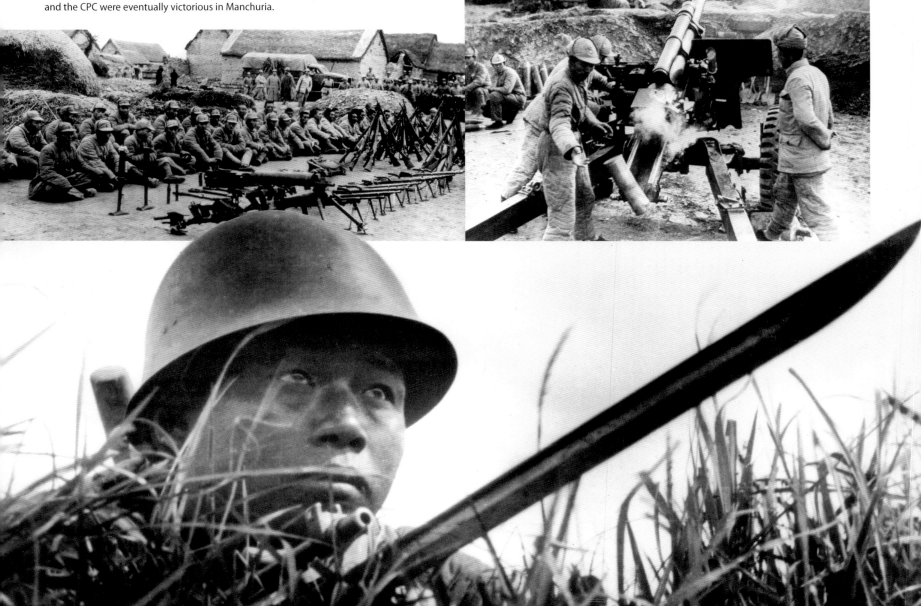

The fall of Nanking

Despite setbacks in Manchuria, the KMT managed to take the Communist base of Yan-an in March 1947. However, the Communist command retreated to new bases further north and continued the fight. In April 1948 they captured Loyang, cutting the KMT off from the major city of Xi'an. More and more provinces fell in late 1948 and early 1949 because the Communist ranks were swelled by the addition of captured KMT troops, and because public support for the CPC surged as a result of the popular land reform they had initiated behind the lines. On April 21, 1949, the Communist Party forces crossed the Yangtze River and captured the Nationalists' stronghold of Nanking.

Communist victory

The US, which had been supporting the Nationalists, had began to cut back both financial and military aid in 1948, and the KMT had gone even further downhill as a result. Soon there was no significant Nationalist military force still intact on the mainland of China, and approximately 2 million supporters withdrew to the island of Taiwan. The US withdrew their aid while this operation was underway, citing the inadequacies of the KMT regime as justification. On October 1 Mao Zedong was able to proclaim the establishment of the People's Republic of China, with its capital in Beijing; only a few pockets of resistance remained. On December 10 the final Nationalist base, the city of Chengdu, fell to the CPC's army, and the last members of the Nationalist government fled to Taiwan.

The Communist Party formed the first strong government that a united China had experienced in many decades. Hostilities finally ended in 1950 after over 20 years of fighting, most of it vicious. The end of the Civil War was unofficial, however, and no peace treaty has ever been signed. The People's Republic of China controls the mainland, and the Republic of China is restricted to the island of Taiwan.

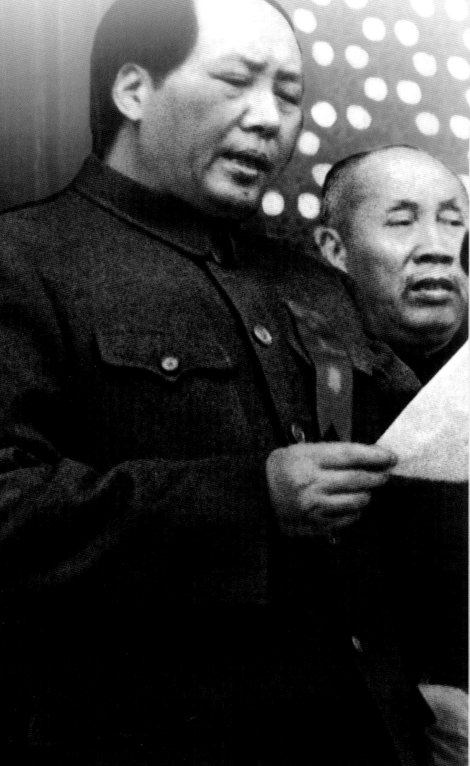

OPPOSITE BELOW: **A Communist soldier with a fixed bayonet keeps watch on positions held by the Nationalist forces.**

OPPOSITE LEFT: **Communist soldiers are held in camps after being captured by the Nationalists at Suchow.**

OPPOSITE ABOVE RIGHT: **Police in Hong Kong's New Territories train in preparation for a possible Communist attack on the British colony.**

OPPOSITE BELOW RIGHT: **Chinese Nationalists gunners eject a shellcase from a 105mm gun on the Suchow front after it had been fired at the Communists.**

LEFT: **Mao Zedong announces the establishment of the People's Republic of China from the rostrum of Tiananmen Gate in Beijing, October 1, 1949.**

DAILY MAIL JANUARY 20, 1949

The fall of China

One of the great events of human history is taking shape in China. Sooner or later it will affect the destinies of everyone in the world.

The Chinese Nationalist Government are suing for peace. This can only mean that they are finished and that Chiang Kai-Shek is on his way out.

Before he goes we should pause to pay him tribute. He was a good soldier and a sincere idealist - a disciple of Sun Yat-Sen. He brought order to China. He was one of the Big Four in the last war. What really finished him was the corruption and inefficiency which have been the curse of China for generations. And now another takes his place upon the stage - Mao Tse-Tung, boss of the Chinese Communists.

These in themselves are big events. They mean the end of the civil war which began long before the recent world conflict and outlasted it by nearly four years.

The map

But more, much more, lies behind them. The fall of China is not only a triumph for the local Communists. It is the biggest victory Russia has won since the Allied defeat of Germany gave her the key to Eastern Europe.

Look at the map. The enormous land mass under Stalin's rule is now rounded off by the vast expanse of China.

Let us not delude ourselves into believing that Chinese Communism is different from any other Communism. Mao Tse-tung is Moscow-trained and indoctrinated. He is Marxist, Leninist, Stalinist.

Let us not imagine, either, that because the Communists have proposed a Coalition Government for China that they have gone democratic. We have seen that bubble burst in half a dozen European countries.

The east

No - China has fallen and will be submerged by Communism. She is becoming detached from Western influences and will merge into the Eastern sphere. It is as though a dam had broken and a mighty torrent had come rushing through the gap, to find fresh strength in new waters.

In China live 450,000,000 patient, diligent, malleable people who could provide millions of excellent fighting men to carry the banner of the Hammer and Sickle.

Here is a land of primitive agricultural and industrial processes which could be collectivised and socialised, mechanised and organised, making the Chinese the most formidable of the races of the earth.

Look, too, at the political possibilities. China borders on India, Burma, and Indo-China. All, in varying degrees, have caught the germ of Communism. Now the risk of infection has reached epidemic proportions.

The west

Finally, there is the strategic aspect. A month ago General Macarthur said that the Communist victories in China were a grave menace to American security, and he demanded reinforcements. His view was that with China in Communist hands Russia would be in a position to seize Japan and to drive the United States from the Western Pacific. He did not say this would happen, but that it could happen - and certainly the Chinese Communists' victory has shifted the balance of strategical advantage against the Western Powers.

It is, of course, too late for them to take any action in China now. But they should concentrate on their strength and on the recovery of Europe while neglecting no opportunity of seeking lasting peace with the East.

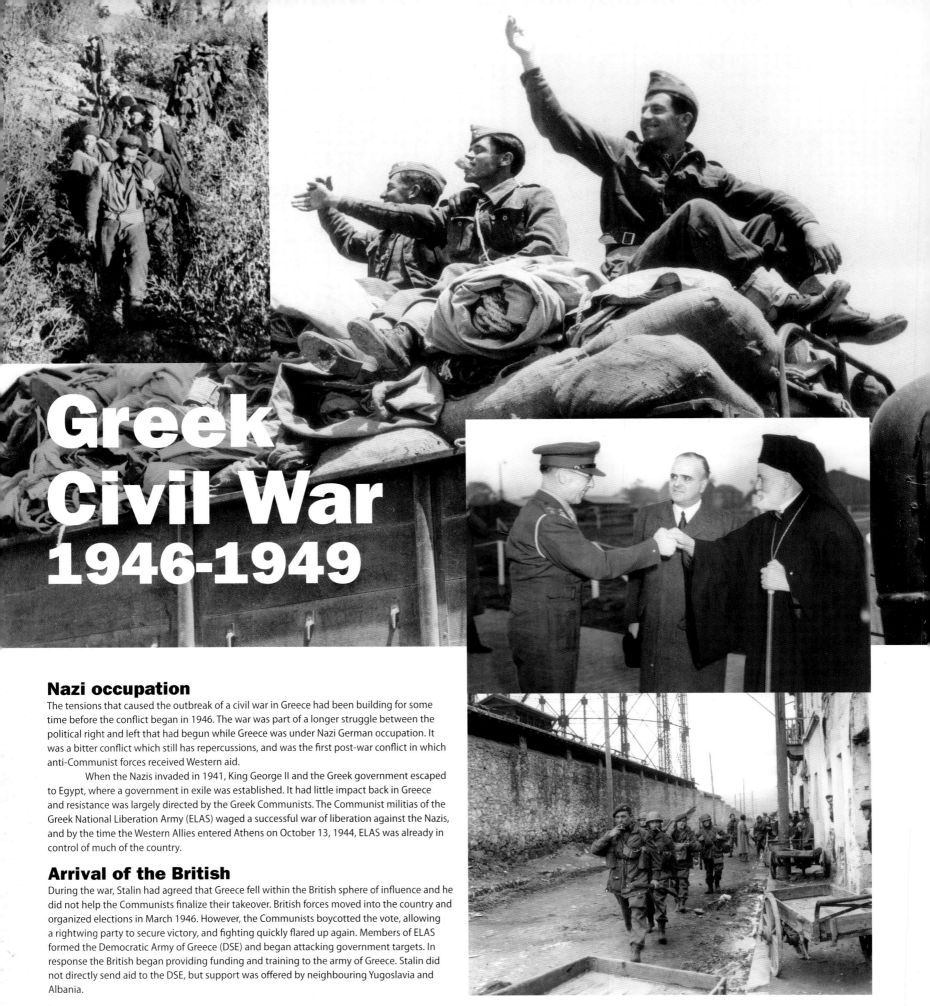

Greek Civil War 1946-1949

Nazi occupation

The tensions that caused the outbreak of a civil war in Greece had been building for some time before the conflict began in 1946. The war was part of a longer struggle between the political right and left that had begun while Greece was under Nazi German occupation. It was a bitter conflict which still has repercussions, and was the first post-war conflict in which anti-Communist forces received Western aid.

When the Nazis invaded in 1941, King George II and the Greek government escaped to Egypt, where a government in exile was established. It had little impact back in Greece and resistance was largely directed by the Greek Communists. The Communist militias of the Greek National Liberation Army (ELAS) waged a successful war of liberation against the Nazis, and by the time the Western Allies entered Athens on October 13, 1944, ELAS was already in control of much of the country.

Arrival of the British

During the war, Stalin had agreed that Greece fell within the British sphere of influence and he did not help the Communists finalize their takeover. British forces moved into the country and organized elections in March 1946. However, the Communists boycotted the vote, allowing a rightwing party to secure victory, and fighting quickly flared up again. Members of ELAS formed the Democratic Army of Greece (DSE) and began attacking government targets. In response the British began providing funding and training to the army of Greece. Stalin did not directly send aid to the DSE, but support was offered by neighbouring Yugoslavia and Albania.

The Truman Doctrine

By 1947 Britain was feeling the effects of the Second World War and could no longer afford to support the Greek government. After much debate, the United States government agreed that it could not let Greece fall to Communism and took over Britain's assisting role. This decision laid the foundations of the Truman Doctrine and gave rise to the Marshall Plan, a major aid programme to help war-torn European countries revitalize their economies.

Fighting increased throughout 1947, with the DSE operating as guerrillas, melting away into the mountains when attacked. By September, after being officially banned by the government the Communist Party formed a provisional government and set about trying to capture a town as an appropriate base. They were unsuccessful, but the size of the Greek Army had to be increased to respond to the new challenge. The DSE remained a major threat through 1948 and at one stage managed to close in on Athens.

End of the Civil War

By 1949, the Communists were facing defeat. The international situation was changing as Stalin no longer supported Tito, the ruler of Yugoslavia. The Greek Communist Party was forced to choose, and chose Stalin. In response Tito barred Yugoslavia to them in July 1949 seriously diminishing their operational capabilities. Meanwhile, the Western contribution to the Greek Army was taking effect and a string of offensives resulted in significant defeats for the DSE. By September, most DSE fighters had either surrendered or fled to Albania. Then the Albanian government announced that it no longer supported the DSE. On October 16 the Communist radio station announced a 'temporary ceasefire' – the end of hostilities.

Greece was in a terrible state. There were deep political divisions and economic chaos. Casualty figures have been estimated at between 50,000 to 100,000, and more than half a million people were displaced; about 10% of the population were homeless. Greece now fell firmly in the Western sphere of influence, and became a founding member of NATO.

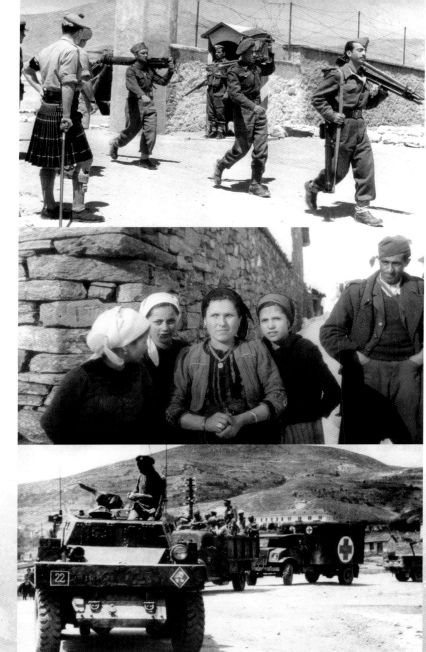

OPPOSITE ABOVE: Greek troops set off from Athens as reinforcements for the forces fighting the rebels, July 1947.

OPPOSITE ABOVE LEFT: Greek Army regulars consolidate their position along the Albanian frontier in the mountainous region around Konitsa.

OPPOSITE BELOW RIGHT: Paratroopers patrol past a gasworks near Athens.

OPPOSITE MIDDLE RIGHT: Greece's King George II departs from London Airport on his journey back home. The results of a September 1946 referendum on the restoration of the Monarchy found in favour of reinstating the King. The Communists disputed the election, further fuelling the civil war.

TOP RIGHT: British troops train the Greek Army in Konitsa.

ABOVE MIDDLE RIGHT: The villagers of Drosopigi turn out to welcome home Communist militias after a raid near Florina.

RIGHT: A military convoy patrols through Amyndeon in northern Greece in an attempt to prevent Communists from crossing the Yugoslavian border.

BELOW LEFT: Newly trained government troops set out on their first mission, July 1947.

BELOW RIGHT: Greek government soldiers and US military observers watch an assault on guerrilla positions in the Mount Grammos Sector near the Albanian frontier in September 1949.

Arab-Israeli War 1948

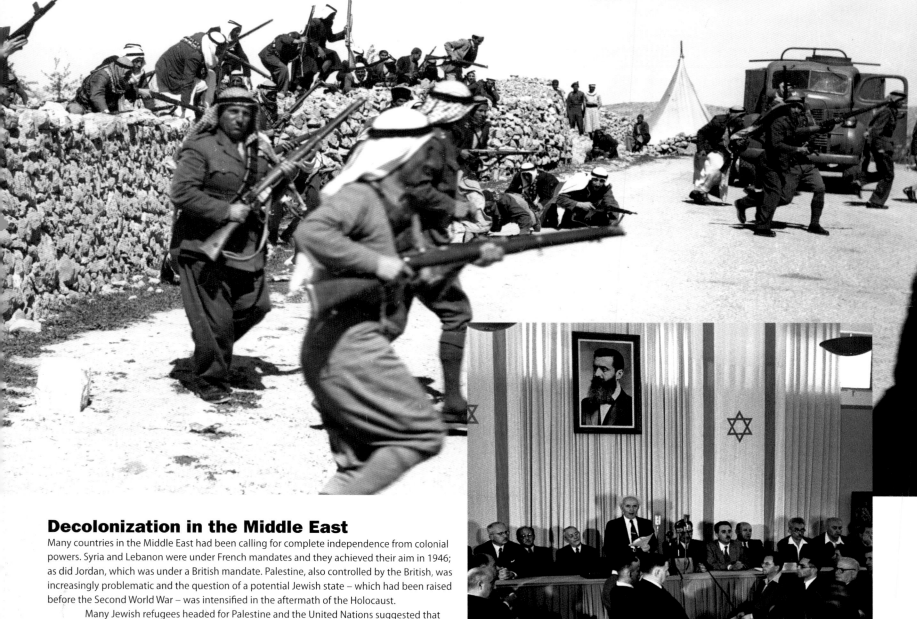

Decolonization in the Middle East

Many countries in the Middle East had been calling for complete independence from colonial powers. Syria and Lebanon were under French mandates and they achieved their aim in 1946; as did Jordan, which was under a British mandate. Palestine, also controlled by the British, was increasingly problematic and the question of a potential Jewish state – which had been raised before the Second World War – was intensified in the aftermath of the Holocaust.

Many Jewish refugees headed for Palestine and the United Nations suggested that the territory be divided into two states, one Jewish and one Arab, with the city of Jerusalem as an international zone. The already high levels of tension between the two communities rose, and by November 1947 there was a civil war under way as each side attempted to control strategically significant positions.

ABOVE: **Arab fighters attack a Jewish settlement in March 1948 as the two communities clash in the run-up to Britain's departure.**

MIDDLE: **David Ben Gurion declares the founding of the state of Israel on May 14, 1948, just hours before the expiration of Britain's mandate.**

RIGHT: **Jewish immigrants arrive at Tel Aviv Harbour in May 1948. Many immigrants who arrived in the newly-created state of Israel had suffered during the Holocaust.**

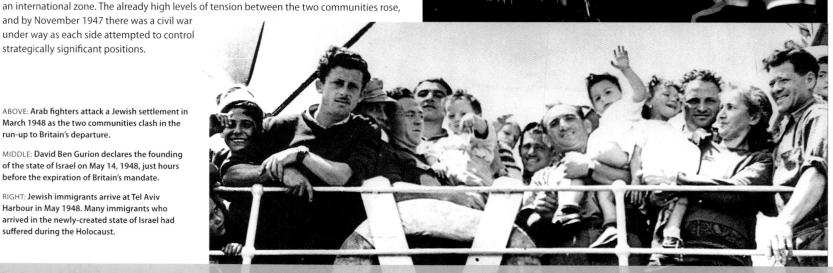

Birth of Israel

This in turn developed into an international conflict following the declaration of the state of Israel on May 14, 1948 and the withdrawal of the British. On the night following the declaration, armies from Iraq, Egypt, Lebanon, Syria and Jordan, together with some volunteers from other Arab nations, invaded the Arab areas with the aim of establishing a Palestinian state. Their action was condemned by both the United States and the Soviet Union.

Initially the numbers involved were relatively small, but both sides quickly increased the size of their forces. The Israeli Defence Forces were officially established on May 26, and they consistently managed to field more troops than their opponents. Their ground troops were supported by the Israeli air force which was initially outnumbered, though the balance began to swing in its favour by the end of May, when the first bombing raid on an Arab capital, Amman, was made.

The heaviest fighting took place around Jerusalem and between there and Tel Aviv. There was heavy fighting in Jerusalem itself at the end of May, and by May 28 it was controlled by the Arabs and all the Jewish inhabitants of the old city had to leave. Elsewhere, Arab advances were halted, and a UN-negotiated truce was developed which held for almost a month. The Egyptians attacked and fighting resumed in July.

Israeli Victory

A large Israeli offensive was aimed at securing the road between Jerusalem and Tel Aviv, and the towns which lay between them were quickly taken. This prompted the first large-scale movement of Palestinian refugees, as about 50,000 people fled. Intense diplomatic efforts led to a second truce, and this held until October 15 despite the assassination of the UN envoy, Count Bernadotte. From then until the eventual end of the conflict in July 1949, the Israelis launched a series of military operations to pursue and drive out the Arab armies and secure their borders, both of which aims they were able to achieve. A variety of armistice agreements were reached, and the last one was signed with Syria on July 20, 1949.

Israel had withdrawn from the Gaza strip following international pressure, and it was now occupied by Egypt; Jordan occupied the West Bank. Though thousands of troops – and some civilians – had lost their lives, by far the biggest overall impact came in the sheer number of refugees who had fled their homes. There were thought to be at least 700,000 Palestinian refugees in either Gaza, the West Bank or in other Arab countries – and probably as many as a million. Nor were they the only ones affected; it is estimated that about 600,000 Jews were also forced to leave their homes. The situation could only lead to further conflict and suffering for the people of the area.

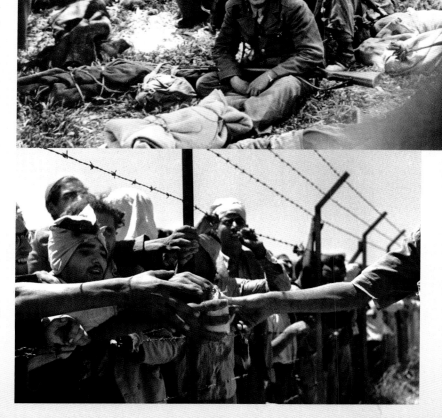

TOP: **Arab soldiers rest in Jerusalem after capturing the city in late May 1948. The United Nations wanted to place the city under international control, but this did not happen and sovereignty over Jerusalem remains in dispute today.**

ABOVE: **An Israeli guard hands food to Arab prisoners at a camp near Ramle.**

BELOW: **Arabs surrender to the Israel Defence Forces in Ramle on the road between Jerusalem and Tel Aviv in July 1948.**

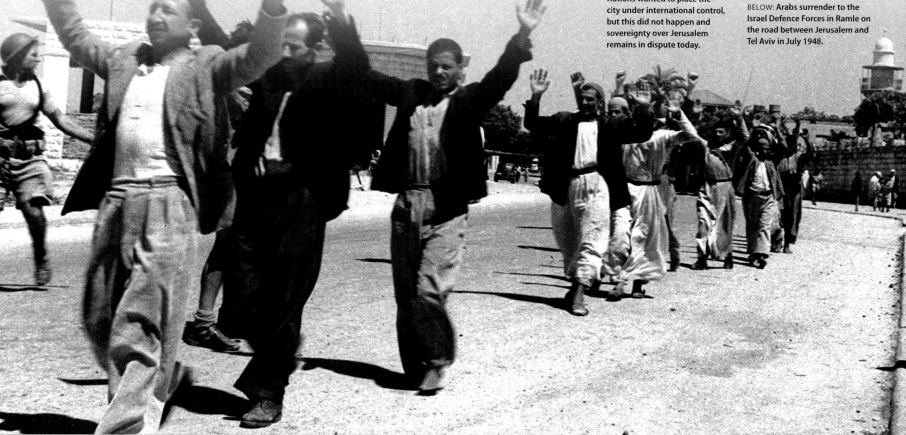

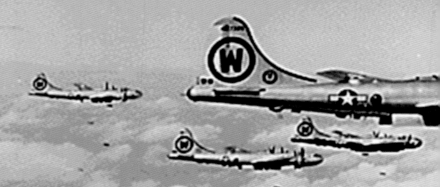

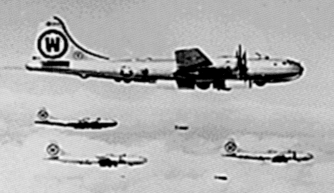

Korea
1950-1953

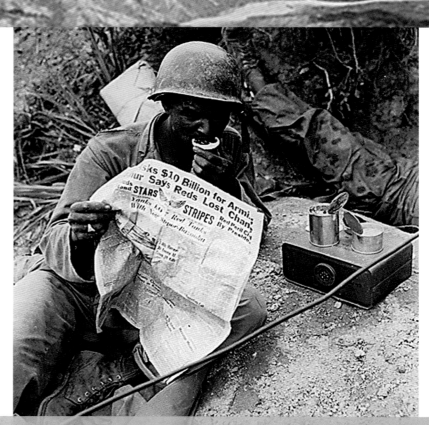

Division of Korea

After the defeat of Japan at the end of the Second World War, its colony on the Korean Peninsula was divided up between the United States and the Soviet Union along the 38th Parallel. With the Americans in charge of the southern portion and the Soviets dominating the north, Korea rapidly found itself on the frontline of a new Cold War.

The original plan was to reunify the two zones before granting their independence, but this became impossible as the United States and the Soviet Union began creating two irreconcilable states in their own images. In the South, the Americans fostered a democracy, albeit with some hostility towards the left. Elections were held in May 1948 and Syngman Rhee became President. In the North, the Soviets supported the Communists and the Democratic People's Republic of Korea was established under the rule of Kim Il Sung. Both governments believed that they were the single legitimate government for the whole peninsula, which was to lead to one of the largest and most destructive conflicts of the Cold War.

Withdrawal of the Superpowers

Soviet troops withdrew in December 1948, and by June the following year most US troops had also gone, except for the US Korea Military Advisory Group, which had 480 members. However, they did not leave behind an entirely peaceful peninsula. Both North and South experienced uprisings and sporadic guerrilla fighting, most of which was connected to problems with landlords. There were also reports of incursions by the North across the 38th Parallel, but the US thought that the Republic of Korea (ROK) army would be able to deal with them.

DAILY MAIL JUNE 28, 1950

Americans in action

America last night joined the war in Korea. Naval and air forces were ordered into battle against the Communists, and warships, bombers, and fighters began the attack immediately. General MacArthur is in supreme command.

At the same time America sent a plain-spoken Note asking Russia to use her influence with North Korea to stop the war or take responsibility for what happens. It promised the US will not fight north of the 38th Parallel.

President Truman, in a 'thus far and no farther' statement, ordered the US Seventh Fleet to protect Formosa (Taiwan), and announced help to French Indo-China and reinforcements for the Philippines.

Britain and other nations were asked to take similar action to help Korea. Mr. Attlee and the British delegate to the Security Council promised full support. So did several other nations.

Seoul, capital of South Korea, was saved by a fierce counter-attack yesterday. Communists retreated nearly 20 miles, then advanced again.

With their eyes open

The world faced its gravest post-war crisis tonight as American bombers and fighters strafed Communist tanks in South Korea.

President Truman's decision to order American planes and warships into defence against the Communist invasion was followed by a frank admission in high official quarters here that the situation held the gravest possibilities. But it is being followed by intense diplomatic activity designed to align other Western Powers solidly behind the dramatic American initiative.

President Truman's announcement said:

In Korea the Government forces, which were armed to prevent border raids and to preserve internal security, were attacked by invading forces from North Korea. The Security Council of the United Nations called upon the invading troops to cease hostilities and to withdraw to the 38th Parallel.

I order ...

This they have not done, but, on the contrary, have pressed the attack. The Security Council called upon all members of the United Nations to render every assistance to the United Nations in the execution of this resolution.

In these circumstances, I have ordered United States air and sea forces to give the Korean Government troops cover and support.

International peace and security

The attack upon Korea makes it plain beyond all doubt that Communism has passed beyond the use of subversion to conquer independent nations and will now use armed invasion and war. It has defied the orders of the Security Council, issued to preserve international peace and security.

In these circumstances the occupation of Formosa by Communist forces would be a direct threat to the security of the Pacific area and to US forces performing their lawful and necessary functions in that area.

Accordingly I have ordered the 7th Fleet to prevent any attack on Formosa. As a corollary of this action, I am calling upon the Chinese Government on Formosa to cease all air and sea operations against the mainland.

The 7th Fleet will see that this is done. The determination of the future status of Formosa must await the restoration of security in the Pacific, a peace settlement with Japan, or consideration by the United Nations.

I have also directed that US forces in the Philippines be strengthened and that military assistance to the Philippine Government be accelerated.

I have also directed acceleration in the furnishing of military assistance to the forces of France and the associated States in Indo-China, and the dispatch of a military mission to provide close working relations with those forces.

Force V law

I know that all members of the United Nations will consider carefully the consequences of this latest aggression in Korea in defiance of the Charter of the United Nations.

A return to the rule of force in international affairs would have far-reaching effects. The US will continue to uphold the rule of law.

I have instructed Ambassador Warren R. Austin, as the representative of the US to the Security Council, to report these steps to the Council.

At present US land forces will not be committed to battle. But this possibility is not excluded if the situation worsens.

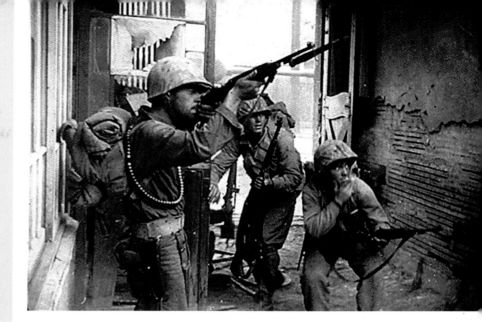

Invasion

On June 25, 1950, North Korean troops crossed the Parallel en masse in an attempt to unify the country. The North Korean People's Army (NKPA) invaded with tanks and full air support, surprising both the South Koreans and the US. It was immediately apparent that this would not be a local conflict; Stalin had approved the North Korean move, and Truman, then US President, sent troops within two days. He was acting in the name of the United Nations' Security Council, which had voted to resist North Korean aggression (the Russians were boycotting the Council at the time because it did not recognize Communist China). Truman authorized the use of air power against the North Korean tanks, and sent the US navy to patrol the channel between mainland China and Taiwan.

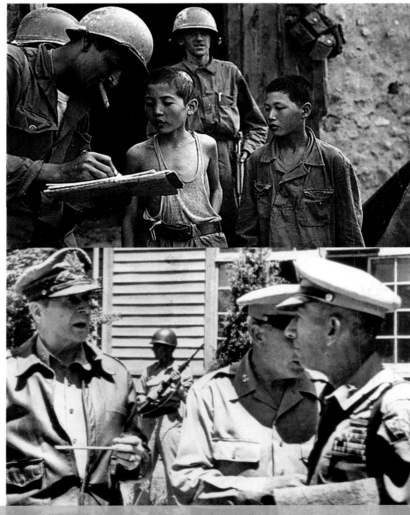

OPPOSITE ABOVE: **B-29 bombers fly in formation over Korea in September 1950. Over 24 million pounds of bombs were dropped from B-29s during the months of July and August.**

OPPOSITE BELOW: **An American radio operator of the 24th Infantry Regiment reads the latest news while eating a meal near Sangju, August 1950.**

TOP: **United Nations troops fighting in the streets of Seoul, September 1950.**

MIDDLE: **Two North Korean boys serving in the North Korean Army are interrogated by a US soldier after they were taken prisoner in the Sindang-dong area by the 389th Infantry Regiment in September 1950.**

RIGHT: **General Douglas MacArthur, commander of the UN force, gives orders to his two top aides, Major General E.M. Almond and Brigadier General John Church at Suwon Airfield.**

Arrival of the Americans

It was obvious that ground troops were needed, and the first US forces arrived on July 1. Their aim was to slow the NKPA advance so that more troops and equipment could be brought in before the North Koreans overran the whole peninsula, but they were outmanoeuvred and forced to retreat. Various defensive lines were drawn up running down the peninsula as the advance continued. The ROK virtually abandoned the western half of South Korea and were now moving further south and east towards the port of Pusan. There were further attempts to hold lines in order to allow an orderly retreat, but the most urgent need was for more soldiers. Troops from Britain and the Commonwealth were now arriving, and the UN forces were becoming more representative.

Pusan Perimeter

It was vitally important that the ROK hold on to Pusan, and US Marines began arriving there on August 2. Many of them were combat veterans of the Pacific War, and they were initially able to push part of the NKPA back. However, the NKPA had combat veterans too, from the Chinese Civil War, and a pattern of repeated advances and retreats set in. At the same time the NKPA were also advancing southwards down the eastern coast. Here the ROK forces had been able to hold them back at first, but the North Koreans were able to retake the city of Yongdok where they were fired on by US fighters, who also dropped napalm.

Despite their success, the NKPA forces had, however, fought themselves to a standstill by the end of August. They were fully extended and had failed to pierce the 'Pusan Perimeter'. Though still determined, they had little choice but to abandon their pattern of offensives, and stalemate set in. The entire Pusan Perimeter was now quiet, but the war was about to change.

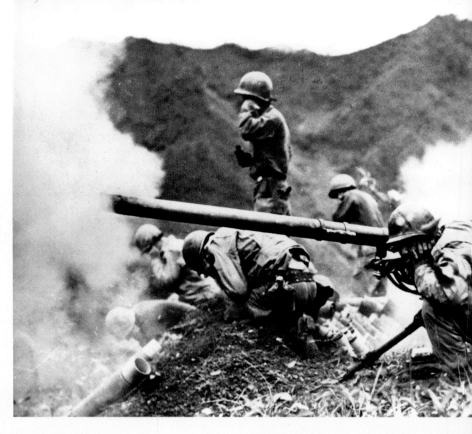

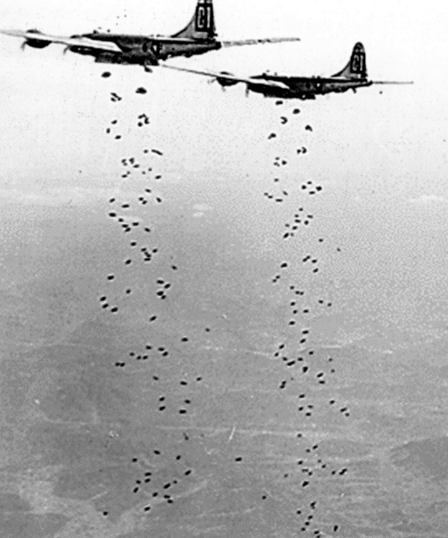

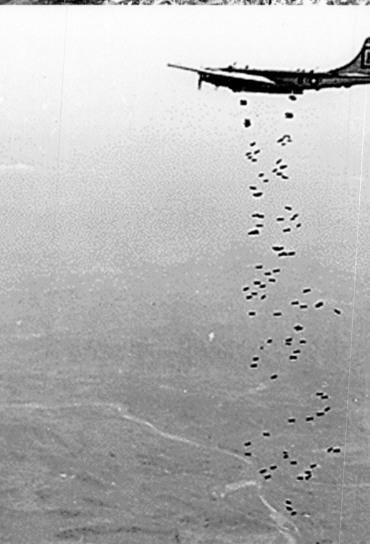

Inchon

The commander of the UN forces, General Douglas MacArthur, was particularly experienced in amphibious warfare. He suggested landing forces behind North Korean lines on the coast at Inchon, only 25 miles from Seoul. The aim was to force a surrender by cutting the NKPA's supply lines. Inchon would not be an easy target; the approaches were difficult and defended, and Seoul was also well defended. A multinational invasion force assembled and the complicated attack began on September 15. A bridgehead was established, and troops were able to fan further out. The battle for Seoul began on September 22, marked by close-quarter fighting, and the city was retaken six days later.

Further south, the Eighth Army had broken out of the Pusan Perimeter and headed north, and by early October the situation had changed completely; the NKPA had been pushed behind the 38th Parallel, and any remnants had been effectively destroyed as a fighting force below it. It was a massive achievement for MacArthur.

On October 7, US troops were to the north of the Parallel. MacArthur urged the North Koreans to agree to a ceasefire, a call which was rejected – and the decision was then made to move further north. The North Korean capital, Pyongyang, fell on October 12, but Kim Il Sung and his government had already left. The swift northwards advance took the armies much closer to Korea's border with China, and altered the nature of the war once more.

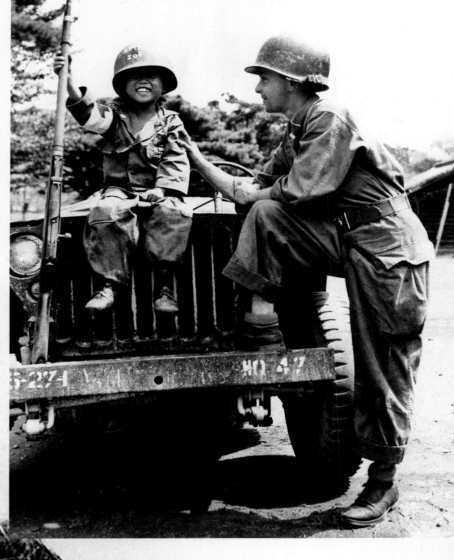

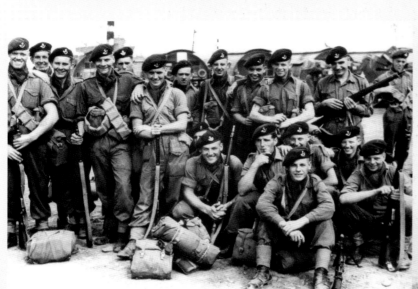

OPPOSITE: **B-29 'Superfortress' bombers drop bombs on North Korean targets.**

OPPOSITE ABOVE RIGHT: **United Nations troops shield their ears from the sounds of their own mortar and heavy machine-gun fire.**

ABOVE: **'Little Joe', a South Korean war orphan dressed in a miniature GI uniform, proudly displays a captured North Korean weapon. He was adopted by a medical company of the American 25th Infantry Division.**

ABOVE LEFT: **British troops of the 1st Battalion, the King's Shropshire Light Infantry arrive at the port of Inchon after the sea voyage from Hong Kong.**

LEFT: **A young refugee carrying her brother on her back walks past a stalled M-26 tank at Haengju as she escapes the North Korean advance.**

China's involvement

As the fighting came closer to the Manchurian border, where China met North Korea, the Chinese became more alarmed and mobilized troops. The Chinese offensive began in early November, and the war took a new and more dangerous turn. The Chinese were masters of a comparatively new style of fighting: their attacks were sudden and unpredictable, and their troops seemed to melt away afterwards. Chinese involvement also increased the potential strength of the North Korean side enormously; there were over five million troops in the People's Liberation Army, and they were familiar with fighting in similar territory and under comparable conditions.

Battle of the Chongchon River

The addition of Chinese forces was effective and the US Eighth Army was forced to retreat at the Battle of the Chongchon River, the worst US defeat of the war. This was followed by a series of Chinese offensives, one of which led to the abandonment of Seoul once more. It was recaptured in March 1951, as the UN forces retaliated and inflicted a major defeat on the Chinese. The spring of 1951 also saw the Battle of the Imjin, involving many British Commonwealth troops who just escaped destruction. There were severe losses, and this battle helped to halt the Chinese advance.

By late spring the Chinese offensive had stalled. Their armies were overextended, and though they reached the outskirts of Seoul on April 29, they lacked the resources to attack the city itself. Their general, Peng, regrouped his forces – and encountered resistance along the entire front for the first time.

BELOW: Trainee South Korean soldiers receive instructions on the use of the 3.5 inch rocket launcher.

RIGHT: Captured North Korean guerrilla fighters detained in a South Korean prisoner camp.

OPPOSITE TOP: Men of the King's Own Scottish Borderers stand guard on the Korean Western Front. Their battalion, together with a Battalion of the Royal Leicester Regiment, had recently repelled an entire Communist division.

OPPOSITE MIDDLE: General MacArthur inspects troops of the 24th Infantry at Kimpo Airfield in Korea during a tour of the battlefront.

OPPOSITE BOTTOM: The 16-inch guns of the USS *Iowa* fire on the North Korean city of Chongjin, a supply and transport centre for the enemy.

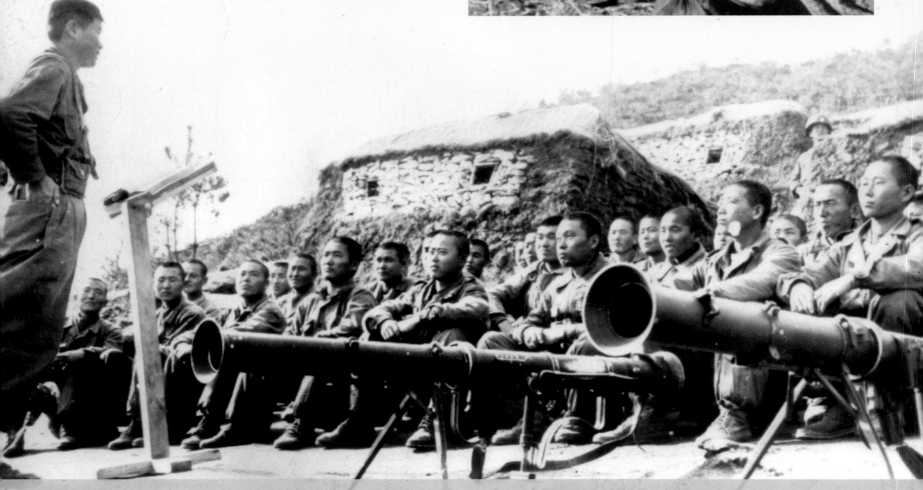

DAILY MAIL NOVEMBER 28, 1950

MacArthur fights stern defensive

Communist China is now fully committed to the war in Korea. The Chinese, operating a massive group of armies, have tonight deflated the United Nations' hope of any quick - or decisive - military victory.

Reports from all sectors of the north-western front show that General MacArthur's confidently launched offensive of four days ago has been transformed into a stern defensive. And this includes a right flank 'of no retreat' which has already been pierced by the Communists. Troops of the Republic of Korea Second Corps, who yesterday gave up Tokchon, were ordered today to 'hold at all costs' a line south of the town running east for 35 miles. But before the line could be organised an enemy combat team had infiltrated in the centre.

An official spokesman tonight described the situation in this sector as 'confused,' and admitted that the South Koreans have been forced to pull back between 12 and 20 miles in the past 24 hours.

All along the front commanders were reporting serious checks even where before the Red had offered comparatively little resistance. At the extreme west of the front the US 24th Division had to withdraw from the recently captured town of Chongju, 'in order to protect its flank.'

In other words, the whole impetus of the offensive has been lost and American veterans of the bleak days of the southern defensive box around Pusan are saying 'the situation now seems as grim as ever it did.'

It is now admitted here that 19 field formations of opposing Chinese have been identified. These were described as 'divisions, or elements of divisions.'

Prisoners say that an entire Chinese army, the 40th, is still in reserve, but is due to attack soon.

Expert Foot-sloggers

It seems certain that its existence was known before the boasted 'over by Christmas' offensive was launched, and therefore it is a fair inference that the effectiveness of the opposition may have been understood.

But the Chinese, who are also efficiently controlling the rebounding North Korean armies, have shown in four days that they are among the most formidable soldiers in the world. They have also achieved success without air support, and little or no artillery or armour has been used.

They have relied on infantry, expert mortarmen, night fighting and infiltration tactics. Today they have been stalling the US 2nd Corps position throughout the daylight hours.

Troops of the US 25th Division were forced to withdraw four miles. No reports have yet been received of British troops being committed to the battle, but it is obvious that General Walker, U.S. 8th Army commander, will need every man at his disposal - and quickly.

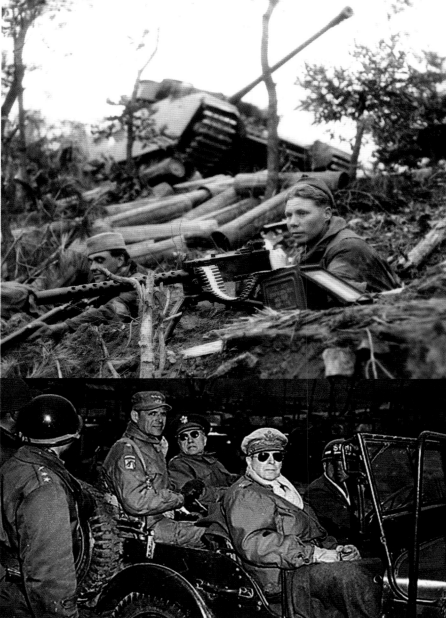

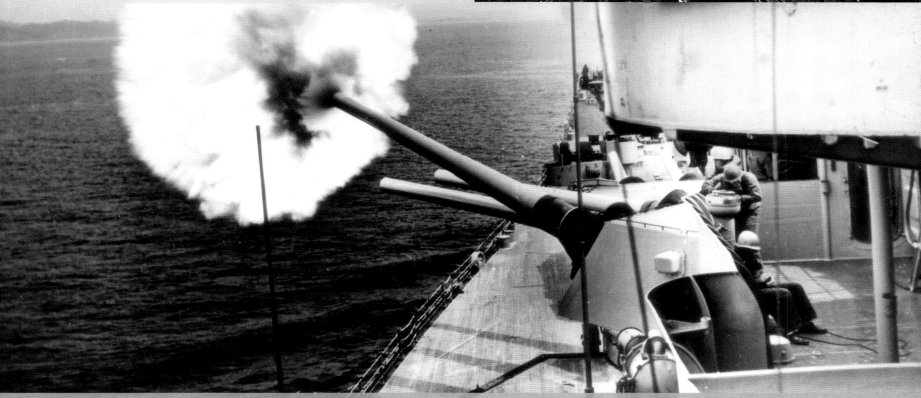

Stalemate

A general international agreement had developed that the situation in Korea must not be allowed to lead to a third world war. Truman now believed that the war in Korea could be contained – the prospect of it increasing in scope with the added possibility of the Atom Bomb being used was terrible, though it had been considered – but MacArthur's strategies were not consistent with the President's aim. He wanted to invade China if he thought it necessary, and was making important strategic decisions without reference to Truman. He was replaced.

By now the opposing sides were almost at a standstill, though serious fighting continued in what was becoming a war of attrition. Neither side could get much of an advantage over the other – they were both fighting from heavily fortified positions and preventing enemy incursions with the use of artillery and mines – though UN forces were superior in the air and at sea. It was becoming obvious that although the Chinese could keep North Korea fighting, they could not overturn South Korea in the face of US opposition. Nor could the US destroy North Korea by conventional means, and Truman was not prepared to launch a nuclear strike.

Peace talks

Negotiations of a sort began in the middle of 1951, opening with discreet discussions between the US and the Soviet Union; they were to take two years. Peace talks were set up and a month-long ceasefire was agreed for the end of the year. However, the war continued in 1952, with each side continuing to test the strength of the other without achieving a decisive outcome, a pattern which persisted into 1953. During that year a new administration under President Eisenhower came into power in the US. It was Republican and strongly anti-Communist, but it was felt that the real centre of the Cold War was Europe. There was also tacit agreement that the outgoing administration had demonstrated their ability to hold on to South Korea well enough.

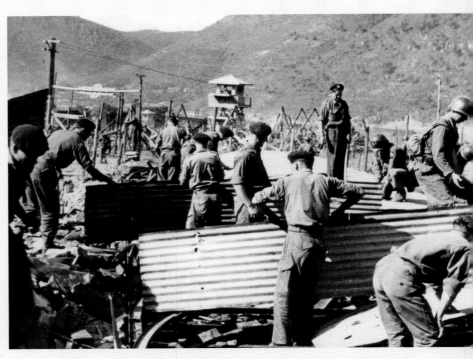

An armistice was signed at Panmunjom at the end of July 1953, though there is still not a formal peace. Relations between North and South remain strained, as are North Korea's relations with many parts of the international community. The border between the two changed very little during the Korean War, but there had been many deaths – estimates range between three and four million, most of whom were Korean civilians. A demilitarized zone was established along the 38th Parallel, and it remains to this day.

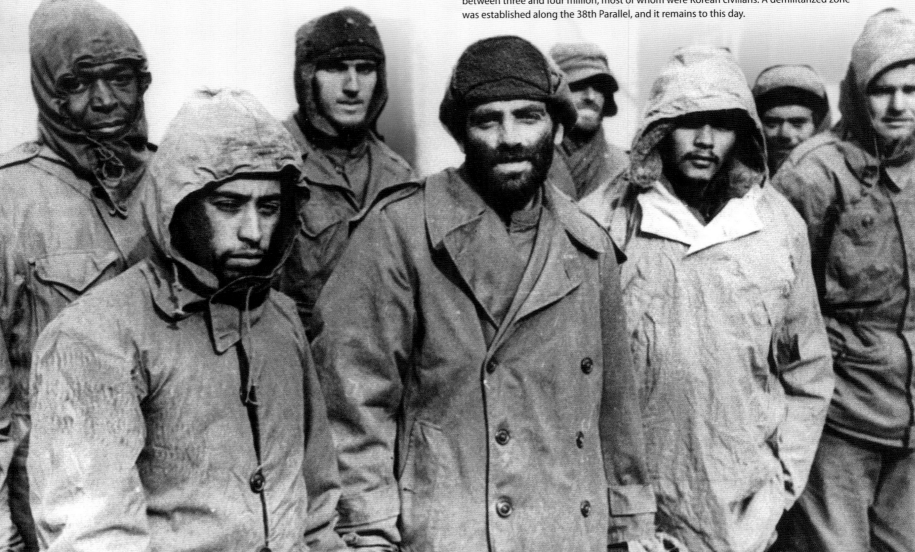

DAILY MAIL JULY 27, 1953

Truce signed - no smiles

The Korean war - the war in which neither side could risk victory - ended today after three years and one month. The armistice was signed at 10.1 a.m. The guns will go silent at 10 o'clock tonight.

Under the terms mighty armies of both sides will be withdrawn one mile and a quarter from the battle line within 72 hours, and exchange of prisoners is expected to begin 'within a week - if the Communists co-operate.'

The chief Allied negotiator in the truce discussion, Lieut.-General William Harrison, landed at Panmunjom at 9.30 a.m. by helicopter and went straight into the prefabricated 'Peace Pagoda.' There were no smiles on either side.

He walked past a United Nations guard of honour representing all units and Services fighting in Korea on his way; the Communist delegation had arrived in jeeps five minutes earlier.

Bulky document

General Harrison entered the ceremony hall at exactly 10 a.m., sat down, and immediately signed the first copy of the bulky truce document. The Communist copies of the agreement were bound in dark brown leather, while the United Nation copies were covered simply by light blue paper.

The documents lay on two green-covered tables near the centre of the huge hall; between the United Nations and Communist tables was a third baize table for the actual signing. The Allied table was bare, with the exception of nine copies of the agreement -written in English, Chinese, and Korean - and nine copies of the supplementary agreement.

The Allied Command announced that front-line troops were prepared to make the withdrawal stipulated in the armistice agreement, but at the same time warned their troops to double their vigilance.

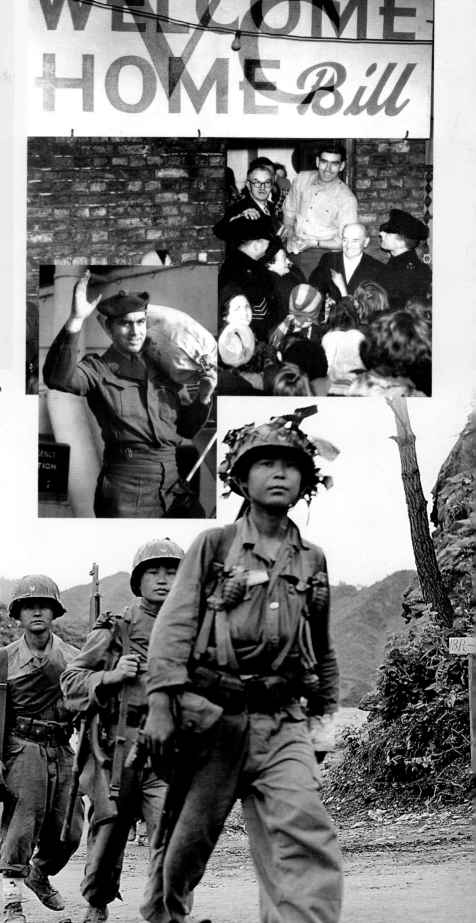

OPPOSITE BELOW: **United Nations Command soldiers detained in North Korean prison camps.**

OPPOSITE ABOVE: **British troops of the King's Shropshire Light Infantry tear apart buildings in compound 66 of the UN's Koje Island Prisoner of War Camp. Communist agents had infiltrated the camp and the compound was suspected of housing their headquarters.**

BELOW: **South Korean soldiers move in single file towards the frontline near Lookout Mountain, east of the Pukhan River in June 1953. The South Koreans retook the mountain after being pushed off by a superior Chinese force.**

RIGHT: **Private Bill Speakman of the King's Own Scottish Borderers was awarded the Victoria Cross, Britain's highest honour for bravery, for his** actions in Korea. He led a team of six men in battle against thousands of Chinese soldiers in order to allow the rest of his company to evacuate.

ABOVE RIGHT: **A large crowd gathers to welcome Private Speakman home from Korea.**

Kenya Emergency
1952-1960

ABOVE: British soldiers and loyalist Kenyans capture a Mau Mau suspect in the Aberdare Hills.

RIGHT: Field Marshal Kanji, a leading member of the Mau Mau, is pictured in the Mount Kenya Forest. The origin of the name Mau Mau is uncertain. It was used by the British and the settlers and the rebels did not use it to refer to themselves.

BELOW: Suspected Kikuyu militants are rounded up on the day Governor Baring declared a State of Emergency in the colony. They were suspected of involvement in the assassination of Senior Chief Waruhiu, a prominent Kikuyu loyalist.

British colonial rule

During the Second World War the 30,000–strong European settler community took advantage of British distraction to increase their control over Kenya's government. When the British attempted to revive their colonial administration after the war, they realized they had to work with the settlers if London was to maintain its control. However, little was done to work with the native Kenyan population, a number of whom had fought and died on the British side in the war.

Mau Mau

The Kikuyu Central Association (KCA) was formed in the 1920s to politically organize the Kikuyu, Kenya's largest tribe. After the war, the KCA began demanding independence and called for a campaign of civil disobedience to meet their goal. However, by the end of 1951 it was clear that radical elements were intent on more violent methods of getting the British and white settlers out of Kenya. These radicals, dubbed the 'Mau Mau', started attacking Kenyans loyal to the British colonial administration. They were also blamed for a number of arson attacks on isolated white-owned farms and were widely rumoured to engage in barbaric oath-taking rituals. This shocked and appalled the European settler community who demanded that the colonial administration do something. The first post-war Governor, Sir Philip Mitchell, was not convinced of the threat, but the new Governor, Sir Evelyn Baring, who arrived in Nairobi in October 1952, had a rather different attitude. He declared a state of emergency in Kenya on October 20 following the murder of Senior Chief Waruhiu, a prominent Kikuyu loyalist. British troops were brought into the country and the supposed leaders of the Mau Mau rebellion were arrested.

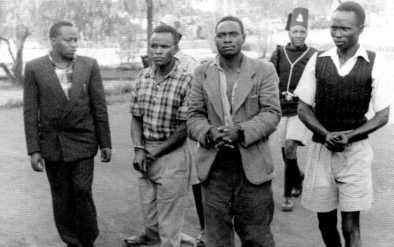

The Ruck murders

The declaration of a State of Emergency only served to exacerbate the situation, and on January 24, 1953, white farmers were directly attacked for the first time. A group of Mau Mau, armed with machete-like implements called pangas, attacked and killed Roger and Esmee Ruck on their farm. Their six-year-old son and Kikuyu servant were also murdered. European settlers began to organize into vigilante groups, and white farmers became suspicious of their own Kikuyu labourers. More attacks on white farmers followed, but most Mau Mau attacks still focused on African 'collaborators'. Attacks generally came at night, and were concentrated in the countryside, but there were forays into Nairobi's suburbs.

British military victory

The British position was revitalized in the aftermath of the attacks. More troops were brought in, draconian measures were initiated and 'pseudo-gangs' were set up to infiltrate the Mau Mau. Nonetheless, it took some time before the British really recognized the scale of the movement. Nairobi was put under military control in April 1954, and lots of people were arrested or deported back to Kikuyu lands. As a result, Mau Mau sources of supply vanished. The effort then moved to other areas and by the end of the year many thousands of people were confined in overwhelmed internment camps. This did, however, mark the beginning of the end of the uprising, as very few Mau Mau were left at large. In 1955 an amnesty was declared, though peace talks collapsed and the Emergency remained in effect until January 1960. It was a clear military victory for the British, though the Mau Mau ultimately got what they wanted as Kenya was granted its independence in December 1963.

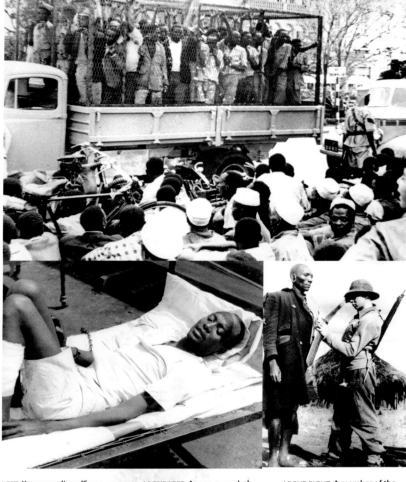

LEFT: Kenyan police officers apprehend two Mau Mau suspects.

TOP: Hundreds of suspected Mau Mau rebels are rounded up by Nairobi police following a clampdown by the British Colonial Administration.

ABOVE LEFT: A man wounded during the uprising recovers in hospital. The majority of those targeted by the Mau Mau were Kenyans.

ABOVE RIGHT: A member of the Lancashire Fusiliers disarms a Mau Mau rebel of his panga during a sweep through the Aberdare Mountains north of Nairobi.

BELOW: Mau Mau are rounded up by local defense forces with the support of the British Army's Lancashire Fusiliers.

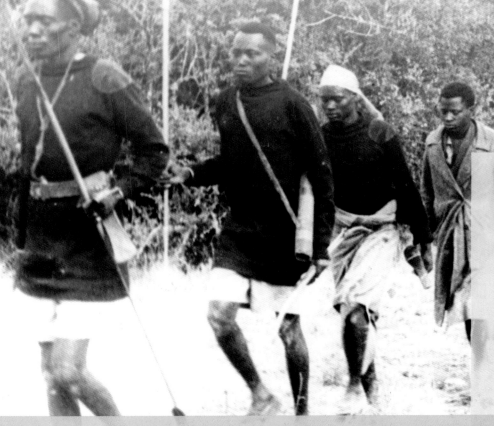

DAILY MAIL DECEMBER 26 1952

Mau Mau Killers Run Amok

In the wildest night of killing and arson since the Mau Mau troubles began - Christmas Eve - terrorists murdered 10 Kikuyu, including a woman, and wounded five others - a man, a woman and three children. Two men escaped unhurt. At least four of the attackers are known to have been wounded. A joint store and two huts were burned down.

This record fulfils the fears that the terrorists were planning a violent outbreak over Christmas and it is significant that the attacks totalled seven -the ritual number used over and over again in Mau Mau ceremonies.

Nearly all the murders and all the cases of arson occurred in the notorious Mau Mau areas of Nyeri and Fort Hall. The only exception was a man killed in Nairobi. Two unknown assailants attacked a bus company employee in his house in one of Nairobi's African locations, shooting him in the head.

Three African homesteads were attacked in the Nyeri reserve by a gang of between 10 and 20. They killed four men with knives and seriously wounded a woman and two children. One man had his head hacked off.

Algerian War of Independence 1954-1962

French colonial rule

On All Saint's Day, November 1, 1954, Algerian independence fighters launched their long and brutal campaign for independence. It was becoming clear that the French Empire was slowly trending towards decolonization as earlier that year Indochina had won its independence and talks were underway for greater autonomy in Tunisia. However, Algeria was unlike other French colonies in that it had a massive French settler population and was widely regarded as an extension of mainland France. The French government committed itself to defending Algeria at all costs, putting itself on course for a violent showdown with the main Algerian rebel group, the National Liberation Front (FLN).

Terrorizing civilians

The FLN operated largely as a guerrilla army, which forced the French to use dubious methods to try to defeat them. The Algerian civilian population was held collectively responsible for FLN activity so as to get the natives to rein in the insurgents themselves, and the use of torture became a commonplace means of intelligence-gathering by the French military. For its part, the FLN also terrorized the civilian population: Algerians who worked for European-owned businesses were targeted in a bid to dissuade collaboration and undermine France's economic stake in the country, and the French population were subjected to brutal massacres in order to encourage the remainder to leave the country.

ABOVE: **Security forces battle against a mob of French settlers opposed to President De Gaulle's attempts to negotiate with the Algerian nationalists.**

MIDDLE: **An armed French farmworker oversees the evacuation of women and children from his village to the relative safety of the city. FLN massacres on remote European-owned farms and villages terrified the settler population.**

RIGHT: **Young French settlers march through the streets of their town during the uprising of May 1958.**

Return of De Gaulle

In April 1958, a new government came to power in Paris under Pierre Pflimlin, who had previously spoken out in favour of negotiating with the FLN. In response, a group of French generals in Algeria, backed by French settlers, rose up in rebellion and took control of Algeria and the island of Corsica. To prevent further unrest and avert a possible civil war, Charles De Gaulle, France's wartime leader, was called back to office in the hope that he could unify the country. De Gaulle sought to reduce the stranglehold Algeria was having over French politics and to shift the country's focus towards strengthening France's role in Europe. In 1959, De Gaulle came out in support of self-determination for Algerians. After a long negotiation process, a referendum was held on July 1, 1962. The electorate voted overwhelmingly in favour of independence, which was granted two days later.

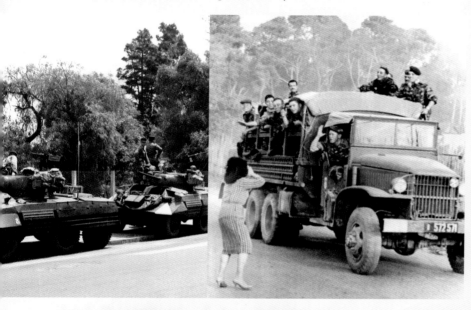

The Secret Army Organization

When it became clear to French settlers in Algeria that they could no longer rely on the support of the French government, they organized into the Secret Army Organization (OAS), and began a campaign of bombings and assassinations against both the French authorities and the FLN. They were unable to stop Algeria from gaining its independence and merely prolonged the suffering on both sides. By the end of the war, hundreds of thousands of Algerians had been killed, 20,000 French soldiers had lost their lives, and almost one million European settlers had fled their homes in Algeria.

TOP RIGHT: General Charles De Gaulle receives a rapturous welcome as he arrives in Algiers, June 1958. The French settler population initially believed he would oppose decolonization.

TOP LEFT: Algerians crowd around the President as he visits Tebessa in the Constantine Region of Algeria in August 1959.

FAR LEFT: A row of armoured cars defend Algiers' military General Headquarters during an army insurrection in April 1961. A group of French generals rose up in opposition to De Gaulle's policy of self-determination for Algeria, but support for the French President remained strong and he was quickly able to defeat the mutiny.

LEFT: A girl blows kisses to a group of paratroopers as they surrender following the failed army uprising in April 1961.

ABOVE: The scene in Algiers following an OAS attack near the Casbah. Women and children were among the thirty people killed when mortar shells were fired into a crowd of shoppers.

BELOW: The police of Algiers come under attack from a stone-throwing mob of French settlers opposed to De Gaulle's policies, November 1960.

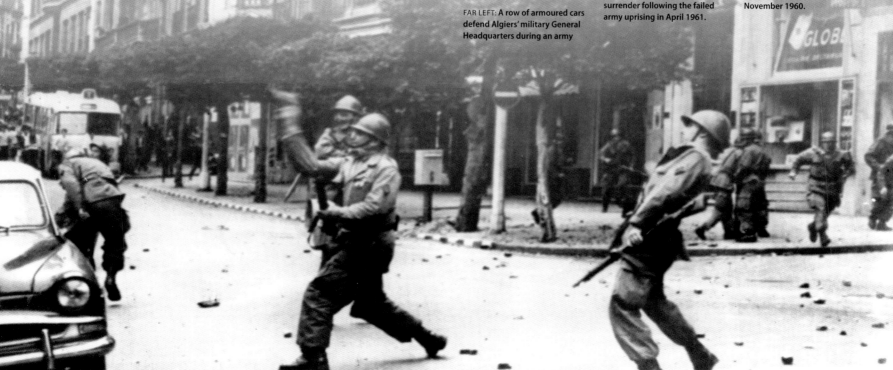

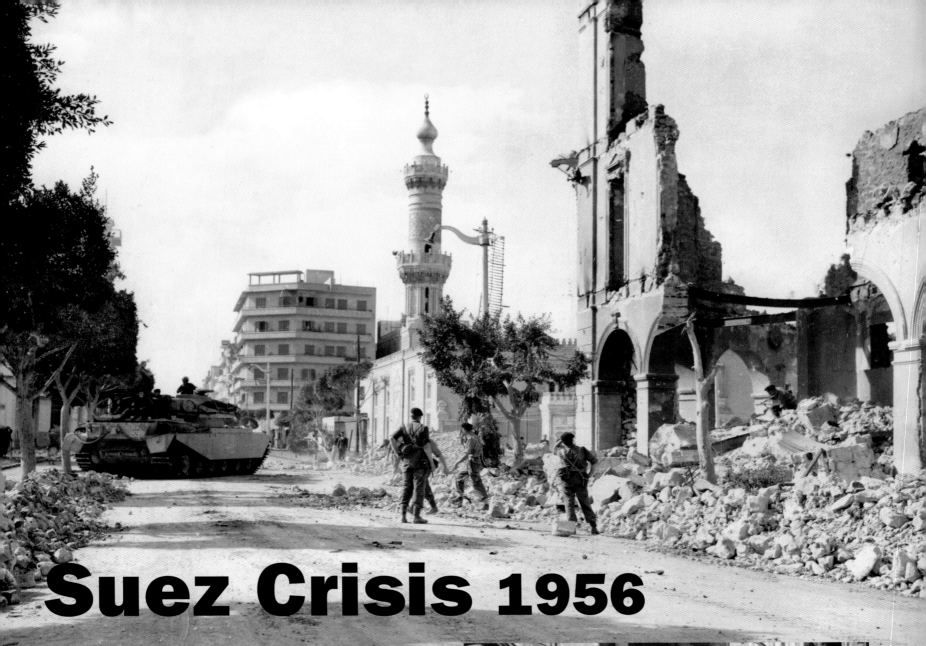

Suez Crisis 1956

British control of the Suez Canal

The Suez Canal had been built between Egypt and the Sinai Peninsula in 1869. Its creation meant that ships no longer needed to make the long and potentially dangerous journey around the coast of Africa, and it provided convenient European access to the oil fields of the Middle East, which were growing in importance. In a comparatively short period of time, it became a vital trade route and economic link for the West. Under a treaty of 1936, Britain had control of the Canal Zone.

The early 1950s were a time of strong anti-Western sentiment in many parts of the Arab world. The establishment of the state of Israel, supported by the US, had put many old alliances under strain, and Israeli success had, in its turn, encouraged the development of nationalist regimes in Iraq, Syria and Egypt. In 1952 a new government, led by army officers, was formed in Cairo.

ABOVE: British troops backed by a tank search buildings for snipers who ignored the ceasefire order in Port Said, Egypt.

RIGHT: The British Peace Committee gathers to protest the war outside the Houses of Parliament in London where MPs had assembled for a special three-day session to discuss the crisis.

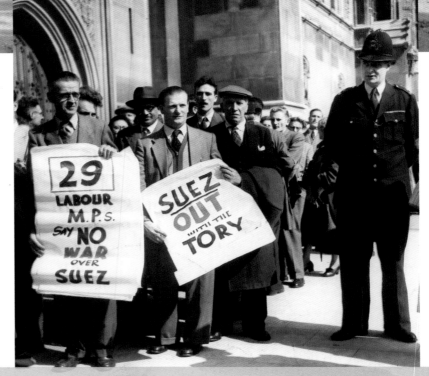

Nationalization of the canal

One of these army officers was Gamal Abdel Nasser, and he became the head of the Egyptian government within two years. He also became, increasingly, the champion of Arab nationalism, and British control of the Suez Canal was impossible as far as he was concerned. He began agitating for the removal of British troops, and in October 1954 Britain signed an agreement to evacuate the Zone by 1956. The last British troops were evacuated in June of that year.

Nasser was a champion of the 'non-aligned movement', a group of countries who took neither side in the Cold War and sought to benefit by playing both sides. However, an arms deal with Czechoslovakia caused the United States to fear that the socialist Nasser was moving too far into the Communist camp. Consequently Washington announced it would halt plans to finance an ambitious dam construction project at Aswan on the Nile. The Aswan Dam was integral to Nasser's modernization programme, and he had to find new sources of funding. His answer was to seize control of the lucrative Suez Canal from the Anglo-French company who owned it. On July 26, 1956, Nasser announced the nationalization of the canal.

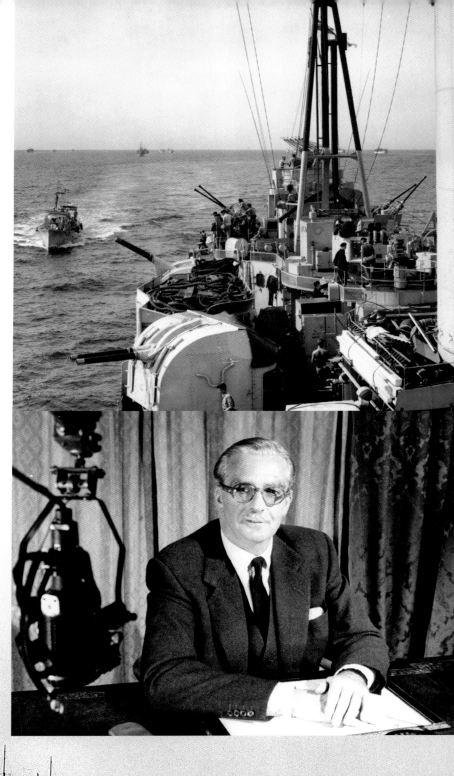

DAILY MAIL JULY 27, 1956

Nasser grabs Suez Canal

Eden calls midnight meeting of Ministers and Service Chiefs after Egypt's rabble-rouser tears up the 1954 Zone Agreement

Colonel Nasser last night threw down his biggest challenge to the West. He seized the Suez Canal only five weeks after the last British troops had walked out. Within two hours Sir Anthony Eden called an emergency meeting of Cabinet Ministers and Service chiefs early today at 10, Downing-street. M. Picot, general manager of the Suez Canal Company, was called hurriedly from his West End hotel. Also present were Mr Selwyn Lloyd, Foreign Secretary; Admiral Earl Mountbatten, First Sea Lord; General Sir Gerald Templer, Chief of the Imperial General Staff;

Air Chief Marshal Sir Dermot Boyle; the American Charge d'Affaires, Mr. Andrew B. Foster, and the French Ambassador, M. Chauvel. King Feisal of Iraq, who had been Sir Anthony's guest at No. 10, was told the news.

In Alexandria Nasser told a wildly cheering crowd of 100,000 that Egypt had nationalised the Canal 'in the name of the nation.' And she would use the revenue to build the Aswan Dam - for which Britain and the US refused aid. Nasser thus tears up the 1954 Agreement under which Britain - biggest shareholder in the Canal and its biggest user - withdrew her troops. His action, in the opinion of some British experts, warrants the use of armed force to maintain our rights.

ABOVE RIGHT: **Britain and France amass the largest naval concentration in the Mediterranean since the Second World War as they prepare for the invasion of the Suez Canal region.**

RIGHT: **Prime Minister Anthony Eden tells the nation that 'this act of plunder must not succeed', following Egypt's nationalization of the canal.**

BELOW: **A ship passes through the Suez Canal just before Egypt's nationalization.**

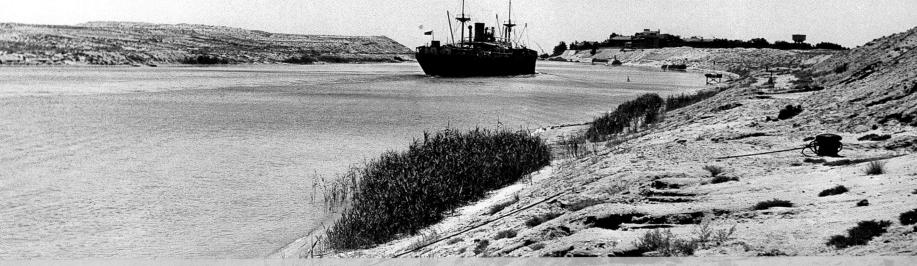

The road to war

Attempts to reach a diplomatic solution to the crisis at the United Nations made slow progress and Britain and France began making contingency plans to retake the canal by force. Both countries were also motivated by a desire to strike a blow to Nasser's government for inciting national liberation movements in their colonies. They were joined by Israel, which had become angered after Nasser closed the strategic Straits of Tiran to Israeli shipping in September 1956.

In mid-October the Security Council, hampered by a Soviet veto, failed to agree a solution. On October 29, Israeli forces crossed into Sinai, and British ships left Malta for Egypt. The next day both Britain and France vetoed a UN motion demanding Israeli withdrawal. They also issued an ultimatum to Egypt (and, disingenuously, to Israel): to cease fighting and allow Anglo-French forces to occupy the Canal Zone. On October 31, there were British and French air attacks on Egyptian airfields and Israel finished occupying Sinai and Gaza. In response, the Egyptians sank some ships in the canal, blocking it to traffic. On November 5, the British and French launched a seaborne assault and landed ground troops in Egypt. They also denied any collusion with Israel, though it was evident that there had been some joint planning.

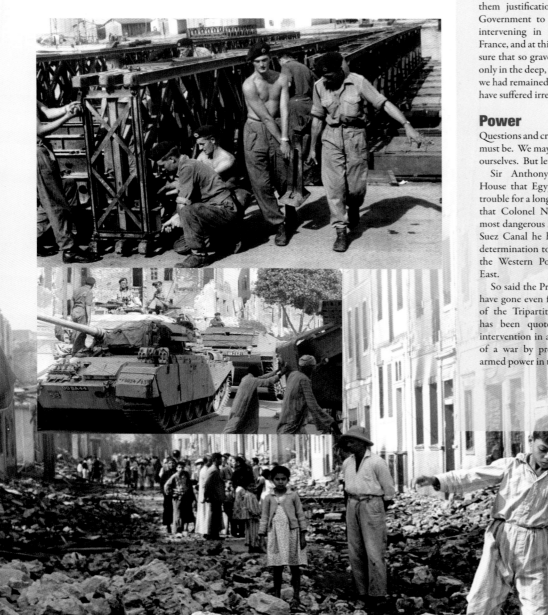

DAILY MAIL NOVEMBER 1, 1956

Britain at war

Britain is at war with Egypt. That is the grim, inescapable, over-riding fact of this November morning. It should serve to damp down the shrill partisan controversy which was raging in the Commons last night.

This morning British soldiers, sailors, and airmen face battle and sudden death for their country. It is for us all to uphold and support them by uniting behind the Government in the action they have taken.

Many people disagree violently with that action. Time may give them justification. It may prove the Government to have been mistaken in intervening in the Middle East with France, and at this juncture. But we can be sure that so grave a decision was reached only in the deep, sincere conviction that if we had remained quiescent Britain would have suffered irreparable damage.

Power

Questions and criticisms there will be, and must be. We may have some to proffer for ourselves. But let them wait.

Sir Anthony Eden reminded the House that Egypt had been stirring up trouble for a long time. There is no doubt that Colonel Nasser is a dictator of a most dangerous kind. Since he seized the Suez Canal he has repeatedly expressed determination to destroy Israel and drive the Western Powers from the Middle East.

So said the Prime Minister. He might have gone even farther back. The object of the Tripartite Pact of 1950, which has been quoted so much, was not intervention in a war but the prevention of a war by preserving the balance of armed power in that region.

Arms

The supply of arms to Israel and the Arab States was to have been carefully regulated. It was Nasser who deliberately upset that balance by importing large quantities of Russian arms - and thus made certain of the war which has now come to his country.

To ignore all this is, as Sir Anthony says, to shun reality. To ignore it is also to put our country in the wrong. It is true, also, that the Suez Canal is not vital to the US as it is to us, and that 'it is sometimes a Government's duty to take decisions for its own country.'

We must all agree with that, but many will agree, too, that it is a pity we could not have acted promptly on that principle when Nasser stole the Canal in July.

Regrets

There are other things in the present situation which are matters for regret.

It is a pity, for example, that Britain, had to impose her first veto after ten years of UNO on a motion tabled by the US.

It is a pity that Mr. Eisenhower's first intimation of the proposed Anglo-French movement was when he read it in the newspapers.

It is a pity that Australia felt it necessary to abstain from voting with Britain in the Security Council, and that Canada and New Zealand should not be wholeheartedly behind us.

It is a pity Britain got into a situation which the US and the U.S.S.R. together voted against her in the Security Council.

It is a pity, finally, that we have to open this grave chapter in an atmosphere of party faction and personal disagreement.

But we are in it now, and all our energies must be bent towards making it a short, sharp, successful operation. That is essential.

American intervention

However, Britain and France had made a serious error in judgement in assuming that they had the support of the United States. Eisenhower was not happy about being hoodwinked, especially as the Suez operation drew international attention away from the Soviet Union's invasion of Hungary, which had begun just days earlier. With the 1956 Presidential Election just days away, he was forced to criticize allies and put pressure upon them to halt the invasion. He even threatened to stop US support for pound sterling, which would have had far-reaching and disastrous consequences for the British economy. Eden had little choice, and gave way. Only two days after troops had landed, they stopped fighting.

End of the crisis

On November 12 Nasser accepted an international peacekeeping force, which arrived three days later. Both the French and British announced their withdrawal from Egypt, and completed it just before Christmas. Clearing the canal began soon afterwards. Israeli troops also gradually withdrew, leaving Gaza in March 1957; they had received a US commitment that they had shipping rights, including right of passage through the Gulf of Aqaba.

The Suez Canal reopened in April 1957, and remains in Egyptian control. Within weeks, the humiliated Anthony Eden had to resign, and Britain was forced into reassessing its entire foreign policy. The Suez adventure also confirmed Arab distrust of Israel, and enhanced Nasser's prestige. However, it did not have any lasting effect on the Cold War or on the overall balance of power in the region.

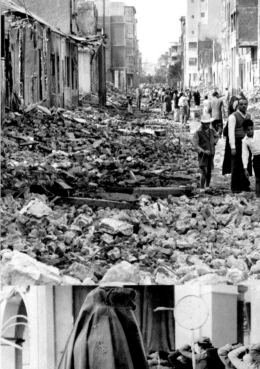

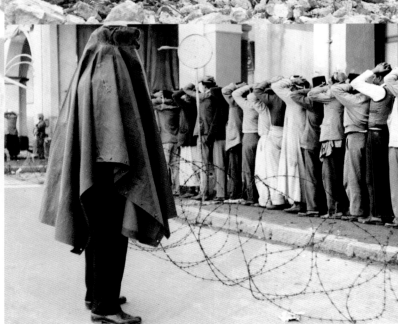

OPPOSITE BELOW: **An Egyptian boy walks amongst the wreckage of buildings in Port Said, Egypt. British and French planes attacked military targets in the town from their bases in Cyprus in preparation for the landing of their troops.**

OPPOSITE ABOVE LEFT: **Royal Engineers construct a bailey bridge over the Suez Canal at Port Said.**

OPPOSITE MIDDLE LEFT: **British soldiers, backed by tanks, conduct ammunition searches after coming ashore at Port Said in the same landing craft as had been used for the Normandy landings on D-Day.**

ABOVE RIGHT: **Locals in Rue Ababi, Port Said, assess the damage done during the Anglo-French bombardment.**

TOP: **British tanks roll down the Rue Mohamed Aly in Port Said.**

ABOVE: **Men of the Royal Scots Regiment break into a house in the Arab Quarter of Port Said, in their search for a kidnapped British soldier, Lieutenant Anthony Moorhouse, December 15, 1956.**

RIGHT: **Suspects arrested in the search for Lieutenant Moorhouse are marched in front of an Egyptian working for the British who has hidden his face to conceal his identity. Nasser later admitted Moorhouse had died in captivity.**

Soviet Invasion of Hungary 1956

Stalinist Hungary

After the Second World War, Stalin controlled Eastern Europe through closely allied Communist governments. In Hungary, as elsewhere, there were repressions during the Stalinist era: over 150,000 people had been imprisoned between 1948 and Stalin's death in 1953, and 480 public figures had been executed following show trials.

After Stalin's death, even the Soviets recognized that Hungary had suffered, and the leadership was replaced in 1953 with an administration led by Imre Nagy, a liberal Communist. He was backed by Moscow, and so was his reforming agenda – initially. Nagy held on to office until 1955, when conservative rivals in the Communist Party persuaded Moscow that he was unreliable. He was removed and the Stalinists returned to power. For about a year, Nagy and his supporters formed an unofficial opposition. Nagy's reforms when in office had attracted popular support, and there was little sympathy for another Stalinist regime.

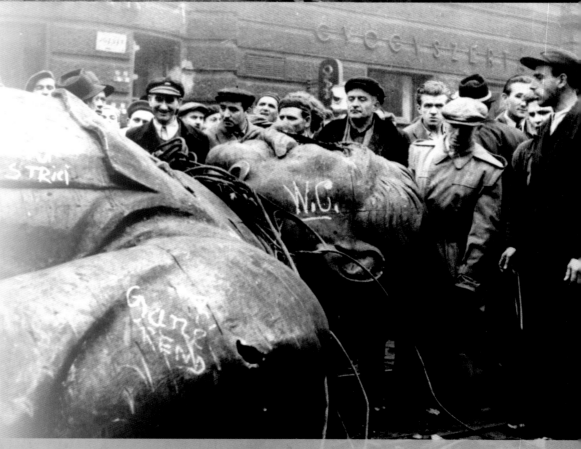

ABOVE: War-torn Budapest during the Soviet invasion.

RIGHT: Hungarians gather around a fallen statue of Stalin in front of the National Theatre in Budapest.

The revolution begins

On October 6, the authorities allowed the reburial of some victims of the show trials. This spark ignited the Hungarian revolution by bringing people onto the streets. Ten days later, students in the provincial city of Szeged organized themselves into the League of Hungarian Students. Similar groups began to form everywhere, and none was allied with the official students' organization.

On October 22, the students at Budapest's Technical University launched a manifesto demanding free speech, economic reform and the return of Nagy. Demonstrations quickly spread on October 23, and escalated into rioting. After a statue of Stalin was overturned, the protesting crowds increased in size and enthusiasm. On October 25, Soviet tanks entered the city to restore order at the request of the Hungarian government and by evening Soviet troops were firing on the demonstrators. The country's Central Committee of the Communist Party announced the return of Nagy the following morning, after an all-night sitting.

ABOVE RIGHT: **Hungarians of London march on the Prime Minister's residence in Downing Street to appeal for British assistance in Hungary. However, the Prime Minister, Sir Anthony Eden was preoccupied with the imminent invasion of Egypt.**

MIDDLE RIGHT: **Hungarians walk past the body of a Soviet soldier lying in front of a wrecked truck in Budapest.**

BELOW: **Rebels ride through the streets of Budapest in a captured Russian tank.**

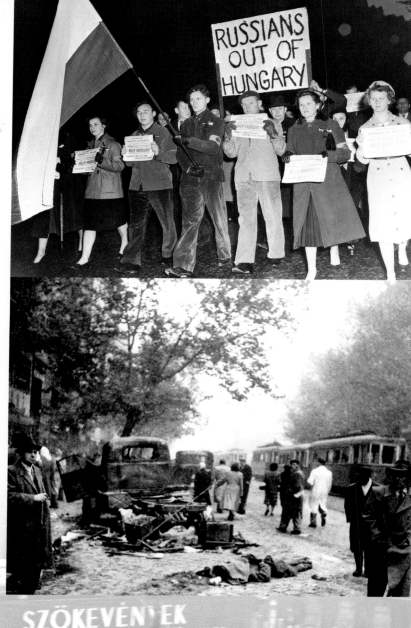

DAILY MAIL OCTOBER 25, 1956

The revolt spreads

The Hungarian rebellion is spreading through the country. Late tonight, while fierce fighting continued in Budapest, battles flared in three big provincial cities - Debrecen, 120 miles east of the capital, and Szolnok and Szeged in the south. Fighting there was admitted in broadcasts from Budapest and Moscow. Shooting was also heard at the little railway town of St. Gotthard, near the Austrian border.

Moscow radio called the rebels 'mutineers,' thus confirming reports that the anti-Russian rising was set off by Hungarian Army officers.

Budapest tonight is an occupied city and a city where many hundreds lie dead. The Red Army, called in because Hungary's new Government could not quell the revolt, has seized the radio station and other key buildings.

Tank ring

A state of emergency has been declared throughout the country. Martial law and a curfew remain in force in Budapest. Red Army tanks patrol the streets and have flung a ring of steel around the city.

Buildings are aflame, and Russian troops are attacking rebel troops who defied the Government's surrender ultimatum and are holding out against Soviet tanks, troops, machine guns, and artillery.

Hundreds of insurgents with machine-guns, pistols and grenades attacked the Robert Karolv military barracks and the Communist Party headquarters. More buildings went up in flames as the tanks wheeled back and forth, guns spattering.

The rebels resisted for several hours before the Red Army finally trapped them. For them capture meant death at the hands of new Premier Nagy's 'Titoist' Government. Red Army troops are said to have executed 'at least 28' Hungarian soldiers who refused to fight the rebels.

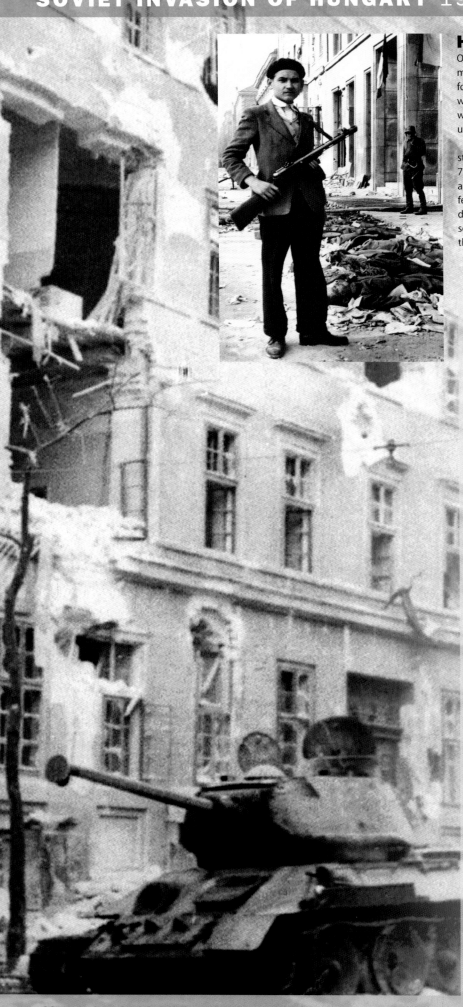

Hungary withdraws from the Warsaw Pact

On the streets barricades were being thrown up, and many of the revolutionaries had managed to acquire arms. Nor was protest confined to Budapest; activist groups had been forming everywhere. As the violence spiked, Nagy proposed a ceasefire and announced what was, in effect, a multi-party government. At his request, the Soviet leader, Nikita Khrushchev, withdrew Soviet tanks from Hungary, but sent more men to the border in case of future unrest.

However, Nagy went too far. He summoned the Soviet ambassador, Andropov, and stated that in response Hungary was now withdrawing unilaterally from the Warsaw Pact. At 7.50 p.m. on November 1 Nagy made a radio announcement that Hungary was now neutral, and asked for United Nations recognition. This was totally unacceptable to Moscow, who feared that other European nations would follow Hungary's example. The West had become distracted by the Suez Crisis and Khrushchev saw his opportunity to act. Negotiations were set up by the Soviet Government, but as soon as members of the Nagy government arrived at the talks, they were all arrested.

DAILY MAIL NOVEMBER 5, 1956

The murder of Hungary

Hungary, the little country that dared to defy Russia, was murdered today. Russian troops struck at the freedom fighters all over the country. More than 1,000 tanks surrounded Budapest. Soviet soldiers stormed into the Parliament building after Premier Nagy had just broadcast to the world an agonised call for help.

They marched Mr. Nagy out at gun-point. He has been charged with supporting counter-revolutionary forces, East Berlin radio said tonight.

It was 2a.m. when the massacre of Hungary began.

AT 11a.m. telephone lines from Budapest to the free world went dead.

At noon Moscow announced: 'The Hungarian counter-revolution has been crushed.'

But tonight a Hungarian rebel station suddenly came on the air again. 'The Russian Air Force is bombing Budapest,' it announced. 'Smoke and flames can be seen for miles. Fighting is going on house by house and street by street.'

The Russians set up a puppet Government. The man they chose to lead it: Janos Kadar. He betrayed Nagy, because he was in Nagy's Government last week.

In a broadcast at 5 p.m., Kadar had to admit that the freedom men were still holding out. He said: 'There still exists the danger they may get the upper hand.'

Budapest radio came on the air again tonight under its new Communist masters. It reported that Erno Gero, former party boss whom Nagy purged, had been murdered 'in a barbarous fashion by the rebels.'

Last broadcast

One of the last broadcasts heard from the freedom fighters was a heart-rending call for help. 'Civilised people of the world. On the watch tower of 1,000-year-old Hungary the last flames begin to go out. The Soviet Army is attempting to crush our troubled hearts. Their tanks and guns are roaring over Hungarian soil.

Our women - mothers and daughters - are sitting in dread. They still have terrible memories of the Army's entry in 1945. Save our souls. SOS – SOS. People of the world, listen to our call. Help us - not with advice, not with words, but with action, with soldiers and arms. In the name of liberty and solidarity we are asking you to help. Our ship is sinking. The light vanishes. The shadows grow darker from hour to hour.

Listen to our cry. Start moving. Extend to us brotherly hands. People of the world, save us. SOS. Help, help, help. God be with you and with us.'

Six thousand Soviet tanks, it is estimated, were used to crush Hungary. The rebels put up an heroic resistance against overwhelming odds. They matched rifles against armoured cars, stone barricades against tanks ... courage against machine-guns. They flung on Stalin T.34 tanks and hurled petrol bombs into the midst of the crews.

Heroes seized At 'truce' talks

Much of the fighting in the provinces went on in snow-covered fields. And thousands of refugees from the Soviet terror trudged miles in bitter cold to find safety in Austria. Tonight they are still escaping over the frontier, crawling across the fields under cover of darkness. They cannot use the normal frontier roads - Soviet tanks have sealed them all.

For Russia wants nobody to know the ruthless butchery which went on today in the name of Communism.

The Russian attack began at the very moment when two Hungarian leaders were negotiating a settlement. Colonel Paul Maleter, hero of last week's rising, and Major-General Istvan Kovacs went to meet Russian commanders. They were going to discuss the withdrawal of Soviet troops. They came face to face with pistols and were arrested.

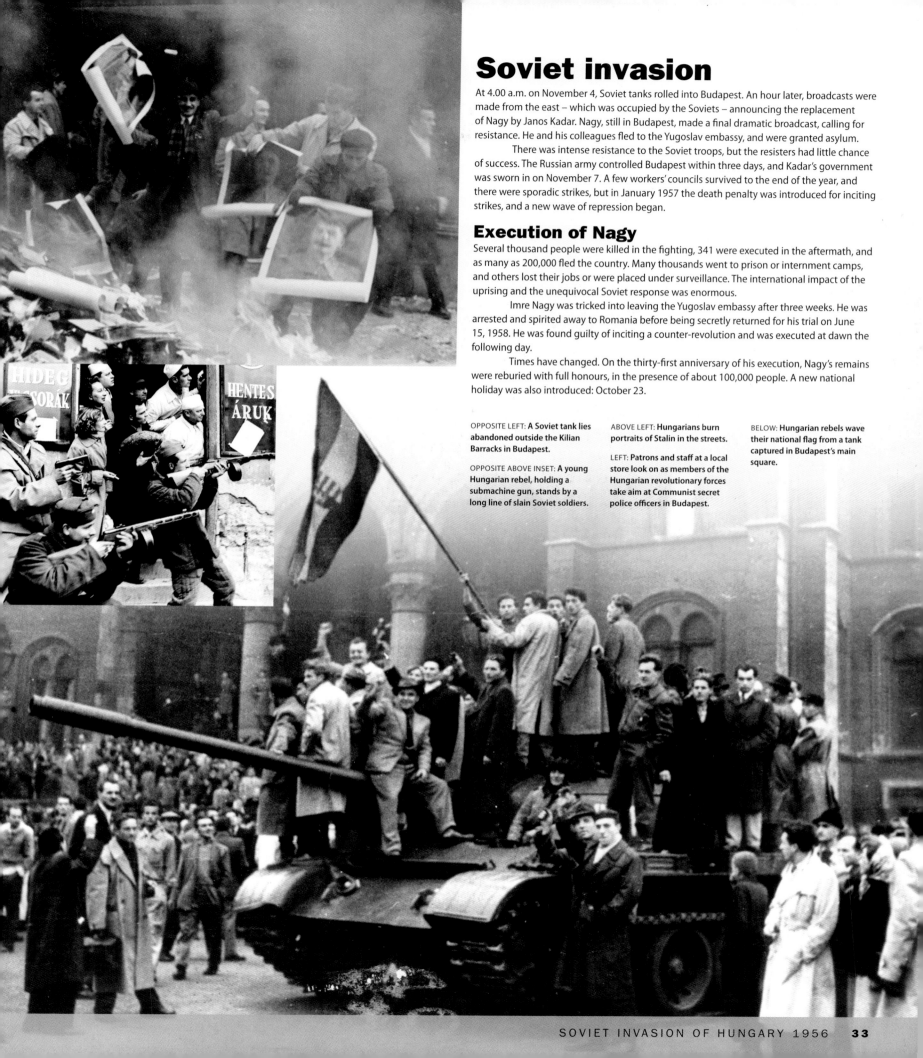

Soviet invasion

At 4.00 a.m. on November 4, Soviet tanks rolled into Budapest. An hour later, broadcasts were made from the east – which was occupied by the Soviets – announcing the replacement of Nagy by Janos Kadar. Nagy, still in Budapest, made a final dramatic broadcast, calling for resistance. He and his colleagues fled to the Yugoslav embassy, and were granted asylum.

There was intense resistance to the Soviet troops, but the resisters had little chance of success. The Russian army controlled Budapest within three days, and Kadar's government was sworn in on November 7. A few workers' councils survived to the end of the year, and there were sporadic strikes, but in January 1957 the death penalty was introduced for inciting strikes, and a new wave of repression began.

Execution of Nagy

Several thousand people were killed in the fighting, 341 were executed in the aftermath, and as many as 200,000 fled the country. Many thousands went to prison or internment camps, and others lost their jobs or were placed under surveillance. The international impact of the uprising and the unequivocal Soviet response was enormous.

Imre Nagy was tricked into leaving the Yugoslav embassy after three weeks. He was arrested and spirited away to Romania before being secretly returned for his trial on June 15, 1958. He was found guilty of inciting a counter-revolution and was executed at dawn the following day.

Times have changed. On the thirty-first anniversary of his execution, Nagy's remains were reburied with full honours, in the presence of about 100,000 people. A new national holiday was also introduced: October 23.

OPPOSITE LEFT: **A Soviet tank lies abandoned outside the Kilian Barracks in Budapest.**

OPPOSITE ABOVE INSET: **A young Hungarian rebel, holding a submachine gun, stands by a long line of slain Soviet soldiers.**

ABOVE LEFT: **Hungarians burn portraits of Stalin in the streets.**

LEFT: **Patrons and staff at a local store look on as members of the Hungarian revolutionary forces take aim at Communist secret police officers in Budapest.**

BELOW: **Hungarian rebels wave their national flag from a tank captured in Budapest's main square.**

Cuban Missile Crisis 1962

The Bay of Pigs invasion

In the early 1960s, the United States had a steadily growing arsenal of nuclear weapons. There had been nine in 1946, there were 841 by 1952, and ten years later there were about 28,000. Some were based in Turkey, in striking distance of the Soviet Union. Though the US had clearly outpaced the Soviets, their nuclear arsenal was also growing. This added a very perilous element to the edgy situation between the two superpowers. Cuba was to become the most serious flashpoint.

The island of Cuba, physically close to the US mainland, had been allied to the States while under the leadership of Batista. However, Batsta's regime had been overthrown in 1959 and it became a Communist state with links to the Soviet Union under Fidel Castro. The US had been trying to depose Castro, and in 1961 an attempt to launch a counter-revolution was made at the Bay of Pigs by CIA-trained exiles. It failed, increasing Castro's wariness in the process, and making it likely that there would be another attempt.

DAILY MAIL APRIL 19, 1961
The truth about Cuba

Let us make no mistake about what is happening in Cuba. This is a trial of strength between the two Great Powers and ideologies which divide the world.

The situation in the island, which has become a Communist outpost, is a deadly threat not only to the US but to all the Americas and the free world. President Kennedy appears to be doing what he can to remove it. We say 'appears' because American 'intervention', if it can be so called, is obscure and confused. No US troops are to be employed, but the landings are certainly by American trained and equipped Cuban rebels.

Is this aggression? Is it Yankee Imperialism? Some people here are already saying it is. So is Mr. Kruschev, who, not for the first time, has organised anti-American demonstrations in Moscow and sent a Note full of menace to Washington.

No one doubts the gravity of what is happening. Everyone knows that military action on any scale anywhere can be a threat to world peace. But is Freedom always to be blackmailed into abandoning its rights? Must Democracy every time give way to Tyranny?

Castro has become a worse dictator than Batista, whom he displaced. He has betrayed his comrades, countrymen, and ideals, and has made Cuba a Red satellite. Such serious charges should be supported by facts and here are a few. In the past nine months more than 30,000 tons of arms, have poured into Cuba from the Iron Curtain countries. Castro's armed forces have been completely re-equipped by the Communists. Today Cuba has the largest ground forces in the American continent, apart from the US.

Such is the size of the military threat - begun, let us note, not by America but by Russia.

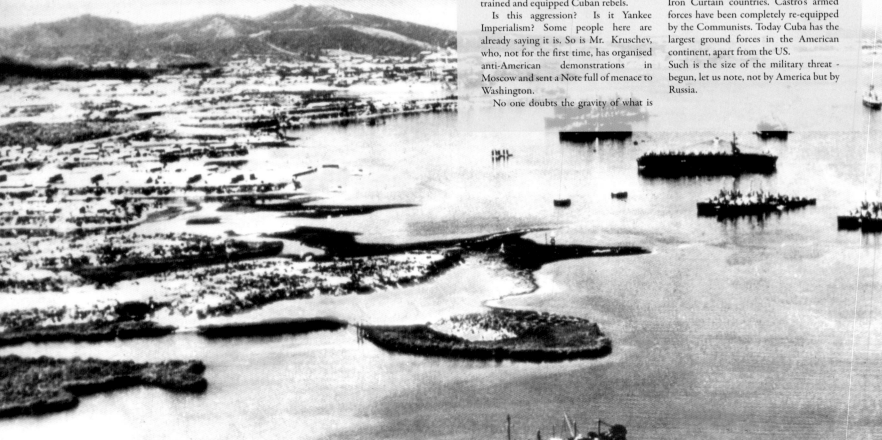

Soviet missiles in Cuba

During April 1962, the Soviet Union under Khrushchev supplied Castro with a range of cruise missiles. The following month the decision was taken to base nuclear missiles in Cuba, under Soviet control. Work began on preparing nine bases, and the first delivery was made during the night of September 8. This helped consolidate Castro's position and also – as far as the Soviets were concerned – went some way to redress the balance of power.

On October 8, the Cuban President Dorticos announced to the UN Assembly that his country would defend itself if attacked, and stated that it now had the means to do so. On October 14, reconnaissance photographs were taken by a US U-2 spy plane revealing that missile bases were under construction on the island. The photographs were shown to US President Kennedy two days later.

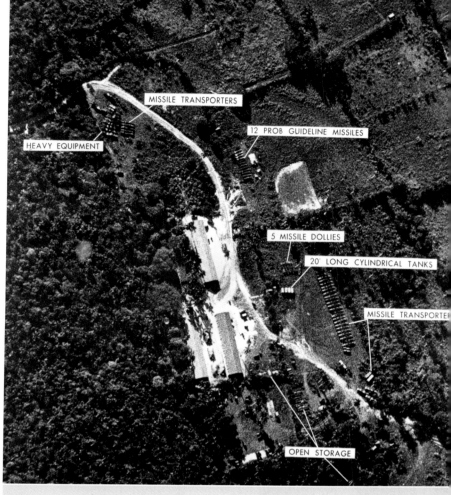

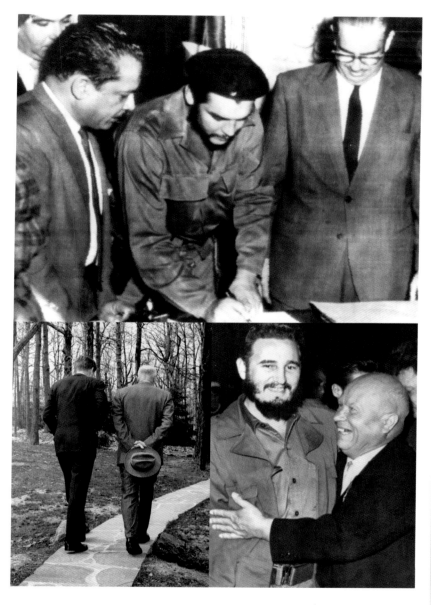

OPPOSITE ABOVE: **Anti-Castro Cubans** train in the use of rifles, pistols and bayonets on No Name Key, about 15 miles from Marathon, Florida, in the Florida Keys.

OPPOSITE BELOW: **The United States Naval base** at Guantanamo Bay, Cuba, pictured just before the crisis. Reinforcements were sent to the base as the sensational events unfolded.

TOP: **The revolutionary hero** Ernesto 'Che' Guevara is sworn in as Cuban Industry Minister in 1961. He played an important role in facilitating the relationship between Cuba and the Soviet Union. He later left Cuba to export the revolution elsewhere, but was captured and executed in Bolivia in 1967.

ABOVE LEFT: **President Kennedy** and former President Eisenhower discuss the Bay of Pigs Invasion at Camp David in April 1961.

ABOVE RIGHT: **Fidel Castro** of Cuba and Soviet Nikita Kruschev embrace on the floor of the United Nations General Assembly in New York in 1960.

RIGHT: **This image**, taken by an American U-2 spy plane, revealed the presence of Soviet missile sites in Cuba and precipitated the crisis.

DAILY MAIL OCTOBER 24, 1962

The evidence - US pictures show rocket sites

THIS is the spy-plane evidence taken from a high-flying U-2 which prompted the Cuban blockade. Here, according to United States experts, is unmistakable proof of Russian missiles being readied on Cuban soil.

Seven 1,100-mile medium-range ballistic missiles lie under canvas covers on their own trailers. In between are two maintenance shelters. To one side stands a giant erector-launcher.

This picture is a segment, enlarged 20 times, from a panoramic view of a square mile of Cuban woodland which is the scene of frenzied activity.

About 1,000 yards from the rockets are the first scars of concrete roads and launching pads under construction. Nearby is a tented missile town - in the open with no attempt at camouflage. Scattered through the woodlands are more erector-launchers and another rocket on its trailer.

The missiles are clearly identifiable as Russian medium-range rockets of a type seen before on sites close to the Iron Curtain. They are early liquid-fuelled type which can carry a warhead in the low megaton range - between 1m. and 5,000,000 tons T.N.T. equivalent. From this site they could reach Washington in minutes.

United States authorities last night released nine pictures as proof of their contention that a Russian build-up in Cuba had begun. The evidence includes photos taken obliquely by high-flying U-2s of rocket bases, airfields littered with Soviet jet fighters and bombers, and a harbour near Havana with Russian Navy patrol boats armed with anti-shipping guided missiles.

Russia on Alert

RUSSIA tonight cancelled leave for all armed forces and put them on 'battle alert.' Demobilisation of rocket troops, men from anti-aircraft detachments and submarine units was halted. The orders were given by Marshal Rodion Malinovsky, Defence Minister, after an emergency Kremlin meeting with Mr. Kruschev and the Council of Ministers of the U.S.S.R. Marshal Andrei Grechko, Commander-in-Chief of the satellite forces of the Warsaw Pact, also ordered an alert for all land and naval forces.

The official Russian news agency, Tass, said the measures were taken 'in connection with the provocative actions of the American Government and the aggressive intentions of the American armed forces.' The new American Ambassador, Mr. Foy Kohler, was called to the Foreign Ministry and handed the Soviet statement saying the blockade could 'unleash a nuclear war.' It was broadcast to the nation every half-hour this afternoon. The blockade was denounced as piratical and President Kennedy accused of cynicism and hypocrisy in declaring that Soviet rockets in Cuba were a menace to the United States.

American Response

There were several possible responses: to do nothing, to find a diplomatic solution, to attack the bases by air, to invade or opt for a naval blockade. The Joint Chiefs of Staff recommended invasion and a blockade, believing that the Soviets would not retaliate. Kennedy was less convinced; he pointed out that the US would retaliate in similar circumstances, and there was no reason to believe that the USSR might behave differently. Kennedy knew that he had to stand firm, but recognized this put him in a dangerous situation, especially if the Soviets retaliated in West Berlin.

On 22 October, Kennedy announced that the Soviet missiles should be withdrawn and ordered a naval blockade. He also said that any nuclear attack would be met by 'a full retaliatory response upon the Soviet Union'. US ships moved into position, and Khrushchev authorized Soviet commanders to launch nuclear missiles if there was a ground assault. Castro certainly believed this was likely, and Cuban forces were prepared.

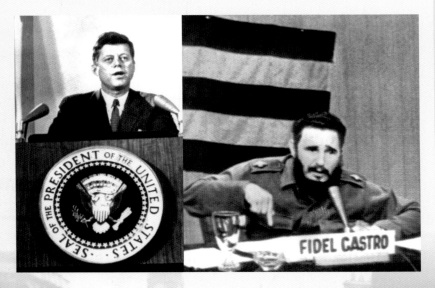

DAILY MAIL OCTOBER 23, 1962

Cuba Blockade

President Kennedy tonight began a drastic military and naval blockade of Cuba. Any ship, Russian or otherwise, found carrying arms to Castro will be turned back.

After the President announced this massive military operation to 'quarantine' the island, the Defence Department said it was prepared to sink Soviet ships if necessary to prevent offensive weapons reaching Cuba.

In an atmosphere of crisis President Kennedy told the nation on television and radio that Russian medium- and long-range missiles capable of delivering nuclear weapons from Hudson Bay to Peru were being installed in Cuba.

President Kennedy announced these moves:

ONE - A strict quarantine on all offensive military equipment being sent to Cuba. 'All ships of any kind bound for Cuba from whatever nation or port will, if found to contain cargoes of offensive weapons, be turned back,' he warned. 'This quarantine will be extended if needed to other types of cargo and carriers. We are not at this time however, denying the necessities of life, as the Soviet attempted to do in their Berlin blockade in 1948.'

TWO - The President directed continued and increased United States air and naval watch on Cuba and its military build-up. He ordered American armed forces 'to prepare for any eventualities - I trust that in the interest of both the Cuban people and the Soviet technicians at these sites the hazards to all concerned of continuing this threat will be recognised.'

THREE - America's policy henceforth will be to regard any nuclear missile launched from Cuba against any nation in the Western hemisphere 'as an attack by the Soviet Union on the United States requiring a full retaliatory response on Russia.'

FOUR - He asked for an emergency meeting of the United Nations Security Council tomorrow to take action against 'this latest Soviet threat to world peace.' The American resolution will call for the prompt dismantling and withdrawal of all offensive weapons in Cuba under supervision of UN observers before the blockade can be lifted.

FIVE - 'I call upon Mr. Kruschev to halt and eliminate this clandestine, reckless and provocative threat to world peace and to stabilise relations between our two nations,' said Mr. Kennedy. 'I call upon him further to abandon this course of world domination and to join in an historic effort to end the perilous arms race and transform the history of man. He has an opportunity to move the world back from the abyss of destruction - by returning to his Government's own words, that it had no need to station missiles outside its own territory, and withdrawing these weapons from Cuba. By refraining from any action which will widen or deepen the present crisis and then by participating in a search for peaceful and permanent solutions.'

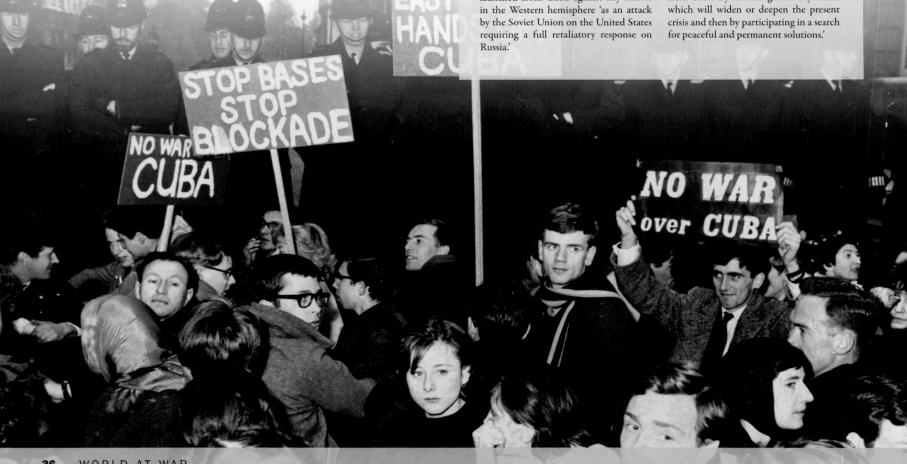

Back from the Brink

No one was in any doubt about the seriousness of the situation; it was taking the world to the brink of nuclear war and the two leaders seemed to be trapped in their relative positions. Finally Khrushchev, older and more experienced, made a move. At 6.00 p.m. on October 26, the State Department received a bargaining message apparently written by Khrushchev himself. It was considered overnight, and an exchange of telegrams and messages – and misunderstandings – between intermediaries began. The following day a spy plane was shot down, and at 3.41 p.m. shots were fired at others; these were later revealed as the result of purely local decisions. At 4.00 p.m. Kennedy sent a message to U Thant, the Secretary-General of the United Nations, asking him to ascertain whether the Soviets would suspend construction of the bases while negotiations took place.

At 9.00 a.m. on October 28 Khrushchev broadcast on Radio Moscow. He stated that there would be no further work undertaken on the bases, and that dismantling would begin. Kennedy praised this as 'an important and constructive contribution to peace'.

Behind the scenes there had been an agreement that the US would withdraw their own missiles from Turkey, but this was not made public and Khrushchev suffered as a result. The US had also agreed, this time publicly, that there would be no invasion of Cuba, ironically strengthening Castro's position. A hot-line was also set up, ensuring that the leaders of the superpowers could talk to each other directly should the need arise in the future. Disaster had been averted.

OPPOSITE LEFT: **President Kennedy reports personally to the nation on the status of Cuban crisis, telling the American people that Soviet missile bases in Cuba are being destroyed.**

OPPOSITE RIGHT: **Fidel Castro denounces the American blockade as 'piracy' and puts Cuba on a war footing during a television broadcast to his nation on October 23.**

OPPOSITE BELOW: **Demonstrators stage a sit-in in Trafalgar Square, London, in opposition to the blockade against Cuba.**

BELOW: **At a meeting of the National Revolutionary Militia in Havana, Castro promises "No gratuitous attacks and no gratuitous hostile acts" against the United States.**

BELOW INSET: **Soviet tanks and troops parade through the streets of Havana, Cuba. Although the nuclear missiles were removed, Soviet influence remained, and the island remains Communist to this day.**

DAILY MAIL OCTOBER 29, 1962

1962 Kruschev pulls out, President Kennedy applauds

The Cuban crisis is over. Mr. Kruschev has ordered all Soviet missile bases to be dismantled and shipped back to Russia. President Kennedy swiftly welcomed the surprise Kremlin move as 'a statesmanlike decision' and 'an important and constructive contribution to peace.'

Tonight, in a personal letter to Mr. Kruschev, the President said that perhaps now - 'as we step back from danger' - East and West could made real progress on disarmament. All signs point to an early Kennedy-Kruschev meeting, possibly burgeoning into a full Summit conference on every outstanding world issue.

Mr. Kruschev struck one sombre note in his 'no strings' offer to get out of Cuba. He charged that an American spy plane had this weekend flown over Russia - in the Chukotka Peninsula area near Alaska. And he warned: 'An intruding aircraft can easily be taken for a bomber with nuclear weapons, and that can push us towards a fatal step.'

Mr. Kruschev's complete surrender came in a new letter to the President early today in which: He conceded that his weapons in Cuba were 'in fact grim weapons,' and said he well understood the anxiety of the American people. He announced he had issued an order for the 'dismantling of the weapons, their crating and return to the Soviet Union' - with UN verification.

He took up as a firm guarantee a pledge by President Kennedy, during their rapid exchange of letters over the weekend, that there would be no invasion of Cuba by the United States or any other nation in the Western hemisphere. He called for a continued 'exchange of opinions aimed at a détente between NATO and the Warsaw Pact nations, a prohibition of atomic and thermo-nuclear weapons, general disarmament and other questions causing international tension.'

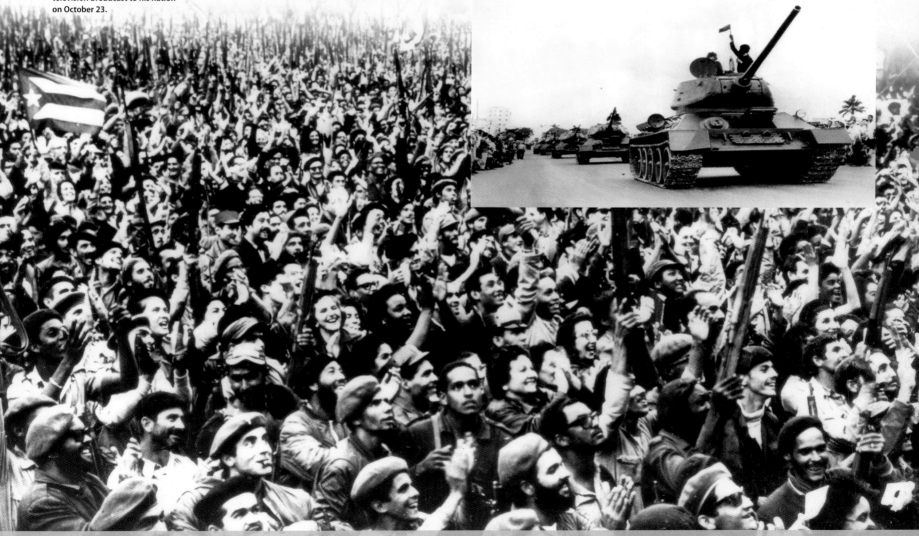

War of Liberation in Zimbabwe 1964-1980

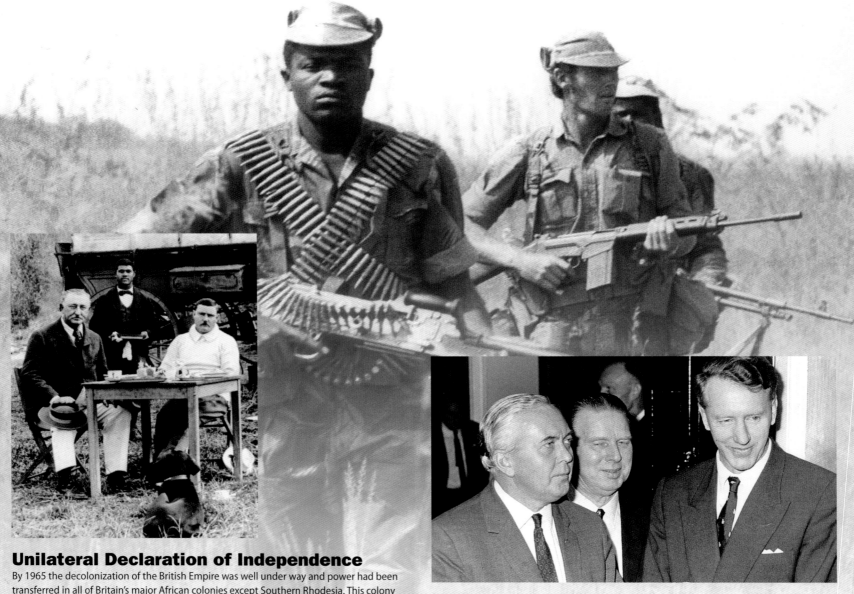

Unilateral Declaration of Independence

By 1965 the decolonization of the British Empire was well under way and power had been transferred in all of Britain's major African colonies except Southern Rhodesia. This colony was home to a sizeable white settler community, which was largely hostile to decolonization on Britain's terms, namely the enfranchisement of Rhodesia's black population. To pre-empt British decolonization and maintain white minority rule, the Rhodesian government of Ian Smith unilaterally declared its independence from Britain on November 11, 1965. The British government's Prime Minister Harold Wilson opted against the use of military force to reverse the illegal declaration, but did impose economic sanctions.

ABOVE: **Rhodesian government forces patrol the bush in search of ZANU guerrillas.**

ABOVE LEFT INSET: **Cecil Rhodes, the statesman who gave his name to Rhodesia, is pictured in** the colony in 1896.

ABOVE RIGHT INSET: **British Prime Minister Harold Wilson (left) welcomes the Rhodesian Prime Minister, Ian Smith (right), to Downing Street for talks just** one month before UDI. Wilson refused to deploy the army to Rhodesia, believing such a move would be opposed by the British public.

National Liberation Movements

National liberation movements had begun opposing white minority rule in Rhodesia even before Ian Smith's unilateral declaration of independence. In 1964, the main movements, the Zimbabwe African National Union (ZANU) and the Zimbabwe African People's Union (ZAPU), were banned by Ian Smith's government and forced into exile in neighbouring Zambia. From there they began an insurgency that raged in the Rhodesian bush for the next fifteen years. ZANU, which came to be ruled by Robert Mugabe, drew its support from the majority Shona ethnic group and obtained its funding from China. ZAPU, under the command of Joshua Nkomo, was backed by the Ndebele ethnic group and was funded by the Soviet Union. In the early 1970s, the Zambian government began clamping down on ZANU and ZAPU, encouraging ZANU to relocate to Mozambique where a Chinese-backed resistance movement, FRELIMO, had liberated large areas from Portuguese colonial rule. From its new bases in Mozambique, ZANU was able to intensify the war in Rhodesia itself from 1972.

Rhodesian Isolation

In 1975 Portugal withdrew from Mozambique and FRELIMO took power. Not only did this greatly benefit ZANU, it also denied landlocked Rhodesia access to its nearest ports. Only the presence of a friendly government in South Africa to the south prevented Rhodesia from being completely encircled by hostile majority-rule governments. However, South Africa was seeking engagement with the continent's black leaders in the hopes of reaping economic rewards, leaving the Smith government increasingly isolated. Smith realized that some form of black participation in the government was necessary and wished to arrange this on his own terms rather than wait to have it imposed by ZANU and ZAPU, which had set aside their differences and joined together in a 'Patriotic Front'. Smith agreed to hold an election in April 1979 to bring moderate black politicians into the government, and Bishop Abel Muzorewa became Rhodesia's first black Prime Minister. However, violence persisted as ZANU and ZAPU did not participate in the election.

Majority Rule

In June 1979, Margaret Thatcher came to power in Britain and sought a lasting settlement to the crisis in Rhodesia. All sides were brought to Lancaster House in London to work out an agreement, which was finally reached in December 1979. Under its terms, majority-rule was introduced, but strict guarantees were issued for the rights of the white minority. Elections were held in March 1980, with ZANU winning a majority of the seats. Robert Mugabe became Prime Minister and Rhodesia was given the African name 'Zimbabwe'.

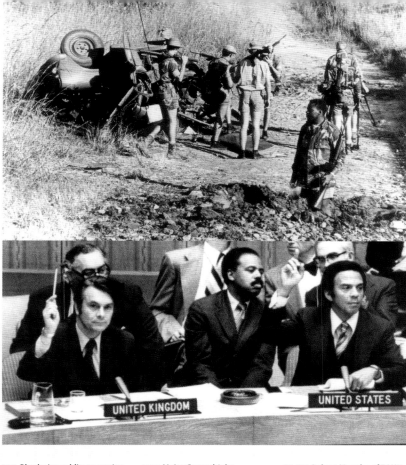

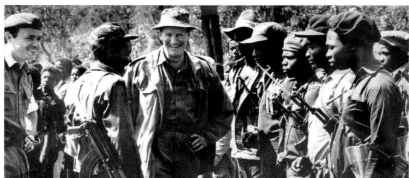

TOP: **Rhodesian soldiers examine the remains of a van that had struck a landmine. The armed wings of both ZANU and ZAPU used landmines which were often obtained in neighbouring Mozambique.**

ABOVE: **Britain and America vote in favour of United Nations Security Council Resolution 415 in September 1977. The Resolution called for the expansion of economic sanctions against the regime, which the UN had first called for in December 1966. The United Nations Security Council met many times to discuss the situation in Rhodesia beginning in November 1965 when the Council condemned the unilateral Declaration of Independence.**

LEFT: **Major General John Acland, the commander of the Commonwealth Monitoring Force in Rhodesia, inspects a group of ZANU's guerrillas. The Commonwealth Monitoring Force was dispatched to the country to ensure that the country's first truly democratic elections were not marred by violence.**

BELOW: **Robert Mugabe of ZANU and Joshua Nkomo, the leader of ZAPU, announce agreement on the terms of the ceasefire at a press conference at Lancaster House in London. ZAPU merged with ZANU in the late 1980s to create the ZANU-PF party under Mugabe's leadership.**

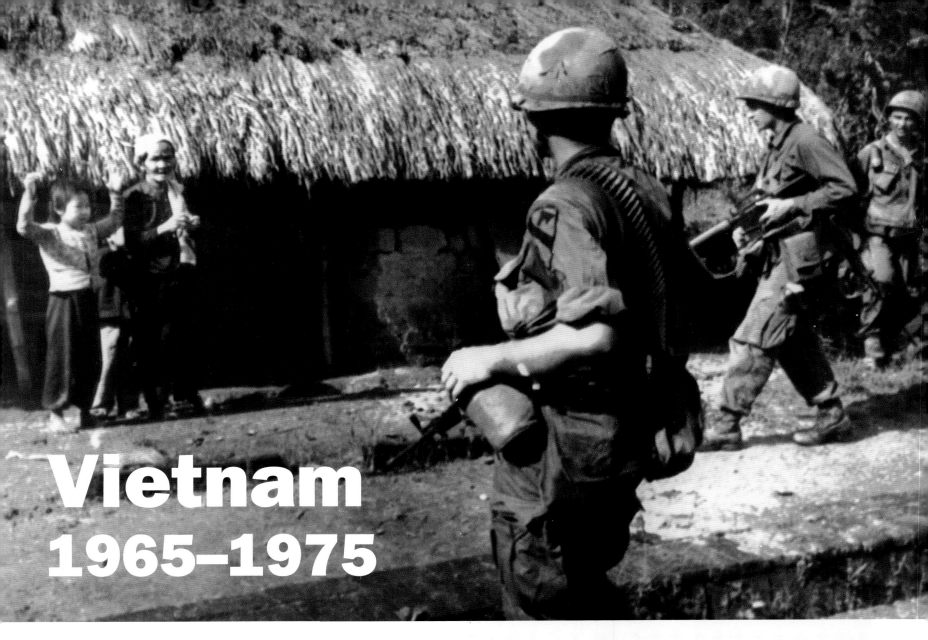

Vietnam
1965–1975

French Indochina

For over 1,000 years, between about 110 BC and AD 940, Vietnam was ruled by China. The collapse of the T'ang dynasty permitted a successful rebellion, which ushered in a period of independence that would endure until the end of the 14th Century. The Chinese would make repeated attempts to regain control, with varying degrees of success, until 1802, when they were expelled with the aid of the French. By 1883 however, France had claimed Vietnam as its own, and it would be subsumed into French Indochina along with Cambodia and Laos.

The First Indochina War

Resistance to French rule grew steadily into the 20th Century, and by 1941, a disaffected young man, originally named Nguyen That Thanh, had established the League for the Independence of Vietnam, or the Vietminh. By this time, he had also changed his name to Ho Chi Minh. During The Second World War, with US support, Vietminh forces defeated the Japanese in the north of the country and Ho went on to found the (largely unrecognized) Democratic Republic of Vietnam in 1945. In the south however, the British liberators returned control to the French, and within a year, skirmishes had broken out between French troops and Vietminh guerrillas that would ultimately escalate into the First Indochina War. France attempted to reunite Vietnam under former emperor Bao Da in 1949, but having previously cooperated with both the Japanese and French, he was mistrusted by Ho's government in Hanoi. The Vietminh continued to wage war and now had the backing of the new Communist government in China. Fearful of Communist expansion in the region, the US then began to supply French forces, but despite superior technology, most notably air support, the French would be overrun by General Vo Nguyen Giap's forces at the Battle of Dien Bien Phu in 1954, bringing the conflict to a close.

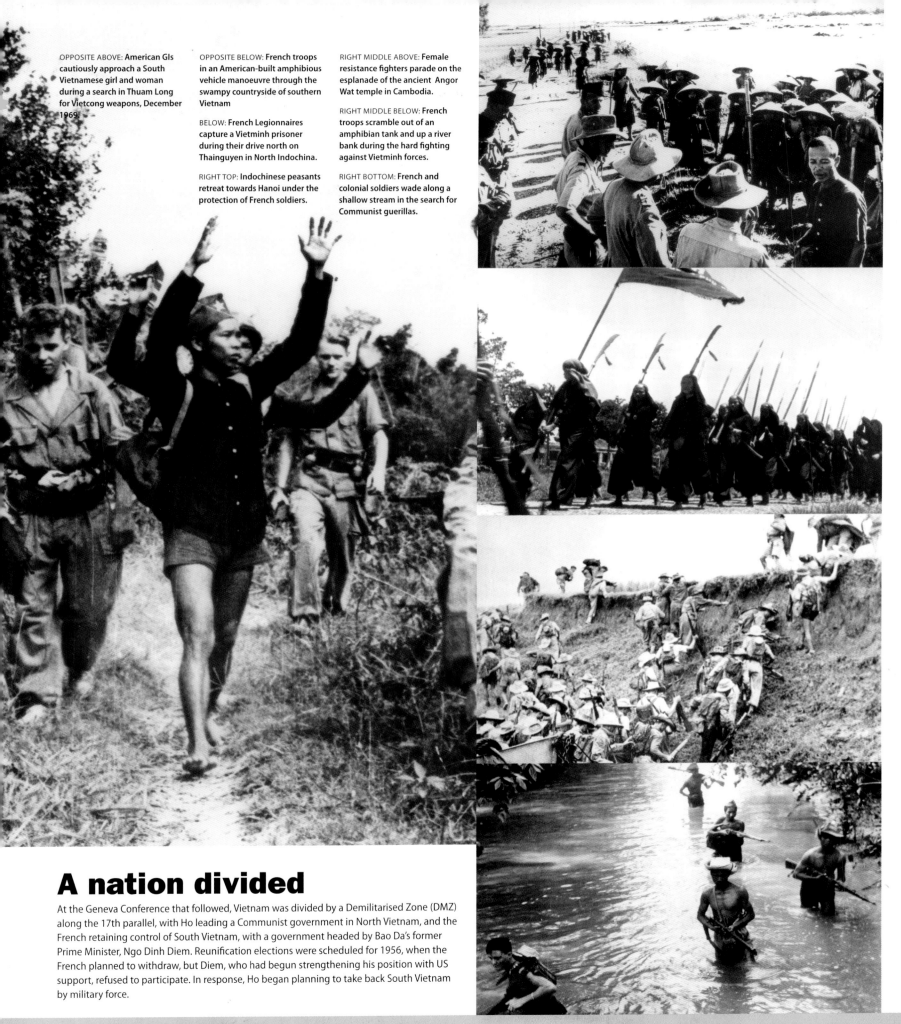

OPPOSITE ABOVE: **American GIs cautiously approach a South Vietnamese girl and woman during a search in Thuam Long for Vietcong weapons, December 1969.**

BELOW: **French Legionnaires capture a Vietminh prisoner during their drive north on Thainguyen in North Indochina.**

RIGHT TOP: **Indochinese peasants retreat towards Hanoi under the protection of French soldiers.**

OPPOSITE BELOW: **French troops in an American-built amphibious vehicle manoeuvre through the swampy countryside of southern Vietnam**

RIGHT MIDDLE ABOVE: **Female resistance fighters parade on the esplanade of the ancient Angor Wat temple in Cambodia.**

RIGHT MIDDLE BELOW: **French troops scramble out of an amphibian tank and up a river bank during the hard fighting against Vietminh forces.**

RIGHT BOTTOM: **French and colonial soldiers wade along a shallow stream in the search for Communist guerillas.**

A nation divided

At the Geneva Conference that followed, Vietnam was divided by a Demilitarised Zone (DMZ) along the 17th parallel, with Ho leading a Communist government in North Vietnam, and the French retaining control of South Vietnam, with a government headed by Bao Da's former Prime Minister, Ngo Dinh Diem. Reunification elections were scheduled for 1956, when the French planned to withdraw, but Diem, who had begun strengthening his position with US support, refused to participate. In response, Ho began planning to take back South Vietnam by military force.

US involvement under Kennedy

After World War Two, the US had adopted a strategy of containment, in order to prevent what Presidents Truman and Eisenhower referred to as the 'domino effect', whereby the fall of one nation to Communism would trigger the fall of neighbouring states. With Castro's seizure of Cuba in 1959, and the Cuban Missile Crisis of 1962, not only was the perceived threat of Communism brought right to America's door, but the very real possibility of nuclear war with the Soviet Union ensured that a conflict against a peasant army thousands of miles away would seem a far more attractive prospect.

However, despite gains by Vietnamese Communist (Vietcong) insurgents in South Vietnam, President Kennedy was reluctant to commit troops, and instead increased financial aid and sent hundreds of military advisors, who would train the Army of the Republic of Vietnam (ARVN) in counter-insurgency.

In early 1963 however, the ARVN were defeated at the Battle of Ap Bac, and the oppressive Diem regime was becoming increasingly unpopular. This led to a Buddhist revolt that culminated in the self-immolation of a number of Buddhist priests. By November, Diem had been overthrown and executed in a coup that was effectively endorsed by the US, and just three weeks later, Kennedy himself was assassinated, to be succeeded by Lyndon B. Johnson.

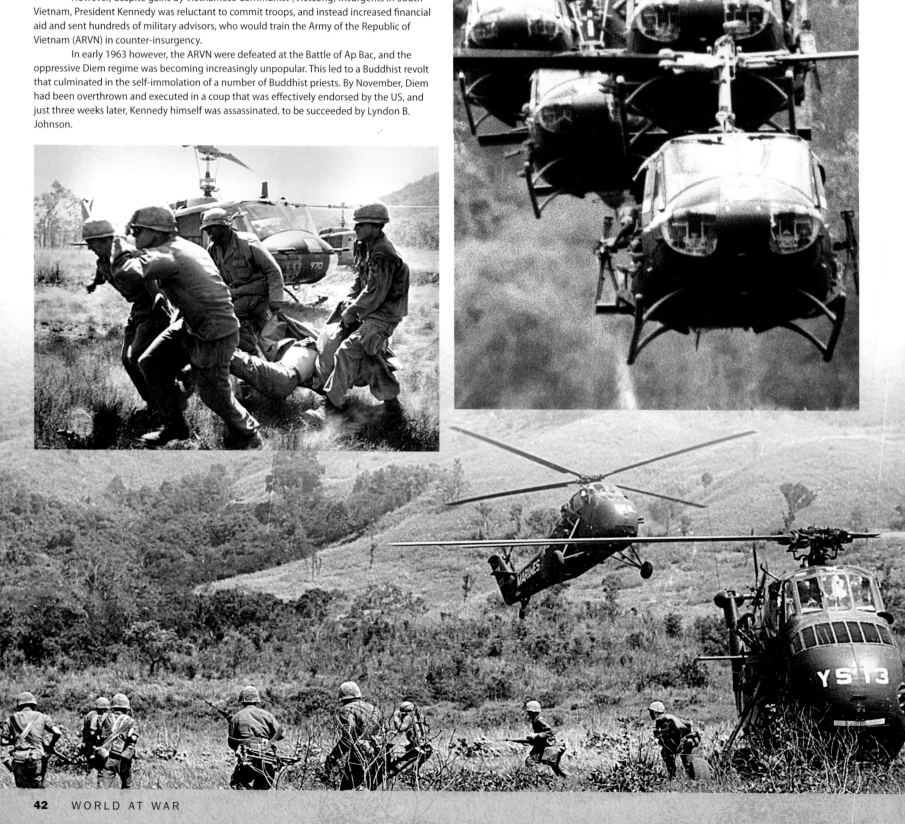

Operation Rolling Thunder

Throughout 1964, the political situation in South Vietnam became increasingly unstable as the North Vietnamese Army (NVA) began infiltrating the South along the 'Ho Chi Minh Trail' through neighbouring Cambodia and Laos. In response, the US began to plan attacks on the North, whilst sending more aid and personnel to the South.

By August, US-backed attacks had begun against coastal radar stations, during which the destroyer USS *Maddox* was reportedly fired upon in the Gulf of Tonkin. The incident would lead Congress to approve the Southeast Asia, or Tonkin Resolution, enabling the President to conduct military operations without a declaration of war.

Despite this, the Vietcong then stepped up their operations, attacking a number of military targets, as well as the Brinks Hotel in Saigon, finally prompting the US to launch attacks against North Vietnam. Operation Rolling Thunder, a sustained strategic bombing campaign began on March 2, 1965 and within a week, the first US ground troops had come ashore at Da Nang. By the summer, the US draft had doubled and the first major ground offensives had begun.

OPPOSITE LEFT: **The body of a slain comrade is carried to an evacuation helicopter by soldiers of the US 1st Cavalry Division in the Ia Drang Valley early in November 1965.**

OPPOSITE BELOW: **US Marine helicopters drop troops near Da Nang amid reports of Vietcong activity in the area, April 1965.**

OPPOSITE RIGHT: **US Army helicopters fall into tight landing formation near Phouc Vinh in war zone 'D'.**

RIGHT: **A Chinook lifts the remains of another helicopter downed by Vietcong ground fire in the An Lao Valley near Bong Son.**

BELOW: **Men of the 3rd Marine Regiment's 3rd Battalion sit silently during Roman Catholic and Protestant memorial services at Da Nang Air Base for 18 Marines who died fighting near Van Tuong in August 1965.**

DAILY MAIL JUNE 10 1965

All The Way With LBJ

The United States appears to be moving inexorably into a full-scale ground war in Vietnam.

Another 2,500 American soldiers landed today at Cam Ranh Bay, 175 miles north-east of Saigon. They are engineers who will build a new port and supply depot. Their arrival came only 24 hours after it was officially announced that henceforth US troops would be committed to 'combat support' of the South Vietnamese Army. These latest reinforcements bring US military strength to 53,500 men.

President Johnson's decision to engage US troops in the coming battles clearly springs from the assessment that on its own the South Vietnamese Army would be unable to withstand the Communist assaults. The President's move marks a critical shift in US policy. After the Korean war, Presidents Eisenhower and Kennedy decided that at all cost the US must avoid involvement in a new ground war on the Asian mainland.

Within six weeks US strength is expected to rise to 70,000. And already there is talk that the numbers will reach 100,000 by the end of the summer. American strategy will be to establish a series of powerful bases along the South Vietnam coast. From them American troops will be sent into battle against the Vietcong forces.

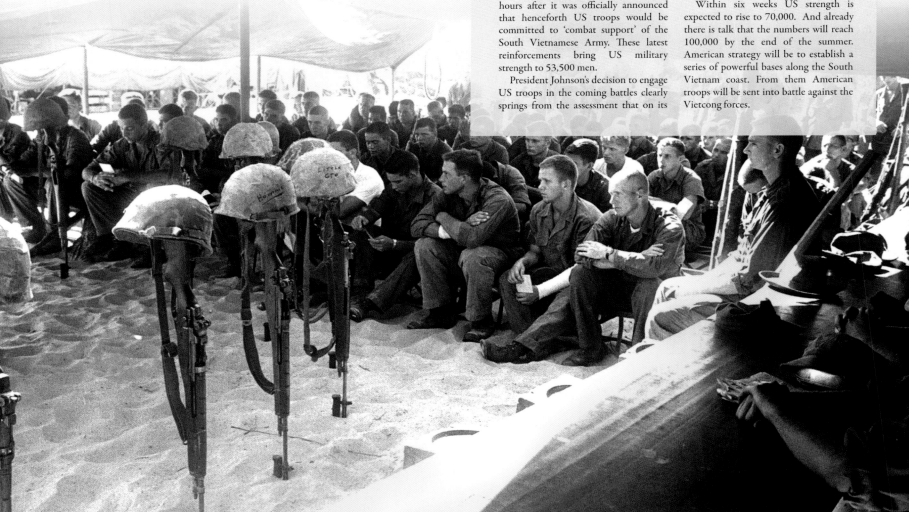

The ground war

Initially, US troops were sent on search and destroy missions, with the intention of engaging the enemy on the battlefield in large numbers, and defeating them with superior technology. However, the NVA and Vietcong were also prepared for a war of attrition, which they would conduct with small-scale guerilla actions; employing hit-and-run tactics to frustrate and demoralise the enemy. By the end of 1966, over 380,000 US servicemen had been committed to Vietnam, with over 5,000 combat deaths and over 30,000 wounded. Most had suffered as a result of snipers, ambushes, mines and home-made booby traps, in a war where the US and their allies (which now included troops from South Korea, Australia and New Zealand), seemed to be fighting a largely invisible foe.

As a result, in early 1967, US forces began clearing huge swathes of jungle north of Saigon with bulldozers, bombs, napalm, and chemical defoliants such as Agent Orange, which would not only expose miles of Vietcong tunnel systems, but result in the deaths and forced resettlement of thousands of civilians. It was hoped that the civilian population could be physically separated from Vietcong insurgents, but by 1967, when General Nguyen Van Thieu became president in the South, it was estimated that over half the rural villages below the 17th Parallel were under Vietcong control, and towards the end of the year, the NVA began launching attacks across the DMZ.

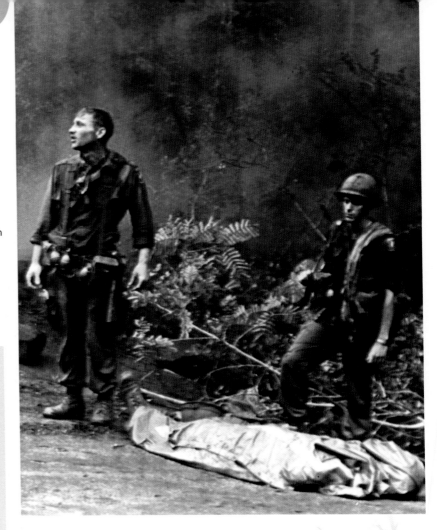

DAILY MAIL MAY 22 1966

Civil war threatens US base

South Vietnam's civil war erupted into new violence last night. Tanks and planes were thrown into a fierce battle in the northern rebel-held city of Da Nang. In Saigon police used truncheons and tear gas against Buddhist demonstrators. The rebels threatened to wreck an American air-base unless US Marines drive South Vietnam Government troops out of Da Nang.

Yesterday's day-long battles shocked the US and plunged the White House into deep gloom. Washington fears the revolt in South Vietnam's Army may grow and force America to disown Marshal Ky, the Premier.

And new Soviet threats of massive aid for North Vietnam could lead to a showdown between Russia and America.

Da Nang's worst day of terror ended last night in a 25-minute machine-gun and mortar battle. government troops, who now hold all the key points, went into action against a rebel relief column – believed to be South Vietnam's 2nd Division –marching on the city.

Government Skyraiders, making their first raid of Da Nang's civil war, strafed an advancing column and forced it back. The rebels said five of their soldiers were killed.

American Marines moved eight wounded to the pagodas where rebel troops and Buddhist monks are holding out.

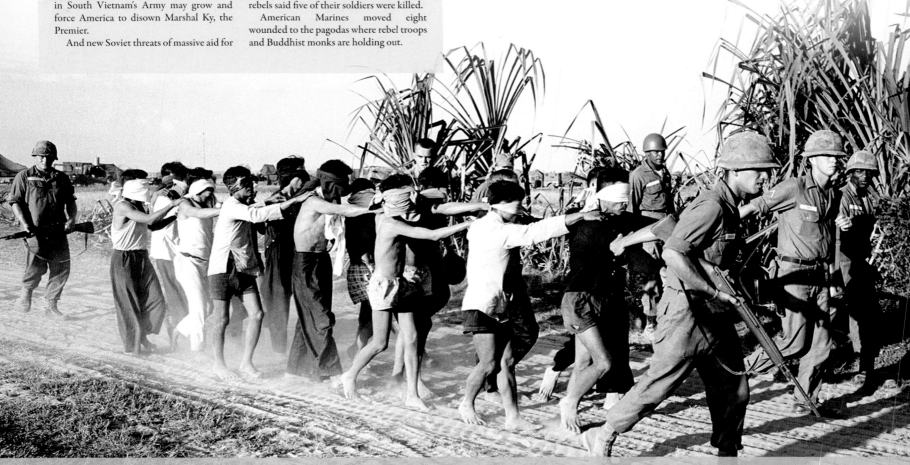

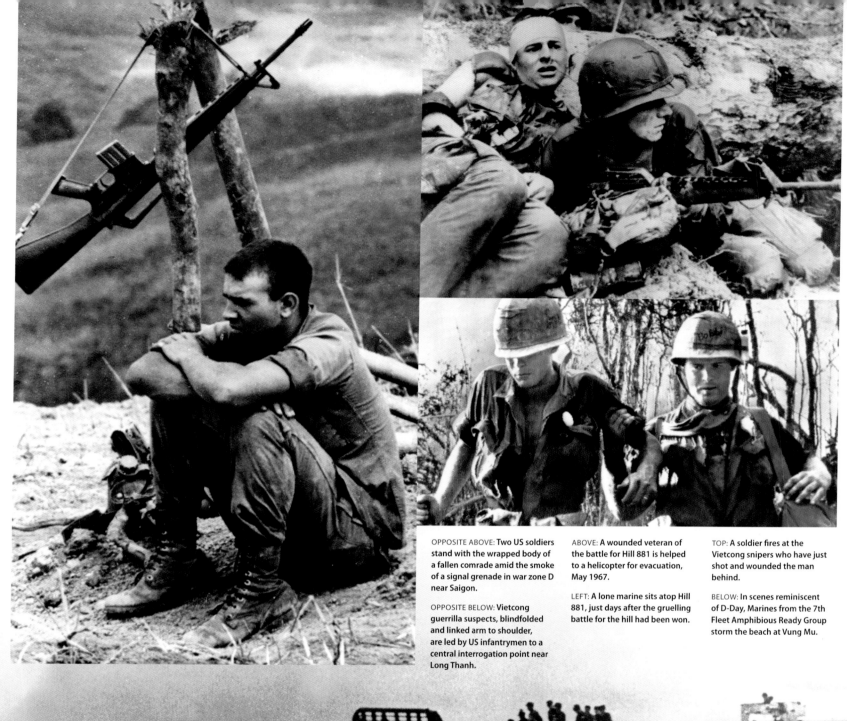

OPPOSITE ABOVE: **Two US soldiers stand with the wrapped body of a fallen comrade amid the smoke of a signal grenade in war zone D near Saigon.**

OPPOSITE BELOW: **Vietcong guerrilla suspects, blindfolded and linked arm to shoulder, are led by US infantrymen to a central interrogation point near Long Thanh.**

ABOVE: **A wounded veteran of the battle for Hill 881 is helped to a helicopter for evacuation, May 1967.**

LEFT: **A lone marine sits atop Hill 881, just days after the gruelling battle for the hill had been won.**

TOP: **A soldier fires at the Vietcong snipers who have just shot and wounded the man behind.**

BELOW: **In scenes reminiscent of D-Day, Marines from the 7th Fleet Amphibious Ready Group storm the beach at Vung Mu.**

The Tet Offensive

By the end of 1967, the Border Battles at the DMZ had given the impression that an invasion of the South might be imminent, but US forces were completely unprepared when the Tet Offensive was launched on January 31, 1968. Breaking a ceasefire respecting the Vietnamese New Year, the NVA and Vietcong hoped to inspire a popular uprising by launching simultaneous attacks in towns and cities across the South. The US Embassy in Saigon was stormed, and battles raged for days in the streets of Saigon and Hué. When the fighting subsided, the US would claim a military victory, but the American public had seen the horrors of the offensive broadcast across the nation, and support for both the President and the war was rapidly eroding. As a result, by March, Johnson had announced that he would not be standing for another term, and by May, peace talks had begun in Paris. The negotiations quickly deadlocked, so Johnson tried to inject some momentum by announcing the cessation of Operation Rolling Thunder, during which almost a million tons of bombs had been dropped on North Vietnam with seemingly little effect. In fact, NVA infiltration into the South had continued to mount in 1968, as had US casualties, whilst social unrest had continued to grow across the US.

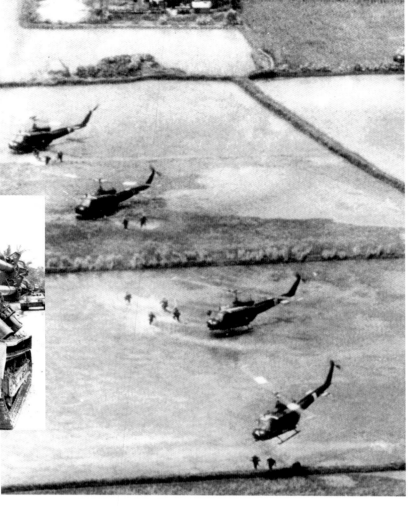

DAILY MAIL MARCH 1 1968

LBJ pours in troops

President Johnson has decided that the US war effort in Vietnam must be expanded. He has ruled out negotiations until the Allies regain the initiative in the fighting.

More troops will be sent to Vietnam as quickly as possible. The number still seems undecided but some reports say that General Westmoreland, military chief in Vietnam, has asked for 200,000. This would bring the total to 725,000. With the military manpower in the US almost exhausted, Mr Johnson has no alternative but to call up reserves.

Meanwhile American peace offers will remain officially open – but Mr Johnson has no intention of pressing them.

Saigon

US bombers struck heavily at North Vietnamese bases being enlarged to launch the first air raids on the south.

Main target was the heavily defended Vinh area, 150 miles north of the demilitarised zone. MiGs and bombers are expected to take off from Vinh to support an offensive along the border zone. Marines at Khe Sanh have been armed already with anti-aircraft weapons.

Hanoi was reported to have been bombed again today. So was the radio centre ten miles away, which controls anti-aircraft defences.

In battles last week 470 American

Servicemen were killed – second only to the record 543 killed the week before. The Communists lost 5,769 dead and the South Vietnamese and other allies lost 453.

Hue

A hundred South Vietnamese soldiers and officials were found shot dead with their hands tied in caves outside Hue. This raised fears for another 200 kidnapped by the Vietcong when they held the city.

Anthony Carthew asks: But are they any good in a war like this?

There are 525,000 Americans tied up in Vietnam, but the generals say this is nowhere near enough. They say dangerous strategic gaps have appeared in the defences and the generals are right – at least in terms of the kind of war they are trying to fight here.

Since the offensive forcing the Americans and South Vietnamese to fall back on the towns and cities, there are great holes in the defensive net which was strung across the country to prevent enemy infiltration. The significant point about the way the Americans have organized their war is that, though half a million men may be serving in Vietnam, only 60,000 to 70,000 are fighting.

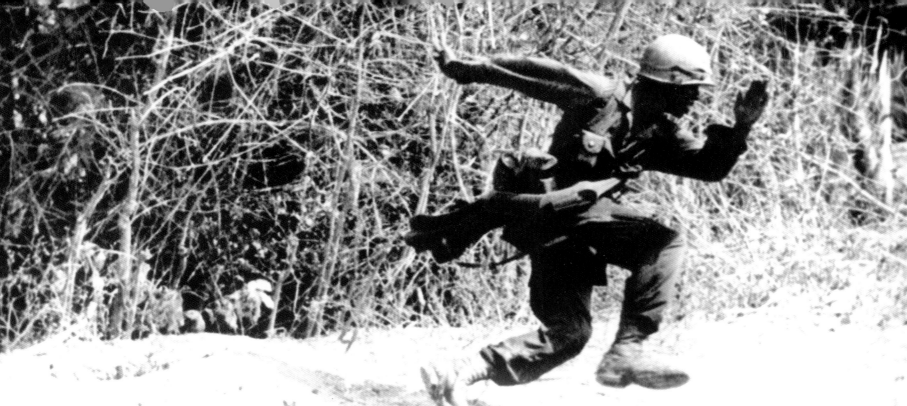

OPPOSITE ABOVE LEFT: **A Marine Armoured Vehicle, armed with six recoiless guns, patrols the streets of Hue at the end of the 26-day battle for control of the city during the Tet Offensive.**

OPPOSITE ABOVE RIGHT: **The 1st Brigade, 9th Infantry Division disembark from assault helicopters in rice paddies near Tan An after patrol helicopters report sighting Vietcong in the area.**

OPPOSITE BELOW: **Marines use empty shell casings to further strengthen the fortifications around the fort of Khe Sanh near the Vietnamese border. The North Vietnamese Army attacked the fort for ten days before the start of the Tet Offensive to draw US troops away from garrisoning towns and cities in the South.**

ABOVE: **A soldier runs for safety after dropping a grenade into the Vietcong bunker (seen on the left of the picture).**

RIGHT: **Marines help one another across a stream swollen by monsoon rains near Da Nang.**

BELOW: **Frightened refugees from the towns and villages around Khe Sanh shelter from North Vietnamese mortars at the American base.**

BELOW RIGHT: **Marines at Khe Sanh use sniperscopes attached to their M-16 rifles to get a better aim at the North Vietnamese encircling their base.**

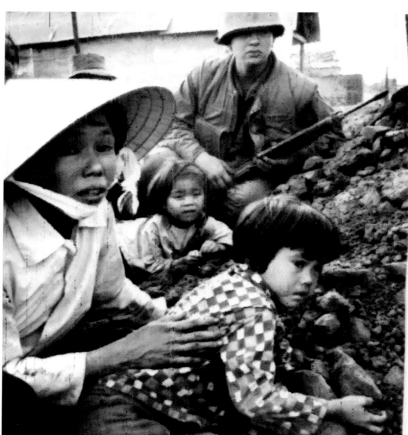

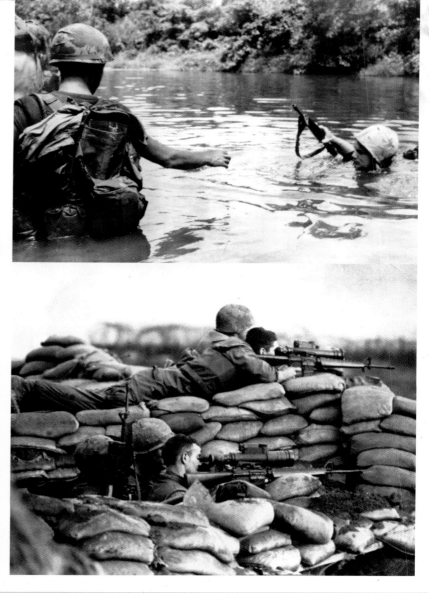

Nixon and 'Vietnamization'

On January 20, 1969, Richard Nixon was inaugurated as the President of the United States. By March, secret bombing raids would be launched against the Ho Chi Minh Trail in Cambodia, despite the country's neutrality. Soon afterwards, the last major engagement between US and NVA troops would take place at Ap Bia, or 'Hamburger Hill', and the seemingly senseless loss of life entailed would herald not only a return to small-scale operations, but an escalation in anti-war sentiment both in the US, and amongst frontline troops.

Within five days of his inauguration, Nixon resumed peace talks in Paris. He proposed a simultaneous withdrawal of NVA and US troops from South Vietnam, but negotiations once again stalled, this time over Vietcong participation in a coalition government in the South. Nevertheless, by July the US began withdrawing troops as part of Nixon's plan for 'Vietnamization'; a gradual removal of US ground forces to allow the ARVN to take over more of the fighting. In parallel, Nixon's National Security Advisor, Henry Kissinger, began behind-the-scenes discussions with the North Vietnamese government. However, Ho Chi Minh died of a heart attack in September 1969 and was succeeded by Le Duan who pledged to continue to fight on until the US had pulled out of the war.

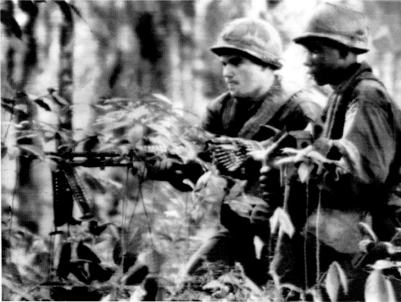

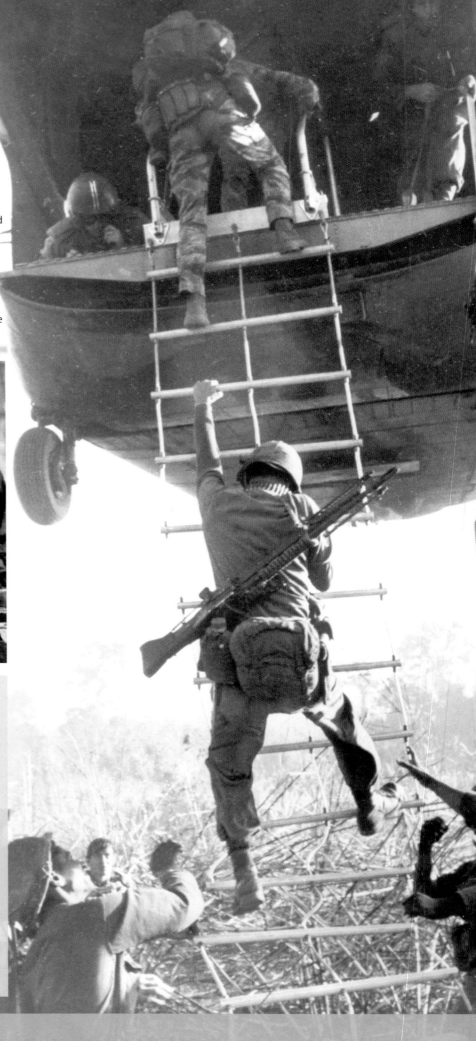

DAILY MAIL JUNE 9 1969

Nixon pulls out 25,000 troops

America is to withdraw 25,000 combat troops from South Vietnam, President Nixon announced in Midway Island today. The withdrawal will start within 30 days and will be completed by August 31.

President Nixon spoke during a lunchtime break in his talks with President Thieu of South Vietnam. He said the Americans would be replaced by South Vietnamese troops. Further withdrawals of United States forces will be considered as conditions in Vietnam permit.

President Nixon said President Thieu had recommended the initial troop withdrawal and the US Commander in South Vietnam, General Creighton Abrams, had given his approval.

President Thieu, speaking immediately after Mr Nixon, said the withdrawal was made possible by the improvement in the South Vietnamese Armed Forces and by progress in the pacification and rural development programmes. He expressed gratitude for 'the sacrifices generously accepted by the American people in joining us in the defence of Vietnam.'

He was now confident of a 'bright and beautiful tomorrow and long-lasting peace, prosperity and brotherhood in Asia.'

President Nixon's announcement reflects optimism that the Paris peace talks, which began in May 1968, may now make some progress after months of stalemate.

America has just over 500,000 troops in South Vietnam. More than 34,000 US Servicemen have been killed there since January 1961.

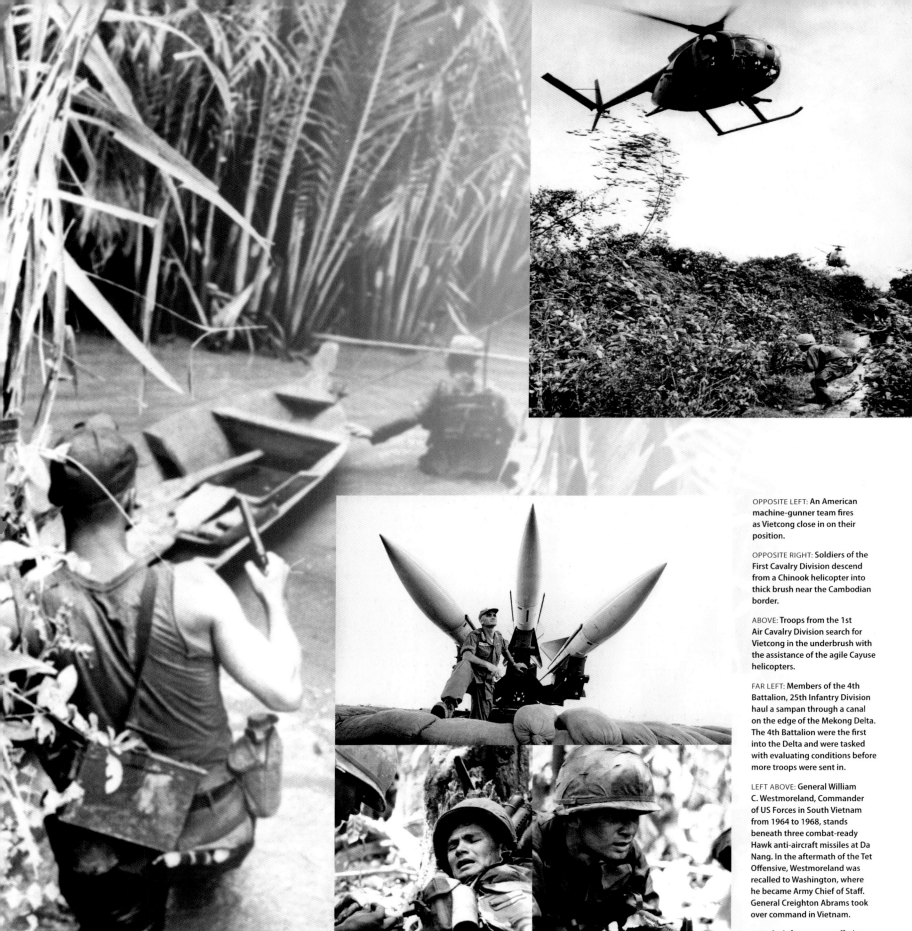

OPPOSITE LEFT: **An American machine-gunner team fires as Vietcong close in on their position.**

OPPOSITE RIGHT: **Soldiers of the First Cavalry Division descend from a Chinook helicopter into thick brush near the Cambodian border.**

ABOVE: **Troops from the 1st Air Cavalry Division search for Vietcong in the underbrush with the assistance of the agile Cayuse helicopters.**

FAR LEFT: **Members of the 4th Battalion, 25th Infantry Division haul a sampan through a canal on the edge of the Mekong Delta. The 4th Battalion were the first into the Delta and were tasked with evaluating conditions before more troops were sent in.**

LEFT ABOVE: **General William C. Westmoreland, Commander of US Forces in South Vietnam from 1964 to 1968, stands beneath three combat-ready Hawk anti-aircraft missiles at Da Nang. In the aftermath of the Tet Offensive, Westmoreland was recalled to Washington, where he became Army Chief of Staff. General Creighton Abrams took over command in Vietnam.**

LEFT: **An infantryman suffering a gunshot wound to his hand receives treatment (left) before immediately resuming his duties (right).**

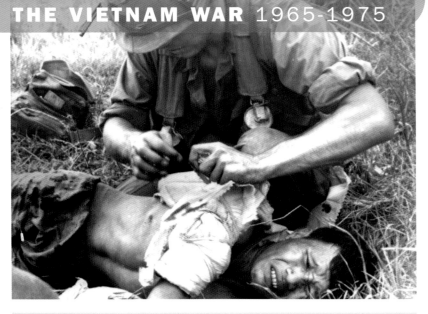

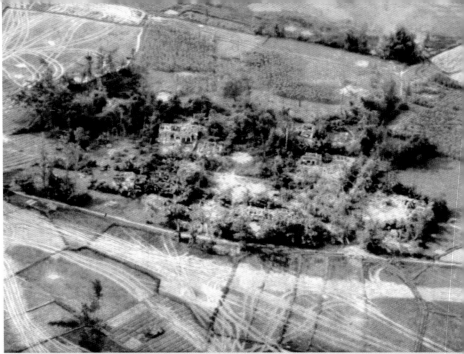

DAILY MAIL OCTOBER 16 1969

Millions in Vietnam protest

Candlelit processions and vigils closed Moratorium Day across America tonight. It was a long day of non-violent protest marred only by a few disturbances and scuffles to involve the police.

In thousands of cities, towns and hamlets it was rallies, speeches, marches, prayers – with counter-protests by the people who opposed the massive call for the ending of the Vietnam war. The demonstrations centred on the college campuses – but elementary and high schools were half empty in many parts of the nation.

Tonight ten New York theatre shows closed down, and on the stages that stayed open curtain speeches were made in support of the Moratorium. When the curtains fell,

many of the actors and actresses converged on garish Times Square for a demonstration – while on Fifth Avenue the candle-bearing marchers massed at St Patrick's Cathedral.

Streets were blocked as thousands of people thronged from the rallies to new assembly points – but all was still orderly.

Mayor Lindsay, Senator Eugene McCarthy and other prominent speakers at the series of rallies ran into opposition, with some counter-demonstrators flaunting placards like 'Moratorium Day is for Commies and pigs.'

But, by and large, as the sun fell and the candles were lit, the verdict was an impressive display of non-violent protest on a scale never before known.

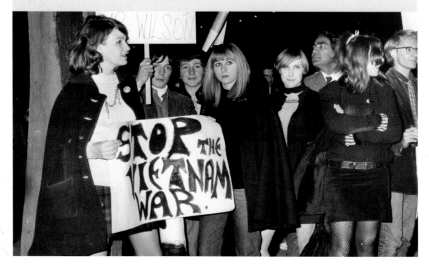

DAILY MAIL NOVEMBER 21, 1969

The story that stunned America

The massacre of two Vietnamese villages is being felt here as a grave American defeat.

After 20 months of official secrecy all attempts to stifle revelations about the slaughter in My Lai and the neighbouring Son My villages broke down today. Cleveland, an American city the size of Liverpool, woke up to see the first, frightening evidence in pictures of the killings in My Lai. Their local newspaper, the Plain Dealer, was the first in the world to print pictures alleged to show the massacre.

Most of Cleveland's 800,000 people were dimly aware of reports of the massacre because the death toll was built up slowly over several days – first 30 civilians, then 109, then 300, now 567 according to the latest reports.

Terror

But not until the front page picture of scores of tangled bodies of men, women and children strewn across the ground reached them did the reports ring true. Vain attempts were made by the Army authorities last night to persuade the Plain Dealer's editor not to print pictures of the dead taken after the massacre.

The Plain Dealer printed the pictures as fact, not allegation pictures. It said nothing to suggest that their authenticity might be in doubt. One of the eight pictures showed three South Vietnamese women, one holding a little boy, cowering with terror on their faces and a small girl sheltering behind them.

The photographer, Ronald L. Haeberle, 28, an Army combat photographer, said in a page one article that moments after he took the picture the entire group was cut down. 'I noticed a woman appear from some cover and this one GI fired at her first then they all started shooting at her. I'd never seen Americans shoot civilians like that.'

Many Cleveland people refused to believe that American soldiers could be responsible for the massacre. Others were upset and angry. Mr Haeberle added in his article that as troops moved in closer to the village 'they just kept shooting at people. I remember this man distinctly, holding a small child in one arm and another child in the other walking towards us. Then all of a sudden a burst of fire and they were cut down. They were about 20ft. away. One machine-gunner did it – he opened up. There was no reaction on the guy doing the shooting. That's the part that really got me. I turned my back because I couldn't look. They opened up with two M16s. On automatic fire they went through the whole clip – 35, 40 shots. I couldn't take a picture of it, it was too much.'

Haeberle said that the attack came at 5.30 a.m. on March 16, 1968. C Company, First Battalion, 20th Infantry Regiment, 11th Light Infantry Brigade went into the hamlet of My Lai Number 4. The Number 4 indicates that there are three other villages in the district with the same name.

'No one really explained the mission, but from what I heard it was suspected that these villages were Vietcong sympathisers and it was thought there were Vietcong there.' The newspaper said that it had checked with the Adjutant General's office at Fort Benning, Georgia, that Haeberle was present in the hamlet as an Army photographer on March 16.

The My Lai revelations come at a time when President Nixon is trying to muster world opinion against Hanoi's refusal to negotiate in Paris. They are a serious blow to his attempts to persuade 'the great silent majority' of his fellow-Americans not to join the camp of the peace marchers. The Pentagon is declining comment on the incident while it is decided whether to court-martial a lieutenant for 'multiple murder.'

TOP: A US medic works on the shattered arm of a Viet Cong prisoner who had just been discovered hiding in a bamboo thicket near Duc Pho.

ABOVE: Placards at the ready, a group of mini-skirted girls assemble on the Victoria Embankment in London as they prepare to march on the Labour Party Headquarters to protest against the British government's support for the war in Vietnam.

ABOVE RIGHT: An aerial view of the destroyed Tu Cung and My Lai hamlets where on March 16, 1968, American troops massacred Vietnamese civilians and burned the villages.

OPPOSITE BELOW: An American mortar team fires 60mm shells against Viecong in support of US marines under attack at Cua Viet.

OPPOSITE ABOVE LEFT: A wounded paratrooper awaits evacuation during the battle for 'Hamburger Hill' (Dong Ap Bia). Forty-six Americans and more than 500 North Vietnamese died in the battle.

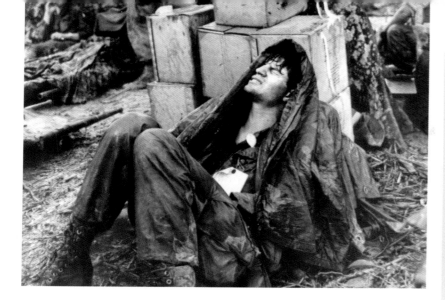

DAIL MAIL MAY 1, 1970

2am:
US troops in Cambodia attack

American combat troops poured over the Cambodian border in a massive attack early today.

In the most momentous statement of his career President Nixon told the American people in a nation-wide TV broadcast that he had just ordered the troops to make the night assault.

The soldiers were launched against what the President described as 'the headquarters for the entire Communist military operation in South Vietnam.' They moved in after US B-52 bombers made their first raids into Cambodia.

The area of the new attack is 50 miles north of the 'Parrot's Beak' which South Vietnamese troops were attacking with a hundred or so American military 'advisers.'

President Nixon dramatically dropped all pretence that the assault on the North Vietnamese bases behind the Cambodian frontier was a South Vietnamese affair with Americans giving only support and guidance. The President announced: 'This is not an invasion of Cambodia. The areas in which these attacks will be launched are completely occupied and controlled by North Vietnamese forces. Our purpose is not to occupy the areas. Once enemy forces are driven out of these sanctuaries and their military supplies destroyed we will withdraw.'

Cambodia and Laos

The conflict took a dramatic turn in March 1970, when Prince Sihanouk of Cambodia was deposed in a coup by General Lon Nol. In order to regain power, Sihanouk aligned himself with the Cambodian Communist group known as the Khmer Rouge. By appearing to have royal assent, the Khmer Rouge saw its ranks swell, prompting further US incursions into the country. This apparent widening of the conflict prompted renewed protests in the US and four demonstrators were killed at Kent State University, Ohio, when National Guardsmen opened fire with live ammunition. From then on, anti-war sentiment in the US grew dramatically and by 1971, Congress had refused funding for any operations involving US ground troops in either Cambodia or Laos. This provided the opportunity to test Nixon's 'Vietnamization' policy in the form of Operation Lam Son 719, an incursion into Laos by 17,000 ARVN troops. Despite US air support, the operation was to prove a massive failure, with the incursion force being routed, having lost almost half of their number. Nevertheless, US troop withdrawals would continue, whilst Australia and New Zealand would announce their intention to pull out of the war.

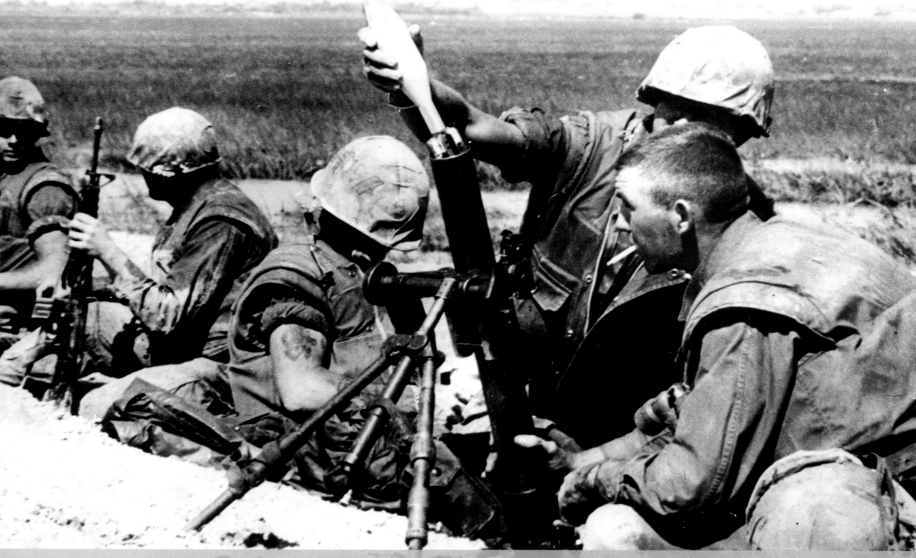

DAILY MAIL MAY 5, 1970

Four students shot dead in riot

Four students – two of them girls –were shot dead and 15 people injured yesterday when a college demonstration against America's invasion of Cambodia erupted into a gun battle with National Guardsmen and police. The students who died were aged 19 and 20. Three were shot in the chest and one in the head. Four of the injured are in a serious condition.

The shooting broke out at Kent State University in Ohio after National Guardsmen broke up a 300-strong rally with tear gas. Students threw stones at the troops and hurled back tear gas canisters. Then snipers fired on the Guardsmen, who opened up with M1 semi-automatics.

'The crowd was harassing them, they turned and opened fire', said Jerry Stoklas, 20, a campus newspaper photographer. 'I saw five people go down.'

A state of emergency was ordered in Kent. Guardsmen sealed off the town and a curfew was imposed. The university, scene of three days of turmoil, was closed.

Mary Hagan, a student, said: 'The troops started pelting everyone with bullets. Some of the students fell. Then a Guardsman ordered a cease-fire.' Doug McLaran, another student, said: 'I looked towards the sound of guns and saw several people wounded. I ran like hell.'

Adjutant-General Del Corso said: 'The Guard expended its entire supply of tear gas and the mob started to encircle the Guardsmen. A sniper opened fire on the troops from a rooftop and they were also hit by stones and bricks. Guardsmen facing almost certain injury and death were forced to open fire on the attackers.'

President Nixon, who last week called dissenting students 'bums,' commented: 'When dissent turns to violence it invites tragedy. I hope this tragic and unfortunate incident will strengthen the determination of all ... to stand firmly for the right of peaceful dissent and just as strongly against the resort to violence.'

A Justice Department inquiry may be ordered into the shooting.

ABOVE: **A helicopter picks up supplies to take to one of the 9th Infantry Division's forward base camps in the Mekong River Delta.**

ABOVE RIGHT: **Sandbagged bunkers topped with canvas play home to the 4th Infantry Division at a forward camp near the Cambodian border.**

MIDDLE RIGHT: **Army repairman Jerry Blackston passes time before being called to duty. His job is to fix the 'People Sniffers',** electrical noses that are fitted to patrol helicopters to 'sniff' out enemy hiding places. They work by picking up traces of chemical compounds unique to humans.

RIGHT: **Battalion Commander Lt. Colonel Ardie E. McClure of the 1st Battalion 8th Cavalry Regiment calls for assistance as he evacuates Private First Class Lyle who was wounded in fighting near Bong Son.**

OPPOSITE LEFT: **A South Vietnamese paratrooper wounded by a shelling attack on his unit southwest of Quang Tri waits for medics to give him an injection.**

OPPOSITE RIGHT: **Lt. Commander Mike Christian addresses a crowd during 'Mike Christian Day' April 7, 1973 in his hometown of Huntsville, Alabama. He spent six years as a North Vietnamese prisoner of war.**

Peace at hand

Back in the US, the publication of the 'Pentagon Papers', secret documents that revealed a catalogue of military and governmental transgressions, were putting the Nixon administration under further pressure to find a peaceful solution. In early 1972, Nixon decided to open diplomatic relations with North Vietnam's allies, China and the Soviet Union. However, by the time of his visit to Moscow, the NVA had launched a concerted effort to invade the South, which would prompt the indefinite suspension of negotiations, and a massive resumption of bombing in North Vietnam. By the time talks resumed, the last US ground troops had left Vietnam, and in October both the US and Hanoi governments would agree to significant concessions. Kissinger would declare, 'peace is at hand', but before the year was out, negotiations had collapsed and the bombing had begun once more.

The end in sight

By January 1973, North Vietnam had returned to the negotiating table, and on the 23rd, the Paris Peace Accords were announced. A ceasefire would begin and the US would withdraw all remaining personnel, but NVA soldiers stationed in the South would be allowed to remain. Agreements were also made regarding the exchange of POWs, and an outline put in place for a political solution in the South. The Accords were signed on the 27th, and two months later the last US troops were withdrawn. By June, in a reflection of the public mood, Congress had forbidden US military involvement in Southeast Asia, leaving the Khmer Rouge free to seize power in Cambodia, and North Vietnam poised to reclaim the South.

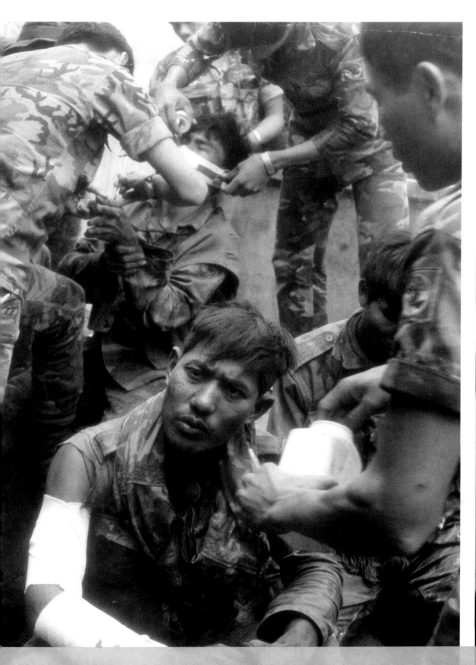

DAIL MAIL JANUARY 24, 1973
Nixon says it: Peace!

The Vietnam war is over. President Nixon went on nationwide television at 3 a.m. today to tell the world that America has achieved 'Peace with honour.'

The agreement initialled in Paris yesterday will effect a ceasefire throughout the war-torn country at midnight on Saturday. Within sixty days from then, said the President, all American troops will leave Vietnam and all US prisoners will be released by Hanoi.

The peace will achieve what America had fought for over so many bloody years, Mr Nixon said. 'South Vietnam has gained the right to determine its own future.'

Millions of Americans watched the Presidential broadcast, listening to the words they had waited so many years to hear. They saw Mr Nixon, calm, composed and matter of fact as he made his historic broadcast.

They saw him address himself to both North and South Vietnam in his vision of the peace to come. 'Ending the war,' he said, ' is only the first step to building the peace. All parties must now see to it that this is a peace that lasts and a peace that heals. This means that the terms of agreement must be scrupulously adhered to.

'Throughout the years of negotiations we have insisted on peace with honour,' the President said. 'In the settlement that has now been agreed to, all the stipulations I have set down have been met.'

Simultaneous announcements

As Mr Nixon spoke, simultaneous announcements were made in Hanoi and Saigon. In the South, President Thieu claimed that his refusal to accept the original peace accord last October and Mr Nixon's subsequent escalation of the bombing of the North had made a significant difference in the peace terms.

Hanoi, he said, had been forced to admit that North and South Vietnam were two separate countries and thus the sovereignty of the South was embodied into the peace agreement.

To the leaders of North Vietnam, the President pledged that the United States was prepared to make a major effort to help the country recover from the war. He said the United States would abide by the agreement but reciprocity would be needed to achieve peace.

President Nixon said: 'To the other major Powers that have been involved, even indirectly, now is the time for mutual restraint so that the peace we have achieved can last.

'Let us be proud that America did not settle for a peace that would have betrayed our ally, that would have ended the war for us but continued the war for the 50 million people of Indochina.'

DAILY MAIL FEBRUARY 13 1973

Goodbye Hanoi ... hello to freedom

The first group of repatriated American prisoners of war walked proudly back to freedom yesterday with smiles and waves to cheering crowds and thumbs up to television cameras to let America know they remained unbowed by their confinement in Communist camps. It was an emotion-packed homecoming for the 142 men. They walked down a long red carpet from the huge jets that had brought them from Vietnam and boarded ambulance buses for a swift ride to the military hospital where most of them will spend the next three days. There was a special cheer for Lieut.-Commander Everett Alvarez, 36, of California, who has spent almost nine years in captivity – the longest time spent by any prisoner in the North.

For 27 of the men there had been a nerve-tingling, last-minute hitch in Vietnam when a group of Vietcong prisoners refused to board their own freedom plane to Hanoi because they feared a trick. The Americans had to wait until the Communists were airborne before being whirled from Loc Ninh to Saigon by helicopter. By contrast, the release in Hanoi went like clockwork. Escort officer Lt. Col. Richard Abel said:

'When the men got off their buses, they were lined up by the ranking officer and marched to the North Vietnamese side. They didn't say anything. They stood at attention and looked straight ahead. But once aboard the planes, they embraced each other and began hugging the nurses and members of the crew. One PoW asked: "Tell me, who won the war?" He was told that South Vietnam didn't lose ... and North Vietnam didn't win.

The telephone rang in Marian Purcell's Kentucky home at 9.35 yesterday morning and the operator said 'Connecting you with the Philippines.' Then the voice she hadn't heard for nearly eight years came over crisp and clear: 'Hello Marian – how've you been?' asked her husband, Lt.-Col. Robert Purcell. Mrs Purcell, eyes swimming with tears, said: 'I saw you on TV – you were beautiful.' Another of the released men phoned the President – 'One of the most moving experiences I have had in the White House,' said Mr Nixon afterwards. Col. Robinson Risner made the call because he wanted to thank the President for his actions 'in getting us out of Vietnam.'

ABOVE: Released prisoner of war Lt. Col. Robert L. Stirm is greeted by his family at Travis Air Force Base in Foster City, California, March 17, 1973.

LEFT: Sentry geese help guard the strategic Y-Bridge in Saigon. The geese acted as an early warning system for the US troops guarding the bridge, which was Saigon's main highway link to the South.

OPPOSITE ABOVE: Chaotic scenes on the roof of the American Embassy where evacuees try to board the last flight out of Saigon, April 30, 1975. A plainclothes American punches a Vietnamese man as he tries to board the helicopter.

OPPOSITE BELOW RIGHT: A US Marine helicopter lifts off from the landing pad during the frantic US evacuation of Saigon, April 30, 1975. The 11 Marines evacuated that day were the last remaining American troops to leave Vietnam.

OPPOSITE BELOW LEFT: Evacuees scramble up the ladder to get on board one of the Air America helicopters charged with transporting Americans and foreign nationals out of Saigon and on to navy ships waiting off the coast.

The fall of Saigon

In August 1974, Richard Nixon resigned due to the Watergate Scandal, a 'dirty tricks campaign' stemming from the 1972 presidential election. His Vice President, Gerald Ford became Commander in Chief and had to deal with resumed North Vietnamese attacks in South Vietnam. Ford would call for increased aid to Saigon in early April 1975, but by this time the NVA were advancing on the city, and the evacuation of all remaining US personnel, as well as thousands of refugees had already begun. The final evacuation, 'Operation Frequent Wind', which centred around the US Embassy, was completed on the morning of April 30, just hours before the fall of Saigon. By midday, Communist forces had made their way to the Presidential Palace, where President Minh, who had been in power for less than two days following Thieu's resignation, would make his surrender, ending the Vietnam War.

For the United States of America, the conflict had been the longest, most expensive, and least successful that the country had ever engaged in. Of the almost three million US personnel rotated through Vietnam, some 60,000 had lost their lives, whilst many of those that returned home, found themselves deeply traumatized, unwelcome, and unable to readjust to a nation that was itself damaged and divided. For the Vietnamese meanwhile, the conclusion of the war marked an end to a struggle for unification, and a fight against foreign oppression, which had persisted for centuries. The country would be officially reunited as the Socialist Republic of Vietnam on July 2, 1976.

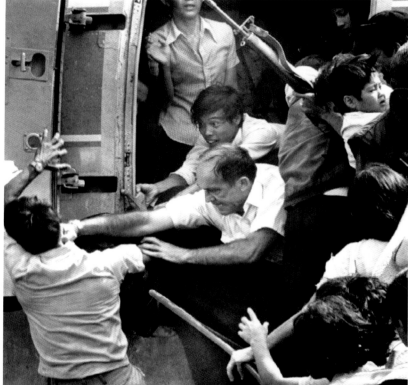

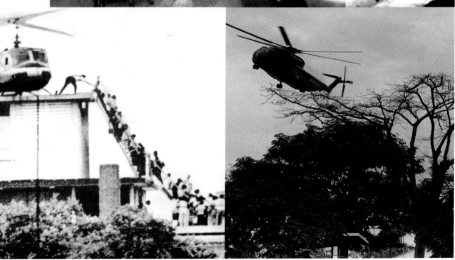

DAILY MAIL MAY 1, 1975

I watched the tanks roll in

Well, they're here. And here is no longer Saigon, the capital of an independent South Vietnam. Today it is Ho Chi Minh City, named in honour of the man who began it all 32 years ago but who died before he could see the realisation of his dream – a united, Communist Indo-China.

Now, with Cambodia under their belt and Laos half digested, that reality has come near. For those who like historical records, it was exactly 10 a.m., Wednesday.

Handshakes

An errant tank ignored the gate hurriedly opened into the presidential palace by a hopefully smiling soldier and smashed its way through the fence. A soldier on the turret fell off. The Communists had arrived.

They arrived smiling and polite. They greeted newsmen with handshakes and Saigonese with kisses. They toured hotels to ask if it were at all possible for their soldiers to be accommodated.

They sat, somewhat self-consciously, in the open-air bar on the Continental Hotel where three days ago Americans drank dry Martinis and whisky sours and sipped orange juice.

They arrived in the middle of a panic-driven frenzy of looting by South Vietnamese soldiers and civilians who smashed into Government and American warehouses. On the streets, armed soldiers were holding up the few remaining Westerners, demanding our money and our cars. Within an hour, the looting stopped.

The guns were garlanded with flowers and one puzzled clerk said: 'We were told we would be killed. It looks as if that was another lie.'

The first Communist troops to drive in looked no older than 15. Their rifles were bigger than they were. Later I saw girl soldiers – all about 17 years old – in a tank column. They were in the Vietcong uniform of black pyjamas and watched unsmiling the Saigonese who came on to the streets to greet them with white flags, cheers and laughter.

Three hours after the occupation, the victors sat on the grass-lined boulevards of this beautiful, French-inspired city, talking and making tea. Children were given lifts on the tanks. People handed the troops cigarettes and fruit. They smiled and chanted 'Victory, victory!'

After thirty years of war, this city was so happy you could actually feel the relief.

At the Palace last night the Vietcong flag – red and blue, with a gold star in the middle – fluttered from a flagpole. It was run up by a soldier as the 'two-day President,' Duong 'Big' Minh, was driven away an hour after broadcasting his surrender message. Last night he was in custody.

Pockets of resistance

There were, of course, isolated pockets of resistance. Some soldiers near the zoo saw the opposition and decided it wasn't worth it.

Another group, three miles outside the city on the Newport Bridge, were intent on a last minute redoubt. It collapsed in five minutes' fighting and some newsmen who had driven up to watch were forced from their cars by a South Vietnamese colonel who sped away in their vehicle. Apparently he hadn't worked it out that there was nowhere to go.

Salute

In the centre of Saigon, opposite the Assembly building, there is a huge monument of two soldiers, surging forward to fight the aggressor. To this, as the Communists entered, came a South Vietnamese police colonel. He saluted the statue, raised a gun to his head and pulled the trigger.

On the steps of the National Assembly Building, a Vietcong colonel said: 'This should be a great day for those who love peace. You will have more freedom. The curfew has been relaxed and will not begin until 6 p.m.'

At 5.55, the streets of Ho Chi Minh City were deserted. The Communists had arrived. Completely.

The victors

These are the conquerors of Saigon, the victorious troops of the North Vietnamese Army, some of them still only children. Boys of 15 in short-sleeved shirts and black strapped plastic sandals, dwarfed by the weapons they carried, marched with the units who took the city yesterday.

Girl soldiers of 15 and 17, stern and unsmiling, stood on the front of camouflaged tanks that rolled through the streets. They wore white and black silk suits, held their heads high and cradled rifles in their arms.

Yesterday the fighting was over and the Young Ones had their reward. They moved through the streets chanting 'Victory, victory' and giving clenched fist salutes. They loaded themselves with captured American-made equipment, grenades and rifles and drank picnic tea on the grass beside the roads. Their great day had come. To their nation they were the heroes of the revolution.

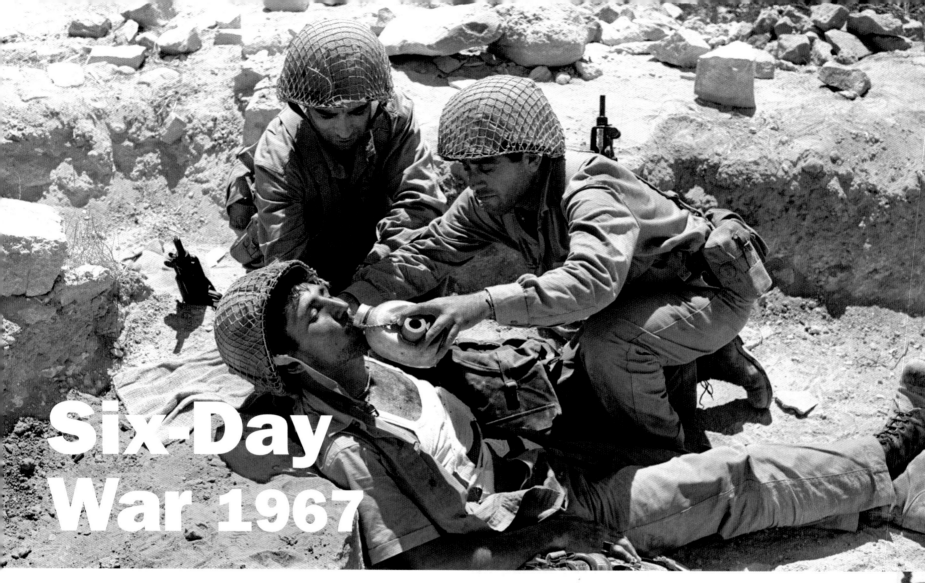

Six-Day War 1967

Pre-emptive strike

On June 5, 1967, Israel launched a pre-emptive strike on Egypt, sparking a six-day war against three of its Arab neighbours. The situation in the region had been deteriorating following the seizure of power by a militant anti-Israeli faction in Syria in February 1966. For more than a year, Israel and Syria had engaged in deadly skirmishes, and in November 1966, Egypt and Syria had joined together in a mutual defence agreement. In May 1967, President Nasser of Egypt demanded the withdrawal of the United Nations Emergency Force that had been stationed in the Sinai Peninsula following the Suez Crisis in 1956. He began moving his own troops in, closed the Straits of Tiran to Israeli shipping and brought Jordan into the defence pact. Israeli decision-makers became convinced that a war was imminent and launched a pre-emptive strike to destroy Egypt's air force.

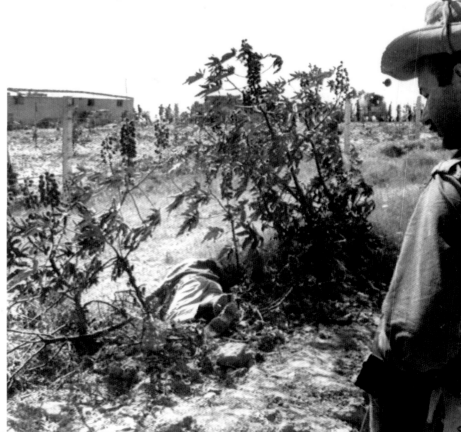

ABOVE: **An injured Israeli soldier is given water and medical attention during the Six-Day War.**

RIGHT: **Yitzakh Rabin was Chief of Staff of the Israel Defence Forces (IDF) at the time of the Six-Day War. He went on to become Israel's Prime Minister and was an instrumental player in the Peace Process. In November 1995, he was assassinated by a man who was opposed to negotiating with the Palestinians.**

FAR RIGHT: **An Israeli soldier looks down at the bodies of Palestinian guerrillas killed during the battle for Gaza. The Gaza Strip had been occupied by Egypt since the 1948 war.**

Israeli Victory

The war was a disaster for Egypt, Jordan and Syria, who failed to coordinate their response. The Israeli army did not have to face a three-front war and was able to confront each adversary individually. After defeating Egypt and occupying the Sinai and Gaza, the Israelis turned their attention towards Jordan, capturing the West Bank and East Jerusalem, which includes some of the holiest sites in Judaism, Christianity and Islam. Israel then pressed on to engage Syria, which had been slow to mobilize, and took control of the Golan Heights after barely one day of fighting.

A ceasefire was signed on June 10. Within just six days Israel had grown to three times its original size. The United Nations Security Council passed resolution 242, which demanded that Israel withdraw from its newly won territories and also indirectly called upon the Arab States to acknowledge Israel's right to exist. None of the parties complied immediately and the Six-Day War has continued to shape regional politics to this day.

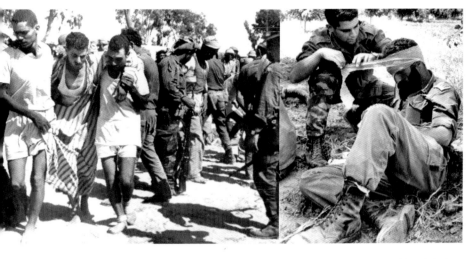

ABOVE LEFT: Captured Egyptians carry their wounded comrades to a POW camp. The Israeli defence minister, Moshe Dayan, praised Egyptian soldiers for fighting much better than they had done during the Suez Crisis.

ABOVE RIGHT: An Israeli soldier is bandaged after being wounded on the Syrian front.

BELOW: Israeli soldiers defend a captured anti-aircraft gun along the banks of the Suez Canal. Israeli forces overwhelmed the Egyptian military and reached the canal within seventy-two hours of the start of the war.

DAILY MAIL JUNE 6, 1967

Tank Battle Rages In Sinai Desert

A fierce tank battle raged last night near the Egypt-Israel border. Armoured units said to be larger than those that fought at Alamein were locked in savage fighting in the Kuntilla area of the Sinai Desert.

Israel said she had advanced 43 miles. But Egypt claimed to have launched a successful counter-attack after Israel had thrown in an entire infantry brigade and large numbers of tanks. 'Our forces repulsed the attack and moved into Israel, destroying all enemy positions.' Cairo radio said. 'Israeli helicopter-borne troops were completely wiped out,' it added.

Earlier Israeli planes attacked airfields in the Cairo and Suez Canal area, Northern Sinai, and in Jordan and Syria.

Early today Israel's Premier, Mr. Levi Eshkol, and Army Chief of Staff, Major-General Yitzhak Rabin, claimed complete victory in the air.

Shot Down

General Rabin said 374 Egyptian, Jordanian, Syrian and Iraqi planes were destroyed in the day's fighting and 34 probably destroyed, for the loss of only 19 Israeli aircraft. General Moshe Dayan, the new Defence Minister, called it a 'devastating blow.'

Cairo Radio replied that 86 Israeli planes had been shot down. Claims by Jordan, Syria and Lebanon raised the number of Israeli planes brought down to 161.

In land battles Israel claimed her forces had slashed deep into the Sinai peninsula and captured Egypt's main base at El Arish - a key target in the 1956 Suez war. A large number of prisoners and big quantities of war material, including weapons, guns and tanks, were captured, said General Rabin.

Jordanian guns set up a bombardment of Tel Aviv, its airport area at Lydda, and other targets. Some of the shells landed a few hundred yards from where correspondents in Tel Aviv were waiting for a Press conference. One shell hit an electric power pole and switched on all the street lights in the blacked-out city. Engineers quickly had them off again.

Syrian planes were said to have bombed the oil refinery at Haifa and set it ablaze. Israel said her jet bombers hammered targets on the outskirts of Damascus in three-hour-long raids.

Other bombers were reported to have hit Amman, capital of Jordan, and set planes ablaze.

Jerusalem: Fighting raged until after dark between Jordanian and Israeli forces. Jordan claimed to have destroyed 38 Israeli tanks and 23 planes.

Gaza Strip: Israel said she had captured Khan Younis, cut off the Gaza Strip and trapped thousands of Palestine Liberation Army troops. Cairo denied the claim and said the Israelis lost 30 tanks and had been forced to withdraw.

Forces

This is the line-up of the forces of Israel and her Arab enemies:

Israel: Forces 250,000, tanks 800, modern jets 240, missiles 60.

Egypt: Forces 195,000, tanks 1,000, strike aircraft 70-plus, fighters 300-plus, missiles 100.

Jordan: Forces 65,000, tanks 132, modern jets 12.

Syria: Forces 81,000, tanks 350, modern jets 100.

Iraq: Forces 82,000, tanks 320, modern jets 87.

Saudi Arabia: Forces 55,000, modern jets 18.

Soviet Invasion of Czechoslovakia 1968

Prague Spring

Before the Second World War, Czechoslovakia was a democracy but after the war the Soviets took control and installed a Communist government in Prague. For many years Czechoslovakia was stable under Soviet influence, but in the 1960s the economy began slowing significantly. The Czechoslovakian military also wanted to develop its own defence strategy, feeling that the Soviets had overstated the threat from the West. In early 1968, during a period known as the 'Prague Spring', Antonin Novotny was ousted as the head of the Communist Party of Czechoslovakia and was replaced by Alexander Dubcek. The new government ended censorship and announced a planned series of reforms designed to improve the economy and allow more freedom to the army, although these were intended to fit within the existing Communist framework

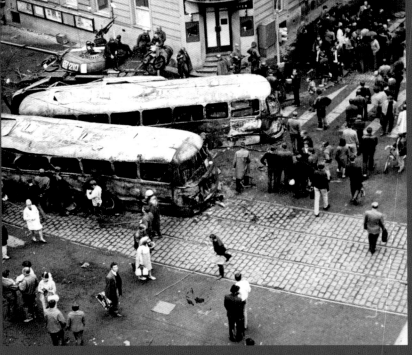

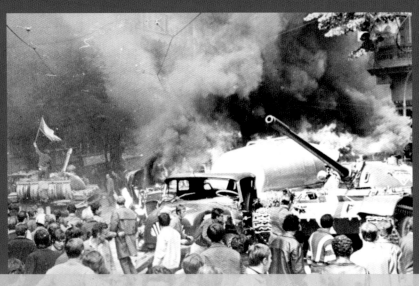

TOP: A wounded Czechoslovakian civilian is rushed to hospital during the first day of fighting in Prague.

ABOVE: Prague residents build a barricade to halt the advance of Soviet tanks using the shells of two burnt-out streetcars.

LEFT: The streets of Prague burn as Soviet tanks enter the city on August 21.

Invasion

The developments in Czechoslovakia alarmed Soviet leaders – who were concerned that other parts of Eastern Europe might follow suit, leading to widespread rebellion against Moscow's leadership. On August 20, 1968, Soviet and Warsaw Pact troops entered the country. The invasion was intended to establish a more conservative and pro-Soviet government in Prague and it caught both Czechoslovakia and much of the Western world completely off guard. The Soviet Union had moved troops into place by announcing Warsaw Pact military exercises, but instead they swiftly took control of Prague and other major cities in Czechoslovakia. The United States was involved in Vietnam and had a policy of non-involvement in the Eastern Bloc, so although Washington condemned the invasion it did not take action. Resistance in Czechoslovakia continued into 1969, but in April 1969 Dubcek was forced from power. The new conservative leadership reinstated censorship and limited freedom of movement, but it also managed to improve economic conditions helping return stability to the country,

The invasion temporarily delayed the break-up of the Eastern Bloc but also briefly halted the progress of arms control agreements between the Soviet Union and the United States. After the invasion, Soviet leadership justified the use of force with the Brezhnev Doctrine, which established their right to intervene if a Communist government was under threat. This doctrine later led to the Chinese-Soviet split, as China feared it would be used to justify interference with Chinese Communism. The invasion not only led to a loss of support for the Communist Party in many Western countries but also raised doubts in many countries of Eastern Europe, who were alarmed at how quickly an ally could become an invading force.

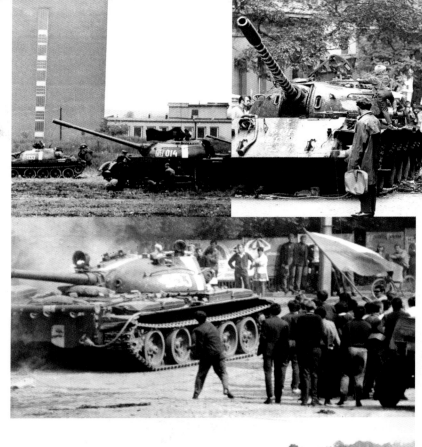

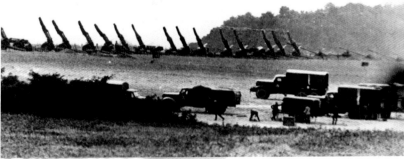

DAILY MAIL AUGUST 21, 1968

The Russians invade

Russian troops and those of four of their satellites invaded Czechoslovakia today. The shock news came from Prague Radio at 3 a.m. The station said troops of the Soviet Union, Poland, East Germany, Hungary and Bulgaria started to cross the frontiers at 11 o'clock last night.

But the radio said the Praesidium of the Czech Communist Party appealed to the people not to resist the advancing troops.

The announcement said the invasion 'goes against the basic rights of States and relations between Socialist countries.' But it asked all Government and party officials to stay in their jobs and urged the people to keep calm.

A normal radio transmission had started to broadcast on the earlier crisis meeting of the Czech Communist Party Praesidium. Then it went dead.

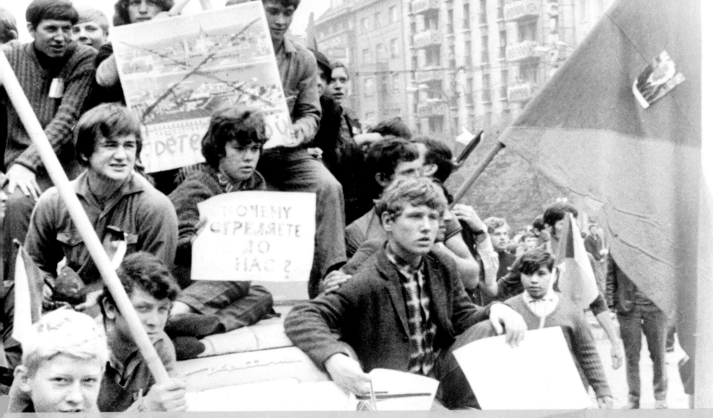

TOP LEFT: Soviet tanks and troops withdraw to the suburbs of Prague in September after successfully repressing the 'Prague Spring'.

TOP RIGHT: A Czechoslovakian boy climbs onto a Red Army tank as Soviet troops take a break.

MIDDLE: Supporters of Czechoslovakia's reformist government throw stones and paint at a Soviet tank to demonstrate their opposition to the invasion.

ABOVE: Soviet and Warsaw Pact troops, armed with heavy artillery, maintain their presence on the outskirts of Prague in late 1968 to dissuade any further dissent.

LEFT: Protesters in Wenceslas Square hold placards reading 'Go Home' and 'Why Are You Shooting At Us?'

Northern Ireland Troubles 1969-2007

The background

The source of the conflict in Northern Ireland is centuries old – from the 12th century there have been constant revolts challenging British rule. The climax of these ongoing problems was the 1916 Easter Rising in Dublin, which sparked a chain of events leading to the partition of Ireland in 1921. In the south, 26 counties formed a separate independent state, while six counties in the north stayed within the United Kingdom. Over the years, the large Catholic minority in Northern Ireland suffered discrimination over housing and jobs, fuelling bitter resentment among a people who perceived themselves as culturally Irish. The Catholic community came to believe that the northern six counties should leave the United Kingdom and join the Republic of Ireland. However, the majority Protestant population, which sees itself as culturally British, has remained fiercely loyal to the union with the United Kingdom.

Start of 'The Troubles'

Although a few killings happened earlier, the modern conflict in Ireland resulted from a civil rights protest in 1969. On New Year's Day a small Catholic Civil Rights group named the People's Democracy set off from Belfast on a four-day protest march to Derry/Londonderry. On the last day the group was attacked by a group of loyalists, sparking riots in Bogside, the predominantly Catholic area of Derry/Londonderry. Bogside was declared a 'no-go area' for the authorities and dubbed 'Free Derry'. As the Catholic community began a growing campaign for equal rights, unionists began to feel that Protestant dominance of Northern Ireland was under threat.

Derry/Londonderry is the venue for the annual Protestant Apprentice Boys parade, which commemorates 13 young apprentices who closed the gates of the walled city in 1688 to stop the advancing forces of the Catholic King James' army. The 1969 August parade in Derry quickly led to clashes with local Catholic youths, and police trying to separate the two factions were stoned and petrol-bombed. This led to police entering Bogside with armoured vehicles and water cannons, resulting in two days of rioting known as the 'Battle of the Bogside'. It also led to serious violence erupting in Belfast, where Catholic homes were set alight.

On August 14, British troops were deployed on the streets of Northern Ireland to restore law and order, but they soon came into conflict with the Provisional IRA and the fighting escalated.

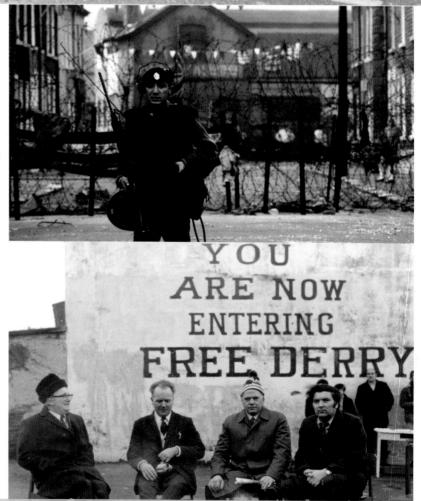

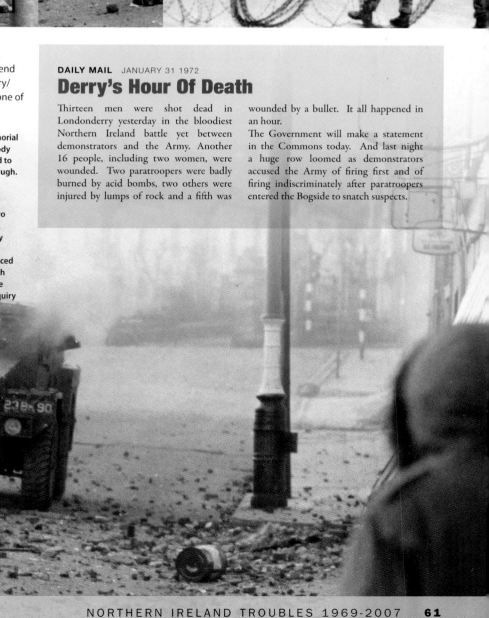

Bloody Sunday

On January 30, 1972, some 10,000 people gathered in Derry/Londonderry to take part in a banned Northern Ireland Civil Rights Association march against the British government's policy of internment without trial. Soon after it began, a British paratroop regiment shot dead 14 Catholic marchers. The soldiers later claimed that the IRA had fired on them as they moved forward to make arrests, but the Catholic community maintained that the crowd was peaceful and that the British Army murdered unarmed civilians. There was an immediate public outcry and the British government later made out-of-court settlements with the bereaved families. Bloody Sunday has come to be one of the most symbolic moments of The Troubles and – although even today it is not clear exactly what happened – to many sympathetic to the nationalist cause it represents the brutality of the British state against the Catholic community.

Bloody Friday

As the situation deteriorated, Northern Ireland's parliament was suspended and direct rule was imposed from London. However, a brief truce was declared in June 1972, when Republican leaders were secretly taken to London for talks with the British government. Unfortunately the talks failed and on July 21, a day that became known as Bloody Friday, the Provisional IRA detonated at least 22 bombs in Belfast city centre. The attack lasted for 65 minutes and included car bombs, mines and other devices; 11 people died and 130 were seriously injured. The horrific nature of the attack led some to believe that even if the Republican side had true cause for complaint, the Provisional IRA had passed far beyond justifiable action. At the end of July, British troops were ordered to dismantle IRA barricades in the no-go areas of Derry/Londonderry and Belfast. Over the remainder of 1972 violence escalated and it became one of the bloodiest years of The Troubles, with most of those killed innocent civilians.

OPPOSITE ABOVE: British troops are hit with petrol bombs on the streets of Belfast.

OPPOSITE MIDDLE: A British soldier of the Queen's Regiment mans a barricade in the Falls Road area of Belfast, October 1969.

OPPOSITE BELOW: Hunger strikers sit at 'Free Derry Corner' underneath a mural, painted in 1969, announcing the entrance to the Bogside area of the city.

TOP RIGHT: British paratroopers run through the streets of Derry/Londonderry on Bloody Sunday, January 30, 1972.

ABOVE RIGHT: Violent rioting takes place on the streets of Derry/Londonderry in the aftermath of Bloody Sunday. Fourteen people lost their lives when British troops opened fire on the demonstrators.

ABOVE LEFT: Residents come upon an army roadblock as they carry white crosses through the streets of Dungiven in memorial of the people killed on Bloody Sunday. The soldiers agreed to let the procession pass through.

BELOW: Another day of civil disturbance in Derry/Londonderry, more than two weeks after Bloody Sunday. British soldiers claimed they came under fire from the crowd before they commenced shooting. In 1998, the British government established the ongoing Bloody Sunday Inquiry to investigate.

DAILY MAIL JANUARY 31 1972

Derry's Hour Of Death

Thirteen men were shot dead in Londonderry yesterday in the bloodiest Northern Ireland battle yet between demonstrators and the Army. Another 16 people, including two women, were wounded. Two paratroopers were badly burned by acid bombs, two others were injured by lumps of rock and a fifth was wounded by a bullet. It all happened in an hour.

The Government will make a statement in the Commons today. And last night a huge row loomed as demonstrators accused the Army of firing first and of firing indiscriminately after paratroopers entered the Bogside to snatch suspects.

Mainland bombing campaign

In the early 1970s, the Provisional IRA began a bombing campaign against the British mainland. On October 5, 1974, they targeted two pubs in Guildford, known to have been popular with army personnel. The pub bombings claimed five lives and the police were immediately under pressure to locate the culprits. Three men and a woman, termed the 'Guildford Four' were apprehended and wrongfully charged for the crime. Their convictions were later overturned as their confessions had been obtained by torture. Just over a month later on November 21, a similar attack was made on two pubs in central Birmingham. 21 people were killed and six men, known as the 'Birmingham Six,' were found guilty and sentenced to life imprisonment. As with the Guildford Four, the Birmingham Six were later released when the evidence against them was discredited.

Margaret Thatcher targeted

On August 27, 1979, the Queen's cousin, Lord Mountbatten, was murdered when a bomb exploded aboard his boat, and hours later, eighteen British soldiers were killed in an ambush at Warrenpoint in Northern Ireland. These attacks were followed by a series of killings of Catholic civilians by Loyalist paramilitaries. The Provisional IRA continued their bomb campaign throughout the 1980s, striking two London parks on July 20, 1982, killing eleven people. In December 1983, Christmas shoppers were targeted by a bomb outside the Harrods store, six people were killed and scores were injured. The following year the IRA conducted their most significant attack on the mainland: a bomb exploded at a hotel hosting members of the British Cabinet during the Conservative Party conference in Brighton. The Prime Minister, Margaret Thatcher, narrowly escaped assassination, but five others, including a Member of Parliament were killed in the attack.

Warrington bombings

The 1990s saw a continuation of the bomb campaign and two boys were killed in an attack in Warrington. On April 10, 1992 the Provisional IRA launched a bomb attack on the Baltic Exchange in London that killed three and caused hundreds of millions of pounds worth of damage. As the peace process took hold, the bombings began to peter out, but in 1996, the IRA broke a ceasefire to launch a devastating attack on the London Docklands in February and the Arndale Shopping Centre in Manchester in June. As was their style, the IRA called in both bomb threats ahead of time allowing authorities to evacuate both areas, saving many lives.

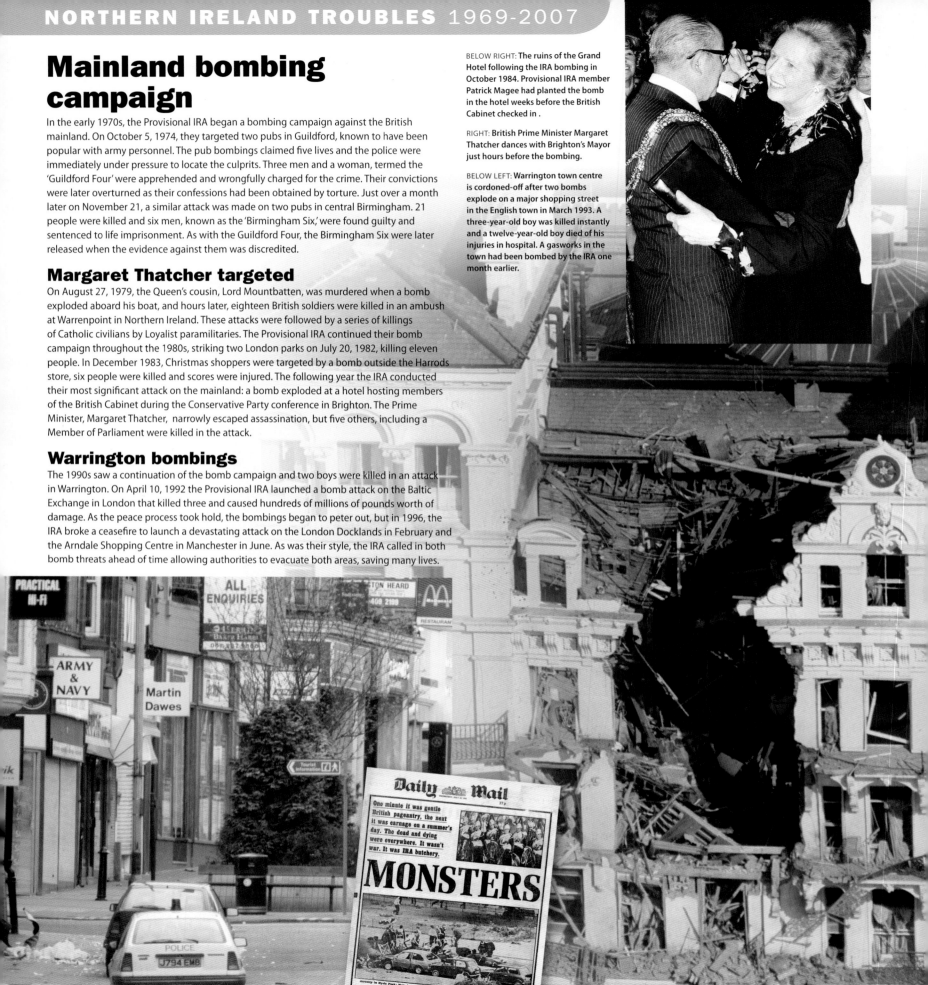

BELOW RIGHT: The ruins of the Grand Hotel following the IRA bombing in October 1984. Provisional IRA member Patrick Magee had planted the bomb in the hotel weeks before the British Cabinet checked in .

RIGHT: British Prime Minister Margaret Thatcher dances with Brighton's Mayor just hours before the bombing.

BELOW LEFT: Warrington town centre is cordoned-off after two bombs explode on a major shopping street in the English town in March 1993. A three-year-old boy was killed instantly and a twelve-year-old boy died of his injuries in hospital. A gasworks in the town had been bombed by the IRA one month earlier.

Enniskillen bomb

On November 8, 1987, at a Remembrance Day parade to honour British soldiers killed in action, an IRA bomb ripped through the town of Enniskillen. The blast killed 10 people and wounded many innocent civilians who had come to watch the parade. Amateur video footage of the immediate aftermath was shown on television and it horrified people everywhere. The bombing was widely condemned and the IRA lost much of their support, both locally and across the world. At first Loyalist paramilitaries were intent on retaliation, but family members of the victims called for forgiveness, engendering a feeling of reconciliation and not long afterwards the first signs of a real change appeared.

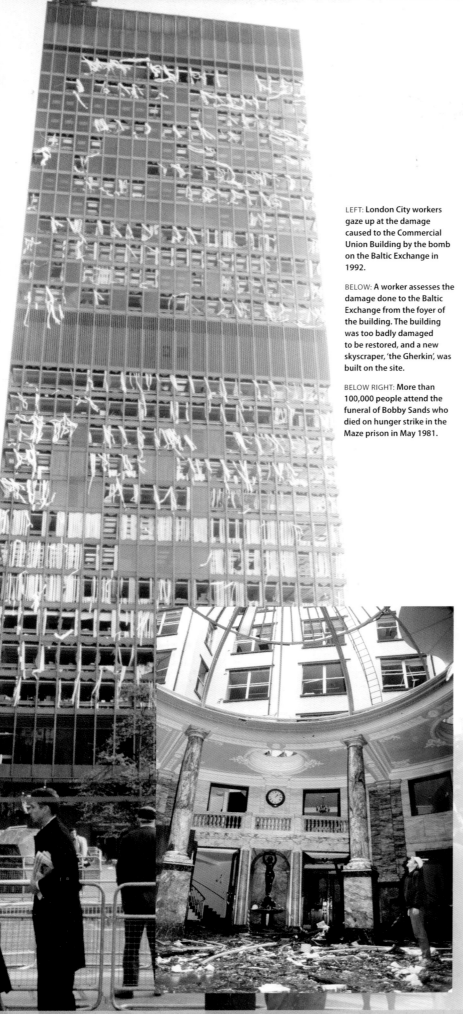

LEFT: London City workers gaze up at the damage caused to the Commercial Union Building by the bomb on the Baltic Exchange in 1992.

BELOW: A worker assesses the damage done to the Baltic Exchange from the foyer of the building. The building was too badly damaged to be restored, and a new skyscraper, 'the Gherkin', was built on the site.

BELOW RIGHT: More than 100,000 people attend the funeral of Bobby Sands who died on hunger strike in the Maze prison in May 1981.

DAILY MAIL OCTOBER 27 1981
IRA target the children

IRA bombers brought death and chaos to the shopping heart of London yesterday -terror apparently aimed at children most of all.

As a bomb disposal man died when the device he was trying to defuse exploded, it was half-term in most London schools. The West End was crowded with children - young ones with their mothers, older ones with friends - up in town for early Christmas shopping.

The bomb that went off was planted in the basement seating area of a Wimpy bar in Oxford Street - just the place for mothers to take the kids for a break, just the place for teenagers to go and have a coffee. The suspicion that the terrorists had this specifically in mind was sickeningly

confirmed by these words in a statement claiming responsibility for the bombing issued by the Provisional IRA in Dublin: 'Let the British people take note that Irish children, the victims of plastic bullets fired by their soldiers, do not have the luxury of receiving warnings.'

There were about 20 children among the 120 or so people evacuated from the Wimpy bar after a telephoned warning from the terrorists. The warning also said there were bombs in two Oxford Street stores, Debenham's and Bourne's. One was found in Debenham's and quickly made safe. But six hours later, the police were still searching for the bomb supposed to be on the fifth floor of Bourne's.

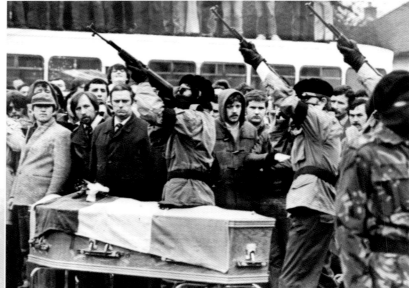

Hunger strikes

In 1981 a number of IRA inmates at the Maze prison in Belfast went on hunger strike to demand to be treated as political prisoners rather than common criminals. The strikes turned into a test of will between the prisoners and the British Prime Minister Margaret Thatcher. Thatcher refused to relent even after one of the strikers, Bobby Sands, won a by-election and became a Member of the UK Parliament. The hunger strikers attracted media attention around the world and even the Vatican attempted to mediate. However, a solution was not reached and ten people, including Bobby Sands, died of starvation.

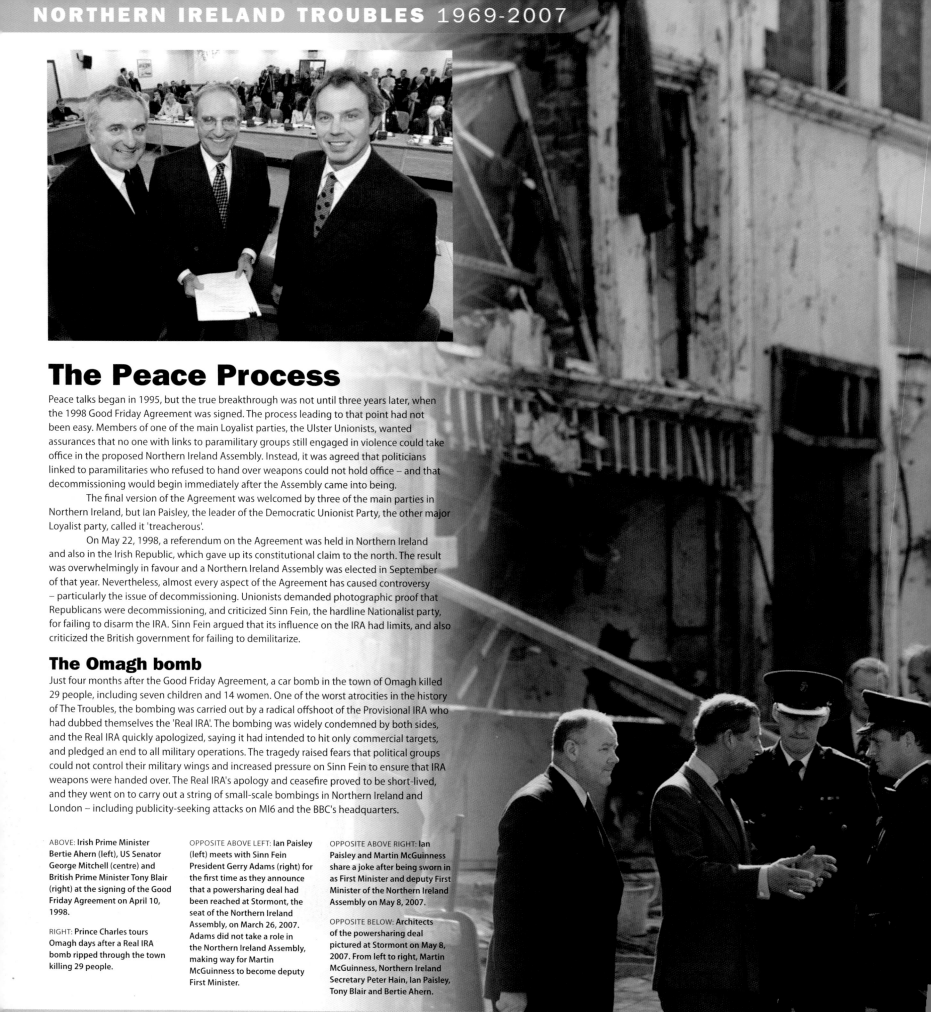

The Peace Process

Peace talks began in 1995, but the true breakthrough was not until three years later, when the 1998 Good Friday Agreement was signed. The process leading to that point had not been easy. Members of one of the main Loyalist parties, the Ulster Unionists, wanted assurances that no one with links to paramilitary groups still engaged in violence could take office in the proposed Northern Ireland Assembly. Instead, it was agreed that politicians linked to paramilitaries who refused to hand over weapons could not hold office – and that decommissioning would begin immediately after the Assembly came into being.

The final version of the Agreement was welcomed by three of the main parties in Northern Ireland, but Ian Paisley, the leader of the Democratic Unionist Party, the other major Loyalist party, called it 'treacherous'.

On May 22, 1998, a referendum on the Agreement was held in Northern Ireland and also in the Irish Republic, which gave up its constitutional claim to the north. The result was overwhelmingly in favour and a Northern Ireland Assembly was elected in September of that year. Nevertheless, almost every aspect of the Agreement has caused controversy – particularly the issue of decommissioning. Unionists demanded photographic proof that Republicans were decommissioning, and criticized Sinn Fein, the hardline Nationalist party, for failing to disarm the IRA. Sinn Fein argued that its influence on the IRA had limits, and also criticized the British government for failing to demilitarize.

The Omagh bomb

Just four months after the Good Friday Agreement, a car bomb in the town of Omagh killed 29 people, including seven children and 14 women. One of the worst atrocities in the history of The Troubles, the bombing was carried out by a radical offshoot of the Provisional IRA who had dubbed themselves the 'Real IRA'. The bombing was widely condemned by both sides, and the Real IRA quickly apologized, saying it had intended to hit only commercial targets, and pledged an end to all military operations. The tragedy raised fears that political groups could not control their military wings and increased pressure on Sinn Fein to ensure that IRA weapons were handed over. The Real IRA's apology and ceasefire proved to be short-lived, and they went on to carry out a string of small-scale bombings in Northern Ireland and London – including publicity-seeking attacks on MI6 and the BBC's headquarters.

ABOVE: **Irish Prime Minister Bertie Ahern (left), US Senator George Mitchell (centre) and British Prime Minister Tony Blair (right)** at the signing of the Good Friday Agreement on April 10, 1998.

RIGHT: **Prince Charles tours Omagh** days after a Real IRA bomb ripped through the town killing 29 people.

OPPOSITE ABOVE LEFT: **Ian Paisley (left) meets with Sinn Fein President Gerry Adams (right)** for the first time as they announce that a powersharing deal had been reached at Stormont, the seat of the Northern Ireland Assembly, on March 26, 2007. Adams did not take a role in the Northern Ireland Assembly, making way for Martin McGuinness to become deputy First Minister.

OPPOSITE ABOVE RIGHT: **Ian Paisley and Martin McGuinness** share a joke after being sworn in as First Minister and deputy First Minister of the Northern Ireland Assembly on May 8, 2007.

OPPOSITE BELOW: **Architects of the powersharing deal** pictured at Stormont on May 8, 2007. From left to right, Martin McGuinness, Northern Ireland Secretary Peter Hain, Ian Paisley, Tony Blair and Bertie Ahern.

The Mitchell Review

By the autumn of 1999, the peace process appeared to have stalled. The IRA showed no signs of giving up a single bullet, and Ulster Unionists were refusing to allow Sinn Fein to take their seats in the Assembly until decommissioning had taken place. To resolve the stalemate, US senator George Mitchell, who had chaired the talks leading to the Good Friday Agreement, returned to Northern Ireland to review the situation.

After weeks of patient diplomacy in strict secrecy, Senator Mitchell managed to get all parties to give ground in some areas in return for progress in others. Ulster Unionists accepted that Sinn Fein could sit on the executive before the IRA handed over any weapons and also recognized the Republicans' right to campaign peacefully for a united Ireland. Sinn Fein conceded that decommissioning was essential and made a commitment to peaceful progress. In May 2000, the IRA agreed to start taking its weapons 'completely and verifiably beyond use', providing that the Good Friday Agreement was implemented in full. Since then, several IRA arms dumps have been opened to international inspectors who have confirmed that the weaponry was beyond use.

Power-sharing

In 1998, elections to the Northern Ireland Assembly had been won by moderate parties on both sides and a power-sharing agreement was reached. However, the winners of the 2003 election, the Democratic Unionists and Sinn Fein, were more hard-line, and could not agree to work together. A series of negotiations took place, culminating in the St. Andrews Agreement in October 2006. Fresh elections were held in March 2007, which again saw the Democratic Unionists and Sinn Fein emerge on top. On March 27, 2007, it was announced that the two parties had agreed to a power-sharing deal, and, as the staunchest of foes began governing Ireland together, The Troubles finally seem at an end.

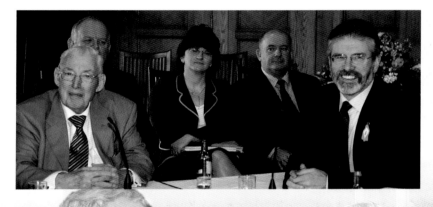

DAILY MAIL MAY 9, 2008

Time for peace in Northern Ireland

It is the scene many thought they would never see.

Reverend Ian Paisley and Sinn Fein's Martin McGuinness, bitter enemies for more than 30 years, sit together as the leaders of Northern Ireland's powersharing government.

Dr Paisley, famous for his mantra 'No Surrender' to the Republicans, appeared relaxed as he joked with former IRA commander Mr McGuinness, Mr Blair and Irish Premier Bertie Ahern over a pot of tea in his new office.

Later, the four men were met with rapturous applause as they descended Stormont's main stone staircase together, to the rather unlikely strains of Westlife's number one hit 'You Raise Me Up'.

Invoking the Bible, Dr Paisley declared there was "a time for love and a time for hate; a time for war and a time for peace." He added: "From the depth of my heart, I can say Northern Ireland has come to a time of peace. How good it will be to be part of a wonderful healing in this province".

Mr McGuinness paid tribute to Dr Paisley and said he was confident that both parties could put aside their longstanding differences to work together for the sake of the people of Northern Ireland. The Deputy First Minister said: "We know the road we are embarking on will have many twists and turns. It is, however, a road which we have chosen and which is supported by the vast majority of our supporters." He added that local politicians were embarking on "the greatest, yet most exciting challenge of our lives."

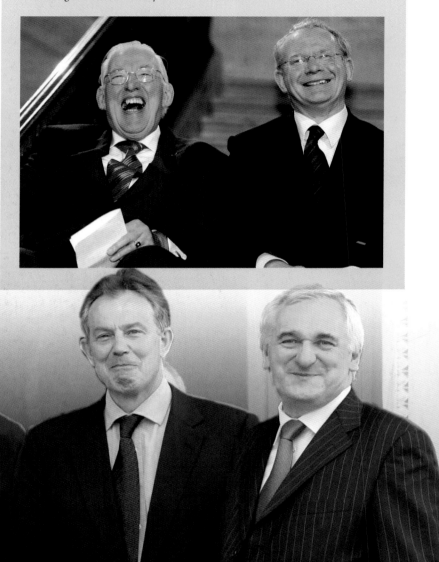

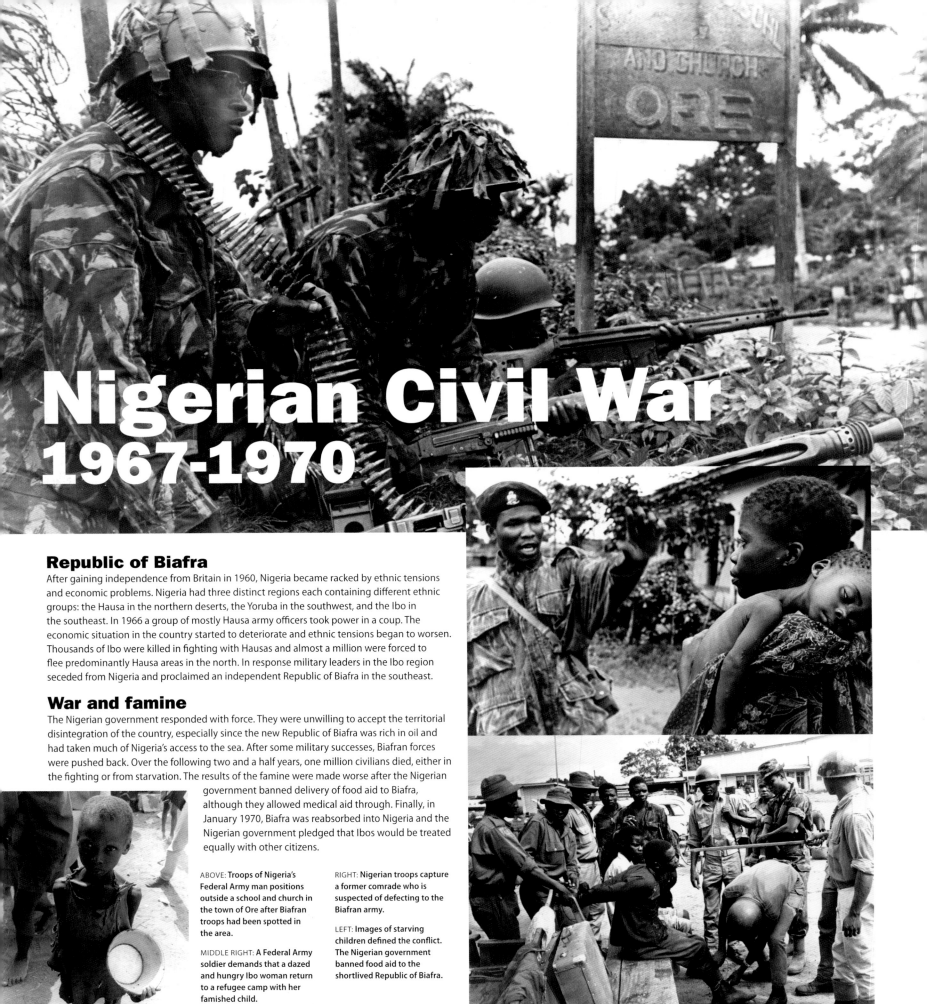

Nigerian Civil War 1967-1970

Republic of Biafra

After gaining independence from Britain in 1960, Nigeria became racked by ethnic tensions and economic problems. Nigeria had three distinct regions each containing different ethnic groups: the Hausa in the northern deserts, the Yoruba in the southwest, and the Ibo in the southeast. In 1966 a group of mostly Hausa army officers took power in a coup. The economic situation in the country started to deteriorate and ethnic tensions began to worsen. Thousands of Ibo were killed in fighting with Hausas and almost a million were forced to flee predominantly Hausa areas in the north. In response military leaders in the Ibo region seceded from Nigeria and proclaimed an independent Republic of Biafra in the southeast.

War and famine

The Nigerian government responded with force. They were unwilling to accept the territorial disintegration of the country, especially since the new Republic of Biafra was rich in oil and had taken much of Nigeria's access to the sea. After some military successes, Biafran forces were pushed back. Over the following two and a half years, one million civilians died, either in the fighting or from starvation. The results of the famine were made worse after the Nigerian government banned delivery of food aid to Biafra, although they allowed medical aid through. Finally, in January 1970, Biafra was reabsorbed into Nigeria and the Nigerian government pledged that Ibos would be treated equally with other citizens.

ABOVE: Troops of Nigeria's Federal Army man positions outside a school and church in the town of Ore after Biafran troops had been spotted in the area.

MIDDLE RIGHT: A Federal Army soldier demands that a dazed and hungry Ibo woman return to a refugee camp with her famished child.

RIGHT: Nigerian troops capture a former comrade who is suspected of defecting to the Biafran army.

LEFT: Images of starving children defined the conflict. The Nigerian government banned food aid to the shortlived Republic of Biafra.

Bangladesh War of Liberation 1971

East Pakistan

The Indian Subcontinent had been divided up arbitrarily as the British left in 1947, creating the two independent countries of India and Pakistan. Pakistan had two distinct parts that were not even connected geographically: West Pakistan and East Pakistan. East Pakistan was more populous and mainly comprised Bengali-speakers, but political power rested in the Punjabi-dominated West Pakistan. A charismatic leader from the East, Sheikh Mujibur Rehman, formed a party demanding more autonomy for East Pakistan and in the 1970 general elections they won a complete majority in the East. The West Pakistan ruling elite reacted by throwing the Sheikh into prison, causing widespread revolt on the streets of East Pakistan. Independence was declared and the country was renamed Bangladesh.

Indian Intervention

As the Pakistani Army attempted to quash the rebellion, hundreds of thousands of Bengalis died in a series of horrific massacres and more than 8 million refugees fled over the border into India. Left with the burden of supporting a massive influx of people, the Indian Prime Minister, Indira Gandhi, decided to help the Mukti Bahini (Bangladesh Liberation Army) liberate East Pakistan so that the refugees could return to their homelands. On December 3, 1971, the Pakistani Air Force (PAF) launched a pre-emptive strike on several Indian airfields. India responded by officially declaring war and attacking along the borders on both East and West. On the West front the aim was to avoid losing territory to Pakistan, while in the East the objective was to take as much of East Pakistan as possible, and install a Bangladeshi interim government. India was geographically closer to East Pakistan and defeated the Pakistani army within just two weeks. Hostilities ended when West Pakistan, now known simply as Pakistan, surrendered on December 16, 1971.

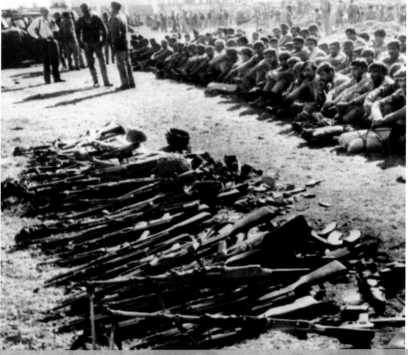

ABOVE: **Indian troops advance unopposed into Bangladesh following the unconditional surrender of Pakistan's army.**

MIDDLE LEFT: **Men suspected of collaborating with Pakistani forces are attacked by pro-independence militias in Dacca.**

MIDDLE RIGHT: **An injured member of the Mukti Bahini (Bangladesh Liberation Army) is** helped to hospital following a battle with the Pakistani Army.

RIGHT: **Pakistani troops surrender themselves and their ammunition to Indian forces in Bangladesh.**

Yom Kippur War 1973

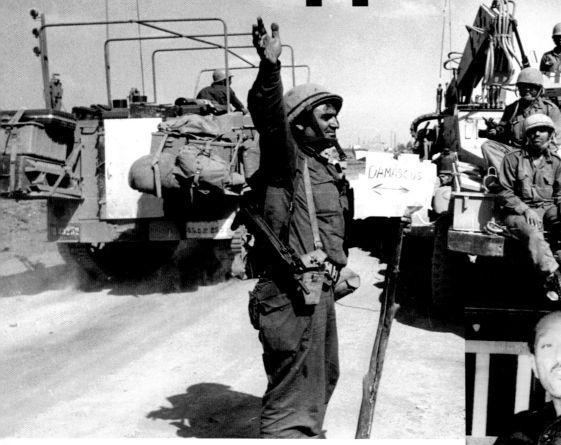

Legacy of the Six-Day War

Following the Six-Day War of 1967, the Arab world was thrown into disarray. The humiliating defeat and a dire economic situation had led to disillusionment with pan-Arab ideology. Instead each Arab state reverted to nationalism, and each adopted their own approach to their relations with Israel. Egypt, under Anwar Sadat, sought an approach based upon negotiation, while Syria, under Hafez al-Asad, wanted a military solution.

Egyptian-Syrian alliance

Egypt and Syria did still share the goal of regaining the territory they had lost to Israel in the Six-Day War. Although Sadat wanted to regain the Sinai through diplomatic channels, he believed Egypt might need to prosecute a limited war to bolster its negotiating position. In addtion, he thought that a brief war would diminish the defeatist attitude of his population and increase Egypt's regional standing.

Knowing that al-Asad wanted a retaliatory war against Israel, and knowing Egypt could not fight alone, Sadat entered into an alliance with Syria. A series of secret meetings took place between the two countries in late 1972, culminating in the establishment of a joint military command in January 1973. On October 6, 1973, a surprise attack was launched.

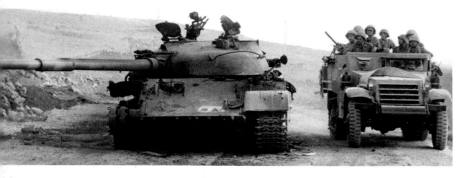

TOP: **Israeli troops set Damascus in their sights during the Yom Kippur War.**

MIDDLE RIGHT: **A bandaged Major General Ariel Sharon and Major General Haim Bar-Lev confer over a map in the Israeli desert.**

MIDDLE LEFT: **Egyptian President Anwar Sadat. Sadat believed a war with Israel could reverse his country's fortunes and strengthen his position at the negotiating table.**

ABOVE: **An Arab family from Jabta al Chatab wave a white flag to the Israelis. Much of the town evacuated along with the Syrian army in the wake of the Israeli advance.**

LEFT: **Israeli troops pass a disabled Syrian tank as they move up in the Golan Heights.**

DAILY MAIL OCTOBER 11, 1973

Big two send arms

The Middle East conflict took on a new dimension of danger last night as both Russia and America began airlifting fresh weapons to each side.

But Britain opted out. Foreign Secretary Sir Alec Douglas-Home told the Israeli Ambassador to Britain, Mr Michael Comay, that the Government had imposed an arms embargo on the Middle East. That, in effect, means Israel will no longer get vital spare parts for her British-built Centurion tanks.

This decision, bitterly attacked by Israelis, came at the close of a day of torment for Israeli commanders, who now know that they face a long, bone-crushing war before they re-establish ascendancy. They have recaptured the Golan Heights, but at great cost in men and material.

And Israeli military commanders admit that the major battle still to come against the Egyptians in the Sinai Desert will not be easy or quick.

Great power intervention

In the first few days of the war, Israel appeared to be close to defeat. The Israeli army was under strength because many soldiers had been allowed leave to celebrate Yom Kippur and Egypt and Syria were experiencing the benefits of Soviet military aid.

Israel's defences held and the tide was turned two weeks later when American military supplies began arriving. Syria and Egypt were forced onto the defensive and the Israelis reached the outskirts of Damascus and completely routed the Egyptian Third Army. However, Israel ceased firing and adhered to a UN-sponsored ceasefire when the Soviet Union hinted it would send troops to help their allies if the war continued.

Peace treaty.

The 1973 war was pivotal in Arab-Israeli relations as it led to a groundbreaking peace treaty between Egypt and Israel in 1979. The treaty negotiated land for peace; Egypt was able to gain back the Sinai, the Suez Canal was opened to Israeli shipping, and each country bestowed diplomatic recognition on the other. As a result, Egypt was expelled from the Arab League and Sadat was assassinated by militant Islamists in 1981. Syria lost the most in the war; it was unable to meet its aim of regaining the Golan Heights, which Israel still controls to this day.

ABOVE LEFT: **An Egyptian prisoner of war is treated for his wounds by Israeli doctors.**

TOP RIGHT: **Israeli soldiers prepare to move into the Sinai peninsula.**

ABOVE RIGHT: **The Israeli army captures a Soviet-built Egyptian surface-to-air missile during their advance through Sinai.**

FAR RIGHT: **Following the ceasefire, Egyptian soldiers keep watch over Israeli positions from every available balcony of an apartment building on the desert road from Cairo to Suez.**

RIGHT: **Less than 30 metres away Israeli forces wait around for orders. United Nations mediators go back and forth between the two camps trying to arrange the passage of humanitarian supplies to the Egyptian Third Army, which had been routed in the Israeli advance.**

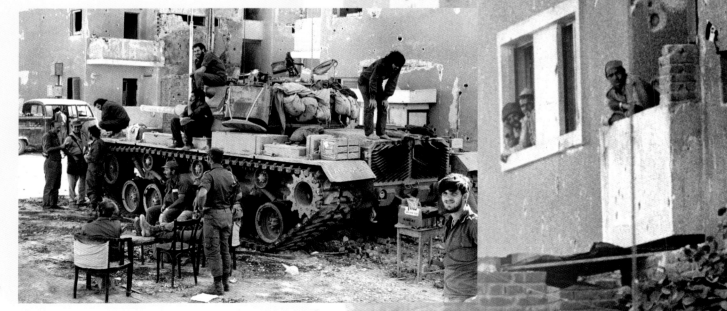

Turkish Invasion of Cyprus 1974

Colonial Cyprus

In 1570 Cyprus was conquered by the Ottoman Empire and Turks soon began arriving to settle among the Greek inhabitants of the island. The imperialists showed a relatively high degree of toleration for the Greeks and did not significantly suppress their language or religion. As a result, over the three centuries of Ottoman rule, two distinct communities developed; one Turkish and Muslim, the other Greek and Christian.

When the Ottoman Empire collapsed at the end of the First World War, the island came under the control of the British, who had been leasing it since 1878. In 1955, Greek Cypriots formed the National Organization of Cypriot Fighters (EOKA) with the goal of kicking the British out and unifying the island with Greece. The EOKA waged war against British interests on the island and also attacked Turkish Cypriots and any Greek Cypriots who were unsupportive of unification. In response, Turkish Cypriots established the Turkish Resistance Organisation (TMT) to repel EOKA attacks and to advocate a partition of the island between the two communities.

When the British granted Cyprus its independence in 1960, a political framework was established within which it was hoped that the Greek and Turkish populations could work together. However, the new government quickly became deadlocked by ethnic squabbles and Cyprus entered a decade of unrest. During this time EOKA was reorganized and placed under control of a new military junta in Athens. Members of the Greek Cypriot community had been slowly abandoning the idea of unification with Greece and the junta wanted to reverse the tide.

Turkey invades

In July 1974, the military dictatorship in Athens fermented a coup against the Cypriot government with the aim of replacing it with a regime loyal to the goal of unification. On July 15 President Makarios was overthrown and Nicos Sampson, a member of the reorganized EOKA, came to power.

Within five days of the coup, Turkey had responded by landing an invasion force on the island under an operation codenamed 'Atilla'. A bitter war broke out on the island as the Greek Cypriot forces tried in vain to halt the Turkish advance on the capital, Nicosia. In Athens, the military junta collapsed as a result of the crisis and a new civilian government came to power. Without the support of the military junta, Nicos Sampson's government fell and Makarios' government was restored.

Partition

On August 10 a conference began in Geneva to try and resolve the situation. Turkey demanded partition of Cyprus in a manner that would hand Turkish Cypriots a disproportionately large section of territory. The government of Cyprus refused partition and Turkey went on the offensive again to take what they could not get at the negotiating table. Turkish forces seized one third of the country within just two days and then called a ceasefire. This completed the division of Cyprus. A United Nations administered Green Line ran across the country from Morphou Bay in the northwest through the capital to Famagusta in the east. Both sides quickly set about ethnically cleansing their respective territories, forcing hundreds of thousands of people from their homes and across the new border.

OPPOSITE ABOVE: A Turkish army tank passes through the streets of Nicosia on July 24, 1974. The portrait of Kemal Ataturk, the founder of the modern Turkish republic, adorns one of the nearby buildings.

OPPOSITE BELOW LEFT: Greek Cypriot soldiers kneel with their hands behind their heads after being taken prisoner by Turkish troops.

OPPOSITE MIDDLE RIGHT: Turkish soldiers on the advance on the first day of the invasion, July 20, 1974.

OPPOSITE BELOW RIGHT: Turkish troops pull ashore a Greek Cypriot torpedo boat damaged during the fighting in Kyrenia.

LEFT: President Archbishop Makarios III was overthrown in a Greek-sponsored coup on July 15, 1974 and managed to escape to Malta. Makarios was reinstated after the new government collapsed. He died of a heart attack in August 1977.

BELOW: Greek Cypriot demonstrators march through the streets of London to protest the Turkish invasion. They set out from the Cyprus High Commission destined for the Turkish Embassy.

LEFT: The protest becomes especially heated as it passes by the American Embassy. Washington was unable to intervene decisively because it was allied to both Greece and Turkey through NATO.

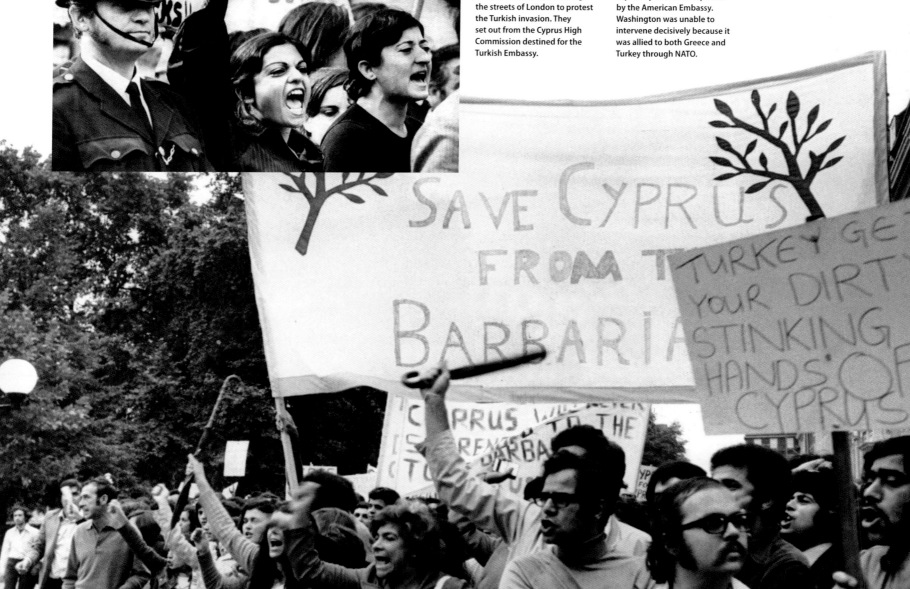

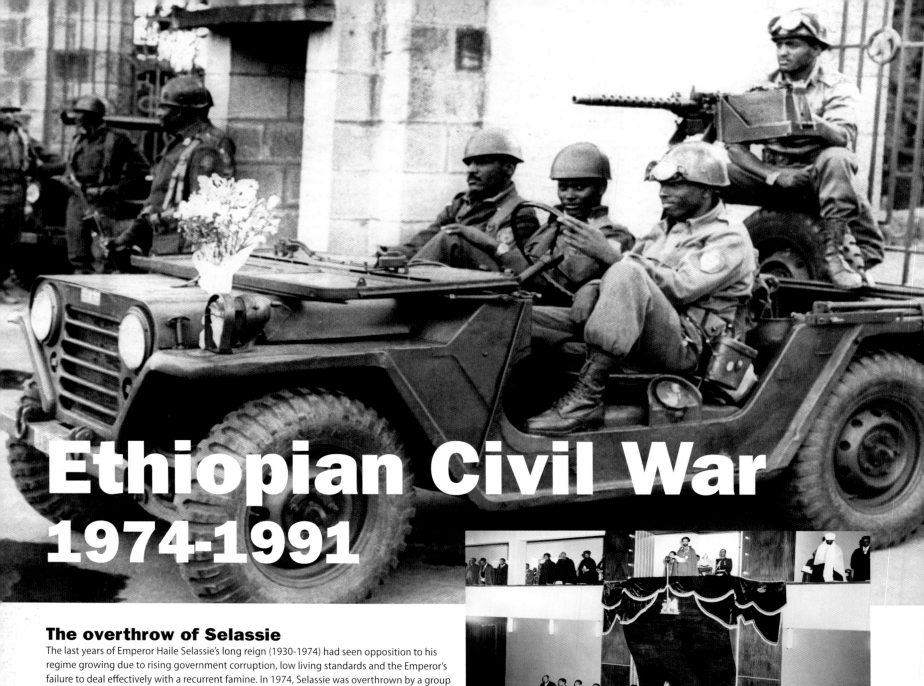

Ethiopian Civil War
1974-1991

The overthrow of Selassie

The last years of Emperor Haile Selassie's long reign (1930-1974) had seen opposition to his regime growing due to rising government corruption, low living standards and the Emperor's failure to deal effectively with a recurrent famine. In 1974, Selassie was overthrown by a group of Marxist army officers and died in detention the following year. Initially the officers ruled together in a council called 'the Derg', but by 1977 it was clear that real power lay with one man, Mengistu Haile Mariam.

After consolidating power in a brutal 'red terror', Mengistu turned his attention towards ending the regional separatist conflicts in Eritrea and Tigray. Eritrea had been an Italian colony until the end of the Second World War, at which time it had been placed under Ethiopian control. Many Eritreans resented Ethiopian rule and an insurgency had been raging since 1961. Selassie had been unable to end the conflict, but Mengistu thought he could stamp it out once and for all.

Civil war

The Ethiopian government received financial and military aid from the Soviet Union and Cuba, which allowed Mengistu to score early victories, and Asmara, the Eritrean capital, was captured in February 1975. The government managed to retake territory around major towns and cities and along some principal roads in 1978 and 1979, but a decisive victory eluded Mengistu and the conflict proceeded to ebb and flow almost yearly. The main Eritrean rebel party, the Eritrean People's Liberation Front (EPLF), had a broad base of popular support and was a highly structured political and military organization, despite the fact that ideological disagreements had prevented it from forming a united front with other separatist movements. In addition, Eritrean and Tigrayan rebels soon began to cooperate, with the EPLF providing training and equipment that helped build the Tigrayan People's Liberation Front (TPLF) into a better fighting force.

End of the conflict

By the late 1980s, the tide had begun to turn; a devastating famine had distracted Mengistu's government and Soviet aid was beginning to dry up as the Cold War drew to a close. Rebels in Eritrea and Tigray managed to gain control of the majority of both regions by scoring decisive victories over the Ethiopian army in 1988. By May 1991, the EPLF controlled most of Eritrea and had declared independence for the province, setting up a Provisional Government under its leader, Isaias Afwerki. The Tigrayan People's Liberation Front joined forces with a number of other resistance movements to form the Ethiopian People's Revolutionary Democratic Front the EPRDF. In May 1991, they marched on the Ethiopian capital, Addis Ababa, and forced Mengistu to flee into exile, ending the civil war.

Ethiopian-Eritrean war

While Eritreans voted overwhelmingly in favour of independence from Ethiopia in a 1993 referendum, the EPRDF came to dominate the new democratic government of Ethiopia. Initially relations between the two countries were good, but they rapidly deteriorated over the two countries' poorly defined border. In June 1998 an incident in the disputed border town of Badme escalated into a war that was to claim tens of thousands of lives. The war ended in stalemate two years later, with the United Nations intervening to keep the peace. However, unless both sides can peacefully agree to officially demarcate the border, a recourse to war is likely.

OPPOSITE ABOVE: **Ethiopian troops occupy the National Palace days after the overthrow of Emperor Haile Selassie in September 1974.**

OPPOSITE MIDDLE: **Emperor Selassie addresses the Ethiopian parliament. Selassie is perhaps best known outside Ethiopia for being worshipped by Rastafarians. Rastafarianism holds that Selassie is a prophet in a similar manner to Jesus.**

OPPOSITE BELOW: **Mengistu, the dictator of Ethiopia from 1977 to 1991, cheers during a peasants' militia parade in Addis Ababa in June 1977.**

LEFT: **Mengistu and Cuban President Fidel Castro ride in an open car through the streets of Addis Ababa. Castro was one of the Ethiopian regime's most important allies, and sent thousands of men to help Ethiopia defeat Somalia in a war over the ownership of the Ogaden province in 1977. Although the majority of Ogaden's population was Somali, the territory was governed by Ethiopia.**

BELOW LEFT: **Musician Bob Geldof visits Ethiopia's famine victims after staging 'Live Aid' concerts across the world on July 13, 1985 in order to raise money and draw attention to the Ethiopian famine.**

BELOW RIGHT: **Ethiopians bury famine victims. The famine distracted Mengistu's attention from the war with separatist groups.**

BOTTOM LEFT: **A young victim of the Ethiopian famine cries from hunger.**

BOTTOM RIGHT: **Famine victims are buried in a makeshift cemetery in Bati. The burial ground was surrounded by stones to prevent people and animals from walking over the gravesite.**

Famine

Many countries in Africa had been affected by famine in the early 1970s, and Ethiopia had never recovered. By the middle of 1984 another drought led to a further major famine in large parts of northern Ethiopia. Crops failed almost entirely in the north, and fighting hindered the delivery of emergency supplies by international aid organizations. The following year there was yet another drought, and by 1986 the famine had spread to the south of the country, made even worse by plagues of locusts and grasshoppers. The government had a policy of withholding aid shipments to rebel areas, which brought international condemnation even from the regime's supporters. By the end of this period the combined effect of famine and war had brought the economy of Ethiopia to a state of collapse.

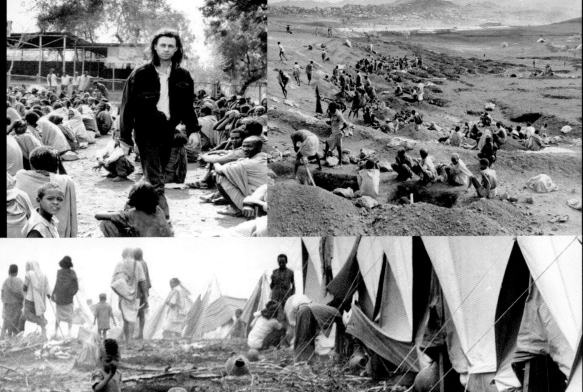

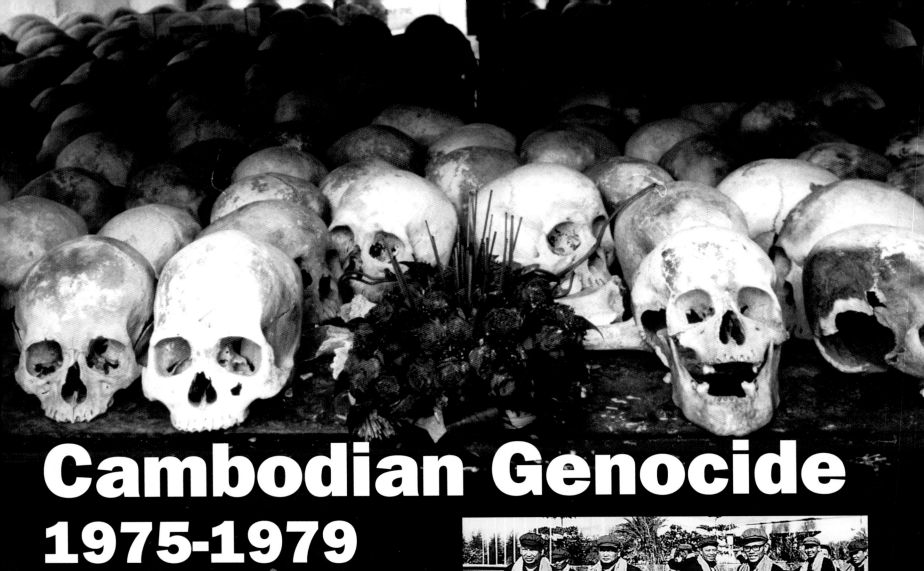

Cambodian Genocide
1975-1979

Civil War

In March 1970, the ruler of Cambodia, Prince Norodom Sihanouk, was ousted by a group of right-wing generals led by Lon Nol. The monarchy was abolished and the country was renamed the 'Khmer Republic'. Khmer had been the name of a great empire centred round Cambodia during the Middle Ages. Prince Sihanouk formed a government in exile in China and enhanced his ties with Cambodia's Communist Party, which was later to become known as the Khmer Rouge. With royal support, the Communist Party grew in size and strength and began to present a formidable opposition to Lon Nol's government.

Civil war broke out as both sides became locked into a five-year struggle for control of the country. The Khmer Rouge scored remarkable victories in the countryside, and by 1974 Lon Nol's authority had been reduced the main urban centres. In early 1975, the Khmer Rouge launched a sustained push to take the capital, Phnom Penh. It fell in April and Lon Nol's government surrendered, officially ending the war.

ABOVE: **The skulls of the Khmer Rouge's victims stand as a reminder of the murdrousness of the regime that ruled Cambodia from 1975 to 1979.**

LEFT: **Pol Pot emerged as leader of the Khmer Rouge in the early 1970s. He escaped from the Vietnamese invasion and continued to lead the movement into the 1980s. He was denounced by fellow members of the Khmer Rouge in 1997 and died under house arrest the following year.**

ABOVE: **The leaders of the Khmer Rouge, Pol Pot, Noun Chea, Leng Sary and Son Sen, pictured in Phnom Penh shortly after taking power.**

LEFT: **Khmer Rouge fighters celebrate the surrender of the Cambodian government at the Information Ministry in Phnom Penh in April 1975.**

Genocide

After seizing power, the Khmer Rouge set about reorganizing Cambodia in line with their Communist ideology. The country was renamed 'Kampuchea', private ownership was abolished, and almost the entire urban population was forcibly relocated to the countryside to work on collective farms. Hundreds of thousands of people died from starvation, disease and overwork during the upheaval. Many more were killed in a Red Terror, which the Khmer Rouge instigated to get rid of anyone linked to the previous government or considered to be an enemy of the Revolution. Intellectuals, the bourgeoisie and foreigners were all targeted and often were tortured before they were killed so they would implicate others. It is estimated that more than two million people were killed as a result of the Khmer Rouge's brutal social reorganization.

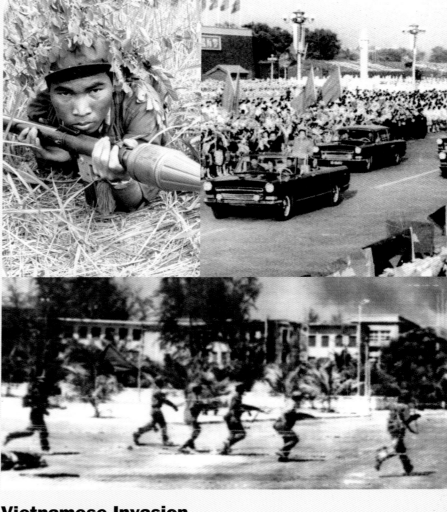

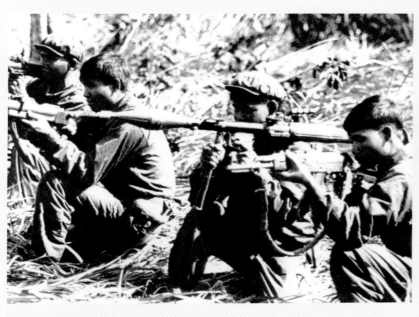

TOP LEFT: **A camouflaged Khmer Rouge soldier trains with a rocket launcher in the Thai border region of northwestern Cambodia in 1980.**

TOP RIGHT: **Pol Pot parades through Tiananmen Square during an official visit to China in September 1977. The Khmer Rouge sided with China in its ideological and political split with the Soviet Union.**

ABOVE: **Guerrillas loyal to Pol Pot hold positions in the Cambodian jungle during the Vietnamese invasion.**

RIGHT: **Cambodian forces loyal to Vietnam move in to liberate Phnom Penh from the Khmer Rouge, January 7, 1979.**

BELOW: **Photographs of Cambodia's genocide victims hang at S21, a former prison camp turned into a memorial museum. The camp was established to 're-educate' enemies of the regime, but the majority did not make it out alive.**

Vietnamese Invasion

The violence and turmoil in Cambodia was only halted by the invasion of neighbouring Vietnam following a border dispute. The war was one of the first major conflicts between two Communist countries and highlighted the ideological and political division that had beset the Communist bloc.

The invasion began on December 25, 1978 and within weeks the Khmer Rouge had been forced from power. The Vietnamese installed a new government comprising Cambodian Communists who were politically and ideologically aligned to Hanoi. The Khmer Rouge established new bases in Thailand with the assistance of the United States and China and continued to skirmish the Vietnamese-backed government into the 1980s and early 1990s.

The Angolan Civil War 1975–2002

Portuguese withdrawal

The Angolan civil war, which started in 1975, lasted throughout the Cold War years and continued until 2002. It was one of the most prolonged of all the conflicts in Africa. By the time it ended, it left a country laid waste by war, a ravaged economy, and a generation that knew nothing but conflict. Millions of inhabitants had been displaced as thousands of refugees had left the country or fled to other areas of Angola. It is estimated that more than 500,000 people died and many tens of thousands more were left mutilated by anti-personnel mines.

The civil war erupted in 1975 shortly after Angola had gained independence from Portugal. Although there were a number of guerrilla movements involved, the two main factions were the MPLA (Popular Movement for the Liberation of Angola) and UNITA (National Union for the Total Independence of Angola) who had been fighting each other, as well as the Portuguese, throughout the War for Independence – which had lasted from 1961 until independence was granted on November 11, 1975.

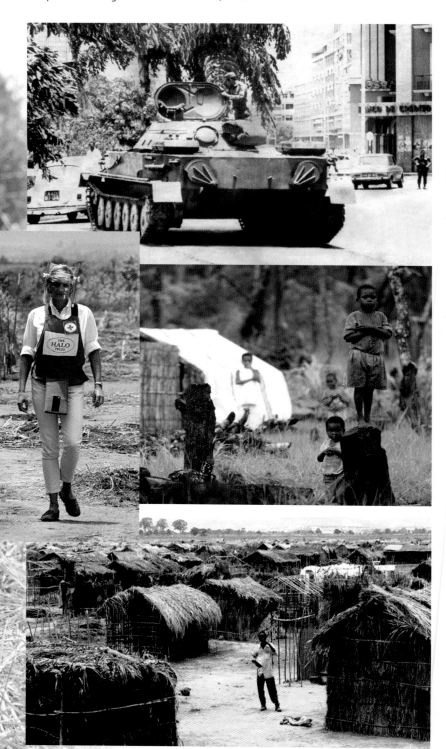

The Cold War in Angola

The Communist MPLA, supported by Cuba and the USSR, and anti-Communist UNITA, backed by white South Africa and the USA, were bitter rivals even before the start of the civil war. As the Portuguese authorities and military forces withdrew from the territory UNITA and the MPLA stepped up their attacks on one another in a battle for supreme control of the country. Fearing Communist influence in southern Africa, South African troops invaded in October 1975 with the intention of putting UNITA in power. However, they were unable to capture the capital, Luanda, because Cuban troops arrived with Soviet equipment to shore up the MPLA. South Africa withdrew, allowing the MPLA to form a government under the leadership of Agostinho Neto, who became the country's first President.

 The United States stayed out of the war during the 1970s because Congress had refused funding for operations in Angola. However, in the 1980s President Reagan stepped up American support for UNITA after taking a liking to its charismatic leader, Jonas Savimbi. Savimbi claimed his movement represented 'real Africans' – those living off the land as opposed to the wealthy urban elite. With UNITA strengthened by American support and with the MPLA weakening as the Soviet Union collapsed, the fighting escalated.

Towards agreement

As the Soviet Union disintegrated, Washington decreased its financial assistance to anti-Communist resistance movements worldwide. Cold War conflicts across the world were ending and initially the Angolan Civil War was no exception. Peace accords were signed and national elections were held in 1992. However, when he lost at the polls, Savimbi refused to accept the results and the fighting resumed with an even greater intensity. More peace talks followed and the UN sent in a peacekeeping force in 1995, but tension continued to mount and it withdrew in 1999 after one of its planes was shot down. The war finally came to a conclusion in 2002 when Savimbi was killed in battle. Devoid of its leader, UNITA quickly suspended its activities and entered into peace talks with the MPLA.

DAILY MAIL FEBRUARY 23, 2002

UNITA leader 'killed by army'

The Angolan army has killed UNITA leader Jonas Savimbi, who led the rebel group's fight for power in Angola for more than 30 years, the government said in statements. The armed forces said Savimbi died during an army attack on UNITA forces in Moxico province in southeast Angola at around 3 p.m. (1400 GMT) on Friday. There was no independent confirmation of the claim. UNITA officials, who are hidden in the Angolan bush, were not available for comment.

Savimbi, who was 67, was a key player in the Cold War struggle for dominance in Africa but became internationally isolated after he resisted democracy. He has not been seen for several years. If confirmed, Savimbi's death could open the way for long-lasting peace in the Southwest African country where the devastating civil war has raged on-and-off for the past 27 years.

The civil war is believed to have killed about 500,000 people, though there are no confirmed figures. About 4 million people – roughly one-third of the population –have been driven from their homes by the fighting, creating a humanitarian crisis.

OPPOSITE LEFT: **Mine clearing in Angola, which is thought to have more landmines than anywhere else in the world. The MPLA government used mines to keep UNITA away from the main cities, while UNITA used landmines to deliberately incapacitate the civilian population in order to make them a drain on the government's resources.**

OPPOSITE LEFT INSERT: **Princess Diana walks through a cleared stretch of minefield during her Red Cross mission in January 1997. Her visit inspired her to call for an international ban on landmines.**

OPPOSITE ABOVE RIGHT: **Tanks on the streets of Luanda at the start of the civil war in 1975.**

OPPOSITE MIDDLE RIGHT: **These children are among the 50,000 Angolan refugees living in the Meheba refugee camp in Zambia, January 2001. The camp is also home to refugees from the war in the Democratic Republic of Congo.**

OPPOSITE BELOW RIGHT: **A refugee camp at Cambambe outside the city of Caxito, January 1999.**

ABOVE LEFT: **Jonas Savimbi at the UNITA base camp in Jamba. Savimbi refused to accept defeat in the Presidential Election in 1992 and the fighting continued until his death in 2002.**

ABOVE: **Angolan President Jose Eduardo dos Santos welcomes South African President Nelson Mandela on a state visit in April 1998. Dos Santos, the leader of the MPLA, became President of Angola in 1979 after the death of Agostinho Neto.**

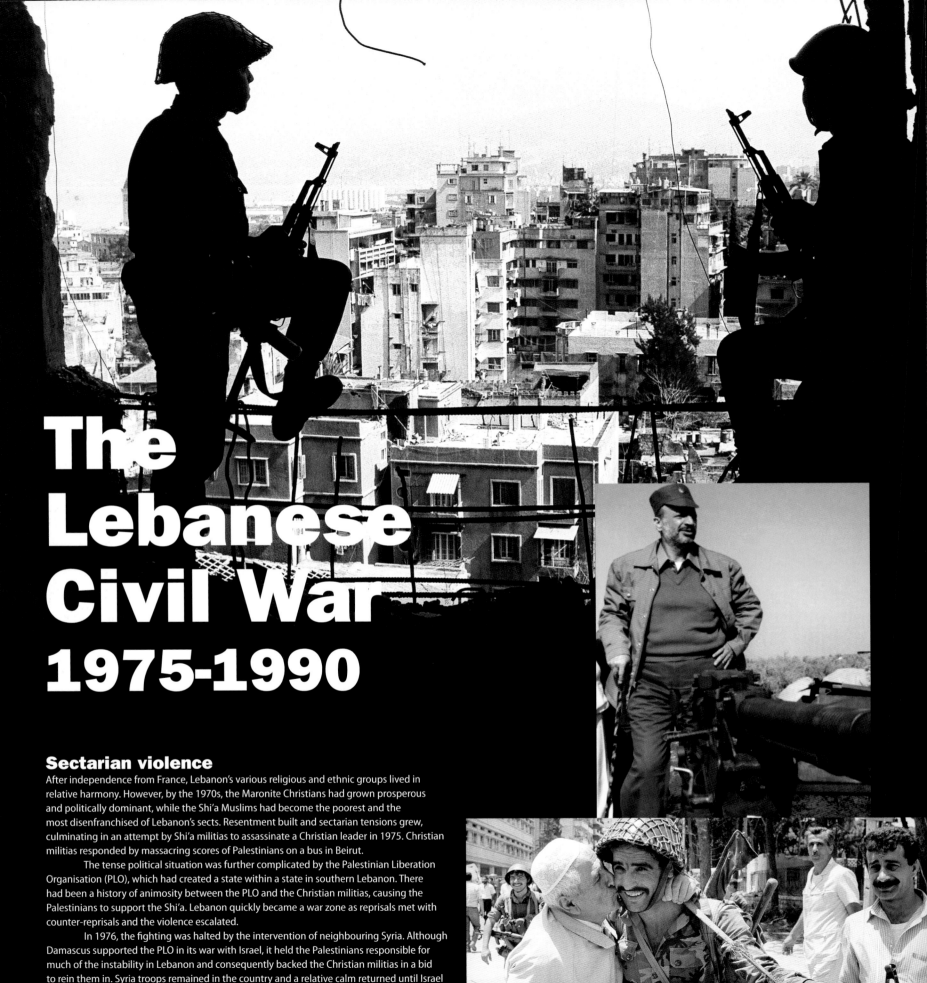

The Lebanese Civil War 1975-1990

Sectarian violence

After independence from France, Lebanon's various religious and ethnic groups lived in relative harmony. However, by the 1970s, the Maronite Christians had grown prosperous and politically dominant, while the Shi'a Muslims had become the poorest and the most disenfranchised of Lebanon's sects. Resentment built and sectarian tensions grew, culminating in an attempt by Shi'a militias to assassinate a Christian leader in 1975. Christian militias responded by massacring scores of Palestinians on a bus in Beirut.

The tense political situation was further complicated by the Palestinian Liberation Organisation (PLO), which had created a state within a state in southern Lebanon. There had been a history of animosity between the PLO and the Christian militias, causing the Palestinians to support the Shi'a. Lebanon quickly became a war zone as reprisals met with counter-reprisals and the violence escalated.

In 1976, the fighting was halted by the intervention of neighbouring Syria. Although Damascus supported the PLO in its war with Israel, it held the Palestinians responsible for much of the instability in Lebanon and consequently backed the Christian militias in a bid to rein them in. Syria troops remained in the country and a relative calm returned until Israel invaded in 1978.

Israeli invasion

In March 1978, Palestinian militias hijacked a bus on the road from Haifa to Tel Aviv in Israel, killing thirty-eight passengers and wounding many more. The attack convinced the new Israeli government under Menachen Begin to stage a limited war against the PLO in southern Lebanon. The war was a success for Israel as they had managed to strike a blow at the PLO and to strengthen ties with Lebanese Christians. As the Israeli forces withdrew they handed over territory to the South Lebanon Army, a predominantly Christian militia group opposed to the PLO presence.

The PLO remained a serious threat to Israel and Begin and his defence minister, Ariel Sharon, began to plan another attack to remove the organization from Lebanon once and for all. The pretext for the invasion was an assassination attempt on Shlomo Argov, the Israeli Ambassador to the United Kingdom, on June 3 1982. Three days later Israel launched 'Operation Peace for Galilee'.

OPPOSITE ABOVE: Syrian soldiers stand guard over West Beirut after Shi'a militias besieged the Shatila Palestinian Refugee Camp.

OPPOSITE MIDDLE: PLO leader Yasser Arafat pictured in southern Lebanon in 1978.

OPPOSITE BELOW: A Lebanese man thanks Syrian troops for bringing stability back to his country.

ABOVE RIGHT: Beirut residents and tourists take advantage of a lull in the fighting to go swimming in the Mediterranean Sea in the summer of 1979.

BELOW: Yasser Arafat inspects the bomb damage in the Arab University area of West Beirut following an Israeli bombardment in August 1982.

BOTTOM: Yasser Arafat attends a farewell gathering of PLO officers in West Beirut before leaving to establish new headquarters in Tunis.

BELOW RIGHT: Israeli soldiers pictured at the Litani River in Lebanon during the first Israeli invasion in 1978.

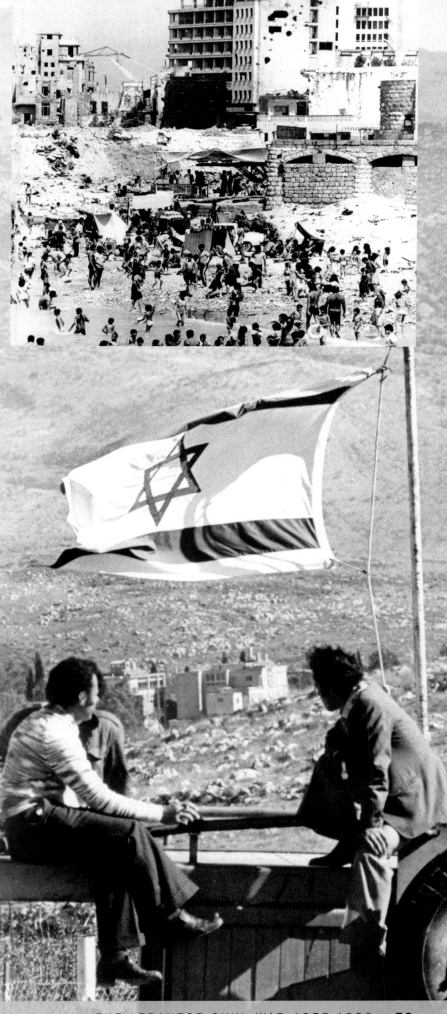

The siege of Beirut

Israel laid siege to Beirut in July 1982 in a bid to force the PLO from its headquarters in the western part of the city. Israel was condemned for attacks on the city that resulted in many civilian casualties. The international community, including the United States, called for restraint and negotiation. However, Israel was able to fulfil its goal as the PLO leadership left Beirut for Tunis in Tunisia. In August, the US negotiated an Israeli withdrawal and announced the introduction of a multinational force comprising American and French soldiers who would help maintain political stability.

Despite the PLO withdrawal to Tunis, the cycle of violence continued. On September 14, the newly elected Christian President, Bashir Gemeyal, was assassinated in Beirut. Days later, with indirect Israeli assistance, Christian militias entered the Palestinian refugee camps of Sabra and Shatila and slaughtered more than one thousand people.

Hezbollah

The withdrawal of the PLO did not mark the end of the war in Lebanon; bitter sectarian violence continued and even reached new heights following the emergence of Hezbollah. In the early 1980s, the new Shi'a Islamist regime in Iran sought to export its style of government to Lebanon, where the Shi'a population was largely represented by a secular-leaning militia called Amal. Iranian revolutionary guards were sent to Lebanon with the assistance of Syria to unite the country's weak and divided Islamist groups under the banner of Hezbollah, the 'Party of God'. Resentment of the Israeli invasion certainly strengthened the movement's appeal as did a series of high-profile attacks: in April 1983 a group linked to Hezbollah bombed the US Embassy and in October of that year they bombed French and US military barracks, killing hundreds. During the war, Hezbollah became infamous for taking westerners hostage. Scores of people were kidnapped, and those who were not murdered were held in terrible conditions; Terry Waite, for example, was kept in solitary confinement for much of his four-and-a-half-year captivity.

Marine barracks bombing

After the tumultuous year in Lebanon in 1982, a multinational force led by the United States, France and Italy went to Lebanon to maintain peace and stability while Israel and the PLO withdrew. On the morning of October 23, 1983, an Islamist suicide bomber drove a truck into the lobby of the barracks housing US Marines and detonated the explosives packed inside. 241 American servicemen were killed in the terrorist attack, which made it the single most deadly attack on the American military since the Vietnam War, and on the United States Marine Corps since the Battle for Iwo Jima. A simultaneous suicide attack on the barracks of French paratroopers killed 58 people. As a result of the bombings the multinational force pulled out of Lebanon entirely by April 1984.

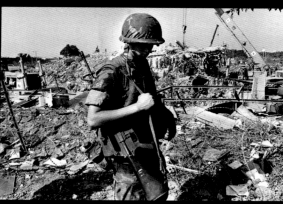

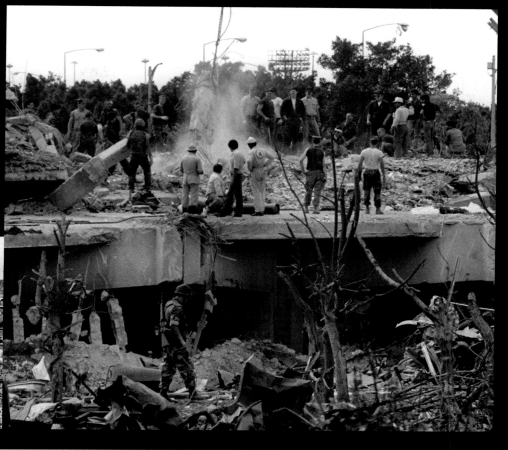

OPPPOSITE LEFT: **President Reagan answers questions about two Americans held hostage in Lebanon. It later emerged that the Reagan administration had secretly sold arms to Iran in the hope of getting Tehran to use its influence to free the hostages. Funds from the sales of weapons to Iran were used to train the anti-Communist 'Contras' in Nicaragua in an episode known as the Iran-Contra Affair.**

OPPPOSITE ABOVE RIGHT: **Terry Waite is escorted by the Lebanese Army to his flight at Beirut Airport. Waite, an envoy of the Church of England and a veteran hostage negotiator, managed to secure the release of several hostages before being taken prisoner himself. He was held hostage for more than four and a half years, spending much of that time in solitary confinement.**

OPPPOSITE BELOW: **Israeli artillery pounds Hezbollah targets in southern Lebanon.**

ABOVE LEFT: **A US marine stands in front of the ruins of the marine barracks in Beirut, Lebanon, October 24, 1983.**

ABOVE RIGHT: **Rescue workers search the wreckage of the US marine barracks.**

BELOW: **An explosion rips through a Royal Jordanian ALIA airline Boeing 727 at Beirut Airport in June 1985. The hijackers, linked to Hezbollah, allowed their hostages to escape before detonating the explosives they had left behind.**

The end of the Civil War

Between 1985 and 1986, the Shi'a Muslim militia group Amal fought a bitter battle against Sunni Muslim Palestinians in their refugee camps in Beirut and elsewhere. The 'War of the Camps', as it was known, resulted in thousands of deaths until Syria intervened. In 1987, the fighting worsened when the Lebanon's Christian President engineered the succession of a Christian, General Aoun, as Prime Minister, despite an unwritten understanding among Lebanon's sects that the Prime Minister would always be a Sunni Muslim. Muslims refused to accept Aoun and followed Salim al-Hoss instead, meaning that Lebanon essentially had two parallel governments. The fighting was stopped once again with the intervention of Syria who pushed Aoun into exile in France, and it was this act that finally ended the civil war in October 1990.

Syria was the victor of the Lebanese Civil War, and the peace agreement, signed at Taif in Saudi Arabia reflected that. Backed by other Arab nations, the Taif Agreement gave Syria a mandate to keep the peace in Lebanon, and by extension it offered Damascus the opportunity to meddle in Lebanese affairs for the next fifteen years.

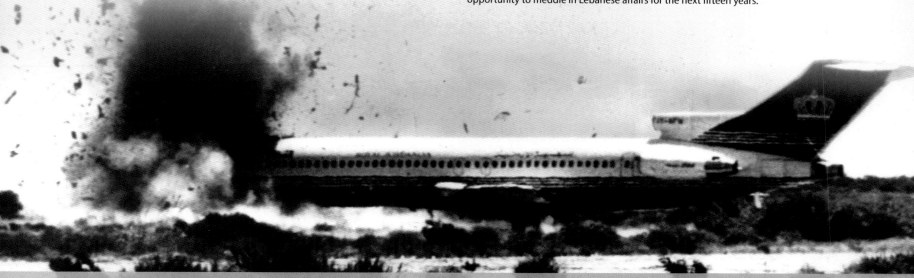

Soviet Invasion of Afghanistan 1979-1989

Revolution in Afghanistan

Afghanistan has long courted the interests of great powers on account of its strategic location in the heart of Asia, but its harsh terrain and severe climate has made it almost impossible to conquer. The country is crossed by largely impassable mountain ranges, which makes travel difficult and ensures that people's loyalties are usually regional rather than national.

In the 1950s the USSR began giving more aid to Afghanistan, which was then a monarchy. Roads and irrigation systems were built, as were some oil pipelines. The monarchy was overthrown in 1973, and the regime that replaced it was in turn overthrown in a revolution led by Communists five years later. The new regime tried to apply Soviet-style reforms to this conservative Muslim society, and met with resistance. A rebellion started in the remote area of Nuristan in 1978, and soon spread further.

Soviet troops enter Afghanistan

The Afghan government repeatedly requested Soviet assistance, and troops were deployed there in 1979. The USSR had several reasons for what was now, in effect, an invasion: not only could it support a friendly regime, it could also consolidate and extend its own position in Asia as well as protecting its existing interests. Kabul, the capital, was quickly secured by the 100,000 soldiers who were sent in.

However, controlling the countryside was a very different matter. Here resistance fighters, the Mujahideen, saw external rule as not only an infringement of independence but also as a defilement of Islam. They declared a jihad or holy war against the Soviets and received support from the Islamic world – and also from the United States, who were to send many millions of dollars' worth of arms and food aid over the years.

ABOVE: **A Russian personnel carrier moves through the Salang Pass as the Soviet invasion of Afghanistan begins at Christmas 1979.**

LEFT: **Mujahideen on horseback in the rugged western region of Afghanistan in January 1980.**

BELOW: **British journalist Sandy Gall accompanies the Mujahideen in October 1985. He returned home to set up a charity to help landmine victims in Afghanistan.**

The Mujahideen

The Mujahideen waged a guerrilla war against the invaders, one perfectly suited to the terrain, attacking quickly and then disappearing into the mountains. Their supply of weapons was somewhat improvised, with a mixture of inherited arms, more modern ones taken from Soviet troops and those supplied by the US, but this made no difference as fixed battles were not part of their plan. Nor did they have a single base; they were scattered throughout the country.

Soviet attempts to control the rural areas, where people supported the Mujahideen, were devastating. Villages were bombed, destroying homes, crops and ancient irrigation systems, as well as killing large numbers of civilians. Many more were left homeless and starving as a result. Land mines were scattered and caused appalling injuries and deaths, and many people fled across the Pakistani border where enormous refugee camps were set up.

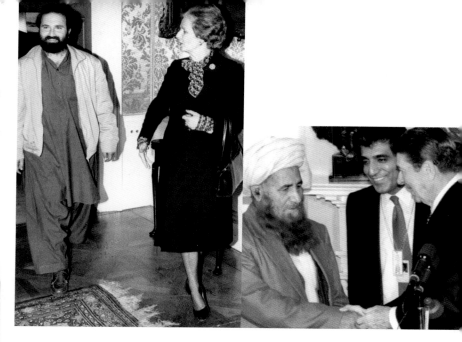

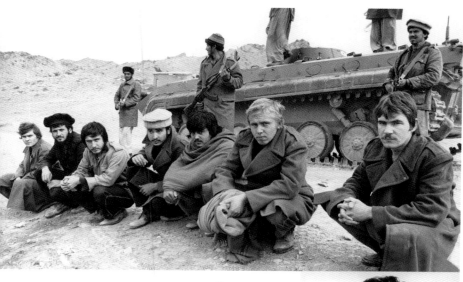

Soviet withdrawal

There was a wave of international protests, with the United Nations condemning Soviet actions. Resistance grew and persisted instead of dying down, and the Soviet troops became bogged down in a vicious and unwinnable war for most of a decade. They achieved very little, except a level of brutality that affected both the Afghan people and their own lower ranks. Discontent spread at home. Not only did the USSR have a large Muslim population, but demoralized veterans were also returning and proving impossible to silence.

By the late 1980s it was becoming even more obvious that the war was unsustainable. In 1987, US shoulder-launched anti-aircraft missiles were introduced, and they had an immediate impact as the Mujahideen shot down helicopters and planes every day. In addition there were problems at home. The Soviet economy was essentially out of control and the country was in trouble; some commentators even thought there was a danger of a coup d'état from disaffected generals and veterans of the war. The Soviet leader, Gorbachev, decided that the time had come for the Soviet Union to withdraw. The first half of the Soviet contingent left in the summer of 1988; the rest were withdrawn by February 15,1989. This withdrawal was largely peaceful as ceasefires had been negotiated with the Mujahideen. Fighting between factions in Afghanistan continued, however, with ramifications to the present day.

During the occupation there were about 15,000 Soviet deaths, and almost half a million soldiers had been either wounded or were sick (with a variety of serious diseases, including typhoid and hepatitis). It is not certain how many Afghans died, but the figure is probably over a million. About five million fled to the refugee camps – an astonishing third of the pre-war population. The damage to the country's infrastructure was almost without parallel.

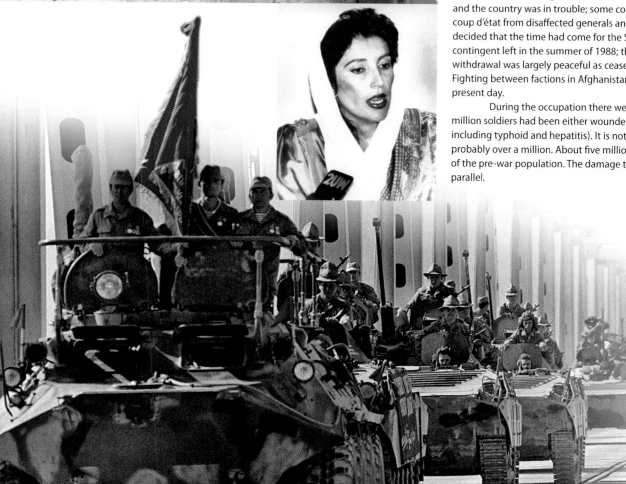

TOP LEFT: **Afghan resistance commander Abdul Haq urges Margaret Thatcher to exert pressure on the Soviets during a meeting in Downing Street in 1986.**

TOP RIGHT: **President Reagan meets Maulavi Yunis Khalis, the newly installed head of the Afghanistan resistance, at the White House.**

ABOVE LEFT: **Russian soldiers captured by the Mujahideen in 1984**

ABOVE LEFT INSERT: **Prime Minister Benazir Bhutto of neighbouring Pakistan tells a news conference that Moscow should scale down the conflict to encourage a political solution to the country's long-time civil war.**

LEFT: **A convoy of Soviet armoured personnel vehicles cross a bridge in Termez, at the Soviet-Afghan border, during the withdrawal of the Red Army from Afghanistan, May 1988.**

Iran-Iraq War 1980-1988

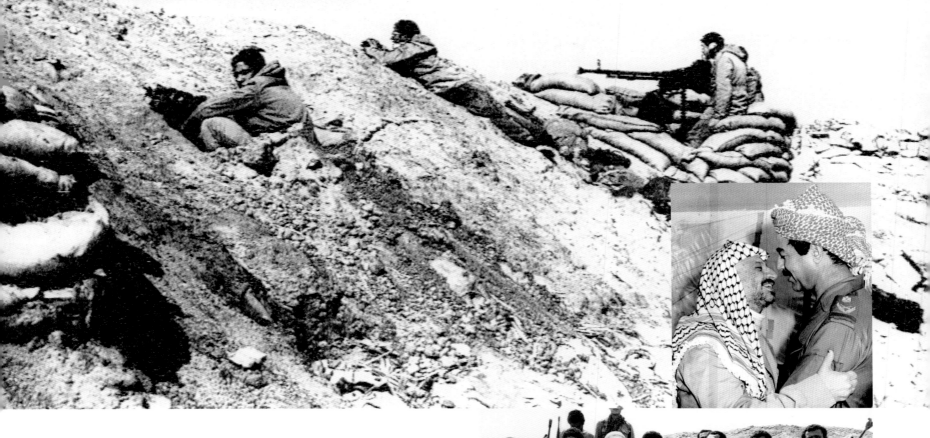

The Iraqi offensive

The eight-year war between Iran and its neighbour Iraq was the longest conventional war of the twentieth century. It was the result of a long-standing border dispute over the strategic Shatt al-Arab waterway combined with Saddam Hussein's fear that Iran was attempting to spread its Islamic Revolution to Iraq.

Iran's Revolution was barely a year old when Iraq invaded, and the Iranian military was severely weakened by internal strife. As a result, Iraq scored early victories in the oil-rich province of Khuzestan, capturing the city of Khorramshahr and closing in on Abadan, the centre of Iran's oil refining operation.

The Iranian counteroffensive

The Iraqi invasion helped Iran to overcome its military difficulties as hundreds of thousands of volunteers signed up to protect the Revolution and repel the invaders. By late 1981, the tide started to turn. Iranian warplanes began menacing the Iraqi army, whose supply lines were already overstretched, and the superior Iranian navy was able to impose a blockade against Iraq in the Persian Gulf. In May 1982, Khorramshahr was recaptured following a bloody battle in which thousands of Iraqis were taken prisoner.

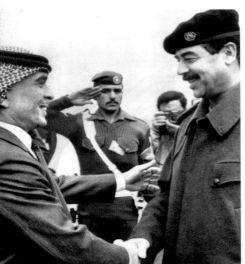

TOP: Iranian troops man a position along the front lines. The trenches dug out in the Iraqi desert were reminiscent of France during the First World War.

LEFT: King Hussein of Jordan welcomes Saddam Hussein to a Pan-Arab Summit. Jordan tried to get the whole of the Arab world behind Iraq, but Syria and Libya refused and continued to back Iran.

ABOVE INSET: Saddam Hussein weclomes Yasser Arafat to Baghdad soon after the outbreak of the conflict. The Palestinian Liberation Organization tried to mediate a ceasefire between the two countries and re-focus their attention on the Arab-Israeli conflict.

ABOVE: Victorious Iranian soldiers crowd in for a photograph following the liberation of Ahvaz, the provincial capital of Khuzestan, in May 1982.

The fight for Basra

In July 1982, Saddam pulled his armies out of Iran and called for a ceasefire. The Iranians rejected it and pushed into Iraqi territory, focusing their attacks on the southern port city of Basra. However, they met with determined Iraqi resistance and resorted to futile 'human wave' tactics to make use of their numerical superiority and to compensate for their relative lack of military hardware. These waves proved easy targets for the Iraqis, but the Iranians continued to threaten Basra. In response Saddam allowed the use of chemical weapons against Iranian soldiers and began pummelling Iran's cities from the air. The Iranians began bombing Iraq's cities in return, giving rise to the so-called 'war of the cities', in which thousands of civilians lost their lives.

The Tanker War

Iran and Iraq attacked tankers carrying one another's oil in the Persian Gulf, and Iran later widened this offensive to include tankers carrying oil supplies from Iraq's allies, Kuwait, Saudi Arabia and other Arab nations. This seriously affected the global supply of oil and drew the superpowers into the conflict. The United States and the Soviet Union had already been supplying weapons to Iraq, but the Tanker War drew them directly into the conflict. Tankers belonging to Arab nations were 'reflagged' so they could be given legal protection by the superpower whose flag they were flying so as to maintain the flow of oil.

Ceasefire

The land war had reached a stalemate: the Iranians were unable to take Basra, but the Iraqis were unable to repel them. In July 1987, the UN Security Council passed a resolution calling for a ceasefire and return to the pre-war border. Iran had more to lose from this and so refused to accept the terms until a major Iraqi offensive in 1988 drove its forces back across the border. In August 1988, both sides agreed to a ceasefire with both claiming victory. The exact death-toll is not known, but it is estimated to be upwards of one million, making the Iran-Iraq War one of the deadliest of the twentieth century.

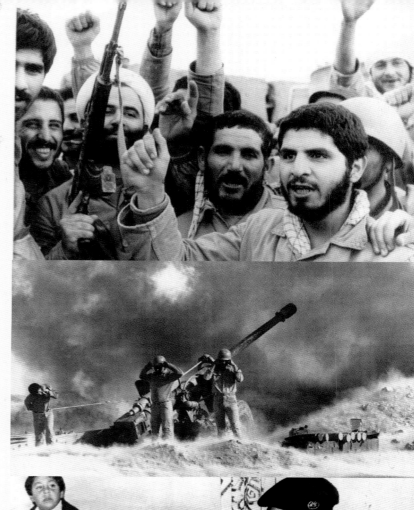

TOP RIGHT: **Iranian troops celebrate as they press on Basra.** They were never able to capture the strategic port city, despite making it the focus of their resources.

MIDDLE RIGHT: **Iranian troops open up with a US-made 103mm howitzer.** Much of the Iranian arsenal comprised old American hardware that was bought during the Shah's rule. However, an American arms embargo on the new regime made it difficult for Iran to get spare parts. In

1986, it emerged that members of the Reagan Administration had been selling arms to Iran in order to get Tehran to convince Hezbollah to release American hostages being held in Lebanon. The funds from arms sales to Iran were being used to train right-wing rebels in Nicaragua.

RIGHT: **Saddam Hussein visits a kindergarten to try to convince the Iraqi public that it is business as usual, despite the war with Iran.**

BELOW: **A group of Iranians pictured in northern Iraq in January 1988.** The Iranians allied with the Kurdish people of the region who resented being ruled from Baghdad. They waged a guerrilla insurgency which distracted Iraq from the war with Iran. Saddam responded with great ruthlessness, culminating in a deadly chemical attack on the Kurdish settlement of Halabja. Thousands of people were killed instantly.

Falklands War
1982

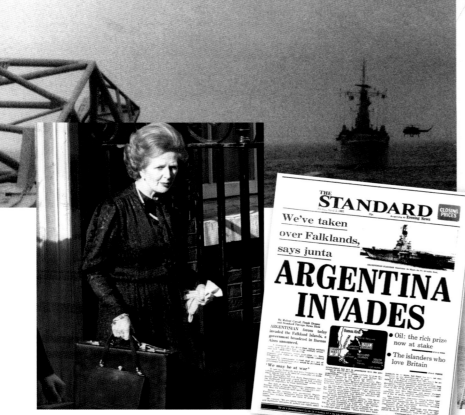

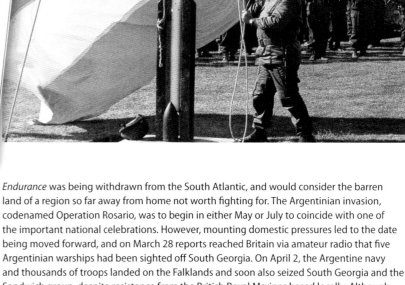

Disputed Ownership

The Falklands War lasted for just 74 days and arose from the disputed ownership of a collection of islands, situated in the South Atlantic some 350 miles off the southeast coast of South America. Both Britain and Argentina claimed the Falklands, which also administer the tiny uninhabited islands making up South Georgia and the South Sandwich Islands to the east and southeast. A small band of Argentinians had settled on the Falkland Islands in 1826, but after a dispute over seal hunting a US warship arrived in 1831 and declared the islands free of government. In 1832 a British expedition landed and in 1833 Britain expelled the Argentine governor and declared sovereignty over the territory, although this was never recognized by Argentina. Over the intervening years the population on the islands had grown to 1800 inhabitants, who were happy to live under British government and had British traditions – even though most people in Great Britain would not have been able to point to the islands on a map.

Argentina invades

In March 1982 the military junta ruling Argentina decided to invade the Falklands, known to them as Las Malvinas, and restore them to Argentina. The junta believed that a short and successful war would engender a bout of national pride, divert attention from the shattered economy, and restore their waning popularity. They were also under the mistaken belief that Britain would not be able to defend the islands after it was announced that HMS

Endurance was being withdrawn from the South Atlantic, and would consider the barren land of a region so far away from home not worth fighting for. The Argentinian invasion, codenamed Operation Rosario, was to begin in either May or July to coincide with one of the important national celebrations. However, mounting domestic pressures led to the date being moved forward, and on March 28 reports reached Britain via amateur radio that five Argentinian warships had been sighted off South Georgia. On April 2, the Argentine navy and thousands of troops landed on the Falklands and soon also seized South Georgia and the Sandwich group, despite resistance from the British Royal Marines based locally. Although the UN Security Council immediately called for troops on both sides to withdraw and renew negotiations for a peaceful solution, Argentina refused to comply and Britain began to assemble a large naval taskforce.

Over the first few weeks of April, British ships, aircraft and troops all headed for the South Atlantic, along with the P&O cruise liner *Canberra* and the *QE2*, which were acting as troopships. Meanwhile, the United States began trying to negotiate a peace treaty with the military junta, but they had little success and talks very soon broke down. By April 22 the British task force had arrived in Falklands waters and a few days later a small British commando force re-took the island of South Georgia. The British Government then proceeded to impose a 200-mile exclusion zone around the islands, which at one point was extended to within just 12 miles of the Argentinian coastline.

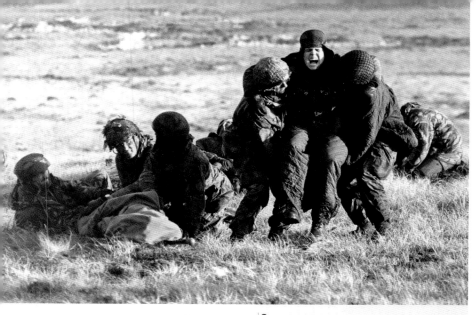

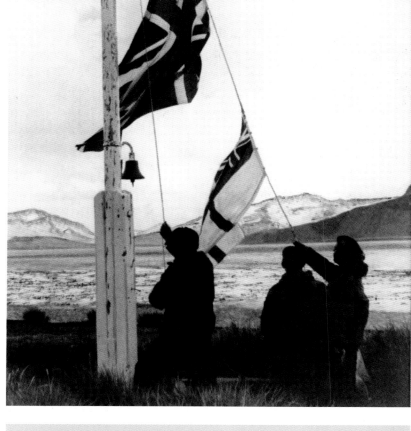

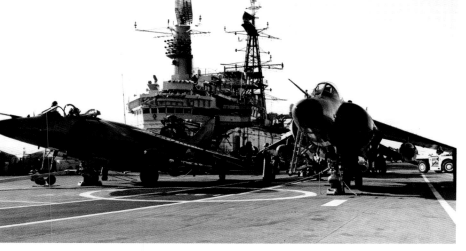

OPPOSITE TOP: **A Lynx helicopter comes into land on a County-class guided missile destroyer. In the background, a Wasp helicopter hovers forward of a frigate.**

OPPOSITE LEFT: **Britain's Prime Minister, Mrs Margaret Thatcher leaves 10 Downing Street in London after the latest development in the Falklands crisis.**

OPPOSITE RIGHT: **The Argentine Army stands to attention as their national flag is hoisted up the flagpole outside Government House in Port Stanley, the capital of the Falkland Islands.**

ABOVE RIGHT: **The Union flag and white ensign are raised on South Georgia, after the island's recapture by the British.**

ABOVE: **Sea Harrier jump jets on the flight deck of HMS *Hermes*, a British aircraft carrier built at the end of the Second World War.**

TOP LEFT: **British paratroopers come under fire while carrying out emergency medical treatment on Mount Longdon.**

BELOW: **Argentine soldiers take position in Port Howard in May.**

DAILY MAIL MARCH 29, 1982

Britain Sends In Marines

Forty-Two Royal Marine Commandos were on their way to the disputed Falkland Islands last night amid growing friction between Britain and Argentina. Their arrival will double our military strength in an area where tensions have increased because of an Argentine 'invasion' of South Georgia, an island dependency.

They will be stationed in the Falklands capital of Port Stanley – base for the past year for 40 other Marines, 12 of whom are now aboard HMS Endurance off the South Georgia coast 800 miles away. There they await orders to 'evacuate the intruders if necessary'. The latest detachment to be sent out to the South Atlantic made the first leg of the journey, to Uruguay, by chartered jet. Then in Montevideo they trooped aboard the Antarctic survey ship, the John Biscoe.

As they headed for Port Stanley two of Argentina's missile-carrying corvettes were steaming towards South Georgia with a heavy patrol boat capable of putting ashore 400 marines, and a supply vessel. According to a spokesman in Buenos Aires, the warships would 'protect' the remaining ten members of a party of scrap metal dealers who last week made an illegal landing on South Georgia and flew the Argentine flag.

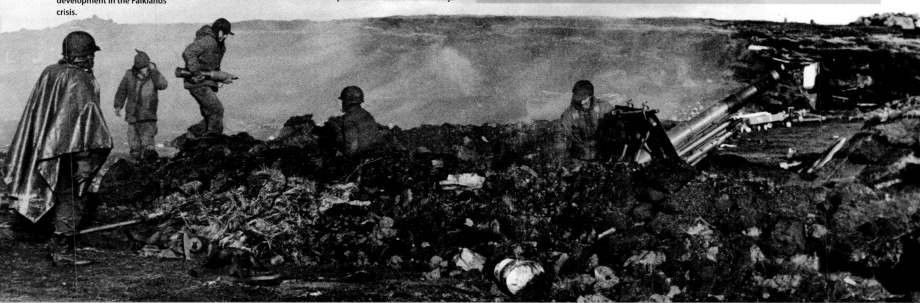

Sinking of the *Belgrano* and the *Sheffield*

On May 2 the British nuclear submarine HMS *Conqueror* torpedoed the Argentine cruiser ARA *General Belgrano* some 30 miles outside the exclusion zone. The *Belgrano* sank quickly and 323 crewmembers died in the attack, although over 700 more men were rescued from the ocean despite the stormy weather. The incident hardened the attitude of the Argentinian junta and they refused to consider a comprehensive peace plan that had just been proposed by the President of Peru, Belaúnde Terry. However, the sinking did have a major effect on the course of the war, since the entire Argentine fleet returned to port afterwards and did not leave again during the hostilities.

A few days later, on May 4, the British destroyer HMS *Sheffield* was struck by an Exocet missile, launched by an Argentinian aircraft. The missile hit amidships, and although it is not clear whether it actually exploded it did cause massive fires to break out, which led to the loss of 20 men, and severe injuries to another 24 crew members. The *Sheffield* was abandoned to burn and later sank as it was being towed out of the exclusion zone. The destruction of *Sheffield* had a profound impact in Britain, making people realize that the 'Falklands Crisis' was a real war with real people dying. Britain accepted the peace plan proposed by Peru, but without Argentinian approval it could not proceed.

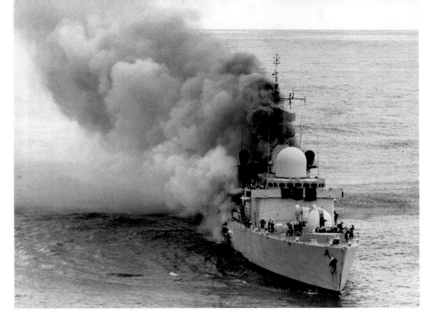

ABOVE RIGHT: The destroyer HMS *Sheffield* burns on May 25, after being hit by an Exocet missile fired by an Argentine Navy aircraft. The ship sank with the loss of twenty lives.

BELOW LEFT: Paratroopers of the British Falkland Islands Task Force clean out a mortar on East Falkland before the final push on the capital Port Stanley.

BELOW RIGHT: A British Royal Marine guards some of the 1,400 Argentine prisoners captured during the battle at Goose Green.

BOTTOM LEFT: The Union flag flies over Port Howard, West Falkland in June 1982. It is the first time in more than two months and is hoisted by 40 Commando, Royal Marines.

BOTTOM RIGHT: The launch of HMS *Coventry* which sank with the loss of 20 lives.

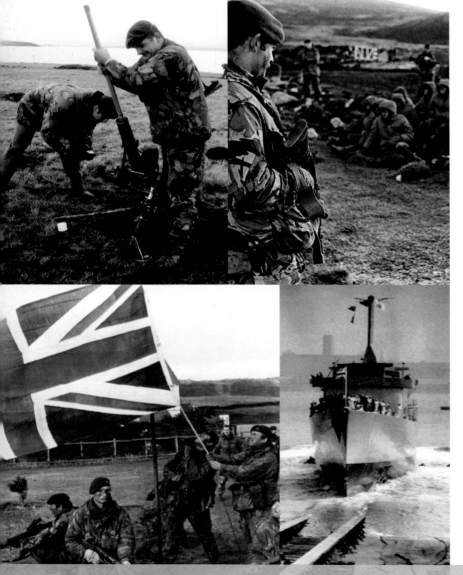

DAILY MAIL JUNE 10, 1982

Disaster At Bluff Cove

Argentine jets have mounted a devastating attack on exposed British supply ships unloading men and ammunition near Port Stanley. The number of killed was not known, but was believed to be 'substantial' and between 78 and 80 men were badly burned from explosions.

The attack came when the most daring tactical gamble of the Falklands war was within an hour of total success. Even in its bloody aftermath, the British operation had established a crucial beachhead for the assault on the Falklands capital Port Stanley, under 15 miles away.

Brigadier Tony Wilson, commanding Five Infantry Brigade, had discovered that the Argentines had abandoned the settlements of Fitzroy and Bluff Cove. There was low cloud and fog. He gambled on getting thousands of men in by sea, undetected by the Argentines and by-passing their patrols on land. The risk was that he had no anti-aircraft cover. Setting up Rapier ground-to-air missiles on the hills around the landing site took time. For two days, men and materials poured ashore. Still the Argentines did not discover the operation.

Heroism And Selflessness

Michael Nicholson, of ITN, watched from the shore what he described as 'a day of extraordinary heroism and selflessness.' He reported:

The attack happened so fast there wasn't even time to think of finding cover and as the ships were hit many men aboard hadn't even time to put on their anti-burn asbestos masks and gloves to save them from the heat flash as the bombs exploded. Many were brought ashore with second degree burns.

'Our air defences which had come off the ships that morning were still being set up on the hillside overlooking the estuary and had the Argentine planes come just that one hour later we would have been ready for them.

'As it was the Skyhawks came in to attack and were out again with our gunfire chasing them too late. The bombs hit Sir Galahad aft through the engine room and accommodation sections.

'As I watched from the shore less than 400 yards away the impact of boxes of ammunition aboard exploding shook the ground beneath us. We crouched with other soldiers around us as bullets from the ship whistled and whirled past us. We could see them coming by the red tracers.

'I saw hundreds of men rush forward along the deck, across the hold, putting on their lifejackets, putting on their survival suits, some, the ship's crewmen just off watch, putting on shirts and trousers. Many, trapped on the wrong side of the fire, jumped overboard.

Horror

But one hour away from unloading the last men and equipment – and from the Rapiers being set up ready to fire – the weather suddenly cleared. An Argentine patrol spotted the landing and radioed its position. The Argentines sent a wave of Skyhawk jets, heavily loaded with bombs and missiles, to attack the British ships. Their main target was the supply ship Sir Galahad, which together with its sister ship Sir Tristram was unloading hundreds of men 200 yards off-shore. On Sir Galahad were up to 400 men, many of them sleeping and resting before transferring to landing craft.

The ship had no warning and little to fight back with. The troops on shore could only look on in horror as bomb after bomb crashed into Sir Galahad setting it and the surrounding sea ablaze. Last night it was feared it might have sunk.

Battle at Goose Green

Throughout May the conflict escalated, although Britain continued to offer ceasefire terms to the Argentinians and the UN was still trying to negotiate a peaceful solution. British troops landed on the Falklands near Port San Carlos on May 21, and on May 28 they took Darwin and Goose Green, which were blocking further progress and were being defended by a large section of the Argentine army. The British lost 17 men, including Lieutenant-Colonel Herbert 'H' Jones, who was later awarded a Victoria Cross. The Argentine death toll was ten times greater and 1,400 prisoners were taken. Many military sources believe that the death toll would have been much lower if the impending attack had not been announced on the BBC World Service just before it took place. Goose Green was a significant victory for the British, however, as it put a sizeable part of the Argentinian army out of action and opened the way for troops to move forward towards the capital, Port Stanley.

Bluff Cove

As a preliminary to making an attack on Port Stanley itself, British troops advanced on Fitzroy and Bluff Cove. To back them up, early on June 7 RFA *Sir Galahad* and RFA *Sir Tristram* arrived with more troops who were due to be shipped ashore at Fitzroy. However, due to mistakes and mix-ups the troops were ferried the far longer journey to Bluff Cove instead, leaving the *Sir Galahad* and the *Sir Tristram* vulnerable to attack for some considerable time. On June 8, Argentine Skyhawk aircraft took advantage of the opportunity: the *Sir Galahad* caught fire and sank, while the *Sir Tristram* was badly damaged but salvageable. Their escort ship, the HMS *Plymouth*, was also hit. A total of 48 British servicemen were killed in the attack, and many more were seriously wounded – some of them suffering terrible burns. The disaster led to harrowing and sobering images of war being sent around the world, as television news footage showed helicopters hovering in thick smoke to winch survivors from burning ships.

The Fall of Stanley

On the night of June 11, the British launched the first major assault on the heavily defended high ground around Port Stanley, taking the areas of Mount Harriet, Two Sisters and Mount Longdon. Two days later the areas of Wireless Ridge and Mount Tumbledown were captured, which were Port Stanley's last lines of defence. On June 14, the Argentine garrison at Port Stanley was finally defeated and Brigade General Mario Menéndez surrendered to Major General Jeremy Moore, marking an end to hostilities. By June 20 Britain had also retaken the South Sandwich Islands. A Falklands Protection Zone of 150 miles later replaced the 200-mile exclusion zone.

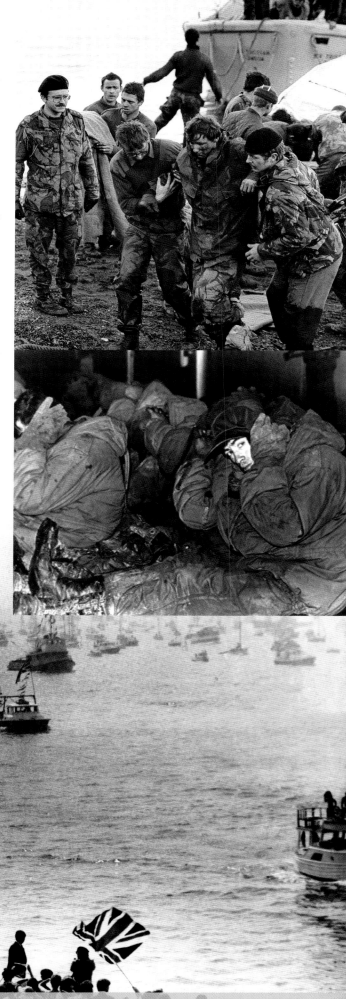

RIGHT: Survivors are helped onshore at Bluff Cove, East Falklands, after two British landing ships the *Sir Galahad* and the *Sir Tristram* suffered air attacks. One week later the Argentine forces surrendered Port Stanley, ending the Falklands War in which 255 Britons and 652 Argentines died.

BELOW RIGHT: An Argentine POW waits for a prisoner transport ship in San Carlos Water.

BELOW: HMS *Hermes* returns to a hero's welcome in Portsmouth, England, on July 21.

Grenada 1983

Soviet threat in America's backyard

In 1983 Grenada was ruled by a leftwing government that had seized power in a coup in 1979. The government was aligned to the Soviet Union and Cuba, and both countries had been helping to build an airstrip on the island, ostensibly for commercial use. However, President Reagan feared that Moscow's real intention was to turn the small Caribbean island into a Soviet military airbase. His fears were shared by members of the Organization of East Caribbean States, who appealed to Washington for assistance in the matter.

Coup d'état in Grenada

In October 1983, the political situation in Grenada rapidly deteriorated. The Prime Minister, Maurice Bishop, was overthrown and later murdered by members of his own party. Bishop, a relative moderate, was considered too close to Washington by the coup plotters. The worsening political situation, combined with the strategic threat to the United States and its regional allies convinced Reagan of the need to intervene. The final trigger came when the new regime imposed a strict 'shoot-on-sight' curfew, which compromised the safety of some 1,000 US nationals in the country, mostly medical students at St George's University.

Operation Urgent Fury

Operation Urgent Fury, as the invasion was codenamed, began early in the morning of October 25, 1983. In what was the US military's first major foreign operation since Vietnam, 1,900 marines were airlifted on to the island with the support of over 2,000 members of the army. They faced limited resistance from Grenada's 6,500 troops and a contingent of 700 Cuban construction workers. The US secured control of the island within just two days, but at a cost of 19 American and up to 100 Cuban and Grenadan lives. Democratic elections in 1984 brought to power a pro-American government and Soviet influence on the island was removed.

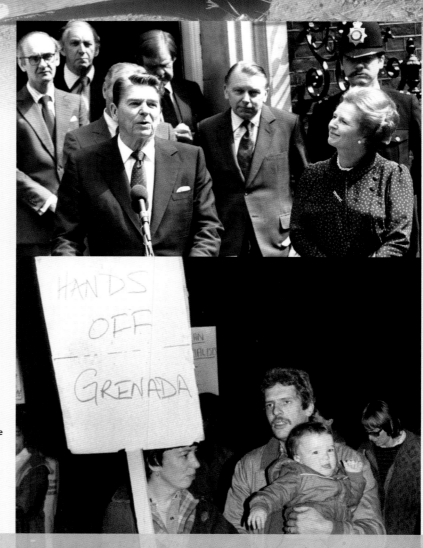

ABOVE: **An American soldier stands next to an anti-Communist sign on the Caribbean Island of Grenada on November 11, 1983. There are few pictures of the actual invasion because Washington ordered a media blackout.**

ABOVE RIGHT: **President Reagan outside 10 Downing Street during** his state visit to the United Kingdom in June 1982. Reagan rode with Queen Elizabeth on horseback and became the first American President to address the Houses of Parliament. Reagan had supported Thatcher in the Falklands War and there was some anger in America that she did not respond in kind.

BELOW RIGHT: **Demonstrators chant 'Reagan-Thatcher hands off Grenada' as they protest the invasion outside the American Embassy in London.**

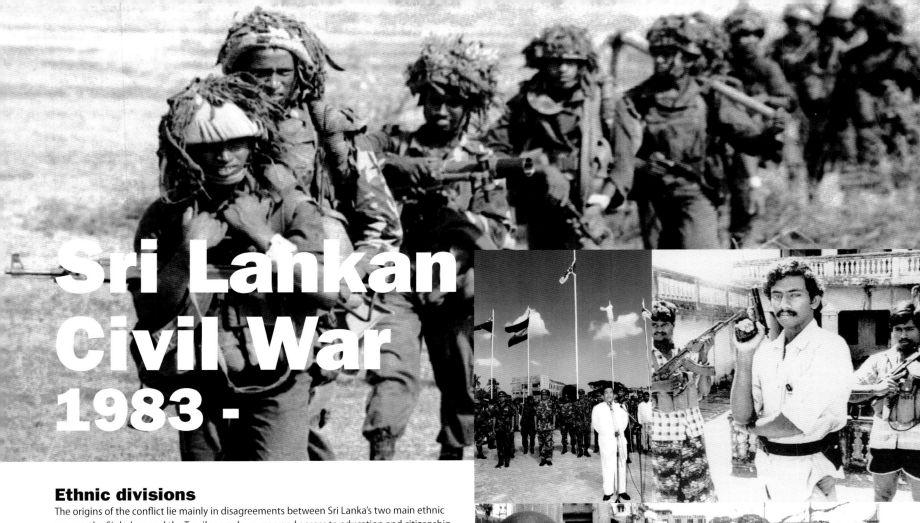

Sri Lankan Civil War 1983 -

Ethnic divisions

The origins of the conflict lie mainly in disagreements between Sri Lanka's two main ethnic groups, the Sinhalese and the Tamils, over language and access to education and citizenship. After independence from Britain in 1948, a democratic government was established in Sri Lanka. This favoured the majority Sinhalese population which comprised more than two-thirds of the eligible Sri Lankan voters. The Tamil population was totally politically marginalized and had to stand by as successive Sinhalese-dominated governments introduced legislation to benefit the Sinhalese people. In 1956 Sinhala was made the official language of Sri Lanka, which led to employment problems for many among the minority Tamil-speaking population, and during the 1970s it was agreed to standardize university admissions, which benefited Sinhalese students at the expense of Tamils.

During these years, there had been some grassroots violence between the two communities, but it was not until the late 1970s, when the Tamils began organizing themselves, that Sri Lanka stood on the precipice of civil war.

Tamil Tigers

In 1976, the Liberation Tigers of Tamil Eelam (LTTE) was formed. Commonly known as the Tamil Tigers, they staged their first major attack on Sri Lankan government forces in July 1983, when they ambushed and killed 13 government soldiers. Outraged Sinhalese took to the streets of Colombo, the capital, to protest and hundreds of Tamils were killed by the mob. Thousands more were forced to flee their homes and move to the Tamil-dominated areas of the north, further polarizing Sri Lankan society.

On the first anniversary of the riots, Tamil guerrillas began a series of attacks, each leading to retaliation by armed forces. Attempts were made to negotiate between the two sides in 1985, but fighting intensified through early 1987 with Sri Lankan government forces pushing deep into Tamil territory in the north, laying siege to the main Tamil city of Jaffna in May.

Indian intervention

In 1987, the Indian government intervened to stop the bloodshed and managed to impose a short-lived peace agreement. The Indo-Sri Lanka Peace Accord of July 29, 1987 demanded official status for the Tamil language and for the Tamil Tigers to surrender arms to a peacekeeping force from India. However, violence soon broke out between the Tamil Tigers and the Indian Peace Keeping Force, leading to full-scale conflict. The IPKF was called back to India in 1989 and after the Tamil Tigers assassinated the former Indian prime minister, Rajiv Gandhi, in 1991, Indian support evaporated.

End of the war

Despite ceasefire agreements in 1990, 1995 and 2002, fighting continued sporadically over the next two decades. The government withdrew from the 2002 ceasefire in January 2008 and the war intensified. The government captured the Tamil Tiger strongholds of Kilinochchi and Mullaittivu in January 2009 and continued to fight until May 2009 when all remaining Tamil Tiger territory was in government hands. Many civilians were killed in the closing months of the war leading to widespread condemnation and calls for an inquiry.

TOP: **Sri Lankan government soldiers move into the Jaffna Peninsula, a Tamil Tiger stronghold in the north of the island, during an offensive in April 1996.**

MIDDLE LEFT: **Defence minister Anuruddha Ratwatte addresses government troops after hoisting the Sri Lankan flag over Jaffna in December 1995. Several thousand died during the offensive to capture the Tamil stronghold.**

MIDDLE RIGHT: **Flanked by bodyguards, a Tamil Tiger makes a show of strength during a photoshoot at a safehouse in Jaffna.**

ABOVE: **Two policemen monitor a curfew in the deserted capital, Colombo following a bomb blast in October 1994.**

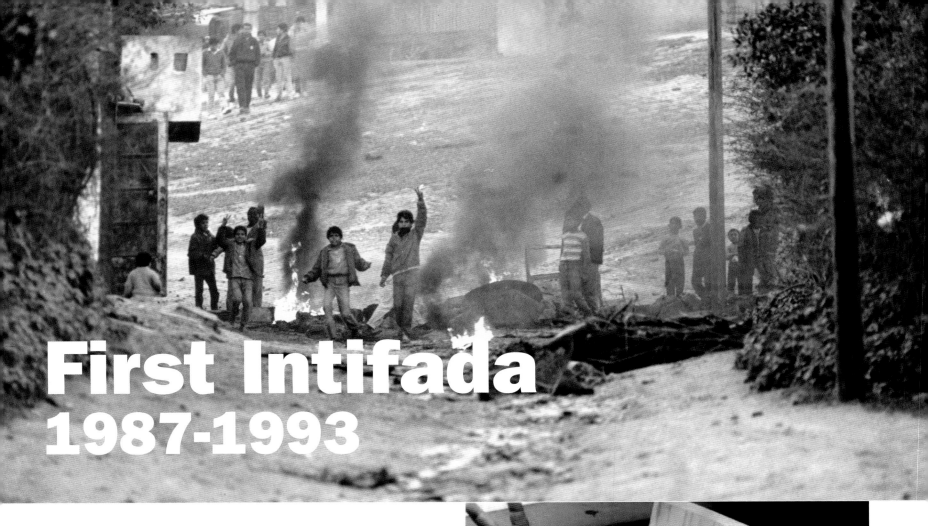

First Intifada
1987-1993

Grassroots uprising

By 1987 the West Bank and Gaza had been under Israeli occupation for two decades. The Palestinian population had grown weary, and the widespread belief that the Arab world had lost interest in their cause only added to their sense of frustration. This frustration translated into a full-scale uprising following an incident at the Jebaliya refugee camp in Gaza in December 1987. The Israel Defence Forces (IDF) used heavy-handed 'Iron Fist' tactics to disperse rioters in the camp, causing an outpouring of anger across Gaza and the West Bank, and giving rise to the First Intifada.

The Intifada, which means 'shaking-off', was very much a grassroots protest involving various acts of civil disobedience ranging from non-payment of taxes and general strikes to stone-throwing. The Palestinian Liberation Organization (PLO), in exile in Tunisia, was keen to coordinate and lead this spontaneous protest, but they were by now rivalled by Palestinian Islamic Jihad and Hamas, two Islamist movements vying for influence. The differing agendas of these three groups served to prolong and radicalize the uprising. The advent of militant Islamist groups saw a rise in the use of terror tactics, which would come to define the Second Intifada a decade later.

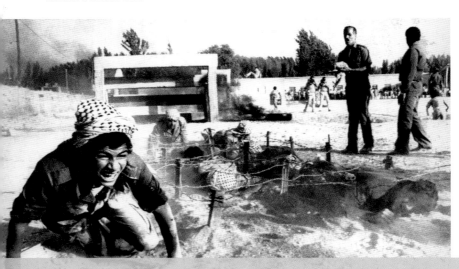

TOP: Palestinian youths set fire to tyres and debris to block the entrance to the Bureij refugee camp in the Gaza Strip.

ABOVE: A Palestinian woman protests against the Israeli occupation outside the Palestinian Affairs Department in Amman, Jordan. When the Intifada broke out in 1987, many Palestinians felt the Arab world had lost interest in their cause.

LEFT: PLO guerrillas train at a camp in Damascus, Syria, in 1986. The Intifada began as a grassroots uprising and initially the PLO had to respond to events rather than lead them.

Peace Process

The image of Palestinians throwing stones at Israeli tanks and well-armed soldiers caught the attention of the world and galvanized the Peace Process. This process began with a conference sponsored by the United States and the Soviet Union in Madrid in October 1991, and culminated in the signing of the Oslo Accords in September 1993. This Norwegian-brokered agreement secured the withdrawal of Israeli troops from parts of the West Bank and Gaza, and placed these areas under the administration of a newly created Palestinian National Authority. The PLO and Israel also bestowed formal recognition upon one another, and their leaders, Yasser Arafat and Yitzakh Rabin, famously shook hands on the White House lawn on September 13, 1993. Despite international jubilation, violence continued as Hamas and other militant Islamist groups remained outside the agreement and pressed on with their campaign against Israel. The Peace Process subsequently stalled as agreement could not be reached on controversial areas not covered by the Oslo Accords, namely control of East Jerusalem, the future of Israeli settlements in the West Bank and the right of Palestinian refugees to return to their homes.

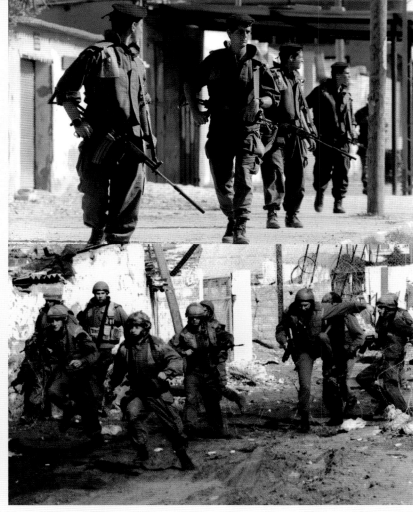

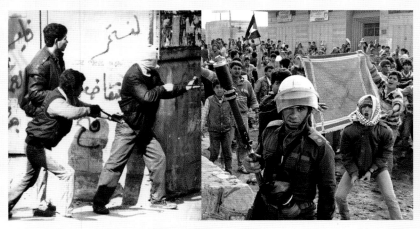

ABOVE RIGHT: **Palestinian youths jeer at an Israeli soldier in the Nuseirat refugee camp in the Gaza Strip. Many Palestinians who took part in the Intifada were youths who had spent their whole lives under the Israeli occupation.**

ABOVE LEFT: **Armed with catapults, Palestinians fire marbles at Israeli troops following Friday prayers in the casbah of Nablus.**

BELOW: **Yasser Arafat, Shimon Peres and Yitzakh Rabin share the 1994 Nobel Peace Prize for their role in the Peace Process. The following year, Rabin was assassinated by a Jewish extremist who was opposed to the Peace Process.**

TOP: **Israeli troops are on high alert as they patrol along Baghdad Street in Gaza City.**

ABOVE: **Israeli troops respond to a group of stone-throwers in the Jebaliya refugee camp in the Gaza Strip.**

Panama 1989

American invasion

On December 20, 1989 the US launched Operation Just Cause, a surprise invasion of Panama. President Bush sought to protect American citizens in the country after an American serviceman had been killed by the security forces of the Panamanian ruler, General Manuel Noriega. Bush also had a legal obligation to protect the Panama Canal Zone and sought to restore democracy and the rule of law in the country following rigged elections. Noriega had fixed a May 1989 Presidential election when it became clear that his opponents would win.

The US already had almost 15,000 men in Panama policing the Canal Zone in 1989, and another 15,000 were brought in for the invasion. Within days the Panamanian Defense Force was defeated and a new government was formed under Guillermo Endara, the legitimate winner of the rigged May 1989 elections. On January 3, 1990, Noriega was captured and later sent to the United States to face trial on charges of drug-trafficking and money-laundering.

ABOVE: US Marines advance through a hostile neighbourhood in Panama City during Operation Just Cause.

MIDDLE: Manuel Noriega talks to the press to deny claims that he rigged the election in May 1989.

RIGHT: President Bush welcomes General Maxwell Thurman, the commander of the US Forces in Panama, to the White House to commend him and his troops for their 'outstanding' work. Twenty-three American servicemen lost their lives during the operation.

Kashmir Insurgency 1989 -

The Kargil War

In May 1999, India discovered that Pakistani troops had crossed the Line of Control near Kargil during the winter while Indian troops had retreated to lower altitudes. The Indian army was mobilized and the Pakistani positions were attacked from the air in what became known as the Kargil War. The Pakistani government denied the incursion, claiming that the troops were insurgents, and criticized India for using airstrikes in Kashmir. The international community quickly intervened to prevent a wider war between the two nuclear powers, and the conflict ended in July 1999, by which time India had already pushed most of the insurgents out of the country.

The Line of Control

Ever since Partition in 1947, both India and Pakistan have claimed ownership of Kashmir, the mountainous territory lying between them in the north. The two countries went to war over the territory in 1948, following which a UN resolution stated that a plebiscite should be held, allowing the Kashmiris to choose. This never happened, and the situation still remains unresolved. War broke out between India and Pakistan again in 1971, after which the old ceasefire line became a formal Line of Control, dividing Indian-controlled Kashmir from the part administered by Pakistan.

Insurgency

In 1989, Islamic militants began an insurgency in Indian-controlled Kashmir. Some of the insurgents were Kashmiris demanding independence from India, while others were veterans of the Soviet-Afghanistan war, looking for a new location to fight their Holy War. In addition to attacking and killing Indian soldiers and Hindu civilians, the insurgents targeted moderate Muslims in an attempt to radicalize and divide the population. Clashes have continued ever since; thousands have been killed, and more than 250,000 people are believed to have fled from their homes.

Despite establishing the Line of Control, the issue of Kashmir has continued to sour relations between India and Pakistan. The Indian government argues that Pakistan has been stirring up the insurgency by helping outside militants enter Indian-controlled Kashmir. Pakistan consistently denies this, charging that the militants fighting against Indian rule are natives.

Continued hostilities

India and Pakistan continued to trade gunfire across the Line of Control and the insurgency in Indian-controlled Kashmir persisted. In October 2001 scores of people were killed when militants attacked the Kashmir Assembly in Srinagar. Two months later they attacked the Indian Parliament building in New Delhi killing seven people and outraging public opinion in India. The Indian government blamed Pakistan for sponsoring the audacious attack and deployed thousands of extra troops to Kashmir. A full-scale war was again averted, but only after General Musharraf, the ruler of Pakistan, made a speech pledging to do more to stop Pakistan-based militants from entering Indian-controlled Kashmir.

Talks between India and Pakistan led to a ceasefire in November 2003. Since then fewer militants have crossed the border and there has been a reduction in violence in Kashmir, although terrorist attacks have occurred in cities across India. The situation remains fragile; with political instability in Pakistan and the presence of large armies on both sides of the Line of Control, a return of hostilities is likely.

TOP: **Indian forces patrol their side of the Line of Control in Kashmir, the world's highest battleground.**

LEFT: **Kashmiri separatist leader Shabir Shah leads a march in Srinagar in Indian-controlled Kashmir. Pakistan claims the insurgency is being fuelled by separatists from within Indian-controlled Kashmir. India argues that the insurgents are coming in from outside with the help of the Pakistani government.**

ABOVE: **A camouflaged Pakistani soldier takes position in a bunker near Chakoti on the Line of Control.**

Romania 1989

The Communist monarchy

By 1989 Nicolae Ceausescu and his wife, Elena, had ruled Communist Romania like King and Queen for more than two decades. In relation to other East European Communist leaders, they were mavericks who broke with Soviet domination and asserted an independent foreign policy. However, the cost of maintaining an independent military, as well as paying for a series of grandiose construction projects, took its toll on the Romanian economy. In the 1980s, Ceausescu instituted a severe austerity programme designed to clear the debt in only a few years. The programme was a failure and resulted in shortages of food, electricity and consumer goods across the country. This led to widespread dissatisfaction with the regime, but the Ceausescus had a well-oiled security apparatus and dissenting voices were normally silenced before they could spread.

Spillover

By December 1989 Eastern Europe had witnessed great upheaval; the Communist regimes in Poland, Hungary, Czechoslovakia and East Germany were all in the process of collapse. The Ceausescus believed their independence from the Soviet bloc and their muscular security services would insulate them from the contagion. However, Romania had an Achilles' heel in the form of a sizeable Hungarian population in the east. These Hungarians watched as Communism unravelled in Hungary, and dissent soon spread across the border.

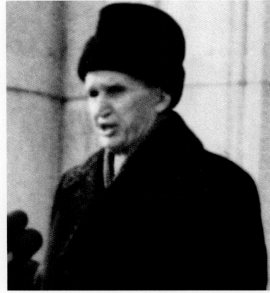

BELOW: Bucharest, December 22, 1989. With the Ceausescus in flight, thousands fill the centre of Bucharest. However, security officers still loyal to the regime continued to engage in a violent counter-revolution.

LEFT: Romania's dictator delivers his last speech from the balcony of the Communist Party Headquarters in Bucharest, December 21, 1989. A stunned Ceausescu listened as the crowd began jeering during his speech.

OPPOSITE ABOVE: The end of an era: a statue of Lenin is removed from a square in Bucharest. Although the National Salvation Front was made up of members of the Communist party, they set Romania on a path to democracy and later EU membership.

OPPOSITE BELOW: A soldier guards Ceausescu's bedroom at his private residence.

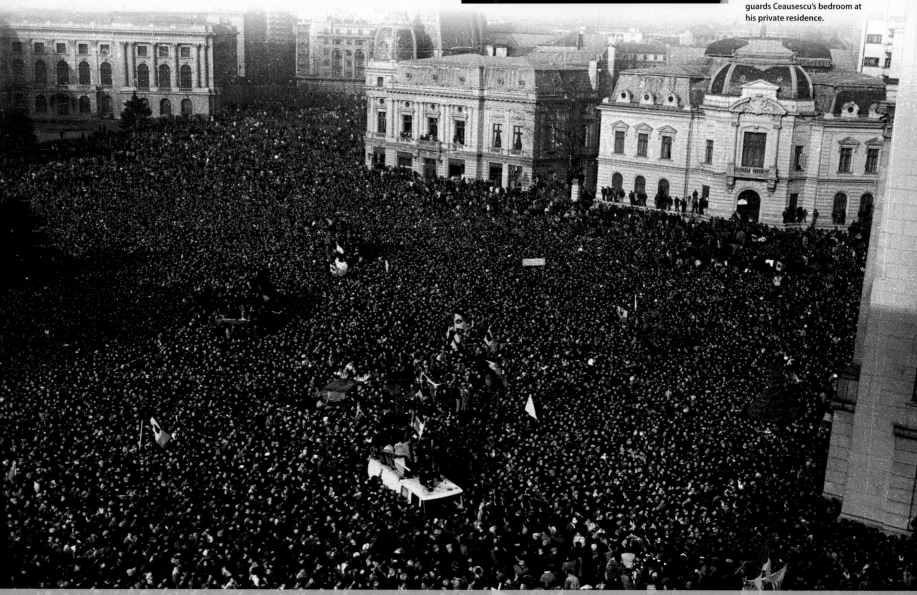

Revolution

The Romanian revolution began on December 16, 1989 when a protest broke out in the eastern city of Timisoara. The regime had tried to evict a Hungarian pastor named László Tökés for publishing an article critical of the regime's policies. Emboldened by changes occurring in Hungary, the town's Hungarian population gathered outside his home and refused to allow the eviction to take place. The insurrection quickly spread as the repressed, impoverished Romanian population of the town took up the cause. The protestors chanted anti-Communist slogans and attempted to burn down the regional Communist party headquarters. Secret police arrested protesters or beat them up, but were unable to stop the protests.

On December 17 martial law was declared and the army was sent in to disperse the crowds. They opened fire and a number of protestors were massacred. The fighting escalated on both sides and Timisoara became a warzone.

DAILY MAIL DECEMBER 26 1989

The Tyrant Is Dead

Deposed Rumanian tyrant Nicolae Ceausescu and his wife Elena were executed last night after a secret court martial. The couple who misruled Rumania with megalomaniac zeal for almost 25 years were found guilty of the genocide of 60,000 people, stealing one billion dollars from the state and undermining the national economy.

The announcement by Rumania's interim government, the National Salvation Front, was carried on state radio and television. The TV said: 'Nicolae and Elena Ceausescu have been sentenced to death, and their property has been confiscated. The sentence is definitive and has been carried out.'

It took viewers completely by surprise and was followed moments later by a cheerful bearded Santa Claus driving through snow and singing Jingle Bells. 'Oh, what wonderful news,' a Bucharest radio announcer said. 'The anti-Christ died on Christmas Day.'

The broadcasts did not specify how or where the executions were carried out or where the two were tried. Executions in Rumania have usually been carried out by firing squad.

There was no word of the fate of the couple's son and daughter Nicu and Zoia-Elena, who were paraded before television viewers after their arrests on Friday and Sunday.

The news was of the executions also given by the French ambassador in Bucharest, M Le Breton. He told French TV viewers: 'I have just been informed that the Bucharest Military Tribunal brought the Ceausescus to trial on a charge of genocide. They were both found guilty and the death sentence was carried out immediately.'

Ceausescu, 71, and his wife, who would have been 71 next month, fled the capital on Friday in a helicopter and were reportedly captured in an underground bunker on Saturday.

The Ceausescus fall

On December 21, after returning from a trip to Iran, Ceausescu addressed an assembly of 110,000 people from the balcony of Communist headquarters in Bucharest. He tried to stoke ethnic tensions by blaming the unrest on Hungarians, but many Romanians in the crowd were unconvinced and began chanting insubordinately. Loud bangs were heard and a rumour quickly spread that the secret police were firing on the crowd. The scene quickly descended into a battle between ordinary civilians and the Ceausescus' security forces. The riots spread as workers downed their tools and joined the revolution. The army switched sides, but the secret police remained loyal and continued to fight, prolonging the bloodshed. The Ceausescus fled the city by helicopter, but they were captured by the army and taken to a barracks for trial. They were found guilty of crimes against the state and were executed on Christmas Day 1989. The violent revolution petered out and a new government called the National Salvation Front came to power promising an end to the one-party system.

ABOVE: The collapse of the Ceausescu regime revealed the terrible plight of Romania's orphans. The Ceausescus outlawed abortion and contraception in a bid to raise the birth rate. However, the country was unable to care for the number of abandoned children and they were forced to live in terrible conditions. A shocked world poured aid into the country during the 1990s and conditions improved.

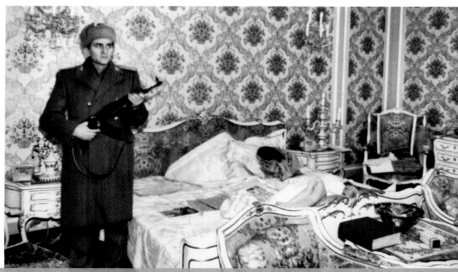

The Gulf War 1990–1991

Operation Desert Storm

The Gulf War, codenamed Operation Desert Storm, lasted for just 42 days in 1991, but the build-up to the conflict played out over a much longer period. The origins of the conflict lie in the bloody Iran-Iraq war, during which more than 200,000 Iraqis were killed in Saddam Hussein's attempt to win military glory and defeat the Islamic Revolutionary government in Iran. Most Arab nations, including Kuwait, supported Iraq, fearing that Iran wanted to dominate the region and spread its revolution.

By the time the war ended in an inglorious stalemate in 1988, Iraq had amassed huge debts in countries across the world. Iraqi oil production had been affected by the war, meaning that Saddam was in no position to repay his foreign creditors. Matters were made much worse when Kuwait increased its oil production by 40 per cent over its OPEC quota, causing a slump in world oil prices. Eager for a clear military victory, unable to finance his foreign debts and desperate to keep his military occupied, Saddam saw an easy answer to all his problems in the oil-rich kingdom to his south.

Iraq invades Kuwait

In 1988 and 1989, the Iraqi government attempted to extract territorial concessions from Kuwait in compensation for fighting the war against Iran on its behalf. Kuwait did not accept the proposal leaving Saddam outraged and on a fast track to war. Emboldened by the belief that Iraq had a historic claim to Kuwait and convinced by a conversation with the US ambassador that Washington would not intervene, Iraq invaded. The pretext for the war would be that Kuwaiti oilrigs were slant drilling and illegally tapping into Iraqi oil fields.

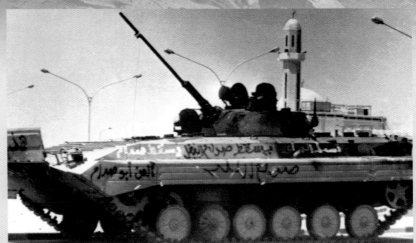

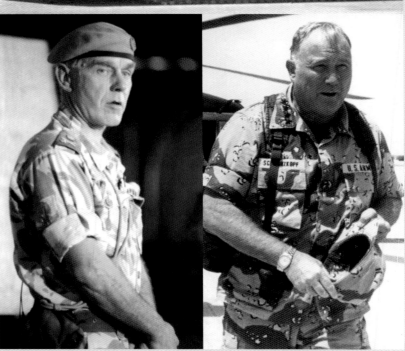

ABOVE: Abandoned vehicles line the 'Highway of Death', the road between Kuwait City and Basra. Following the Allied invasion, Iraqi soldiers tried to flee Kuwait in any available means of transport, but most were intercepted and destroyed.

MIDDLE: An Iraqi tank rolls into Kuwait City during the invasion in August 1990.

RIGHT: The Commander in Chief of British military during the Gulf War, General Sir Peter de la Billiere, was a member of the SAS and had led the Special Forces during the Iranian Embassy Siege in 1980.

FAR RIGHT: As commander of United States Central Command (CENTCOM), the operations in the Gulf fell under the jurisdiction of General Norman Schwarzkopf. Schwarzkopf had distinguished himself during two tours in Vietnam, the 1983 campaign in Grenada and as a teacher at West Point.

OPPOSITE ABOVE RIGHT: The 1st Battalion of the Staffordshire Regiment keeps watch for an Iraqi invasion along the Saudi side of the border with Kuwait.

OPPOSITE ABOVE LEFT: RAF Tornado jets at Bruggen in Germany prepare to fly to the Gulf, August 17, 1990.

OPPOSITE MIDDLE: Iraqi President Saddam Hussein appearing defiant on Iraqi Television.

OPPOSITE BELOW LEFT: Allied troops try out new equipment designed to protect against chemical warfare. Saddam had used chemical weapons during the war with Iran as well as against his own people in the Kurdish village of Halabja in 1988.

OPPOSITE BELOW RIGHT: Wreckage of British Airways Flight 149 at Kuwait International Airport.

Operation Desert Shield

On August 2, 1990, Iraqi forces crossed the border and quickly seized control of the smaller nation. However, across the world this move was seen as a threat to Middle East stability and to worldwide oil supplies, so within days the United States, along with the United Nations, demanded Iraq's immediate withdrawal. Within a week King Fahd of Saudi Arabia had requested help to protect his country from possible attack, since Iraqi troops were now within striking distance of major Saudi oil fields. Iraqi control of these, along with the Kuwait and Iraqi reserves, would have given them ownership of the majority of the world's reserves, so the United States and other UN member nations began deploying troops in Saudi Arabia under the codename Operation Desert Shield. Iraq's access to the sea was quickly blockaded, and a trade embargo was put in place.

By November, with no sign of Iraq complying with requests to leave Kuwait, the UN Security Council authorized the use of 'all means possible' to eject Iraq from Kuwait, and UN member countries began putting together a force to achieve this. By the end of 1990 it was clear that diplomatic measures had failed to achieve an Iraqi withdrawal from Kuwait and meanwhile over half a million Allied troops had been deployed in Saudi Arabia and throughout the Gulf region.

British Airways flight 149

British airways flight 149 from London to Kuala Lumpur stopped as scheduled in Kuwait to refuel in the early hours of the morning on August 2, 1990. Just hours earlier, the Iraqi invasion of Kuwait had started leaving the passengers of flight 149 stranded in a war zone.

The Iraqi army quickly overran the airport and the passengers were rounded up and taken to Baghdad. From there they were relocated to strategic sites across the country to act as human shields to deter the West from airstrikes.

After months in captivity Saddam released the hostages. None was killed by the Iraqis, but all were shaken by their ordeal and one man died from a heart attack.

From the moment the crisis began, questions arose as to why British Airways had landed a passenger airliner in a country teetering on the brink of a war. It has been alleged that the British government used the plane to transport agents into the country ahead of the invasion. British Airways maintains that it had no knowledge that the invasion had started when the plane landed.

The air offensive

The most powerful and successful air assault in the history of modern warfare began on January 17, 1991. After disabling the Iraqi early-warning systems by introducing a virus into the computer systems, Allied forces began a devastating campaign from both land and sea, targeting Iraq and the Iraqi forces still in Kuwait. The bombs and missiles were aimed to destroy Iraq's command and control centres in order to hinder their ability to make war effectively, while at the same time damaging civilian infrastructure to destroy the population's morale. Saddam Hussein immediately ordered the launch of his SCUD missiles in retaliation, targeting both Saudi Arabia and Israel. Although Israel was not directly involved in the attack on Iraq, Saddam hoped that they would be provoked into striking back, igniting the ongoing hostility between Israel and the Arab world and causing the Arab nations to split away from the Allied coalition. Although Israel did indeed want to retaliate, President George Bush pledged to protect Israel from the SCUDs if they held back. As a result, US missile batteries were deployed in Israel to shoot down SCUDs. The SCUD launches successfully diverted Allied air power, since planes were tied up hunting for the mobile SCUD missile launchers rather than continuing to attack. Despite this, the air strikes and cruise missile attacks against Iraq were truly devastating and successfully cleared the way for the ground attack that was to follow.

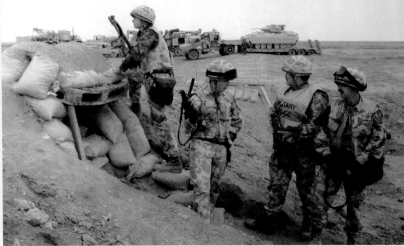

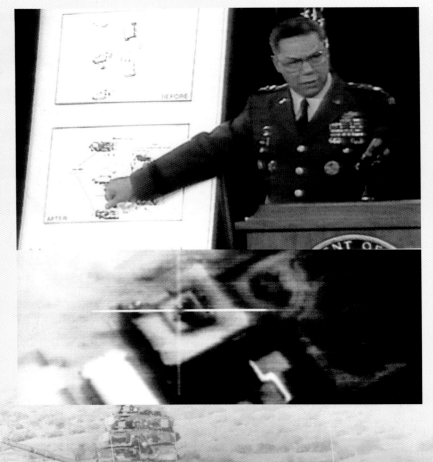

DAILY MAIL JANUARY 17, 1991

Blitz on Baghdad

American and British warplanes blasted the centre of Baghdad early today. Other raids were launched on military targets throughout Iraq in 'Operation Desert Storm'. US Defence Secretary Dick Cheney confirmed that chemical and nuclear plants had been attacked. Iraqi ground fire was largely ineffective, and all the allied planes were said to have returned safely to their bases.

At least five waves of bombers swept in to blitz Baghdad. Saudi Arabian and French planes also took part. The attack, 16 hours after the expiry of the UN deadline for Saddam Hussein to withdraw from Kuwait, took the Iraqi capital by surprise, and the city was still brightly lit as bombs exploded. In Israel a radio ham intercepted messages from the British military network saying the raids had gone 'exceptionally well'.

President George Bush said in a broadcast to America: 'Tonight battle has been joined ... the world could wait no longer.'

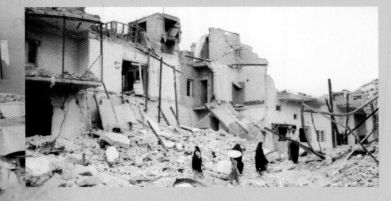

Attack on Saudi Arabia

On January 29, Iraq attacked and occupied the Saudi city of Khafji, which had only been lightly defended. However, within a couple of days the Iraqi troops were driven out of the city again by Saudi and Qatari forces, supported by US Marine Corps and with back-up air strikes. Khafji had become an important strategic position immediately after the Iraqi invasion of Kuwait, since it was ideal as a base for the Iraqis to move into the eastern part of Saudi Arabia and take control of the major oil fields there. It would also have provided an excellent defensive position from which to fight Allied troops, so Iraq's failure to commit armoured divisions to hold onto the city is seen as a grave strategic error.

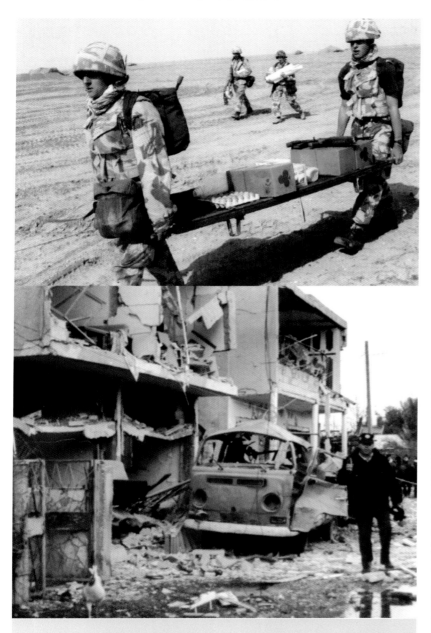

DAILY MAIL JANUARY 22, 1991
What has he done to them?

A shocked world yesterday saw the brutal treatment of captured British and US fliers by Saddam Hussein's regime. Two RAF men paraded on TV by Iraq bore the signs of vicious abuse - by drugs, torture or brainwashing. And the latest threat to Tornado pilot John Peters and his navigator Adrian Nichol is that they will be among more than 20 prisoners used as human shields against air raids.

The Iraqi dictator's cruelty made a mockery of his country's signing of the Geneva Convention on treating PoWs - but he could face fierce retribution. Prime Minister John Major told the Commons yesterday that those responsible for outrages would be brought to account. This could mean Saddam facing a war crimes trial.

President Bush, questioned about the parading of US prisoners, said: 'America is angry, the rest of the world is angry.' Asked whether Saddam would be held accountable, he replied: 'You can count on it.'

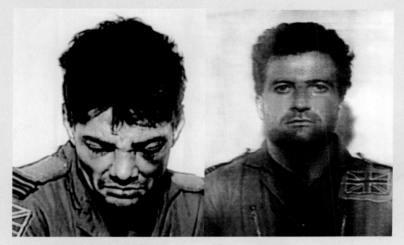

RIGHT: **Tornado pilot Flight Lieutenant John Peters and his navigator, Flight Lieutenant Adrian John Nichol (**_left_**) are paraded on Iraqi** television after being shot down during a bombing raid over Iraq. Both showed signs of having been tortured.

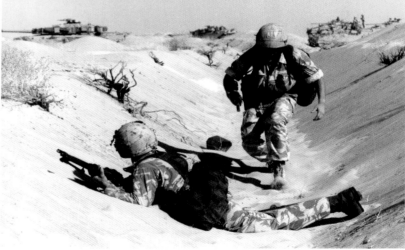

DAILY MAIL JANUARY 18, 1991
Israel hit by missiles

The world's worst nightmare began to unfold early today when Saddam Hussein fulfilled his terrifying promise and sent missiles thundering into Israel. They hit the suburbs of Haifa and Tel Aviv and within minutes Israeli jets were being scrambled for a retaliatory strike across Jordan and into Iraq. Allied jets were also in the air seeking out the Scud launchers.

The Pentagon said that Iraq launched 10 missiles at Israel. Of the eight which landed, two hit Tel Aviv, one near a major hospital. Another fell in the Haifa area, three in unpopulated areas and one was unaccounted for. The Pentagon said it believed they were not carrying chemical warheads.

The Allies believed earlier that their devastating air strikes had taken out all of Saddam Hussein's Scuds in their silos.

OPPOSITE ABOVE LEFT: **Colin Powell, chairman of the Joint Chiefs of Staff, gives a detailed score card of Allied progress one week into the operation. He announced that after 12,000 sorties, coalition forces had gained air superiority.**

OPPOSITE ABOVE RIGHT: **Baghdad on the morning of January 18, 1991. The skies erupt with anti-aircraft fire as US warplanes strike targets in the Iraqi capital.**

OPPOSITE MIDDLE RIGHT: **Military police stand guard in their dugout. They are on hand to police more than half a million men who arrived in Saudi Arabia in a short space of time.**

OPPOSITE BELOW RIGHT: **Iraqis search among the rubble of homes in the Suq Ag Ghaddim District of Central Baghdad on March 12, 1991. These are among the 14 private homes destroyed during the air offensive.**

ABOVE LEFT: **Food rations being carried by stretcher across the desert.**

BELOW LEFT: **The aftermath of an Iraqi missile SCUD attack on Tel Aviv.**

ABOVE: **Allied soldiers train in desert camouflage in Saudi Arabia.**

The ground offensive

When the Allied armies launched the ground war on February 23, the Iraqi occupation forces in Kuwait were in disarray and thousands of soldiers simply gave themselves up. The Allied coalition had managed to convince the Iraqi command that they would attack along the Saudi-Kuwait border and by amphibious assault. However, two entire corps of US forces, supported by British and French divisions, had been swiftly moved to the west under cover, in one of the largest battlefield troop movements in history. More than 250,000 soldiers, spread across a hundred miles, moved deep into Iraqi territory from the Saudi border to deliver a fatal blow behind the Iraqi lines and cut off all avenues of retreat north and west of Kuwait. The Allies pushed through most of Iraq's defences with ease, and even where elite Iraqi forces stood and fought they were no match for superior Allied equipment and training.

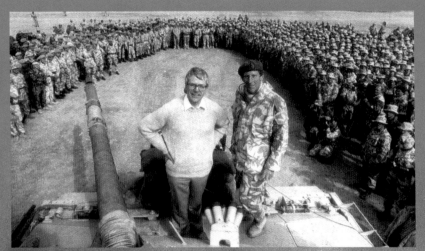

DAILY MAIL FEBRUARY 27, 1991

Freedom

Kuwait city was back in the hands of its people last night, 209 days after being seized by Iraq. Elated residents poured onto the streets, weeping and shouting, after the invaders fled in their thousands leaving resistance leaders to take control. On the outskirts of the capital, a massive Arab army was poised to drive into the centre at dawn to raise the flag of liberation.

But despite a widespread Iraqi retreat across Kuwait, the war was still raging. Just ten miles south of the city, a fierce tank battle was being fought for control of its airport. The Allies said they expected to gain control by dawn.

And on the Iraq border, the Desert Rats were involved in a massive Allied troop movement to surround the Republican Guard after President Bush and Prime Minister John Major both demanded total Iraqi surrender as the price of a ceasefire.

A Republican Guard division of up to 12,000 troops was said to have been defeated in darkness and pouring rain by the US VII Corps late last night. A second division was being engaged but the elite units were offering 'stiff resistance', a senior military officer said. Fifty of the Guard's best T-72 tanks were captured as they fled northward.

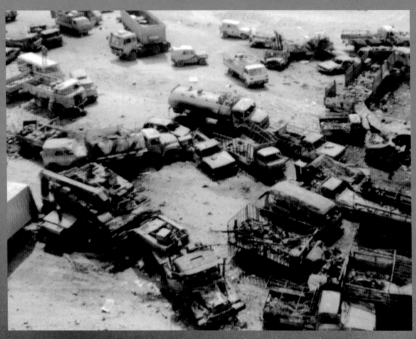

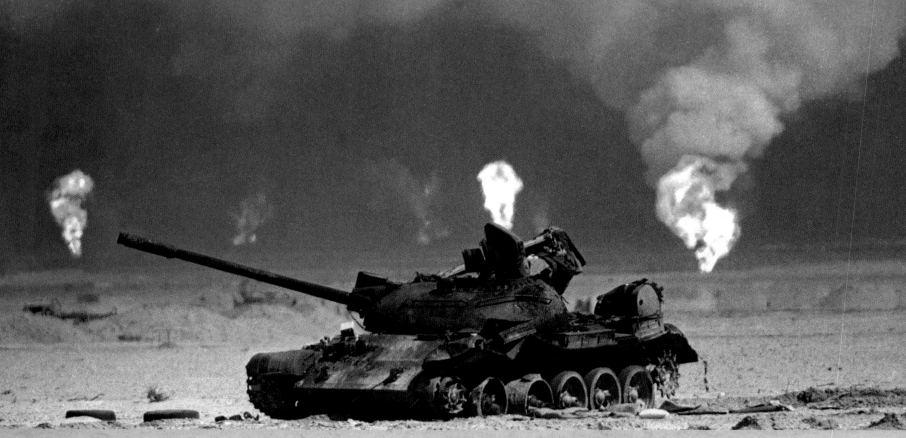

My nightmare, by Stormin' Norman

The tough, uncompromising commander of 550,000 Allied troops in the Gulf yesterday revealed the private emotional toll of war. 'Every waking and sleeping moment my nightmare is the fact that I will give an order that will cause countless numbers of human beings to lose their lives,' said General Norman Schwarzkopf. 'I don't want my troops to die. I don't want my troops to be maimed. It's an intensely emotional thing for me.'

The 56-year-old, four-star general said he didn't think he was getting enough rest. 'I wake up 15, 20, 25 times in a night and my brain is just in a turmoil over some of the agonizingly difficult decisions that I have to make...it's awful lonely at the top.'

Stormin' Norman said he had no specific timetable for the war and the final decision for a ground attack would be based on a compendium of results and 'gut feel.'

Liberation of Kuwait

On February 26 Iraqi troops began retreating from Kuwait, setting fire to Kuwaiti oil fields as they left. Retreating Iraqi troops streamed along the main Iraq-Kuwait highway, which was bombed extensively by the Allies and came to be known as the 'Highway of Death'. Allied forces pursued retreating Iraqis over the border into Iraq, and to within 150 miles of Baghdad before withdrawing. The Allied coalition, along with Kuwaiti resistance forces, now controlled Kuwait City. After the ceasefire on February 27, surviving Iraqi troops were allowed to escape back into southern Iraq and the Emir of Kuwait was quickly restored to power. On March 3, 1991, Iraq accepted the terms of the cease-fire and the fighting ended. However, Saddam Hussein still remained in power in Iraq – although many hoped that he would soon be brought down by an internal rebellion.

OPPOSITE BELOW: As the Iraqi troops withdrew they implemented a scorched earth policy, setting alight to Kuwait's oil wells. The blazes took months to put out and adversely affected both the economy and environment. Eleven years later, on December 7, 2002, Saddam Hussein apologized to the Kuwaiti people for his invasion, saying he was not speaking from weakness but a desire to set the record straight.

OPPOSITE ABOVE LEFT: A devastated convoy of vehicles on the road to Basra, March 1, 1991.

OPPOSITE ABOVE RIGHT: British Prime Minister John Major poses with the Desert Rats of the 7th Armoured Brigade in Kuwait.

FAR LEFT: General Norman Schwarzkopf is met at Heathrow airport by British army commander General Sir Peter de la Billiere in July 1991. Throughout the conflict the two generals met daily to make sure the Allies worked in harmony.

LEFT: Saddam Hussein fires his gun into the air in celebration of George Bush's election defeat, during a visit to the city of Ramadi. A defiant Hussein warned other enemies to learn from Bush's mistake.

BELOW: A column of Iraqi prisoners of war, captured by Task Force Ripper of the U.S. First Marine Division marches to a processing area in Kuwait on February 26, 1991.

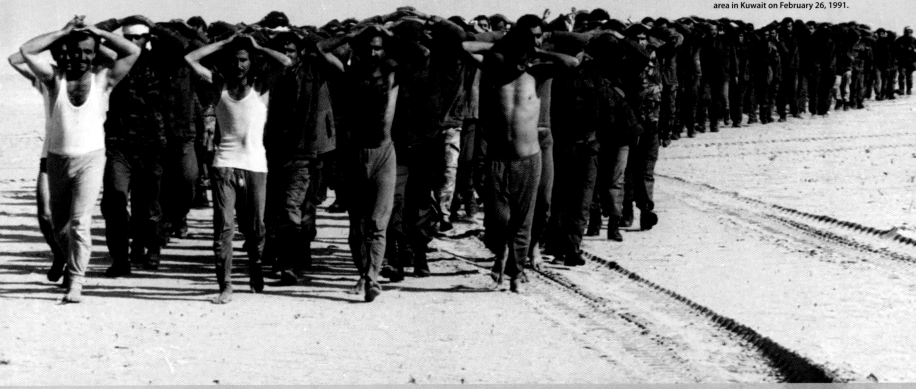

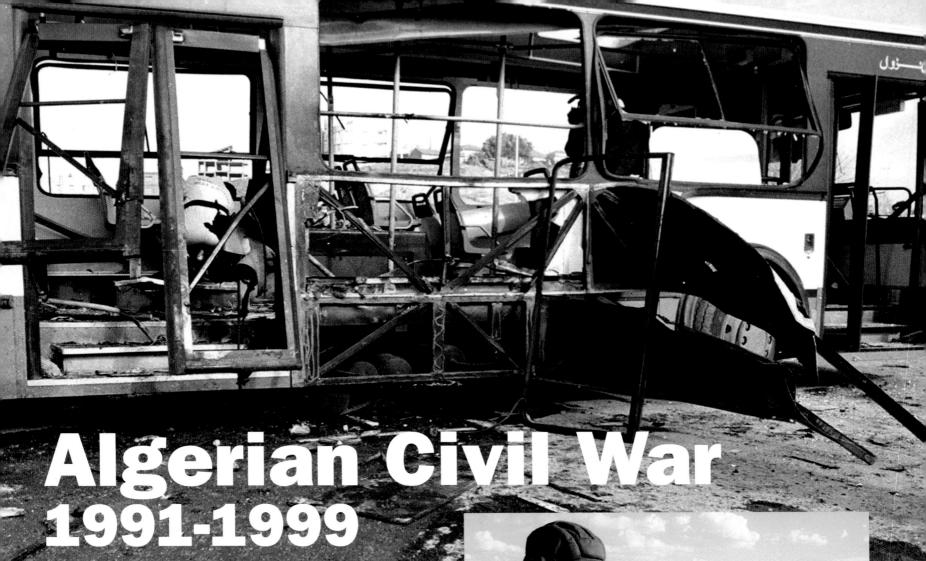

Algerian Civil War
1991-1999

Economic crisis

By the late 1980s, Algeria's economy was almost totally reliant upon its oil exports. A collapse in the price of oil in 1986 sparked a serious economic crisis and led to major rioting by urban youths who were feeling the pinch as unemployment rose sharply. The riots, combined with a global trend towards democratization at the end of the Cold War, convinced the ruling National Liberation Front (FLN) to relinquish its thirty-year-old grip on power and allow democratic elections in Algeria.

With Algeria's leftwing weakened by decades of incumbency, the poor turned towards Islamists to help navigate a way out of the crisis. As a result, the main Islamist party the Islamic Salvation Front (FIS) won a decisive victory in the first round of legislative elections in 1991. However, fearing that the FIS would install Sharia Law and make Algeria an Islamic state, the army staged a coup before the second round of voting could occur. The FIS was banned and its members fled into exile or were sent to internment camps deep in the Sahara desert.

Civil War

The suppression of the elections led many supporters of the FIS to seek non-democratic paths to power. Militant Islamist groups had already been operating in Algeria on a small scale during the 1980s, but their support base swelled in the aftermath of the coup and Algeria plunged deep into a bloody civil war.

The young urban poor supported an Islamist movement called the Armed Islamic Group (GIA), which was a splinter of an Islamist faction founded in the early 1980s. They were assisted by veterans of the war in Afghanistan, who moved to Algeria to continue their jihad following the Soviet Union's withdrawal. GIA's campaign against the government was marked by exceptional violence as Algerian civilians were attacked indiscriminately in order to demonstrate that the military regime could not protect their citizens. GIA also conducted a series of terrorist attacks in France, including the hijacking of an Air France plane in December 1994 and a series of attacks on the Paris Metro in the autumn of 1995.

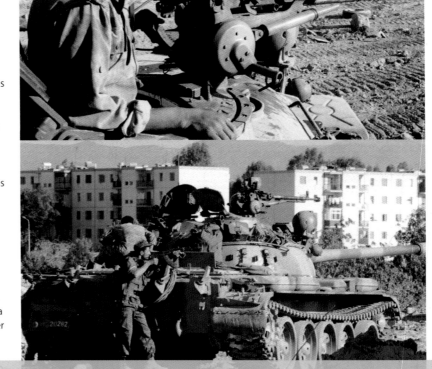

Infighting

Some of the worst bloodshed occurred as a result of infighting within the Islamist movement. The Algerian army had a great deal of success at decapitating GIA, which caused a rapid turnover in its leadership. This resulted in bloody power disputes as the various factions of radical Islam fought over the future direction of the movement. In addition, violent clashes often broke out between GIA and the more moderate Islamic Salvation Army (AIS). The AIS was created by members of the FIS who abhorred the violence of GIA, but believed armed resistance was necessary to ensure the party maintained a role in Algerian political life.

End of the Civil War

The leadership of GIA became ever more extreme and some of the worst atrocities of the war occurred in 1997 and 1998. As a result, people began abandoning the movement in droves, especially after the new president, Abdelaziz Bouteflika, introduced a new law giving amnesty to the majority of guerrilla fighters. Those who did not surrender their campaign broke away from GIA to distance themselves from the atrocities. They formed the Salafist Group for Preaching and Combat (GSPC), which soon began targeting civilians once again. The GSPC, which has strong links with Al Qaeda, has been unable to find much support among the war-weary Algerian population and its operation has largely been confined to the desert.

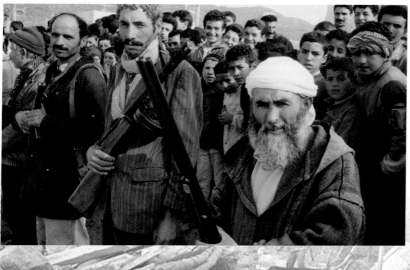

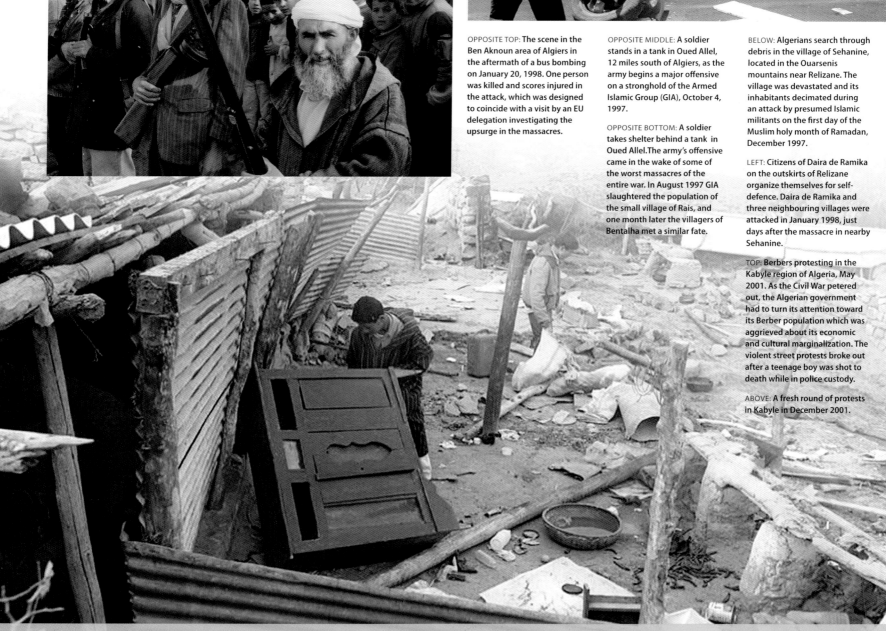

OPPOSITE TOP: The scene in the Ben Aknoun area of Algiers in the aftermath of a bus bombing on January 20, 1998. One person was killed and scores injured in the attack, which was designed to coincide with a visit by an EU delegation investigating the upsurge in the massacres.

OPPOSITE MIDDLE: A soldier stands in a tank in Oued Allel, 12 miles south of Algiers, as the army begins a major offensive on a stronghold of the Armed Islamic Group (GIA), October 4, 1997.

OPPOSITE BOTTOM: A soldier takes shelter behind a tank in Oued Allel. The army's offensive came in the wake of some of the worst massacres of the entire war. In August 1997 GIA slaughtered the population of the small village of Rais, and one month later the villagers of Bentalha met a similar fate.

BELOW: Algerians search through debris in the village of Sehanine, located in the Ouarsenis mountains near Relizane. The village was devastated and its inhabitants decimated during an attack by presumed Islamic militants on the first day of the Muslim holy month of Ramadan, December 1997.

LEFT: Citizens of Daira de Ramika on the outskirts of Relizane organize themselves for self-defence. Daira de Ramika and three neighbouring villages were attacked in January 1998, just days after the massacre in nearby Sehanine.

TOP: Berbers protesting in the Kabyle region of Algeria, May 2001. As the Civil War petered out, the Algerian government had to turn its attention toward its Berber population which was aggrieved about its economic and cultural marginalization. The violent street protests broke out after a teenage boy was shot to death while in police custody.

ABOVE: A fresh round of protests in Kabyle in December 2001.

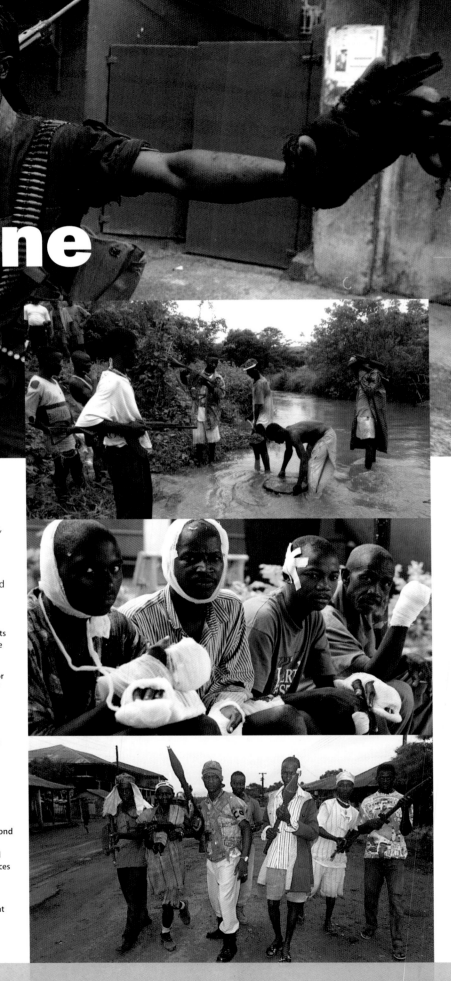

Sierra Leone Civil War 1991-2002

Child soldiers

A civil war broke out in Sierra Leone in 1991 when a rebel group named the Revolutionary United Front (RUF) began attacking settlements in the east of the country. The rebels were opposed to the government's corruption and an unequal distribution of the nation's wealth, especially the funds derived from diamond sales. The war became infamous for the use of child soldiers by the rebels. After being kidnapped from their families or being orphaned in the fighting, these children were turned into killing machines by the rebels, often with the aid of drugs. The pro-government militias, the Kamayors, are also thought to have employed child soldiers.

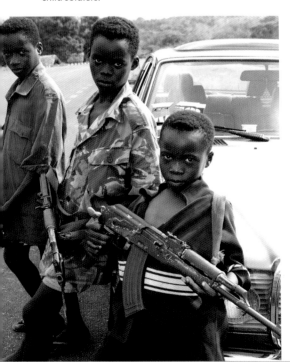

TOP: An armed man patrols the streets of Freetown, Sierra Leone, during the country's decade-long civil war.

ABOVE RIGHT: Civilian workers pan for diamonds under the watchful eye of the Kamayor.

MIDDLE RIGHT: People mutilated by rebels wait for hospital treatment in Freetown. The rebels were infamous for mutilating civilians during the war. By injuring and not killing the civilian population, the rebels were able to increase the burden on the government's resources.

BELOW RIGHT: Pro-government Kamayor militias patrol near a diamond mine in the village of Hanga. Some of the most severe fighting occurred when government and the rebel forces fought for control of the country's lucrative diamond mines.

LEFT: Child soldiers man a checkpoint sixty miles outside the capital, Freetown.

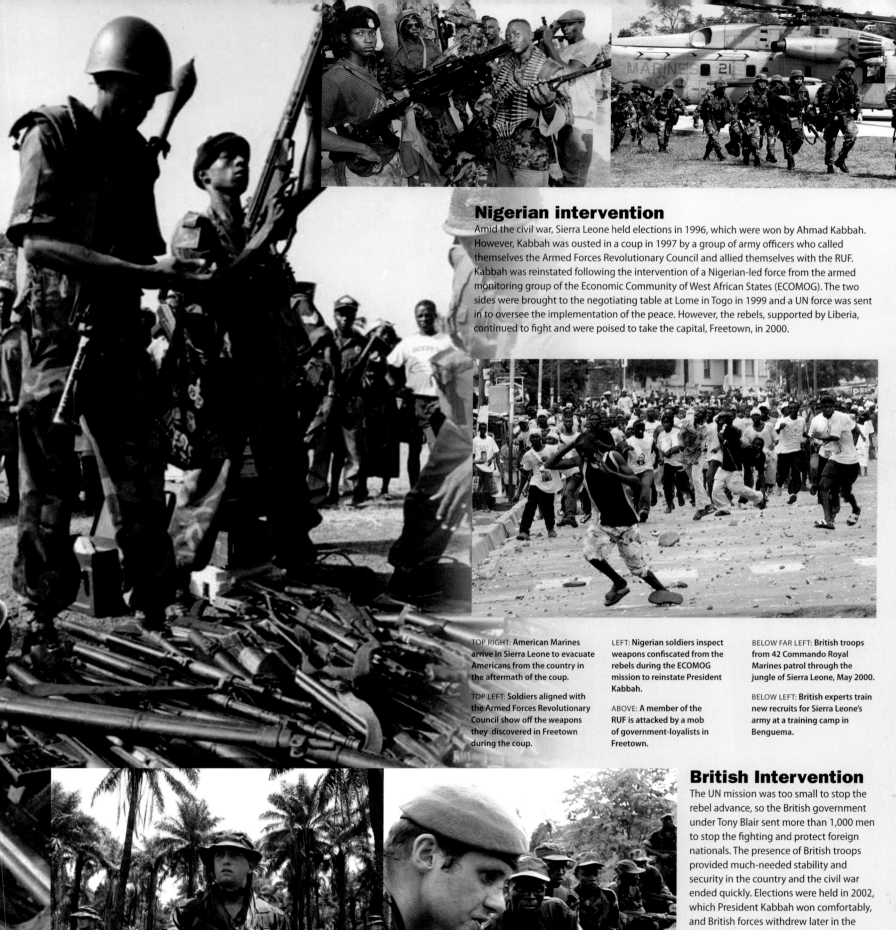

Nigerian intervention

Amid the civil war, Sierra Leone held elections in 1996, which were won by Ahmad Kabbah. However, Kabbah was ousted in a coup in 1997 by a group of army officers who called themselves the Armed Forces Revolutionary Council and allied themselves with the RUF. Kabbah was reinstated following the intervention of a Nigerian-led force from the armed monitoring group of the Economic Community of West African States (ECOMOG). The two sides were brought to the negotiating table at Lome in Togo in 1999 and a UN force was sent in to oversee the implementation of the peace. However, the rebels, supported by Liberia, continued to fight and were poised to take the capital, Freetown, in 2000.

TOP RIGHT: **American Marines arrive in Sierra Leone to evacuate Americans from the country in the aftermath of the coup.**

TOP LEFT: **Soldiers aligned with the Armed Forces Revolutionary Council show off the weapons they discovered in Freetown during the coup.**

LEFT: **Nigerian soldiers inspect weapons confiscated from the rebels during the ECOMOG mission to reinstate President Kabbah.**

ABOVE: **A member of the RUF is attacked by a mob of government-loyalists in Freetown.**

BELOW FAR LEFT: **British troops from 42 Commando Royal Marines patrol through the jungle of Sierra Leone, May 2000.**

BELOW LEFT: **British experts train new recruits for Sierra Leone's army at a training camp in Benguema.**

British Intervention

The UN mission was too small to stop the rebel advance, so the British government under Tony Blair sent more than 1,000 men to stop the fighting and protect foreign nationals. The presence of British troops provided much-needed stability and security in the country and the civil war ended quickly. Elections were held in 2002, which President Kabbah won comfortably, and British forces withdrew later in the year. The United Nations has remained in the country, but peace and democracy remain fragile, especially while Sierra Leone remains one of the world's poorest countries, despite its diamond wealth.

Yugoslavia 1991-1995

Tito's Yugoslavia

At the end of the Second World War, the Socialist Federal Republic of Yugoslavia was formed, with Josip Broz Tito as the head of state. This diverse country was made up of eight republics and major provinces, including Croatia, Slovenia and Boznia-Herzegovina – and Serbia, the largest and the seat of the Federal Republic's capital of Belgrade. The republics had varied ethnic backgrounds, but held together under Communist rule. Following Tito's death in 1980, and during a longstanding economic crisis, ethnic tensions – which had always simmered in the background – began to grow.

Breakup of the Federation

In the Serbian province of Kosovo, which was ethnically Albanian, resentment at Serb domination was expressed in a series of strikes and demonstrations which were suppressed by force. Some other republics supported the Kosovans, and called for more independent representation as well, and the January 1990 Communist Party Congress broke up when Slovenian and Croatian delegations walked out in protest following a speech by the Serbian leader Slobodan Milosevic which only served to emphasise Serbian dominance. There was consternation in Belgrade and a call for martial law to be imposed on the 'rebel' provinces by the People's Army. This action would need to be approved by a majority of the republics, and a vote was accordingly taken. The result was inconclusive; Slovenia, Croatia, Bosnia and Macedonia voted against; Serbia and its dependents – Kosovo, Vojvodina and Montenegro – voted for action. There were few options for Slovenia and Croatia under the existing system.

ABOVE: **Croatian forces pass through a village on the way to the front line.**

RIGHT: **Josip Broz Tito led Yugoslavia's resistance against Nazi occupation and went on to rule the country after the war. After his death in 1980 the Yugoslav federation began to unravel.**

FAR RIGHT ABOVE: **A Slovenian soldier fires on a Federal Army tank from his hiding place in the woods near the Slovenian town of Dravograd.**

FAR RIGHT: **Residents of Slovenia's capital Ljubljana fly their national flag in defiance of the invading Federal Army. Much of the city's population remained indoors for safety.**

Slovenia

Elections were held, and pro-independence leaders were elected in a landslide victory; Slovenia declared formal independence on June 25, 1991. Yugoslavia – the Serbs, essentially – then declared war. However, and in contrast to what was to follow, this was something of an anti-climax: after ten days the Serbs withdrew to focus their attentions on Croatia, which had a sizeable Serb population and was geographically closer to Serbia.

Croatia

Croatia declared its independence at the same time as Slovenia, but it was not in the same position. It was ethnically more diverse, with some ethnically Serbian inhabitants – about 12 per cent – whom Milosevic felt should not be forced to live outside the Serbian state. The attack began with the Serbians shelling Croatian cities but this only strengthened the Croatian spirit of resistance, especially after the fall of the city of Vukovar which had resisted a three-month siege. Vukovar was almost totally destroyed and many people died; survivors were sent to camps by the Serbs. The mixed ethnic composition of Croatia led to what has been called 'ethnic cleansing', which took place on both sides, as each attempted to move – and sometimes kill – those whom it perceived as inappropriate residents of a particular area.

UN Peacekeepers

The worsening situation was of increasing international concern, and the United Nations intervened, sending in a multinational, 14,000-strong, protection force of peacekeepers. Their aims were to bring about a ceasefire and ensure the Serbs retreated, and maintain peace thereafter. The two strongly Serbian provinces of Croatia then declared their own independence, which helped delay the signing of a peace treaty until Croatia snatched them back in 1995. An international arms embargo was imposed, but had little effect on the Serbs. Yugoslavia had previously had a thriving arms industry which they were able to exploit; the same was not true of their opponents, particularly the Bosnian Muslims who were soon to suffer from Serbian attention.

TOP: An ethnic-Serb guerrilla from the Croatian town of Vukovar prepares to launch an anti-armour rocket at Croatian Army postions following the country's declaration of independence from Yugoslavia.

ABOVE: Vocin's fourteenth-century Roman Catholic church lies in ruins in the aftermath of a massacre in the village in December 1991. Serb militias rounded up and murdered almost forty Croat inhabitants as part of their campaign of ethnic cleansing in the Slavonian region of Western Croatia.

LEFT: A member of the United Nations Peace Keeping force assesses an abandoned Croatian village. The 14,000-strong force began arriving in early 1992 to broker a ceasefire, oversee the Serbian retreat and uphold the peace.

BELOW: Two inhabitants of Vukovar are evacuated from their ruined homes as the siege of the city comes to an end. Croat residents and soldiers held out for three months before the city fell to the Federal Army.

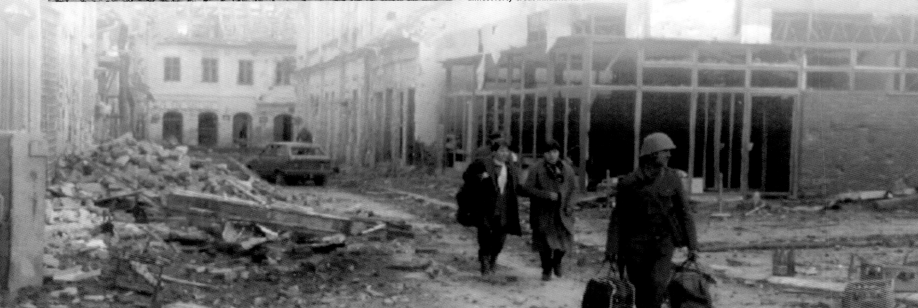

Bosnia

Bosnia's path to independence – originally declared in April 1992 – was similarly stormy, and its ethnic background was even less straightforward. There were three main groups, Serbs, Croats and Bosnian Muslims (Bosniaks). The Serbs, who comprised about a third of the people, violently objected to independence and were able to occupy most of the country. Then the Croats, about 17 per cent of the population, occupied almost all of what remained, and the Muslim population – who were in the majority, at 44 per cent – were left with very little. The Bosnian Serbs began to 'ethnically cleanse' their territory of Muslims, with open support from Serbia itself, in an attempt to create an ethnically homogenous area which could be incorporated into Serbia. As a result, there was a widespread movement of people, and many deaths and reports of atrocities on both the large and small scale.

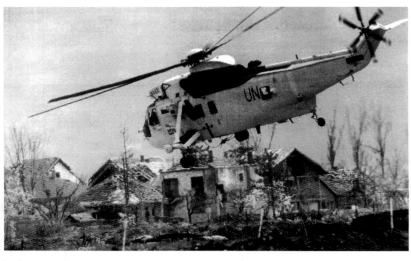

Siege of Sarajevo

The cities of Sarajevo and Mostar were besieged and bombarded by the Serbs, with heavy loss of life; Sarajevo, the Bosnian capital, was under siege for almost four years during which time it came under heavy shell and sniper fire. At first there was anti-Serbian unity between the Croats and the Bosnian Muslims, but they eventually fought each other over territory; peace between them was brokered after about a year, but worse was to come. The UN forces in Croatia were asked to cover Bosnia as well and established safe zones which, it was hoped, would provide some protection. One of these was the town of Srebrenica and the area immediately around it, which has since become notorious.

FAR RIGHT: UN peacekeepers come to the aid of a Bosnian man injured during a heavy artillery bombardment on a village near Vitez. The man later died of his injuries.

ABOVE: A UN helicopter patrol monitors the frontline near Sarajevo Airport after reports that UN planes were coming under sniper fire.

BELOW: Bosnian Serb soldiers cover their ears as they fire a missile at Bosnian Muslim positions on the outskirts of Bihac.

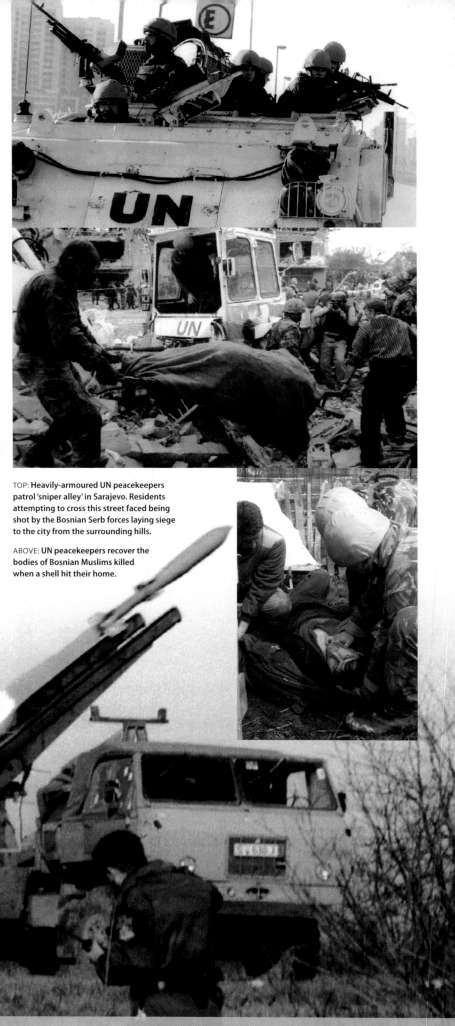

TOP: Heavily-armoured UN peacekeepers patrol 'sniper alley' in Sarajevo. Residents attempting to cross this street faced being shot by the Bosnian Serb forces laying siege to the city from the surrounding hills.

ABOVE: UN peacekeepers recover the bodies of Bosnian Muslims killed when a shell hit their home.

DAILY MAIL AUGUST 29 1995

Slaughter At The Market

They were not soldiers. They were women, children, old people, trying to buy some pitiful provisions to survive in the hell of Sarajevo. Yesterday they were the targets again for the Serb gunners who have the besieged city at their mercy.

Nearly 40 died when two mortar bombs blasted the Markale market place, 50 yards from the scene of a similar outrage last year. Even though gatherings had been banned since then, because of the danger, the area was teeming with people yesterday. They had to buy food or starve.

That was when the Serbs in the hills around Sarajevo decided the time was right to loose another round of carnage on the helpless civilians below.

The scenes that followed were unspeakable. Screaming women and children wandered dazed among bodies. 'Killers, bastards!' screamed a woman covered in blood. 'They all deserve to be slaughtered.'

Scores of wounded were taken to hospitals already overwhelmed with victims of the war. At Kosevo, the main hospital, many people with shrapnel wounds were forced to wait outside. Inside, the more seriously wounded were crowded in the halls and patients' rooms.

The Moslem-led government and the separatist Serbs, who have been laying siege to the Bosnian capital since April 1992, were quick to condemn each other.

Bosnian Serbs accused the government of staging the massacre to put pressure on them as the peace mission by Assistant Secretary of State Richard Holbrooke got under way. The attack, said Bosnian Serb army commander General Ratko Mladic, was 'constructed to stop the peace process and trigger Nato strikes'.

But UN spokesman Alexander Ivanko noted that the mortar was fired from the south of the city where 'most of the positions are Bosnian Serb'.

Srebrenica massacre

In July 1995 Ratko Mladic, one of the main Serbian commanders, led his troops into the zone. It was overflowing with Muslim refugees, and though there were also some 400 UN peacekeepers from the Netherlands, they were able to do little to resist Mladic's forces or prevent what happened. The men and boys were separated and in the following few days – the precise dates are difficult to establish – more than 8,000 Bosnian Muslims were massacred. This was the worst mass-murder in Europe since the Second World War and it was perpetrated under the eyes of the United Nations.

NATO Airstrikes

There was an eventual outcry when the full facts became known, and international opinion – which had already been shifting steadily in that direction – swung round even more firmly against the Serbs, bolstered by the increasingly appalling situation in Sarajevo. When Bosnian Serb forces shelled a busy Sarajevo market on August 28, 1995, NATO decided to use military force for the first time in the organization's history. Operation Deliberate Force began on August 30 with attacks on Serbian munitions dumps. It was quickly obvious that the Serbs actually had few options left despite their much-vaunted military might. A ceasefire was negotiated, becoming the basis for the Dayton Peace Agreement which was reached in November 1995 and signed the following month in Paris. This established a semi-divided Bosnia, one which had a Serb Republic and a separate Croat–Bosnian Muslim Federation.

LEFT: **President Bill Clinton had long called upon the international community to do more to assist the Bosnian Muslims, but other countries were worried that sending in more weapons and conducting airstrikes would jeopardize the safety of UN peacekeepers. In the event, several hundred peacekeepers were used as human shields by the Bosnian Serbs during Operation Deliberate Force.**

BELOW: **The aftermath of a NATO strike on an arms dump in the Bosnian Serb stronghold of Pale, August 31, 1995.**

BELOW LEFT: **Bosnian Serb paramilitaries come under fire from Croat forces amid NATO airstrikes in September 1995.**

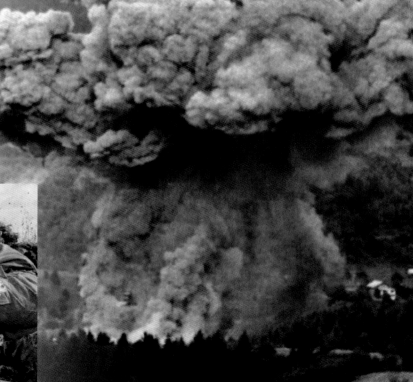

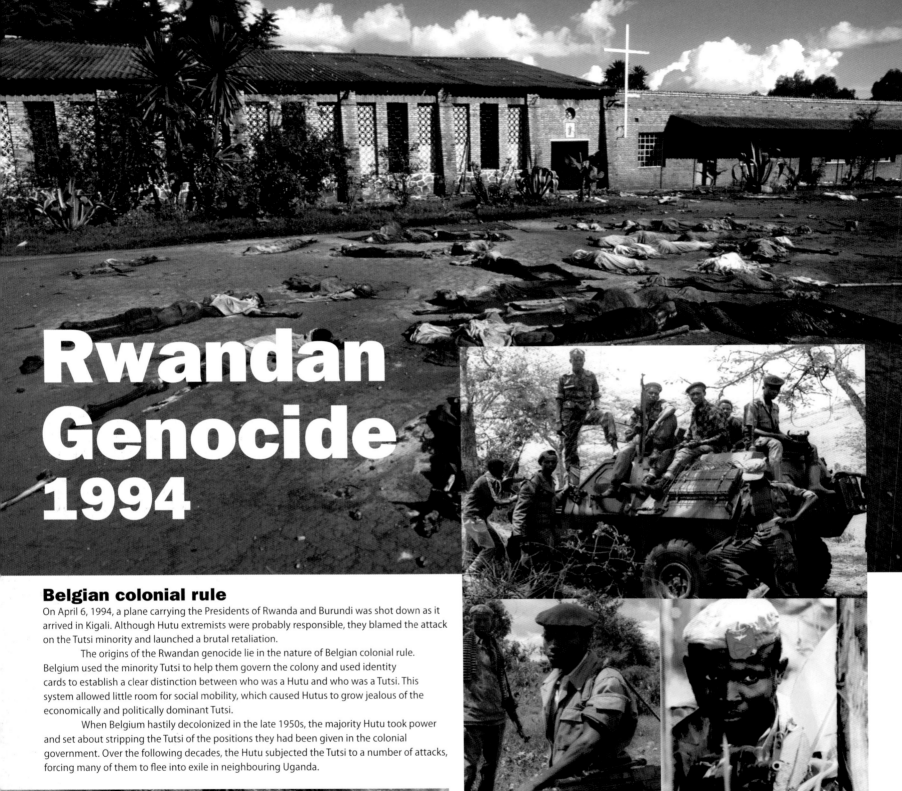

Rwandan Genocide 1994

Belgian colonial rule

On April 6, 1994, a plane carrying the Presidents of Rwanda and Burundi was shot down as it arrived in Kigali. Although Hutu extremists were probably responsible, they blamed the attack on the Tutsi minority and launched a brutal retaliation.

The origins of the Rwandan genocide lie in the nature of Belgian colonial rule. Belgium used the minority Tutsi to help them govern the colony and used identity cards to establish a clear distinction between who was a Hutu and who was a Tutsi. This system allowed little room for social mobility, which caused Hutus to grow jealous of the economically and politically dominant Tutsi.

When Belgium hastily decolonized in the late 1950s, the majority Hutu took power and set about stripping the Tutsi of the positions they had been given in the colonial government. Over the following decades, the Hutu subjected the Tutsi to a number of attacks, forcing many of them to flee into exile in neighbouring Uganda.

The Civil War

During their time in Uganda, the displaced Tutsi matured into a fighting force called the Rwandan Patriotic Front (RPF). In 1990, with the assistance of the Ugandan government, the RPF invaded Rwanda in a bid to regain a stake in their homeland. War dragged on until 1993 when the Rwandan President, a Hutu named Juvenal Habyarimana, agreed to sign the Arusha Accords, which granted the RPF representation in the Rwandan government.

Fearing that any form of power-sharing agreement with the RPF would undermine their power and patronage, Hutu extremists in Habyarimana's government began planning to expunge the Tutsi from Rwanda once and for all.

The genocide

In preparation for the genocide, these extremists stepped up their propaganda campaign against the Tutsi and began arming their militia groups, the Interahamwe and the Impuzamugambi. After President Habyarimana's plane was shot down, the attacks began in earnest. Roadblocks were set up in the capital, Kigali, and the militias went hunting for Tutsi with machetes, clubs and guns. The genocide was spread quickly across the north and east of the country, in the provinces of Gisenyi and Ruhengeri, which were the heartlands of Hutu extremism. South-Western Rwanda initially resisted the genocide until militias were shipped in from the north.

Massacres

Many Tutsis sought refuge in churches or schools, but this often increased their vulnerability and some of the worst atrocities of the genocide occurred in these supposed havens. One such massacre took place in a church in Nyarubuye in eastern Rwanda in April 1994. The thousands of Tutsis who had taken refuge in the church proved easy prey for the Hutu militias and their accomplices. The attacks were thorough and those who survived did so only by hiding under the dead bodies of others. Similar brutal stories unfolded across Rwanda during the genocide. The victims were often lured to communal buildings by people in positions of trust, such as mayors and clergymen, so as to make the killing-machine quicker and more efficient.

Liberating other Tutsi from the genocide gave extra impetus to the invading RPF. As the RPF moved in, thousands of Hutus fled into neighbouring Zaire, being told by the extremists' propaganda machine to expect a retaliatory genocide at the hands of the Tutsi invasion force. In reality, the RPF did not engage in genocide and demonstrated relative restraint as it took over the country. By the time the RPF took control and stopped the genocide, up to one million Tutsis and moderate Hutus had been murdered. In addition, millions of Hutus had fled to neighbouring countries where they were run down by diseases, which added more names to the long list of victims of Hutu extremism.

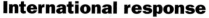

LEFT: **British soldiers arrive in Zaire to help facilitate the return of the first Hutu refugees to Rwanda in November 1996.**

MIDDLE LEFT: **French-trained recruits of the Rwandan National Army pause in a banana forest close to the front lines in June 1994.**

BELOW LEFT: **Bodies of cholera victims are left piled in the street. A cholera epidemic ravaged through refugee camps killing thousands of refugees who fled to Zaire in the aftermath of the genocide.**

OPPOSITE TOP: **The bodies of Tutsi genocide victims lie outside a church in Rukura where more than 4,000 people were killed while taking refuge. Mass murders in churches and schools became a recurring feature of the genocide.**

OPPOSITE ABOVE RIGHT: **Members of the RPF pose with a French-built armoured car, which had been captured from the Rwandan Army at Kagitumba, in northeastern Rwanda in April 1994.**

OPPOSITE MIDDLE LEFT: **RPF soldiers push into the Rwandan bush on April 9, just days after the plane crash killing President Habyarimana.**

OPPOSITE MIDDLE RIGHT: **A Rwandan Government soldier holds his position against the RPF advance at Rwankuba, southwest of Kigali.**

OPPOSITE BOTTOM LEFT: **RPF soldiers fire on Rwandan Government positions near Mukaranye, north of Kigali.**

ABOVE LEFT: **A young Rwandan genocide survivor with a bandaged wound on his face. Many Rwandans have been left with not only the physical scars of genocide, but also the emotional ones.**

ABOVE: **Rwandans bury their dead in the aftermath of the genocide.**

BELOW: **Hundreds of thousands of Hutu refugees pour over the Tanzanian border to escape the RPF invasion in May 1994.**

International response

At the outbreak of the genocide, the United Nations already had a mission in Rwanda to help implement the Arusha Accords. However, it did not have the appropriate authority to intervene in the genocide and the UN peacekeepers had to stand idly by while the mass killing went on around them. There was little appetite for strengthening the UN's mission in Rwanda, especially in the United States, where the recent loss of US servicemen in Somalia played heavily on President Clinton's decision-making. Following the murder of ten UN peacekeepers from Belgium, the UN opted to scaled down its operation and pull most of its peacekeepers out of the country.

The only country to intervene decisively in Rwanda was France. Backed by a UN mandate, French troops began arriving in late June as part of Operation Turquoise. French troops established a safe zone, which helped to save many lives, but which also gave haven to Hutu extremists from the invading RPF. The RPF believed that France showed deliberate bias towards the French-speaking Hutu because members of the RPF had become Anglophonic while in exile in Uganda. In August the French withdrew and the RPF moved in and occupied the remainder of the country.

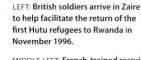

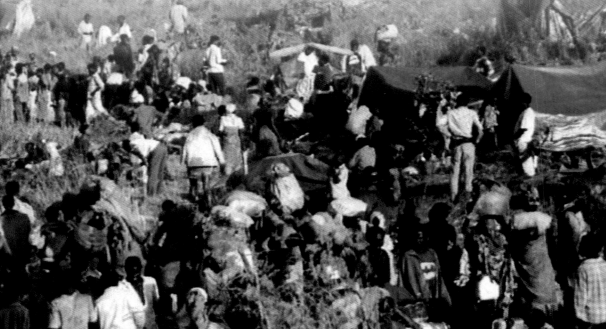

Chechnya 1994-2000

The first war in Chechnya

In November 1991, amid the chaotic demise of the Soviet Union, Chechnya declared its independence. However, Moscow only tolerated the break-up of the Union into its fifteen constituent Republics, and was unwilling to accept the independence of Chechnya, which was an autonomous province within Russia. Troops were sent in, but they were repulsed by Dzhokhar Dudayev, an ex-Soviet general turned Chechen leader.

When Russia had somewhat recovered from the tumultuous years of the Soviet collapse, President Yeltsin turned his attentions towards the breakaway Republic. He feared that unless Chechnya was brought back under Moscow's control, it would set a precedent for other autonomous regions to break away, and would result in the collapse of the Russian state. Moreover, he feared that the predominantly Muslim Chechens would establish an Islamic state within Russia's borders and was concerned that the province had become a haven for organized crime.

After helping to ferment political unrest in Chechnya, Moscow launched an attack in December 1994 under the pretext of restoring order. The Russian military planned a lightning attack on the breakaway region, but they became mired in a quagmire that was to cost many lives. The Russian army was still reeling from the collapse of the Soviet Union and was not able to defeat the Chechen rebels who used effective forms of guerrilla warfare. To try to regain the initiative the Russian military carpet-bombed the capital, Grozny, killing thousands of civilians.

The war dragged on, but Russia was unable to score a decisive victory against the Chechen guerrillas. Support for the war among the Russian public was lacklustre and Yeltsin, facing a Presidential Election in 1996, began to seek exit strategies. A ceasefire was finally signed in August 1996 after Grozny had once again become a bloodbath. The war was over, but the underlying causes had not been addressed, and a return to hostilities was inevitable.

The second Chechen war

Tension in the region flared up again in 1999 against the backdrop of a power transfer from Yeltsin to Vladimir Putin. Russian troops were sent back to Chechnya following a spate of bombings in Moscow and elsewhere in Russia that killed hundreds and outraged Russian public opinion. Chechen militants had also begun operating in the neighbouring province of Dagestan, threatening to widen the conflict and further break-up the Soviet Union.

Again the Russians faced stiff resistance from Chechen rebels using guerrilla tactics. They reached the outskirts of Grozny within weeks of beginning the ground offensive in October 1999, but soon became bogged down in months of bitter urban warfare. Thousands of civilians were caught in the crossfire and Grozny was utterly destroyed before the Russians claimed victory in the city in February 2000. Some rebels escaped Grozny and moved further south where they continued to resist Russian forces for another month. The climax of the fighting in the south came in the village of Komsomolskoye, where hundreds of rebels were killed following a fierce battle in March 2000. Two months later, Moscow reimposed direct rule and the war was essentially over. However, Chechen rebels were not entirely beaten and they have still been able to mount a number of attacks on Russian civilian and military targets.

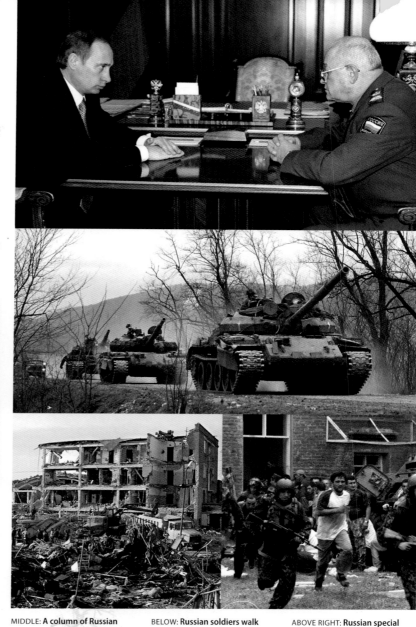

OPPOSITE ABOVE: **Chechen women carry their belongings through the ruins of Grozny in February 2000.**

OPPOSITE ABOVE RIGHT: **Russian President Boris Yeltsin meets with his American counterpart, Bill Clinton, at an OSCE Summit in Istanbul in November 1999. Russia's war in Chechnya topped the agenda of the summit.**

OPPOSITE BELOW RIGHT: **The Khankala military base near Grozny is pictured awash with Russian troop activity amid the second Chechen war in February 2000.**

OPPOSITE MIDDLE RIGHT: **Rescue workers search through the rubble of an apartment building in Volgodonsk after it had been destroyed in a terrorist attack in September 1999. The attack was one of a series of atrocities blamed on Chechen separatists, serving as a reason to send Russian troops back into Chechnya.**

ABOVE LEFT: **Russian soldiers wait at the Slepcovck crossing on the Ingushetian border to check for militants amid the Chechen refugees arriving from Grozny.**

ABOVE RIGHT: **A Russian multiple missile launcher fires on Grozny during an intense offensive in the closing days of 1999.**

TOP: **Russian President-elect Vladimir Putin meets with Defence Minister Igor Sergeyev at the Kremlin to get the latest military intelligence reports on the war in Chechnya.**

MIDDLE: **A column of Russian tanks moves into the foothills of mountains in southern Chechnya where many Chechen rebels fled in the wake of the Russian onslaught.**

ABOVE LEFT: **Workmen remove debris that was once a hospital in Mozdok on Chechnya's border with North Ossetia, August 2003. Scores of people were killed when a Chechen suicide bomber rammed a truck packed with explosives into the building.**

BELOW: **Russian soldiers walk through Komsomolskoye, which was destroyed in heavy fighting in March 2000.**

ABOVE RIGHT: **Russian special forces end a school siege in Beslan in September 2004. Chechen separatists entered the school on the first day of the new academic year and took hundreds of children and a number of parents hostage. Special forces stormed the building after two days, but more than 300 people, mostly children, were killed.**

Democratic Republic of the Congo 1996–2008

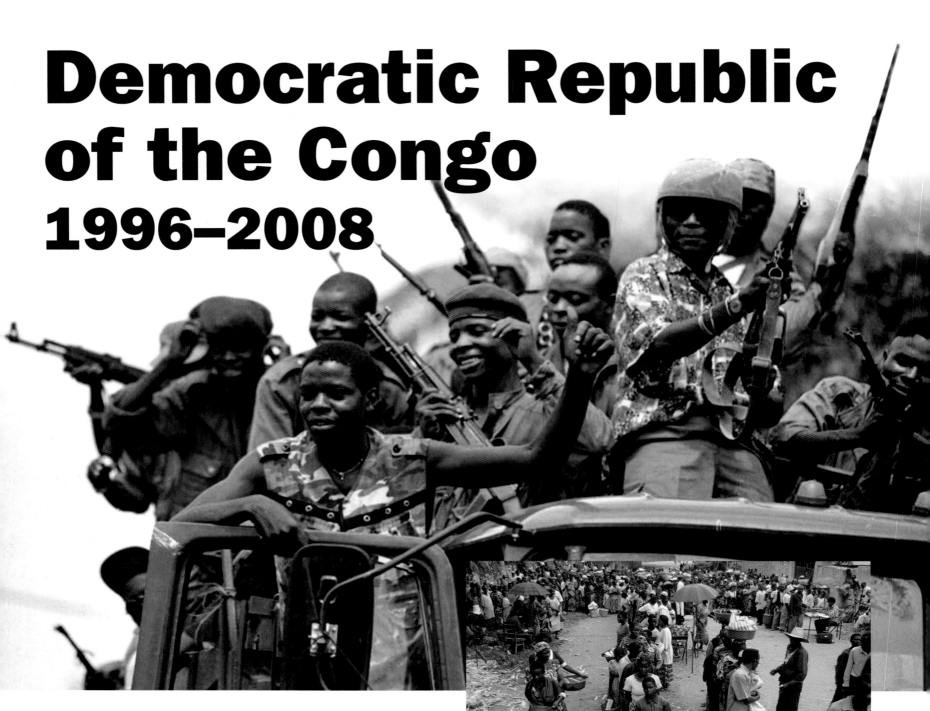

The First Congo War

In the 1990s, while democratization was spreading across Africa, the powerful ruler of the vast country in the continent's midsection was reluctant to follow the tide. Mobutu Sese Seko had ruled Zaire as a personal fiefdom for three decades, exploiting his country for as much as it could give.

During his three decades of misrule, Mobutu developed many enemies, but they were too weak to mount a serious challenge. However, the opportunity for change finally presented itself when genocide spilled over the border from neighbouring Rwanda in 1994. Mobutu had supported the genocide and provided a safe haven for the Hutu extremists who had perpetrated it. The post-genocide, Tutsi-dominated government in Rwanda was looking for revenge and allied with one of the main Zairian opposition groups, the Alliance of Democratic Forces for the Liberation of Congo-Zaire (AFDL), under the command of Laurent Kabila. The AFDL also found support among neighbouring countries such as Uganda and Angola which had interests in Zaire's great mineral wealth.

With outside support, Kabila's AFDL was able to march rapidly and seize the capital, Kinshasa. Mobutu was dying of cancer and did not put up much of a fight. Kabila proclaimed himself President and began limited reforms of the country – starting with a reversion to the country's original post-colonial name: the Democratic Republic of the Congo.

ABOVE: **Bands of militias rove across the country engaging in extreme acts of violence. Rape was often used as a weapon during the war; tens of thousands of women and children suffered horrific abuse.**

ABOVE RIGHT: **Hundreds of displaced Congolese line-up to receive food aid donated by USAID in Bunia, Democratic Republic of Congo, July 2003.**

Each family of five receives 15 kilograms of cornmeal, 5 kilograms of beans and 1.5 litres of cooking oil, for a week.

OPPOSITE ABOVE RIGHT: **Congolese children stand behind razor wire next to a United Nations compound in Bunia after fleeing their villages in the Democratic Republic of Congo.**

OPPOSITE BELOW: **British troops, hovercraft and helicopter in the Congo River as they begin the evacuation of their nationals from Kinshasa as Kabila's men march on the city during the First Congo War. While regional powers played a central role in the conflict, the wider international community has been criticized for turning its back on the country.**

The Second Congo War

In 1998 a new civil war broke out after Rwanda turned against Kabila because he had failed to tackle the Hutu extremists and had instead grown hostile to the Tutsi minority. The Rwandan government backed a new rebel coalition in the eastern part of the country, which almost ousted Kabila, but Zimbabwe and Angola came to his aid at the last minute.

A brutal war dragged on till 2001, when Laurent Kabila was assassinated. The Congolese Parliament unanimously agreed to replace him with his son, Joseph. Laurent had been resistant to democratization, but his western-educated son proved more open. He soon made peace with Rwanda, Uganda and the rebel coalition. In 2006 the nation held its first elections and much of the country has managed to avoid further conflict.

While Congo began its reconstruction, a violent rebellion continued in the east of the country. Tutsi rebels led by Laurent Nkunda rejected the peace process in order to continue the fight against Hutu extremists in the region. Nkunda was finally forced to the negotiating table in Goma in January 2008. Although an agreement was reached, East Congo is rich in resources and may yet experience further bloodshed as a result.

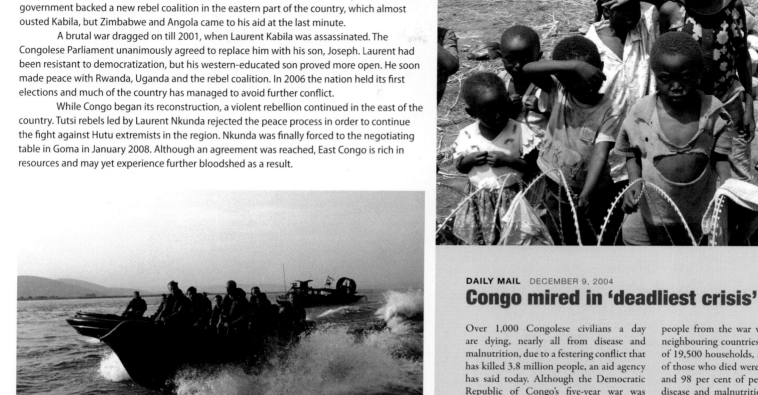

DAILY MAIL DECEMBER 9, 2004

Congo mired in 'deadliest crisis'

Over 1,000 Congolese civilians a day are dying, nearly all from disease and malnutrition, due to a festering conflict that has killed 3.8 million people, an aid agency has said today. Although the Democratic Republic of Congo's five-year war was declared over last year, the International Rescue Committee (IRC) said it was still the 'deadliest crisis' in the world, but the international community was doing too little to stop it. 'In a matter of six years, the world lost a population equivalent to the entire country of Ireland or the city of Los Angeles,' said Dr Richard Brennan, one of the authors of a study by the private New York-based refugee relief agency. 'How many innocent Congolese have to perish before the world starts paying attention?'

The mortality study updates a previous widely agreed death toll of three million people from the war which sucked in six neighbouring countries. Based on a survey of 19,500 households, it found almost half of those who died were children under five and 98 per cent of people were killed by disease and malnutrition resulting from a healthcare system destroyed by the years of war.

Peace deals were signed in 2002 and a transitional government set up last year, charged with leading the vast central African nation to elections in 2005, but huge tracts of the east remain unstable. Highlighting the discrepancy between the $3.5 billion aid budget for Iraq in 2003 and the $188 million earmarked for Congo in 2004, the IRC labelled the international community's response to Congo's crisis 'grossly inadequate in proportion to need'.

Kosovo 1996–99

Balkan tensions

After the Second World War, the Kingdom of Yugoslavia became a socialist federation consisting of six republics: Bosnia-Hercegovina, Croatia, Macedonia, Montenegro, Serbia and Slovenia. Kosovo was not a federal republic, but an autonomous province within Serbia. Located within southern Serbia, the majority of the population of Kosovo was ethnic Albanian, but there was a sizable Serb minority in the north. Initially the province had a high degree of autonomy, but in 1989, amidst growing ethnic tension, Serbian leader Slobodan Milosevic brought Kosovo under the direct control of Belgrade. Yugoslav troops and police were sent in to replace ethnic Albanian security forces and the official language was changed from Albanian to Serbian.

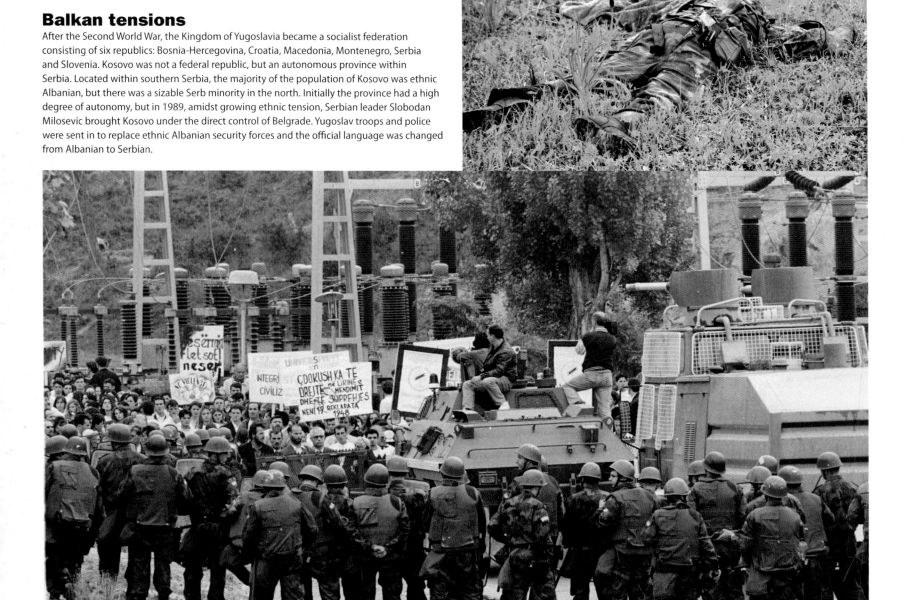

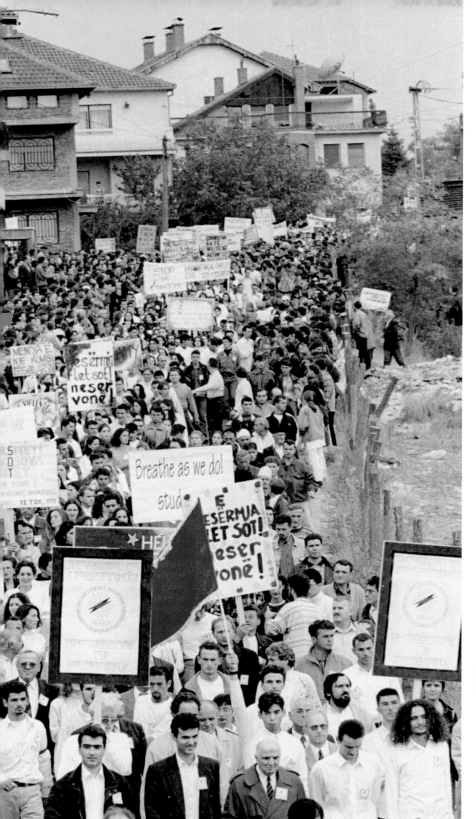

The outbreak of war

In 1996, after six years of Serbian oppression, many among Kosovo's Albanian population had come to feel that armed aggression to achieve independence for the province was the only answer. Four of the six republics had already broken away from the Serb-dominated Yugoslavia and Kosovo's Albanians wanted to follow suit. They established a resistance militia called the Kosovo Liberation Army (KLA), which carried out its first attacks against Serbian security forces in April 1996. The international community supported greater autonomy for Kosovo, but opposed the KLA's demand for independence. However, concern was soon being expressed over the Serbian military's disproportionate response to KLA attacks and Slobodan Milosevic found himself under increasing pressure to bring an end to the escalating violence in the province.

Massacre at Racak

One of the worst atrocities of the war occurred in the village of Racak on January 15, 1999. KLA attacks in the vicinity of the village had resulted in the deaths of four Serb policemen. The Serbs responded by shelling the village early in the morning of the 15th. Later in the day, Serbian soldiers entered the town, rounded up villagers, and marched them to the outskirts. Once there, the Serbs opened fire, killing 45 people in the manner of an execution. This massacre proved to be a turning point in the war as it was an important factor in convincing NATO of the need to intervene.

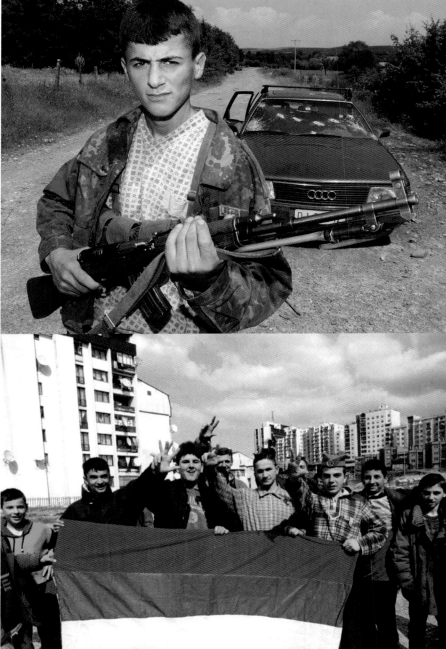

OPPOSITE ABOVE: **The divided town of Mitrovica. The river Ibar separates the ethnic Serbs in the north of the town from the ethnic Albanians in the south.**

OPPOSITE MIDDLE: **A Serb soldier lies dead after a KLA attack.**

OPPOSITE BELOW: **Serbian riot-police forces face down the ethnic Albanian protest over university access. They later used teargas to disperse the crowds.**

ABOVE: **Thousands of ethnic Albanians march through the streets of the Kosovan captial, Pristina, demanding free university access, October 1, 1997.**

RIGHT: **Serbian youths wave Serbia's national flag chanting 'All English and Albanians are stupid'.**

ABOVE RIGHT: **Kalashnikov in hand, a sixteen-year-old member of the KLA stands in front of a car riddled with his bullets that killed the Serb policemen inside. They were ambushed close to a field where more than 120 Kosovan civillians were killed.**

NATO intervention

As far back as June 1998, amid worldwide concern at what was happening in Kosovo, NATO had begun to consider possible military options to resolve the conflict. Air strikes were planned to support diplomatic efforts to make the Milosevic regime withdraw forces from Kosovo, cooperate in bringing an end to the violence and facilitate the return of refugees to their homes. However, at the last moment, President Milosevic agreed to comply and the air strikes were called off. The UN Security Council called for a cease-fire by both parties and limits were set on the number of Serbian forces allowed in Kosovo. Despite these steps the situation in Kosovo flared up again at the beginning of 1999, following a number of acts of provocation on both sides.

Renewed international efforts to find a peaceful solution to the conflict began, with peace talks in Paris. At the end of the second round of talks, the Kosovan Albanian delegation signed the proposed peace agreement, but the talks broke up without a signature from the Serbian delegation. Immediately afterwards, Serbian military and police forces stepped up operations against ethnic Albanians in Kosovo, moving extra troops and modern tanks into the region. Tens of thousands of people began to flee their homes and US Ambassador Richard Holbrooke flew to Belgrade in a final attempt to persuade President Milosevic to stop attacks on the Kosovan Albanians, or face imminent NATO air strikes. However, Milosevic refused to comply and on March 24 the air strikes began. The strikes focused primarily on military targets in Kosovo and Serbia, but extended to a wide range of other facilities, including bridges, oil refineries, power supplies and communications. Over the next 77 days, NATO flew more than 38,000 sorties involving 1,200 aircraft from bases in Italy and aircraft carriers in the Adriatic Sea. The mission was a success for NATO since none of its pilots was killed, and Serb forces only managed to shoot down two of its planes. However, the operation was not without its controversy; several hundred civilians perished in the air strikes, and on May 7, NATO accidentally struck the Chinese Embassy in Belgrade causing outrage across China. Nevertheless, after a relentless bombing campaign, on June 10, 1999, Milosevic finally gave in and ordered a full withdrawal of his forces from Kosovo.

BOTTOM LEFT: Kosovan refugees in Albania take to the river Drina to cool off in summer 1999. Hundreds of thousands of ethnic Albanians fled the country during the fighting.

LEFT: The British 5th Airborne Brigade moving out of Petrovac Camp in Macedonia as they head into Kosovo, June 1999.

BELOW LEFT: Two Puma helicopters landing at Pristina airport, Christmas 1999.

BOTTOM: British troops in an AS90 self-propelled gun of the 26th regiment of the Royal Artillery guard a church outside the town of Podujevo on Christmas Day, 1999.

OPPOSITE ABOVE: The US Airforce's B2 stealth bomber had its combat debut during 'Operation Allied Force'.

OPPOSITE MIDDLE: The remains of the neurology department at Dragisa Misovic Hospital in Belgrade. Three patients were killed in the air raid.

OPPOSITE BELOW RIGHT: In June 1999, after Milosovic agreed to withdraw Serb forces from Kosovo, NATO's Kosovo Force, KFOR, was sent in to maintain peace and security. Here, British paratroopers cross the border from Macedonia into Kosovo.

OPPOSITE BELOW LEFT: Paratroopers secure the only road between Macedonia and Kosovo's capital, Pristina. These men discovered two mass graves in this village with almost 100 people in them.

OPPOSITE BELOW MIDDLE: Nepalese soldiers of the British Army's Gurkha brigade are airlifted from a bridge in Kosovo.

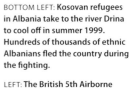

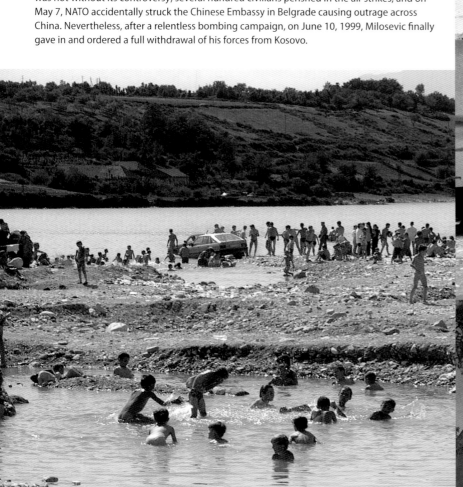

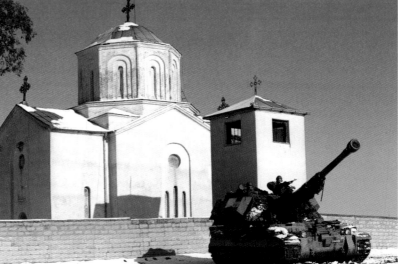

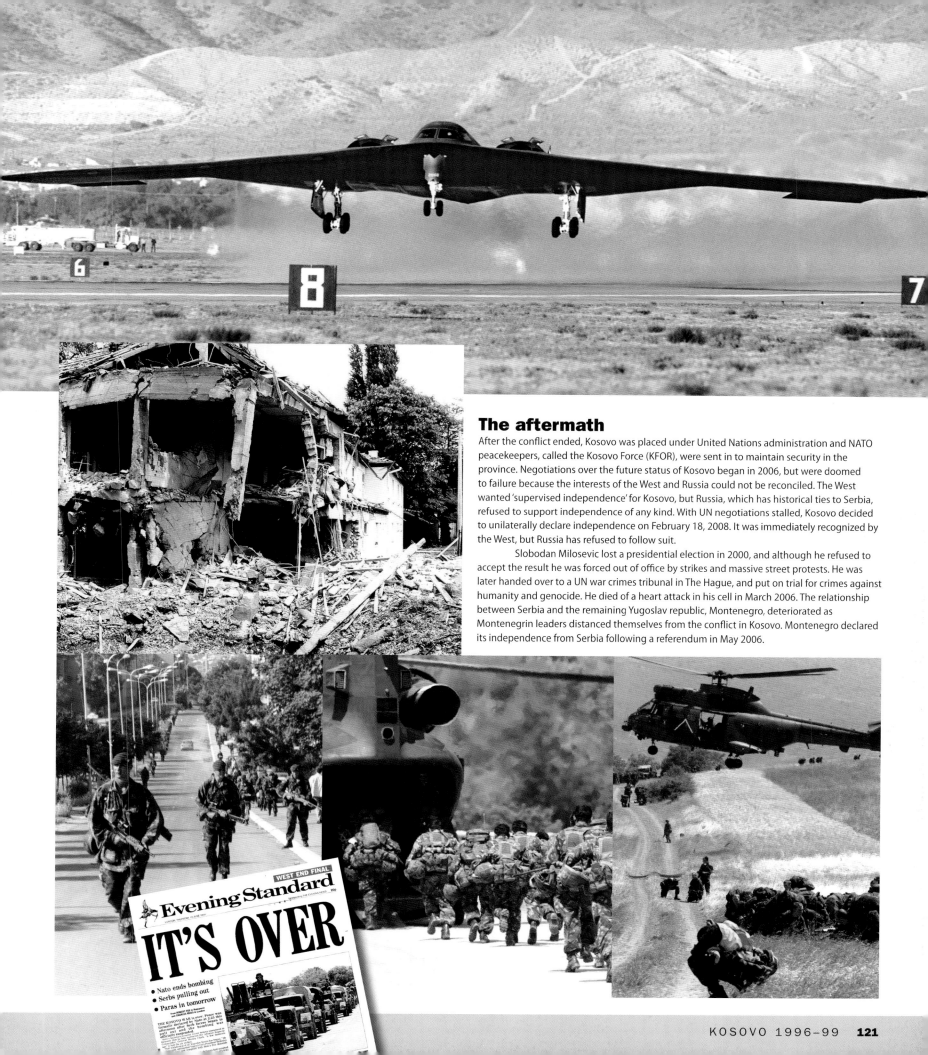

The aftermath

After the conflict ended, Kosovo was placed under United Nations administration and NATO peacekeepers, called the Kosovo Force (KFOR), were sent in to maintain security in the province. Negotiations over the future status of Kosovo began in 2006, but were doomed to failure because the interests of the West and Russia could not be reconciled. The West wanted 'supervised independence' for Kosovo, but Russia, which has historical ties to Serbia, refused to support independence of any kind. With UN negotiations stalled, Kosovo decided to unilaterally declare independence on February 18, 2008. It was immediately recognized by the West, but Russia has refused to follow suit.

Slobodan Milosevic lost a presidential election in 2000, and although he refused to accept the result he was forced out of office by strikes and massive street protests. He was later handed over to a UN war crimes tribunal in The Hague, and put on trial for crimes against humanity and genocide. He died of a heart attack in his cell in March 2006. The relationship between Serbia and the remaining Yugoslav republic, Montenegro, deteriorated as Montenegrin leaders distanced themselves from the conflict in Kosovo. Montenegro declared its independence from Serbia following a referendum in May 2006.

WEST END FINAL

Evening Standard 20p

IT'S OVER

- Nato ends bombing
- Serbs pulling out
- Paras in tomorrow

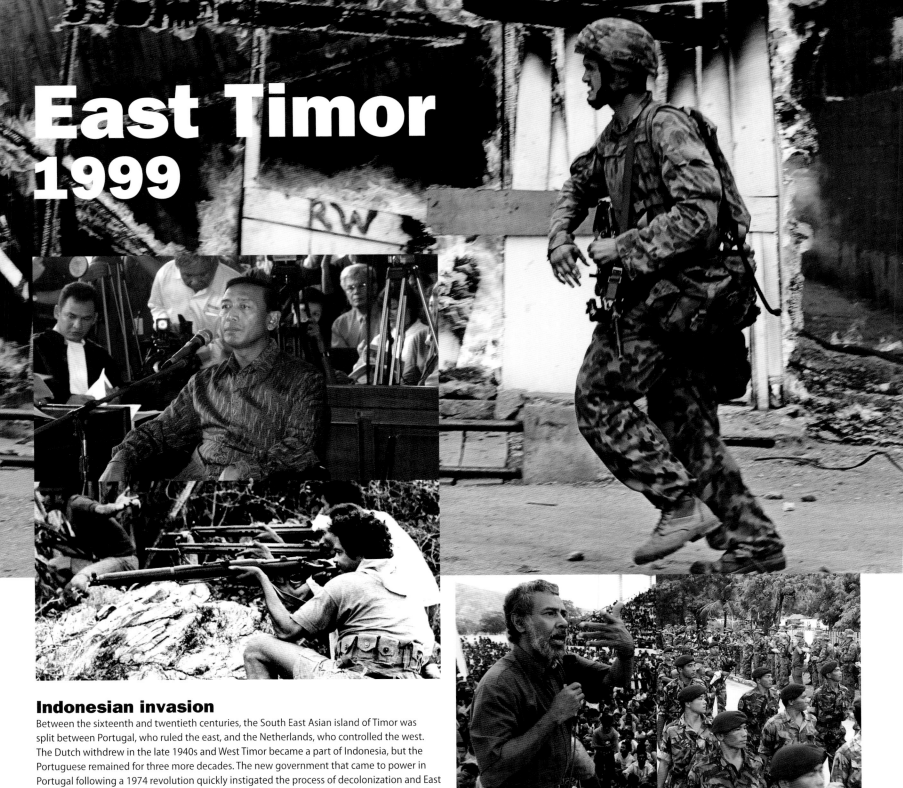

East Timor 1999

Indonesian invasion

Between the sixteenth and twentieth centuries, the South East Asian island of Timor was split between Portugal, who ruled the east, and the Netherlands, who controlled the west. The Dutch withdrew in the late 1940s and West Timor became a part of Indonesia, but the Portuguese remained for three more decades. The new government that came to power in Portugal following a 1974 revolution quickly instigated the process of decolonization and East Timor unilaterally declared its independence in November 1975. However, within days of the declaration, Indonesian forces invaded and turned East Timor into an Indonesian province.

Independence referendum

In 1998, the Indonesian President, Suharto, was ousted after three decades in power and Indonesia underwent a democratic transition. Following talks with Portugal, the new government announced plans to hold a referendum on independence in East Timor in August 1999, but this alarmed members of the Indonesian military who responded by assisting pro-Indonesian militias on the island. When the vote came overwhelmingly in favour of independence, the militias stepped up their campaign of killing and destruction, which had been going on for some time prior to the referendum. Thousands were killed or made homeless and the country's infrastructure was almost completely destroyed. The violence was only halted when an Australian-led United Nations peacekeeping force arrived on the island in late September 1999.

TOP: **An Australian peacekeeper passes a burning building in Dili, the East Timorese capital.**

ABOVE FAR LEFT: **The head of the Indonesian army, General Wiranto, defends his role in East Timor at a tribunal held in Indonesia. He denies the allegation that his forces and the allied pro-Indonesian militias were responsible for human rights abuses in East Timor.**

BELOW FAR LEFT: **Indonesian troops take aim during the 1975 invasion.**

ABOVE LEFT: **Xanana Gusmao, a hero of the East Timorese resistance, addresses a crowd during a political rally. Gusmao became the first President of East Timor in 2002.**

ABOVE RIGHT: **Australian troops applaud as the 2nd Battalion Royal Gurkhas end their tour of duty in East Timor and prepare to return to barracks in Brunei. The Gurkhas were among the first UN troops to arrive following the outbreak of violence.**

Second Intifada
2000 -

Outbreak of the uprising

By 2000 the Arab-Israeli peace process had stalled and economic conditions in the Palestinian territories were worsening. In September, a second Palestinian Intifada broke out after Ariel Sharon, the leader of Israel's main opposition party, visited a disputed religious site. Palestinians began rioting and attacking Israeli worshippers leading to gun battles between Israeli police and Palestinian fighters. The conflict rapidly escalated two days later when a twelve-year-old Palestinian boy was killed in the crossfire.

Suicide bombings

The uprising was far deadlier than the First Intifada, in part because the conflict saw the widespread use of suicide bombing against Israeli civilian targets. In one particularly deadly attack, almost thirty people were killed when a suicide bomber struck a hotel during Passover in March 2002. In response Israel launched a major military operation in the West Bank, dealing a blow to Palestinian militants, but killing a large number of civilians in the process.

Hamas-Fatah split

In November 2004, Yasser Arafat, the leader of the Palestinian Liberation Organization (PLO), died. Since his death, Hamas, the militant Islamist group responsible for much of the suicide bombings, has grown in popularity at the expense of Fatah, the main faction of the PLO. Hamas won a majority in the elections to the Palestinian Authority in January 2006 and ousted Fatah from the Gaza Strip in June 2007.

Gaza War

Israel and Fatah have been trying to negotiate a solution, but conflict has continued between Israel and Hamas. In January 2009 Israel attacked Gaza in a bid to boost its security. The war lasted three weeks and Israel managed to deal a short-term blow to Hamas's operating capability. However, a large number of civilians were killed, leading to widespread international criticism of the war. Hamas remains in charge of the Gaza Strip meaning that another conflagration is likely.

ABOVE: **Masked Hamas militants march through the streets of Khan Yunis in the Gaza Strip to celebrate the organization's nineteenth anniversary in December 2006. Hamas has orchestrated many suicide attacks against Israel and** is deemed to be a terrorist organization by the United States and the European Union.

ABOVE RIGHT: **Palestinian demonstrators taunt the Israeli tanks defending Netzarim, a Jewish settlement in the Gaza Strip, on October 29, 2000.**

BELOW RIGHT: **Palestinian boys throw stones at an Israeli tank in Nablus on September 29, 2003, the third anniversary of the Intifada.**

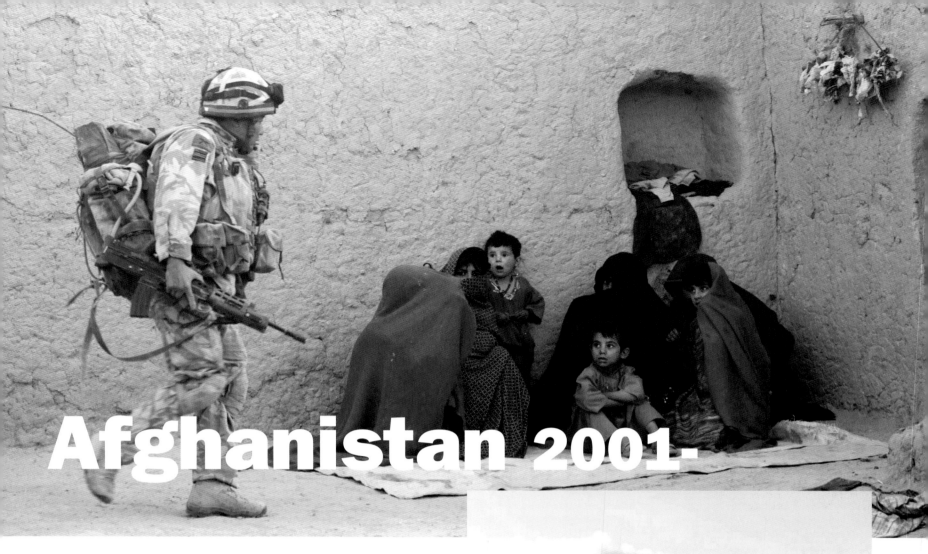

Afghanistan 2001.

Taliban rule

When the Soviet troops withdrew from Afghanistan in 1989, they left a largely unstable country, ravaged by years of war and with its infrastructure either destroyed or badly damaged. They also left a country with a ready supply of weaponry, some Soviet, some supplied by those nations which had aided the Mujahideen. Within a few years, it had degenerated even further, becoming a fragmented and anarchic place, with regular outbreaks of fighting and areas ruled by local warlords. In 1994 alone, thousands of people died in the capital, Kabul. This situation was perfect for the rise of the Taliban, a fundamentalist Sunni Islamist movement, and they were able to seize control of Kabul in 1996. Afghanistan under Taliban rule was marked by severe human rights abuses and heavily restricted freedom for everyone, especially women and girls.

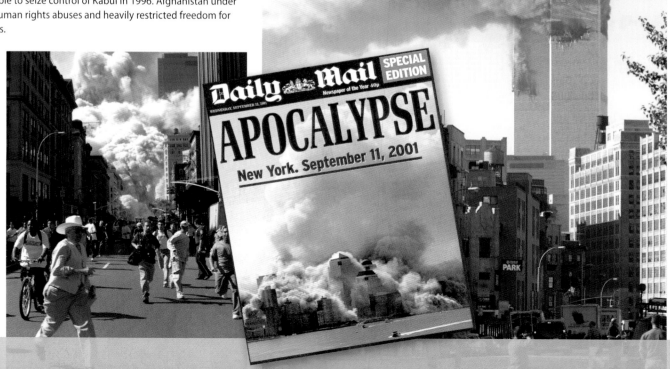

ABOVE: Afghan women and children crouch by a wall as a soldier passes by while searching for Taliban at a compound near their home in Southern Afghanistan.

FAR RIGHT: Smoke billows out of the twin towers of the World Trade Center in New York City following the terrorist attacks of September 11, 2001. Another two planes were hijacked; one struck the Pentagon in Virginia and the other crashed in a field in Pennsylvania after passengers confronted the terrorists.

RIGHT: New Yorkers run from the debris as the South Tower crashes to the ground. Almost 3,000 people, mostly civilians, were killed in the attacks.

9/11 Attacks

The terrorist attacks of September 11, 2001 had an immediate impact on the international situation with regard to Afghanistan. Al-Qaeda, the Sunni Islamist group which claimed responsibility for the attacks, had been based in the country since soon after the Taliban came to power in 1996. Immediately after the attack, the stunned United States sought to bring those involved to justice and the Taliban were asked to hand over Bin Laden. When the Taliban refused, the US began mounting a diplomatic offensive with the aim of achieving consensus and moral support for a retaliatory strike, in an attempt to destroy al-Qaeda and ensure there would be no further such attacks. Most countries responded positively, including some of the Arab states as well as Russia and China. There was also some general support from the United Nations Security Council, and specific support from NATO.

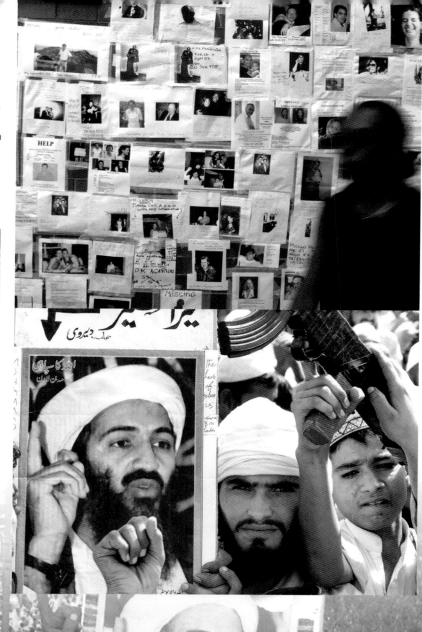

TOP RIGHT: **A wall is filled with the details of missing people at the Bellevue Hospital in midtown Manhattan, in the hope that they might be found alive after the attacks.**

RIGHT: **A Pakistani man holds a poster of Osama Bin Laden while a young boy totes a toy gun during a pro-Taliban demonstration in Karachi, Pakistan.**

ABOVE: **Union Square in New York awash with floral tributes to those who lost their lives in the 9/11 attacks.**

BOTTOM: **A Taliban supporter waves a picture of al-Qaeda leader, Osama Bin Laden, from a lamppost in Karachi during a demonstration called by the pro-Taliban Afghanistan Defence Council.**

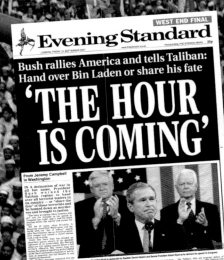

Evening Standard

WEST END FINAL

Bush rallies America and tells Taliban: Hand over Bin Laden or share his fate

'THE HOUR IS COMING'

From Jeremy Campbell in Washington

Operation Enduring Freedom

The assault on Afghanistan, codenamed Operation Enduring Freedom, began on October 7, 2001. It involved mostly US forces, with some from Britain and other NATO countries, and with the emphasis on attacks from the air; initially, few ground troops were deployed. There were several objectives, but they all centred around the removal of al-Qaeda and the destruction of their camps – and, hopefully, the capture of Bin Laden himself. A tape of Bin Laden was released to the Arab news channel al-Jazeera just before the assault; in it he called for a jihad, a holy war against the US.

Airstrikes were made against targets in and near Kabul and two other cities, Jalalabad and Kandahar. They met little resistance; though the Taliban had been able to make use of some of the munitions left over from the struggle against the Soviet Union, it appeared that anti-aircraft weapons were not among them.

ABOVE RIGHT: **The remains of a Taliban jeep lie at the bottom of a huge crater after it sustained a direct hit during an American airstrike.**

ABOVE: **Marines conduct a nighttime patrol in search of Taliban positions in Southern Afghanistan.**

BELOW: **United Nations vehicles cross a river, bypassing a bridge destroyed during a US airstrike, as the organization attempts to provide food relief before the winter sets in.**

US airstrikes

In the longer-term the Coalition attack had two phases: first came the destruction of the training camps, of both the Taliban and al-Qaeda, and then an attack on the Taliban's communications infrastructure. Civilian casualties began to mount up, and it became evident that the Taliban were receiving unofficial aid and support from the tribal areas of Pakistan. By early November, however, the Taliban forward positions had been extensively bombed and their regime began to collapse; as it did so, al-Qaeda assumed control in some areas. Resistance to the Coalition centred on the Tora Bora mountains east of Kabul. This difficult terrain, with a useful cave system, was where both the Taliban and al-Qaeda appeared to be dug in, and the mountains were heavily attacked as a result.

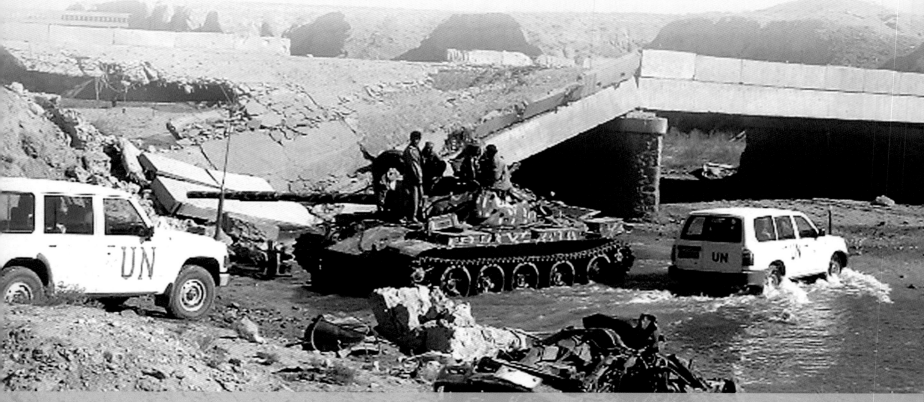

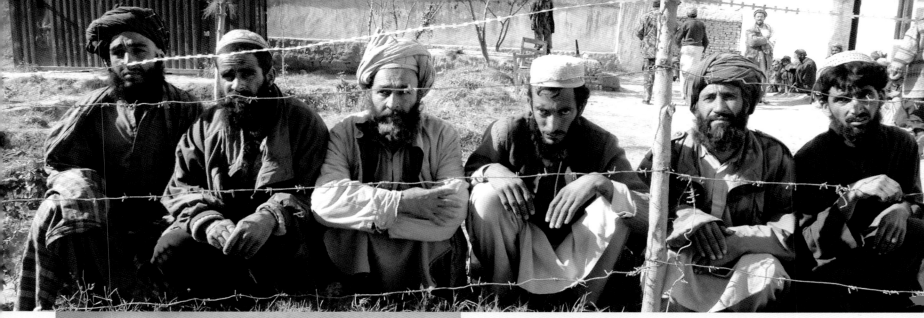

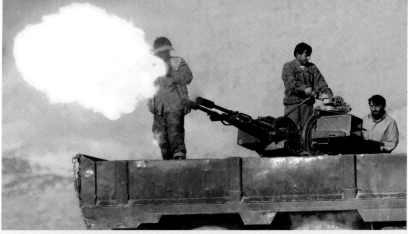

The Northern Alliance

The United States relied upon a native anti-Taliban coalition named the Northern Alliance to do much of the fighting on the ground and relatively few American troops were sent in during the initial invasion. The Northern Alliance largely drew its support from the three main minority ethnic groups, the Tajiks, the Uzbekhs and the Hazara, but they also had some backing among the majority Pashtun ethnic group. The Alliance still controlled territory in the north of the country, which they were able to use as a springboard for their attack.

The Alliance enjoyed considerable success, thanks largely to the US airstrikes and the support of American and British Special Forces. On November 9 the city of Mazar-i Sharif was taken, and during the night of November 12, almost all of the Taliban fled from Kabul itself. The Northern Alliance arrived the following day and found only a small group of Taliban fighters. The fall of Kabul sparked the almost total collapse of the Taliban; local warlords assumed control in many areas, notably the north and east.

Tora Bora mountains

Fighting continued in the Tora Bora mountains and though many Taliban fighters did surrender, a lot also escaped, most likely to the relatively close tribal areas of Pakistan. The Coalition established their first ground base on November 25 near the Taliban centre of Kandahar and the city fell on December 9, essentially concluding the invasion. However, some al-Qaeda members were still holding out in the Tora Bora, though tribal forces were pushing them out. The cave complex was eventually taken, but there was no sign of Bin Laden and it was suspected that he had already been moved to the tribal areas across the Pakistani border. The US forces based themselves at Bagram, close to Kabul. An interim Afghan government was formed under the auspices of the United Nations and aid began arriving.

TOP: Suspected members of the Taliban are held by the Northern Alliance in a makeshift prison camp near the city of Taloqan. Some in the west expressed misgivings over the human rights record of the Northern Alliance and criticized their summary judgement of Taliban suspects.

ABOVE: Northern Alliance soldiers shell Taliban positions along the frontline in Afghanistan.

BELOW: A Northern Alliance fighter garrisons the village of Kashmond Kala in the mountains north of Jalalabad, which was liberated after the withdrawal of al-Qaeda and Taliban forces in mid-November 2001.

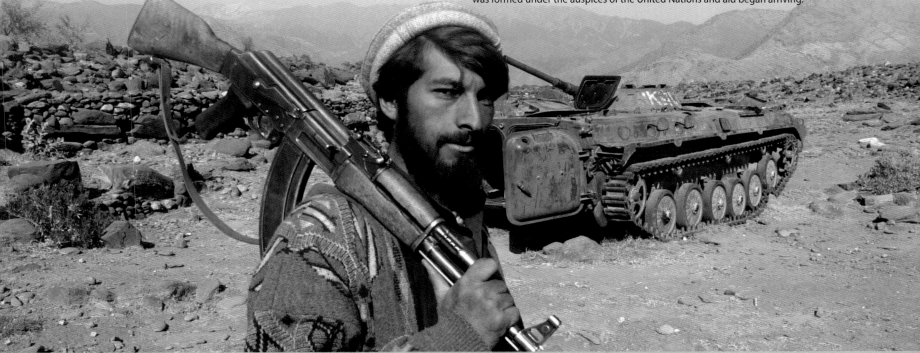

Insurgency

A period of consolidation began, but it was not long before it was interrupted. It soon became clear that neither the Taliban nor al-Qaeda had been destroyed and that they were, in fact, regrouping with the intention of launching a guerrilla insurgency. Many were now based in Pakistan, but some remained hiding in the caves of the Shahi-Kot mountains of eastern Afghanistan. In March 2002, the United States launched Operation Anaconda to drive the insurgents out, many were killed, but many also escaped across the border into Pakistan, from where they continued to launch cross-border raids.

This set the pattern for the next few years – attacks, followed by a Coalition assault, at which point the insurgents would disappear into the mountains and caves or the tribal region of Pakistan. Mobile training camps had been established there, and there had also been something of a recruiting campaign, with a renewed call for jihad. Throughout 2003–2005 there were Taliban rocket attacks, raids and ambushes, often involving the use of IEDs – improvised explosive devices, frequently in the form of roadside bombs. There was also evidence that the Taliban were back inside Afghanistan in increasing strength, using the remoter parts of the south as a base. Joint offensives began with the aim of rooting them out, utilizing troops from both the Coalition and the Afghan Government.

LEFT: British Royal Marine Commandos search Malmand in southern Afghanistan in November 2007 after reports that the town was being used as a Taliban logistics base. More than 8,000 British troops are stationed in the country, mainly in the restive Helmand Province, where much of the world's opium poppy crop is grown.

TOP: France's President, Nicholas Sarkozy makes his first visit to Afghanistan to pledge French support for the NATO-led ISAF mission in December 2007. Sarkozy later announced that he would bolster the number of French soldiers in Afghanistan to more than 2,500. His troop increases were approved by the French parliament despite the loss of ten soldiers in a deadly Taliban attack in August 2008.

ABOVE: Afghanistan's President Hamid Karzai inspects a guard of honour in Kabul with British Prime Minister Gordon Brown. In October 2004, Karzai, an ethnic Pashtun, became the first democratically elected leader of Afghanistan, winning more than 50% of the vote despite facing 17 other candidates.

ABOVE LEFT: President Barack Obama on his first day in office. President Bush began increasing the number of US troops in Afghanistan in 2008, and this surge was escalated by President Obama. In 2010, almost 100,000 American military personnel were serving in Afghanistan.

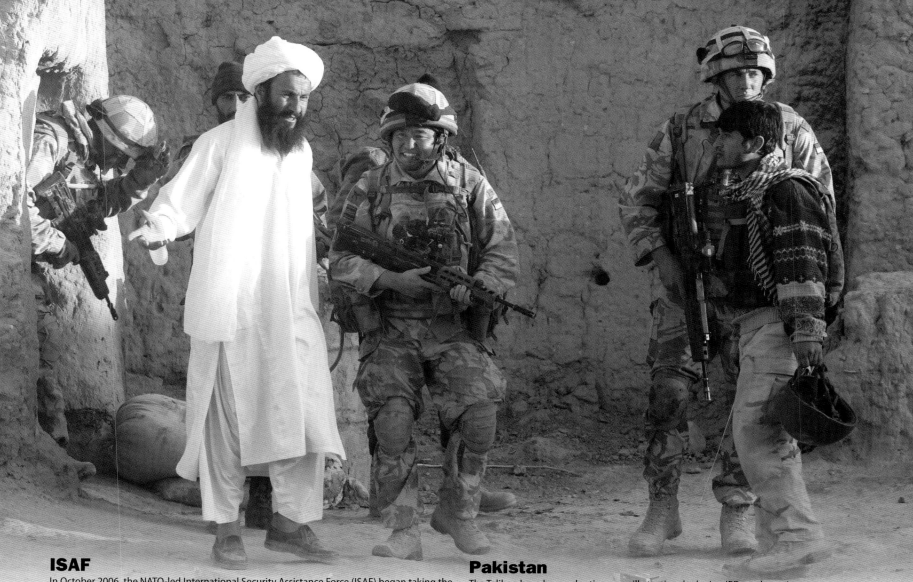

ISAF

In October 2006, the NATO-led International Security Assistance Force (ISAF) began taking the place of the United States, for whom the war in Iraq was assuming much greater importance. Many countries are contributing to ISAF, including France, Australia, Germany, Italy, Turkey, Spain, Poland and Romania.

ISAF has focussed on reconstructing Afghanistan by improving the economy, destroying the opium trade and pushing for better governance. However, it has been bogged down by a resurgent Taliban, especially in the south, where American, British, Canadian and Dutch troops are based.

President Bush began increasing the number of US troops in Afghanistan in 2008, and this surge was escalated by President Obama in 2009. In 2010, almost 100,000 American military personnel were serving in Afghanistan, together with more than 30,000 troops from other nations.

Pakistan

The Taliban have been adopting guerrilla tactics, deploying IEDs and carrying out assassinations and acts of sabotage before fleeing across the border with Pakistan to avoid NATO troops. The international community has put Pakistan under pressure to do more to combat the Taliban within its borders, but it has largely been unable to do so. In September 2008, US commandos raided a Taliban encampment in Pakistani territory. Just weeks later, Pakistani troops fired on two US helicopters hovering near the border; the incidents were followed by recriminations and denials on both sides. Subsequent clandestine raids have been carried out, mostly by unmanned drones.

Future

The death toll has been rising in recent years and public support is evaporating. President Obama plans to begin withdrawing US troops from July 2011. However, the security situation is unlikely to have improved by then unless more pressure is put on the Taliban in Pakistan.

ABOVE: A resident protests as ISAF troops search his home for evidence of the resurgent Taliban.

LEFT: Pakistani President Pervez Musharraf was largely an ally of the United States in the War on Terror. However, he has been criticized for not doing enough to tackle militants operating in his country. During his last year in power, Pakistan was beset by political uncertainty which has continued to destabilize the country, despite Musharraf's resignation in August 2008 .

FAR LEFT: Britain's Prince Harry on duty in southern Afghanistan in January 2008. News organizations agreed not to report that Harry had been serving on the frontline so as not to make him and other servicemen vulnerable. However, an Australian magazine reported the story and the Prince was pulled out of the country having served ten weeks.

Darfur
2003 -

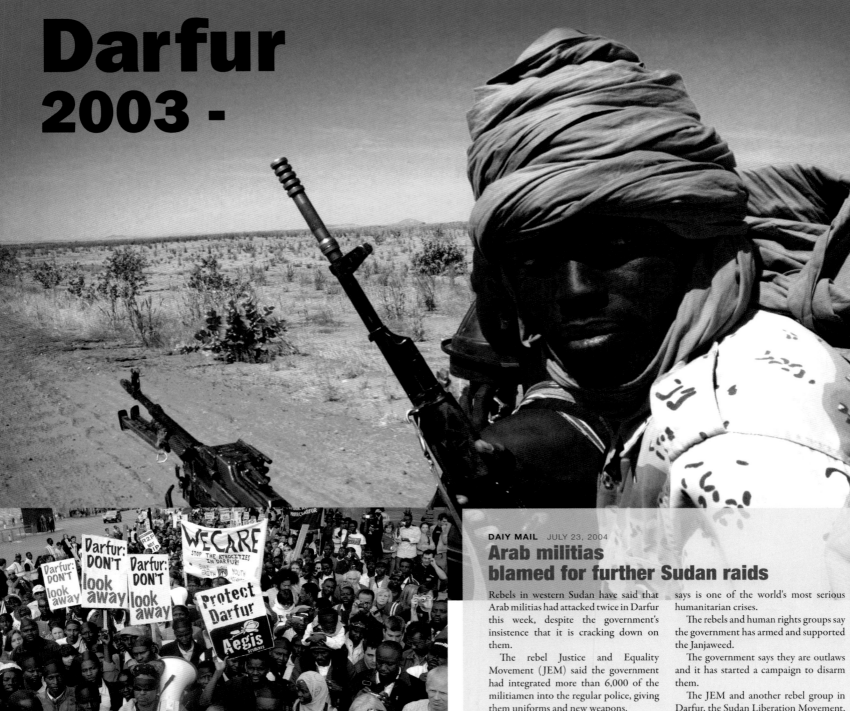

'Genocide'

Since gaining independence from Britain and Egypt in 1956, Sudan has fought two bloody civil wars as the non-Muslim, non-Arab south has resisted the authority of the predominantly Muslim, Arab government based in the capital, Khartoum, in the north of the country.

In February 2003 as the Second Civil War was drawing to a close, a rebellion broke out in the Darfur region in the west of the country. The rebels accused the government of neglecting the region, especially its non-Arab population. The government responded to the rebellion with air strikes and by mobilizing their Arab militias, the 'Janjaweed'. Since then, the Janjaweed have engaged in killing, raping and looting on a large scale in Darfur. An estimated 300,000 people have been killed and millions have fled their homes in what the United States government has labelled genocide. The Sudanese government has said it is attempting to rein in the Janjaweed and African Union troops have been dispatched to the region, but the killing continues.

DAIY MAIL JULY 23, 2004

Arab militias blamed for further Sudan raids

Rebels in western Sudan have said that Arab militias had attacked twice in Darfur this week, despite the government's insistence that it is cracking down on them.

The rebel Justice and Equality Movement (JEM) said the government had integrated more than 6,000 of the militiamen into the regular police, giving them uniforms and new weapons.

JEM general coordinator Abu Bakr Hamid al-Nur said by telephone that police including some of the militiamen, known as Janjaweed, had attacked a rebel camp on Wednesday in the Orshi area north of el-Fasher, capital of North Darfur state.

He said that two days earlier, Janjaweed had killed more than 30 people and kidnapped many women and children at Kfour, between el-Fasher and Kutum, about 120 km (75 miles) to the northwest.

The Janjaweed are at the centre of a conflict that has displaced more than a million people in remote Darfur and created what the United Nations says is one of the world's most serious humanitarian crises.

The rebels and human rights groups say the government has armed and supported the Janjaweed.

The government says they are outlaws and it has started a campaign to disarm them.

The JEM and another rebel group in Darfur, the Sudan Liberation Movement, pulled out of political talks with the government last Saturday because Khartoum rejected their preconditions, including disarmament of the Janjaweed.

The rebel groups took up arms in early 2003 to protect the settled non-Arab people of Darfur from attacks by Arab nomads who have traditionally competed with them for land and grazing.

The US Congress passed a resolution saying that genocide was under way in Darfur - a description many international observers on the ground say is an exaggeration.

The African Union has plans to send a peace force to Darfur to protect monitors and humanitarian workers.

Chadian influence

The conflict in Darfur has been complicated by the intervention of neighbouring Chad. Many of the victims of violence in Darfur belong to the Zaghawa tribe, which is the tribe of Idriss Deby, the President of Chad. Deby has given funding, arms and medical supplies to the rebels in Darfur, and his government most likely played a role in an ambitious rebel attack on the Sudanese capital, Khartoum, in May 2008. This has allowed the Sudanese government to claim the war in Darfur is in part an act of self-defence against Chad. The Sudanese government has reciprocated by supporting rebel groups in Chad and most likely assisted with an unexpected rebel attack on the Chadian capital, N'Djamena, in February 2008.

In February 2010, a ceasefire was signed between the government and one of the main rebel groups, the Justice and Equality Movement. It remains to be seen whether this will lead to a lasting peace for Darfur.

ABOVE: Irish troops, part of a European Union force, patrol through the desert in eastern Chad. The French-led European operation is designed to offer protection for refugees and humanitarian aid workers. Hundreds of thousands of people have fled across the Chadian border since the war in Darfur began.

OPPOSITE ABOVE: A member of one of Darfur's main rebel groups, the Sudan Liberation Army, races through the desert near the city of El Fasher in Darfur in November 2004.

OPPOSITE LEFT: Refugees from Darfur lobby the British government to intervene in Sudan during a rally outside the Prime Minister's residence at Downing Street in London, September 2007.

TOP: Nigerian troops of the African Union patrol the town of Habila Konare in Darfur in March 2006. The AU force was merged into a larger United Nations force at the start of 2008. The UN plans to send 26,000 peacekeepers to the region, but so far have fallen short of this total.

ABOVE: Protest rallies and marches have been held across the world to draw attention to the humanitarian crisis in Darfur.

LEFT: Refugees cram into the sprawling Riyad camp near the town of Al-Geneina in Darfur. The Janjaweed militias often patrol the desert surrounding the camps making it difficult for the refugees to search for food or water.

Iraq 2003 -

Resolution 687

During the Iran-Iraq War, Iraq's President Saddam Hussein had shown a willingness to use 'weapons of mass destruction' (WMDs) against both his enemy and his own people. After the Gulf War in 1991, the United Nations Security Council passed Resolution 687 calling upon Iraq to destroy its WMDs and UN weapons inspectors were sent in to monitor and verify Iraq's disarmament. In addition, no-fly zones were established over Kurdish and Shi'a areas to stop the Iraqi army attacking these communities from the air, and economic sanctions were introduced.

Operation Desert Fox

During the 1990s, Saddam became increasingly non-compliant. He began blocking access to sites suspected of housing WMDs and later began demanding that American members of the weapons inspection team be expelled from the country. Throughout 1998, the UN mission became mired in confusion, until it was withdrawn altogether in December. The following day, the United States and the United Kingdom launched 'Operation Desert Fox', a four-day-long air blitz on Iraq. The aim was to target and destroy sites suspected of housing WMDs and demonstrate that non-compliance had penalties.

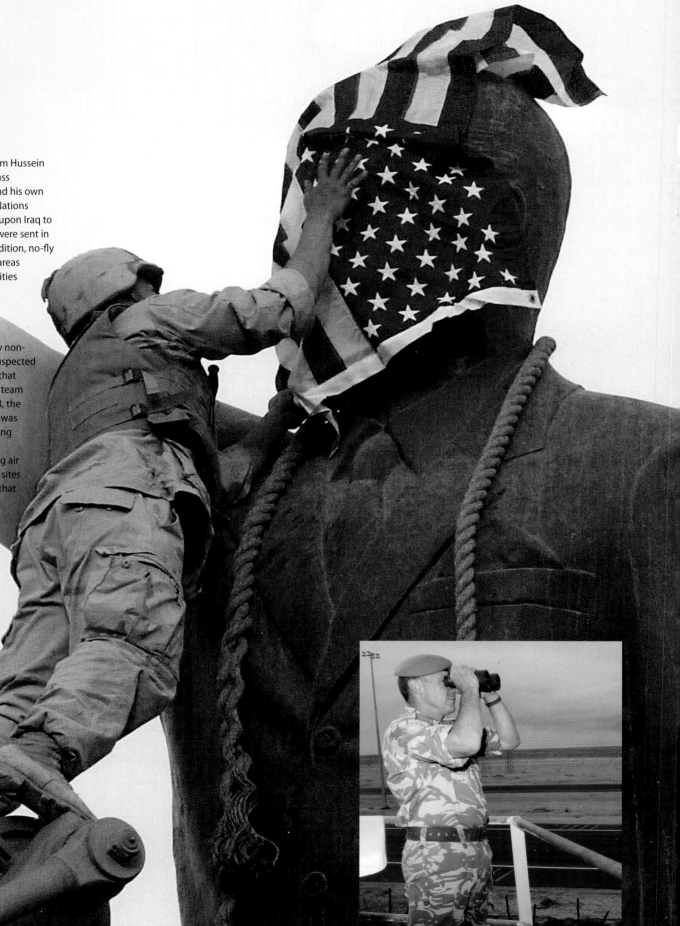

ABOVE: **A US Marine drapes the American flag over a statue of Saddam Hussein in Firdos Square. The statue was toppled shortly after, symbolizing the fall of Baghdad and Saddam's regime.**

RIGHT: **A soldier working for UNIKOM, looks across the border from Kuwait into Iraq in February 2003. UNIKOM, the United Nations Iraq-Kuwait Observation Mission, was set up to monitor the border between the two countries following the first Gulf War.**

The path to war

In the aftermath of the 9/11 terrorist attacks, the US government stepped up its demand that Iraq readmit the weapons inspectors and comply fully with the United Nations. Throughout 2002 UN and Iraqi negotiators met to discuss the readmission of inspectors. Saddam was inconsistent in his position, sometimes agreeing to give them full access, and at other times listing sites that were off-limits. On November 8, 2002, the UN Security Council voted unanimously in favour of Resolution 1441, which gave Iraq one last chance to comply with the weapons inspectors, but did not sanction the use of military force if he did not. Saddam accepted the resolution and the weapons inspectors were readmitted immediately. As per the terms of the resolution, Iraq submitted a lengthy written declaration of its weapons programme, but the US and Britain believed it to contain glaring omissions and war seemed ever more likely. In early 2003, international opposition to a US and British invasion mounted; a long list of countries including France, Russia and Germany refused to support it, millions of people took to the streets in cities around the world to protest, and government ministers in Britain resigned. Knowing that a new Security Council Resolution calling for the use of force would be vetoed, Britain and America decided to press ahead without a UN mandate. On March 17, 2003, the US President, George W. Bush, gave Saddam 48 hours to leave Iraq or face war.

TOP RIGHT: **Hans Blix, the head of the UN weapons inspection team in Iraq, was a key figure in the run-up to the Iraq War as his reports on Iraq's compliance with the UN shaped the international response.**

TOP LEFT: **US and British troops, massing in Kuwait, watch as US Secretary of State Colin Powell gives a speech to the UN just days before the invasion.**

RIGHT: **Millions of people gathered in cities across the world to protest against the war in Iraq in early 2003. On February 15 an estimated one million people converged on London for the largest demonstration in British history.**

ABOVE: **Troops of the 16 Air Assault Brigade train by night in Kuwait.**

BELOW: **US General James Conway of the 1st Marine Expeditionary Force addresses allied British troops in Kuwait on March 14, 2003. By this time it had become clear that other major powers - France, Russia and Germany - would not support an invasion of Iraq. Australia and Poland also sent troops for the initial invasion.**

Invasion

The invasion of Iraq began in the early hours of the morning on March 20, 2003. Airstrikes were launched against Baghdad and troops began pouring across the border from Kuwait. Unlike in Afghanistan, the decision was taken to stage the ground and air offensives in parallel so as to prevent Saddam's forces from destroying the oilfields of Southern Iraq. American and British troops were joined by soldiers from Australia and Poland for the invasion and a number of other countries agreed to play supplementary roles.

The Coalition planned a two-pronged attack with the aim of reaching Baghdad as quickly as possible. One thrust was made to the west of the Euphrates River while the other was made further east closer to the Tigris River. The southern port of Basra was to be captured and occupied by the British but, by and large, major population centres were avoided at first. The US had hoped to make another thrust on Baghdad from northern Iraq, but the Turkish government refused permission for an invasion to be staged from its territory. In the event, a smaller number of troops were parachuted into the region to team up with Kurdish guerrillas who had been fighting Saddam's regime for years.

BELOW: **Iraq's Planning Ministry on the Tigris River in Baghdad is hit by a US missile, on the opening day of the invasion. Thousands of bombs were targeted on sites linked to Saddam's regime in a campaign of 'shock and awe' designed to soften up resistance to the ground troops crossing the Kuwaiti border in the south.**

ABOVE RIGHT: **As coalition troops head north they pass thousands of refugees fleeing the bombing of Basra. The city had been left without water and most refugees pleaded with coalition troops for a drink.**

BELOW RIGHT: **A Royal Air Force Harrier jump jet takes off from an airfield in Kuwait on its way to bomb Iraq.**

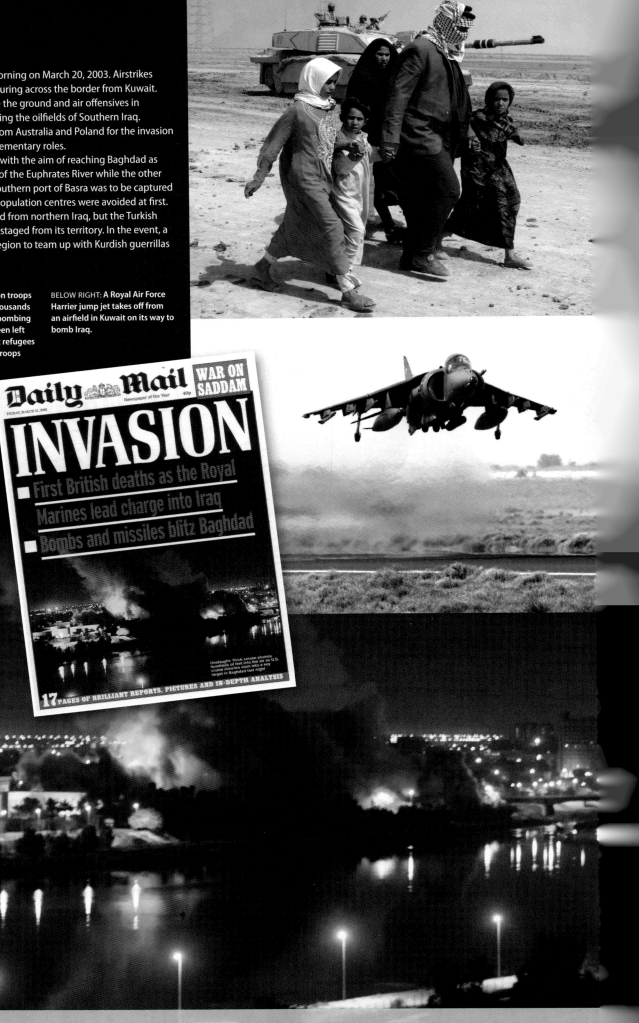

Daily Mail

WAR ON SADDAM

FRIDAY, MARCH 21, 2003

INVASION

- First British deaths as the Royal Marines lead charge into Iraq
- Bombs and missiles blitz Baghdad

Onslaught: Thick smoke plumes hundreds of feet into the air as U.S. cruise missiles slam into a key target in Baghdad last night

17 PAGES OF BRILLIANT REPORTS, PICTURES AND IN-DEPTH ANALYSIS

Iraqi resistance

The US army was expecting to encounter a similar situation to the first Gulf War, but that was not what happened in practice. There was considerably more resistance, and it was better organized. It was also different; American troops faced opposition from guerrilla fighters in built-up areas, who held them back for some time despite the invaders' much superior firepower. This led to a general suspicion of any Iraqi civilian – the guerrillas wore no uniforms – which often had appalling consequences. The local people also remembered the terrible penalties many had paid for welcoming the invading forces in 1991, and often did not greet the incomers as liberators.

The Coalition forces were able to advance swiftly across the desert and open countryside, but they came into problems when they reached Nassiriyah. Here US forces were bogged down by a heavy sandstorm as well as guerrillas and sustained considerable casualties before taking control of the city. Meanwhile, air and missile attacks on Baghdad continued. Although these used precision-guided weapons, and were only aimed at specific targets, mistakes were sometimes made: on the seventh day of the invasion a US plane dropped two bombs on a busy market in northern Baghdad killing and injuring a number of civilians.

Baghdad falls

Saddam Hussein had planned a last-ditch defence of his capital, and expected that his Special Republican Guard would prevent US troops from approaching. In the event, the result looked like a foregone conclusion and the trusted and feared Guard disappeared. Public opinion seemed to be swinging around as the Iraqi people began to believe that, this time, the regime might fall. For his army officers, this meant that there was little point in obeying orders, and the Americans were able to capture Saddam International Airport on April 4. Five days later, Baghdad itself fell, symbolized by the toppling of a large statue of Saddam in Firdos Square in the centre of the city.

Though the mood had changed to some degree, it had not taken the direction the Americans had anticipated. Many people wanted them as little as they had wanted Saddam Hussein, and saw them more as conquerors than liberators. Looting and civil disorder broke out in Baghdad and spread to cities across the country. The looting began with government and Ba'ath Party buildings, but it spread much more widely and the Coalition troops were unable to contain it. Hospitals, schools, museums: nothing which had even the vaguest connection to the regime was immune.

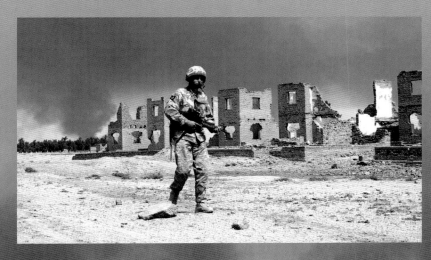

Evening Standard

LONDON, FRIDAY, 4 APRIL 2003 www.thisislondon.co.uk *incorporating THE EVENING NEWS 40p*

GHOST CITY

Disturbingly quiet, the centre of Baghdad. Today three were reports of a ghost city atmosphere with no sign of the usual armed soldiers. Outside the capital 2,500 Republican Guards have surrendered.

Baghdad falls silent with no sign of defences as they await US move

TOP: Paratroopers in the desert during Operation Iraqi Freedom. Coalition forces spent considerable time in the desert as they pushed on Baghdad; conditions could be very inhospitable and sandstorms blighted communications and supply lines.

ABOVE: A British soldier with the 'Desert Rats', Seventh Armoured Division, walks past ruined buildings in Mushirij, a village amid the oil fields west of Basra.

LEFT: Coalition troops camp under the bright light of burning oil wells in Southern Iraq. Iraqi troops managed to set several wells alight, but not as many as had been feared.

Occupation and Insurgency

When the city of Tikrit – Saddam's hometown – fell on April 15, the invasion as such was over. On May 1, President Bush stood aboard the USS *Abraham Lincoln* and declared that major combat operations were at an end. The occupation had now begun. A temporary provisional government was installed and the time that followed was marked by attempts to establish an elected and more representative democratic government. It was also marked by the outbreak of violence against the Coalition forces and among various sectarian groups. Initial opposition to the Coalition came from Saddam's remaining loyal supporters, many of who were tracked down. Saddam Hussein himself was found hiding on a farm near Tikrit on December 13, 2003, and following a year-long trial, he was hanged on December 30, 2006.

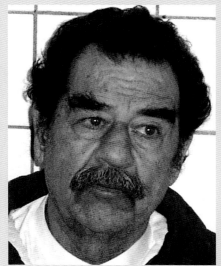

RIGHT: **Saddam Hussein sits in his cell awaiting trial for the torture and murder of the Shi'a population of Dujail in 1982. Saddam was alleged to have ordered the massacre after narrowly escaping an assassination attempt in the town. He was found guilty and sentenced to death by hanging.**

BELOW: **American soldiers search Iraqi youths who were thought to be selling guns on the streets of Baghdad.**

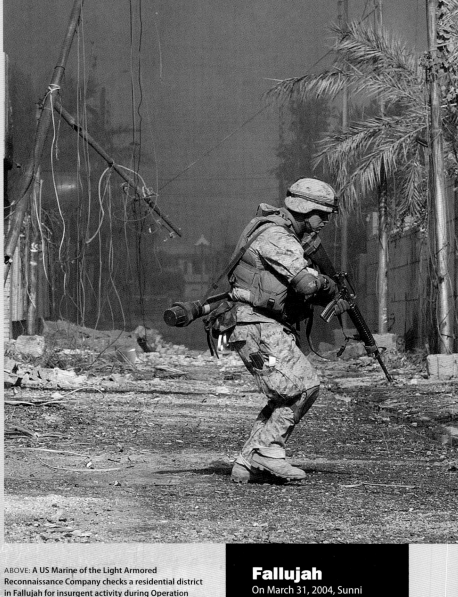

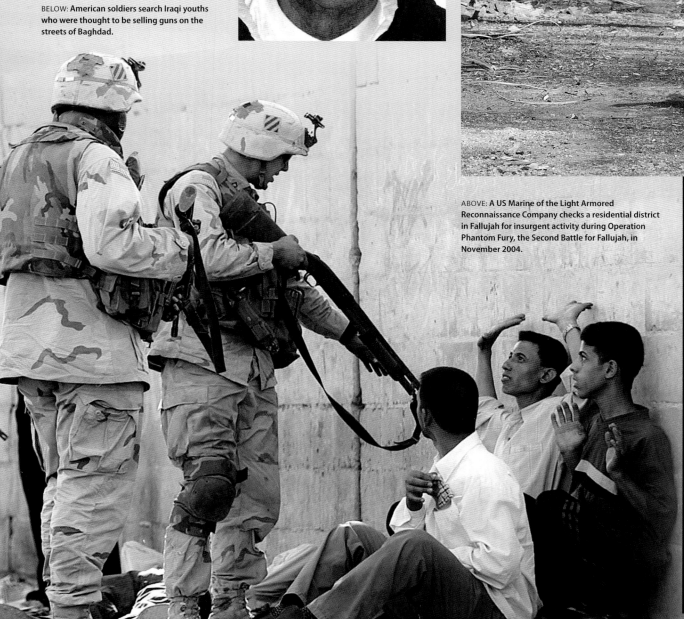

ABOVE: **A US Marine of the Light Armored Reconnaissance Company checks a residential district in Fallujah for insurgent activity during Operation Phantom Fury, the Second Battle for Fallujah, in November 2004.**

Fallujah

On March 31, 2004, Sunni insurgents ambushed a convoy driving through the predominantly Sunni city of Fallujah. Four private American security contractors were killed then their mutilated bodies were hung from a bridge in the city. US troops retaliated in what became the First Battle of Fallujah, but a ceasefire was declared after it emerged that various key members of Iraq's Provisional Government were opposed. Fighting resumed in November when it was clear that Sunni insurgents had tightened their control over the city. Civilians were given a chance to evacuate before the city was pummelled from the air and US troops were sent in. By the end of the operation, half of Fallujah's buildings lay in ruins and many of the insurgents had been killed or captured.

Islamic extremism

Saddam loyalists were later followed by others who stood against the occupation, especially religious extremists of various kinds. Sunni fundamentalists, drawing inspiration from Osama Bin Laden's terrorist network, called themselves al-Qaeda in Iraq (AQI), and began attracting many foreign fighters to help them wage jihad against the occupying 'infidels'. AQI has employed terror tactics, notably suicide bombings and hostage-takings, to terrible effect; thousands of people have been killed and Iraq has been severely destabilized. Since its founder and leader, Abu Musab al Zarqwi, was killed in a targeted US airstrike in June 2006, AQI appears to be in decline, but it remains capable of conducting serious atrocities against civilians and soliders alike.

The main Shi'a insurgent group, the Mahdi Army, has been less inclined to adopt terror tactics, preferring instead to engage Coalition and Iraqi forces in gruelling street battles in Shi'a strongholds in southern Iraq and Baghdad. The Mahdi Army is led by the radical cleric Mutada al-Sadr and gets some support from neighbouring Iran. In August 2007, Sadr agreed to a ceasefire, which has largely held, and he now appears to be pursuing less violent routes to power. However, Shi'a extremists claiming to be linked to the Mahdi Army continue to operate in Southern Iraq, despite the Iraqi government's attempts to disarm them.

Sectarian violence

The insurgency against the foreign occupiers soon gave way to a civil war between Iraq's various extremist factions. The country has been plagued by sectarian violence for years, but it was the bombing of the al-Askari Mosque in Samarra – an intensely holy place for Shi'a Muslims – that unleashed a new level of sectarian bloodshed. Across Iraq Shi'a groups responded by massacring Sunni Muslims and destroying Sunni mosques. This led to a cycle of sectarian violence only somewhat mitigated by a 'surge' in US troop numbers during 2007. August of 2007 saw the single most deadly suicide-bomber attack, when more than 800 members of the non-Muslim Yazidi community died in an attack on the town of Qahtaniya. Al Qaeda in Iraq probably conducted the attack in revenge for their execution of a convert to Islam.

US withdrawal

After assuming office in 2009, President Obama announced that US combat troops would be withdrawn from Iraq within eighteen months. The drawdown proceeded largely as planned and on August 31, 2010, Obama announced the end of Operation Iraqi Freedom. Around 50,000 US troops will remain in Iraq to train Iraqi forces and protect US interests until the end of 2011.

ABOVE RIGHT: **US President George W. Bush meets Marines during his visit to Al-Asad Air Base in Anbar Province, Iraq, in September 2007.**

RIGHT: **British Prime Minister Tony Blair meets students from an elementary school in Basra during a visit to postwar Iraq. Blair was a solid supporter of the Iraq War, despite facing widespread opposition from within his own party.**

BELOW: **A US soldier carries an Iraqi girl away from the scene of three explosions in Baghdad. Insurgents attacked a US military convoy as it passed by the opening ceremony for a sewage station, killing 35 people and wounding scores of others.**

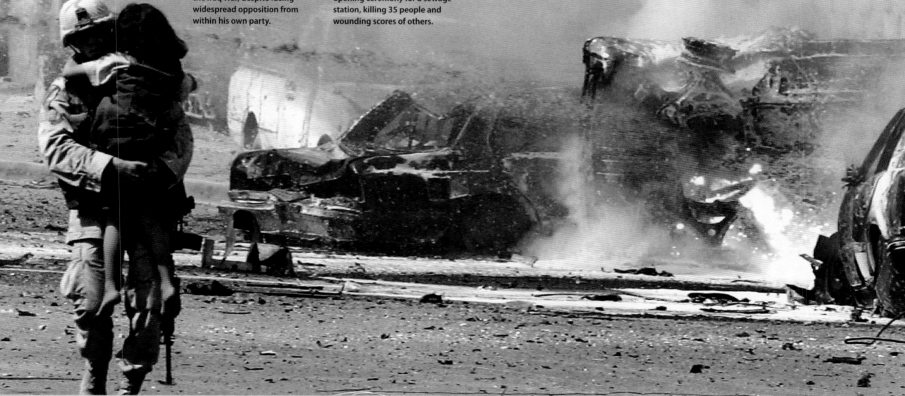

Israel-Lebanon War 2006

Operation Grapes of Wrath

After the end of Lebanon's civil war in 1990, Hezbollah remained armed in order to fight the Israeli occupation of Southern Lebanon. Intermittent attacks occurred over the years, but the closest the two sides came to war was in 1996, when Israel launched 'Operation Grapes of Wrath', a two-week blitz on Lebanon to take out the missile sites Hezbollah had been using to fire rockets into northern Israel. During the operation, Israeli planes struck a UN compound in Qana, killing more than one hundred civilians who had taken refuge there. The strikes were halted after the United States intervened.

Israel withdrew from Southern Lebanon in May 2000, but Hezbollah has argued that a narrow stretch of territory is still being occupied so as to justify its continued attacks on Israeli military targets. The territory, named the Sheeba Farms, was taken from Syria during the 1967 war and was therefore not included in Israel's pullout from Lebanon.

Cross-border raid

On July 12, 2006, Hezbollah captured two Israeli soldiers during a cross-border raid. The Israeli Prime Minister Ehud Olmert perceived this as an act of war and initiated a full-scale offensive aimed at securing the release of the soldiers and more broadly at dealing a decisive blow to Hezbollah. Israel began by bombing cities across Lebanon, concentrating on Hezbollah's strongholds in the south and in Beirut. For its part, Hezbollah stepped up its rocket attacks on northern Israel, killing a number of people during strikes on the country's third-largest city, Haifa. While the air war was ongoing, the Israeli army staged a ground invasion of Southern Lebanon in an attempt to take out the rocket sites.

ABOVE: **A man walks through the devastated Musharachea district of Dahiye, a Hezbollah stronghold in the southern suburbs of Beirut.**

RIGHT: **Flames rise above the skyline of Haifa as a Hezbollah rocket strikes the city, killing at least three people. At the height of the conflict more than one hundred rockets were hitting northern Israel each day.**

Evening Standard
WEST END EDITION

CHILDREN DIE IN NEW BLITZ

Picture captures full horror of the Middle East, with no end in sight

Pressure on Blair to delay his holiday

Ceasefire

The cost to both sides was high, and more than 1,000 civilians are estimated to have been killed during the raids on Lebanon. The civilian suffering galvanized the international community to act and the United Nations passed a resolution demanding a ceasefire and an Israeli withdrawal. Both sides accepted the resolution and the ceasefire came into effect on August 14 after more than one month of fighting. A strengthened United Nations force was sent into the south to maintain peace and security following the withdrawal of Israeli troops. The war failed to deal a decisive blow to Hezbollah or secure the return of the two captured soldiers, leading many Israelis to question the wisdom of the war. In July 2008, it emerged that the two soldiers had been killed and their remains were returned to Israel as part of a prisoner exchange.

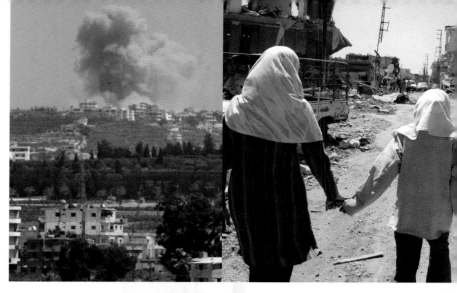

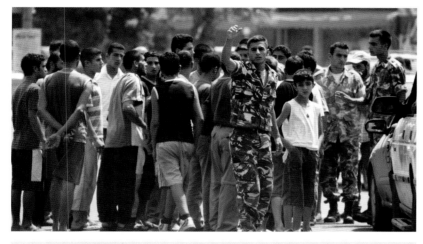

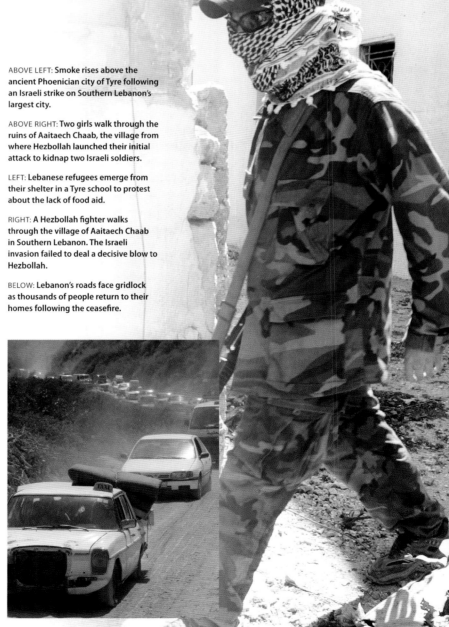

ABOVE LEFT: **Smoke rises above the ancient Phoenician city of Tyre following an Israeli strike on Southern Lebanon's largest city.**

ABOVE RIGHT: **Two girls walk through the ruins of Aaitaech Chaab, the village from where Hezbollah launched their initial attack to kidnap two Israeli soldiers.**

LEFT: **Lebanese refugees emerge from their shelter in a Tyre school to protest about the lack of food aid.**

RIGHT: **A Hezbollah fighter walks through the village of Aaitaech Chaab in Southern Lebanon. The Israeli invasion failed to deal a decisive blow to Hezbollah.**

BELOW: **Lebanon's roads face gridlock as thousands of people return to their homes following the ceasefire.**

DAILY MAIL JULY 17, 2006

Lebanon plunged back into the devastation of the 1980s

Bombs, bloodshed and burials marked the fifth day of Israel's merciless bombardment of Lebanon yesterday. Jets blitzed Beirut and the south of the country, killing at least 36 and turning the clock back a quarter of a century.

In the south of the capital, heartland of the Hezbollah militants, entire buildings were reduced to rubble. One apartment block toppled on to its side while the upper floors of others collapsed on to homes below.

Furniture, blankets, mattresses, clothes and soft toys were scattered on the streets. The wrecked home and office of Hezbollah leader Sayyed Hassan Nasrallah were still smouldering after repeated raids.

The airstrikes, in revenge for Hezbollah's kidnapping of two Israeli soldiers, have so far killed 140 people, almost all of them civilians. Eight Canadians from a single family died when warplanes flattened a house in the border town of Aitaroun. They had come for a summer holiday with relatives.

Only a week ago, Beirut was the self-proclaimed cultural and party capital of the Middle East. It was a magnet for tourists and investors again after years of rebuilding an economy shattered by a long and bloody civil war and the Israeli invasion of 1982. Now Israel has killed

not only scores of its people but Lebanon's future too. It has been plunged back into the devastation of the 1980s when Beirut was a byword for misery, destruction and death.

As well as disbelief, there is despair. 'We feel the entire world has left us alone to be slaughtered,' said Ali Al-Amin, a 40-year-old civil engineer who has stayed at his Beirut home with his sister and mother because they have nowhere else to go. At a nearby school, 11-year-old Aya Al-Siblam wrote on the blackboard: 'Today is the worst day of my life.'

A visibly emotional Prime Minister Fouad Siniora denounced Israel for turning his country into a 'disaster zone' and appealed for foreign aid. Blankets, sheets and medical equipment are all in short supply.

The most horrific attack of the campaign came on Saturday, when at least nine children were among 21 people incinerated when a bomb was dropped on their convoy. They had been following Israeli instructions to leave their border town.

Anger and terror grip Lebanon. No one expects Hezbollah to surrender its arms, and no one expects Israel to end its attacks. Trapped in the middle are the ordinary people.

Ethiopia-Somalia War 2006

The Ogaden war

Frequent clashes have occurred between neighbouring Somalia and Ethiopia ever since Somalia was granted independence from Britain and Italy in 1960. Large-scale war broke out in 1977 when Somalia tried to reclaim the Ogaden region which had come under Ethiopian control. The efforts of Somalia's dictator Siad Barre failed and his troops were forced to retreat in 1978.

In 1991 Siad Barre's regime collapsed when an uprising of the Issk clan in the north-west of the country precipitated a nationwide rebellion. Since then, despite global efforts to help the situation in Somalia, the country has been plagued by violence and has been without a recognized government. The latest phase in the Somalia crisis came in 2006 when Ethiopia intervened to aid the weak Transitional Federal Government in their fight to release the Islamic Courts Union's hold over Mogadishu.

American intervention

On December 3, 1992, the UN passed Resolution 794 authorizing the use of all necessary means to create a secure environment for aid operations in Somalia. The United States led the taskforce, known as UNITAF, under a mission codenamed 'Operation Restore Hope'. In May 1993, following another UN vote, UNITAF was transformed into UNOSOM II and the American mission was renamed 'Operation Continue Hope'.

The US involvement came to a abrupt end when 19 American servicemen were killed during fighting in Mogadishu on October 3, 1993. Somali militias managed to shoot down two Blackhawk helicopters and then engaged American troops in bitter street fighting.

Shocking pictures filtered through the Western press of the soldiers' bodies being dragged through the streets and the American public began to question the necessity of their presence in a country of seemingly limited strategic importance. In March 1994, President Clinton withdrew US troops from Somalia and the UN followed suit a year later. The debacle reduced America's appetite for further intervention on the African continent over the following decade.

Islamic Courts Union

Barre's demise and the rebellion in 1991 gave way to violent clan warfare in Somalia. The only real force of law that existed in the country at this time was regulated by the Sharia-based courts. The courts began to develop into an institution that provided education and health services as well as regulating the police force. As the role of the courts expanded, they gained a wider support base, and in 1999, advocates of the courts formed the Islamic Courts Union. The ICU was assisted partly by Eritrea, who supplied arms to its militia group, which allowed the Islamists to gain control of Mogadishu. Following their seizure of Mogadishu, the Islamic Courts Union brought a degree of stability to Somalia that had not been experienced for years.

As the Islamic Courts strengthened their grip over the country, they threatened to spread their Islamist militancy across the border to Ethiopia's substantial Muslim minority. Ethiopia's Prime Minister, Meles Zenawi, felt compelled to act to prevent the destabilization of his country. In July 2006 reports that Ethiopian troops had crossed into Somalia began to emerge, but Zenawi claimed that they were military trainers in the country helping the Transitional Federal Government. Three months later he declared Ethiopia in a state of war with the Islamic Courts Union.

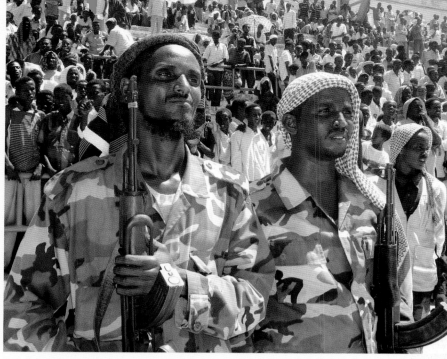

Islamists in Retreat

Battle ensued in Baidoa and in the towns of Bandiradley in Mudug and Beledweyne in the Hiran region. The fighting came to a head at the Battle of Jowhar on December 27, the last major town on the road to Mogadishu. Ethiopia gained control of the town and took the fighting to the capital. The leaders of the Islamic Courts Union could not withstand Ethiopia and its hold over Mogadishu collapsed. Ethiopia sought the assistance of African Union troops to bolster the Transitional Federal Government and allow the unpopular Ethiopian troops to withdraw.

As yet, the African Union has not sent in sufficient numbers of troops and Ethiopian troops remain in the country to avoid another power vacuum, which might allow the Islamic Courts Union to return to power. The collapse of the Islamic Courts Union has led to a re-emergence of clan fighting with almost 2 million Somalis displaced from their homes in Mogadishu alone.

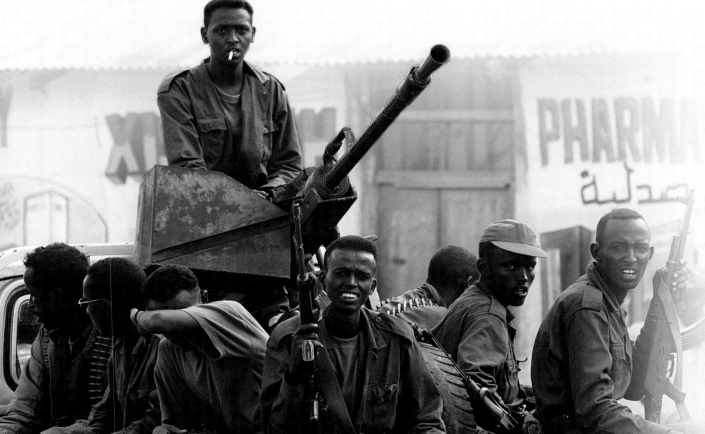

OPPOSITE ABOVE: **Somali youths are trained by the Islamists for the impending war with Ethiopia at the Arbiska training camp near Mogadishu in September 2006.**

OPPOSITE MIDDLE: **Siad Barre, the dictator of Somalia from 1965 to 1991. His overthrow has left Somalia without an effective government.**

OPPOSITE BELOW: **UN food aid arrives at a camp for internally displaced Somalis at Wajid. Millions of people have been displaced by relentless fighting in the country.**

TOP: **Members of the Islamic Courts Union hold an anti-American protest in Mogadishu stadium in December 2006.**

ABOVE LEFT: **An aerial view of Mogadishu on December 31, 2006, days after Ethiopian troops had taken control of the city.**

LEFT: **Troops of the weak Transitional Federal Government ride through the town of Bur Haqaba on December 28, 2006. Before the war, the Ethiopian government helped train these forces in the hope that they could contain the Islamists and reduce the need for direct Ethiopian intervention.**

Russian invasion of Georgia 2008

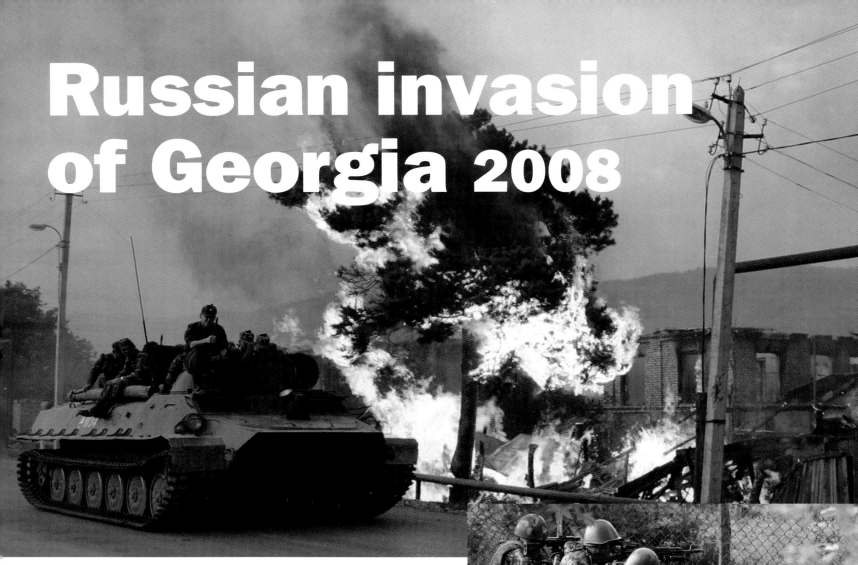

Russia's 'near abroad'

The Russian government has had a history of opposing the emergence of Western-leaning governments in former Soviet States, which Moscow claims to fall within its sphere of influence and names the 'near abroad'. In defiance of this, the Georgian government of President Mikhail Saakashvili, which was swept to power in the popular 'Rose Revolution' in 2003, has sought closer ties with the West and has even bid to join NATO. In response, Moscow has supported separatist movements in the Abkhazian and South Ossetian regions of Georgia, which have helped to undermine Tbilisi's chances of getting into NATO.

Until 2008, the Russian government opted for a subtle approach towards reining in its 'near abroad' so as not to appear too adversarial on the international stage. However, the West's recognition of Kosovo's independence in February 2008, in spite of strong Russian objections, encouraged the Kremlin to play a more overt role in Georgia. Tensions mounted throughout the spring of 2008 and relations reached an especially low point when Russia was implicated in the shooting-down of an unmanned Georgian reconnaissance plane over Abkhazia in April.

War in South Ossetia

Less than four months later, on August 7, border skirmishes between Georgian and South Ossetian forces turned into a full-scale offensive. The Georgian government, which had been calling for peace negotiations, moved troops into South Ossetia and began bombing the capital, Tskhinvali. The following day, Russia came to the assistance of South Ossetia under the pretext that it was protecting its citizens, as many South Ossetians had been issued with Russian passports. On August 9, Russian planes began bombing the town of Gori in Georgia and moved tanks and troops into Georgian territory. Over the next few days, the bombing offensive against Gori continued and was widened to include military targets across the country.

Soon after the war broke out, the international community began calling for a cessation and French President Nicholas Sarkozy proposed a peace plan whereby all sides would withdraw to their pre-war positions. On August 12 President Medvedev agreed to Sarkozy's terms and announced a ceasefire. Russia had met its aim of forcing Georgian troops out of South Ossetia and demonstrating that it still had authority over its 'near abroad'.

DAILY MAIL AUGUST 12, 2008

INVASION:
Russia launches blitz on Georgia as Putin brushes aside calls for ceasefire

Russian troops invaded Georgia yesterday as Vladimir Putin brushed aside the West's appeals for a ceasefire. Soldiers and armoured vehicles advanced 25 miles inside the former Soviet satellite to capture two towns in the west. There were unconfirmed reports that the strategic central city of Gori had fallen after a Georgian retreat.

Georgia was urgently moving troops back to defend its capital Tbilisi from further Russian onslaught. 'The Georgian army is retreating to defend the capital,' a statement said. 'The government is urgently seeking international intervention to prevent the fall of Georgia.'

In Gori, where artillery fire could be heard, Georgian soldiers warned the public that Russian tanks were approaching and advised them to leave. Hundreds of terrified families fled toward Tbilisi, using any means of transport they could find. Many stood along the roadside trying to flag down passing cars. Russia opened up the new fronts as the Kremlin continued to defy international calls for a halt to the four-day conflict.

Moscow said it had moved into Georgia to end military resistance in the area around the disputed enclave of South Ossetia. Georgia's president Mikhail Saakashvili described Russia's actions as the 'cold-blooded, premeditated murder of a small country.'

OPPOSITE ABOVE: A Russian tank rolls past a house in Kvemo-Achebeti set on fire by South Ossetian militia.

OPPOSITE BELOW LEFT: Firefighters tackle a blaze in an apartment block in Gori after it had been hit by Russian bombers.

OPPOSITE MIDDLE RIGHT: Russian troops move into the Khurcha settlement in the breakaway region of Abkhazia. Abkhazian separatists, backed by Russia, used the war in South Ossetia to push Georgian troops out of Abkhazia entirely.

OPPOSITE BELOW RIGHT: Georgian police face down Russian tanks and soldiers on the outskirts of Gori.

BELOW: A Georgian military convoy heads north on the road between Gori and Tbilisi to halt the Russian advance.

TOP LEFT: Georgia's President Mikhail Saakashvili condemns the Russian military action during a nationwide address.

TOP RIGHT: A Russian soldier takes aim as a Georgian tank convoy enters Tskhinvali in South Ossetia.

ABOVE MIDDLE: Georgian troops assemble the military convoy on the outskirts of Tbilisi.

ABOVE: A burnt-out Georgian tank lies abandoned at the roadside two kilometres outside Gori.

LEFT: Russian soldiers in military vehicles wait for orders on the outskirts of Gori.

Picture Acknowledgements

The photographs in this book are from the archives of the Daily Mail.
Thanks to many of the photographers who have contributed.

Getty Images: 64t; 90t; 255b; 94t; 112t; 123t; 132; 302; 134; 137; 138t

David Eldan 13b; Arpad Hazafi 30b; Sanjor Bojar 31m; Bela Jarmai 32b; Paul Vathis 35bl; Peter Arnett 42l; Henri Huet 44b; Slava Veder 54t; Hoang Van Cuong 55t; Paul Faith 65l, 65r; Niall Carson 65b; Jeremy Selwyn 63l, 64tr, 121bl, 121bm; Monty Fresco 68bl, 68br; Bill Cross 69tl, 69bl, 69br; Mark Ellidge 69tl; Karel Prinsloo 76rm; Manuel de Almeida 76br; Luis d'Orey 77l; Peter Andrews 77r; Mourad Raouf 79al; Menhem Kahan 80b; Jim Hollander 81tl 93c; Vitaly Armand 83b; Ghislain Zoccolat 86; Barry Thumma 94b; Mick Forster 91mr; Keith Pannell 92t; Rabih Moghrabi 92r; Martin Cleaver 93ml; Jerome Delay 93mr; Pascal Guyot 98t; Dominique Mollard 100t; Jean-Philippe Ksiazek 106ml; Corin Dufka 107l, 107ar; Alexander Joe 107br; James Miller 108t; Christopher Birbeumer 108m; Steve Bent 109l; Lynn Hilton 109r; Oliver Chukletovic 109b; Giles Penfound 110r; Nick Sharp 110b; Wally Santana 111l; Sayyid Azim 112bl, 112m, 116b; Jaques Collet 112ml; Jean Marc Bouju 112br, 113ml; Murray Sanders 115l; Nikolai Gaiayev 115m; George Mulala 116t; Antony Njuguna 117tr, 140b; David Crump 118t; Nick Skinner 119tl, 120bl; Alex MacNaughton 120br; Ed Wray 122t; Muchtar Zakaria 122l; Charles Dharapak 122r; Fayez Nureldine 123m; Alaa Badarneh 123b; Jamie Wiseman 124t, 126tr, 127t, 128l, 129t; 134m, 135t, 138t, 139; Cavan Pawson 124br, 124bl; 125tr 125l, 134t; Stephen Shaver 125r; Zahid Hussein 125b; Ian McIlgorm 127b; Pete Souza 128; Eric Febeberg 128tr; Peter Macdiarmid 128br; John Stillwell 129bl; Finnbarr O'Reilly 131; Bruce Adams 133tl, 135b; Glenn Copus 133tr; Steve Waters 133r; Mark Richards 133b, 135m, 143b; Michael Thomas 136b; Jason Reed 137t; Guy Calaf 141b; Denis Sinyakov 142t; Vladimir Popov 142m; Irakli Gedenidze 143tl; Mikhail Metzel 142tr; Gleb Garanich 143ml; Scott Hornby 143br.

Every effort has been made to trace any photographers and copyright-holders not mentioned here.
The publishers apologise for any unintentional omissions and would be pleased,
in such cases, to add an acknowledgement in future editions.

The photographs in this book are from the archives of the Daily Mail.
Particular thanks to Alan Pinnock and Steve Torrington and all the staff.

Thanks also to Alison Gauntlett, Alice Hill, Lauren Oing, Michael Quiello, Bradford Swann,
Laurence Socha, Christopher Sullivan, Patricia Annunziata, Caitlin Gildea, Cliff Salter, Jill Dorman and Richard Betts

Published by Transatlantic Press in 2011

Transatlantic Press
38 Copthorne Road
Croxley Green
Hertfordshire, WD3 4AQ, UK

© Atlantic Publishing 2011
Photographs © Daily Mail Archive
Photographs © GettyImages
(See above)

Design by John Dunne

All rights reserved. No part of this publication may be reproduced or transmitted in any form or by any means,
electronic or mechanical, including photocopying, recording, or any information storage and retrieval system,
without permission in writing from the copyright holders.

A catalogue record for this book is available from the British Library.

ISBN 978-1-907176-69-2
Printed in China

JAN 2 5 2012

355.009 H551
Hill, Duncan.
World at war :